RADICAL SENSATIONS

Dear Carl,

This book has
its roots in some
of the talks I
gave at UCSB —

Thanks for
being such
an inspiring
scholar + organizer
of inspiring
events!

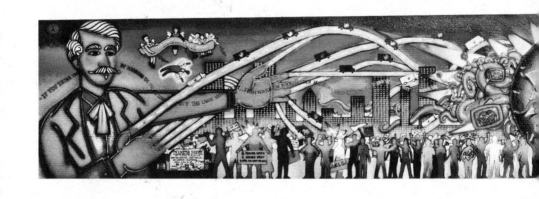

RADICAL SENSATIONS

World Movements, Violence, and Visual Culture

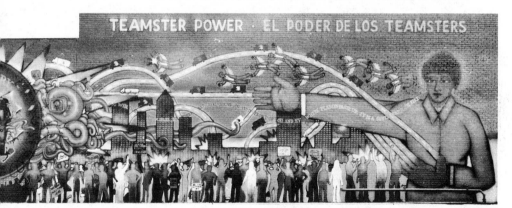

SHELLEY STREEBY

DUKE UNIVERSITY PRESS DURHAM AND LONDON 2013

© 2013 Duke University Press

All rights reserved

Printed in the United States of America on acid-free paper ∞

Designed by Heather Hensley

Typeset in Minion Pro by Tseng Information Systems, Inc.

Library of Congress Cataloging-in-Publication Data appear on
the last printed page of this book.

Frontispiece: Mike Alewitz, Lucy Parsons and the Haymarket
Martyrs, detail from *Teamster Power—El poder de los team-
sters*, 1997, 20′ × 130′. Sponsored by Teamster Local 705 and
the Labor Art and Mural Project. Painted to commemorate
the historic 1997 strike victory over UPS and dedicated to the
women and men who built this great industrial nation.

For **Curtis Marez**,
my beloved companion

in writing this book

and so much more

in Berkeley, Oakland, Chicago,
Ottumwa, Iowa City, Turlock,
Santa Cruz, Felton, San Diego,
Silverlake, Hollywood, and
Leucadia

true love

here, there, and everywhere

CONTENTS

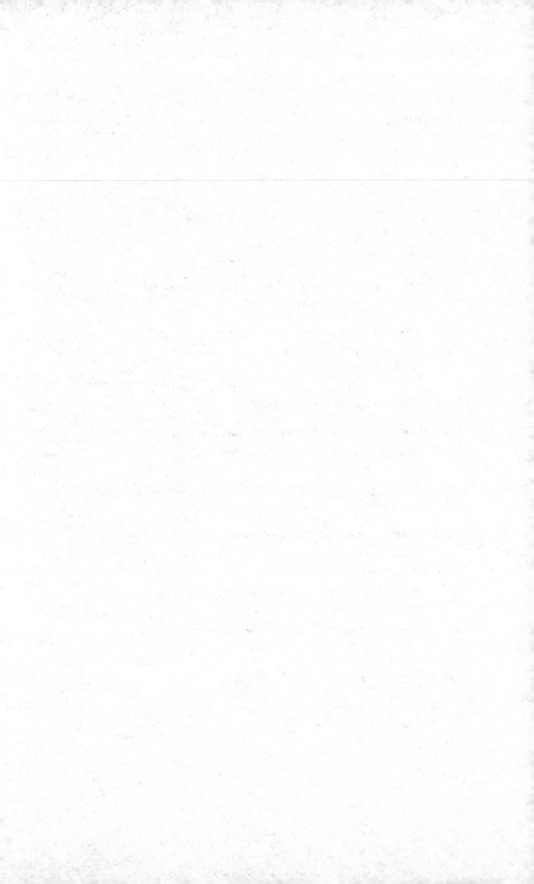

ILLUSTRATIONS

Lucy Parsons, the black, Mexican, and Indian writer, orator, editor, publisher, and organizer who appears in the frontispiece of *Radical Sensations*, is the book's origin point and its inspiration. Following her paper trail from Haymarket to the Mexican Revolution and the First World War era required the excavation of an alternate radical transnational cultural history of the period, one that emerges as much through images as through words. Her trajectory—especially her move from Texas, where she was probably born a slave and where she met the future Haymarket martyr Albert Parsons, to Chicago, where she was a leader of the anarchist movement and active to the end in radical causes—also illuminates an alternate Midwestern history, different than the one most people think they know.

Fittingly, an alternate history of the Midwest as the site of labor and other radical struggles that were crucially shaped by the movements and activity of immigrants, people of color, anarchists, and socialists is also visible in a remarkable mural that Mike Alewitz and others painted in 1998 at a site on South Ashland Avenue in Chicago, not far from where Lucy Parsons once lived and worked. This massive mural is part of a series created by Alewitz and Daniel Manrique Arias in Chicago and Mexico City to symbolize international solidarity. The South Ashland mural commemorates the successful fifteen-day Teamster strike that took place in 1997 against United Parcel Service (UPS) to protest the latter's two-tier system of employment and which broadened into a larger struggle against exploitive part-time, service, and low-wage work.

In a departure from the Teamsters' vexed history of internal corruption, Cold War accommodation and collaboration, conflicts with the United Farm Workers, and support for the Republican Party, under the leadership of the reformer Ron Carey the union shifted tactics and remembered some of the more inclusive organizing strategies of the Industrial Workers of the World (IWW), the "One Big Union" that Lucy Parsons helped to establish in 1905: the IWW tried to reach across lines of race and nation and to orga-

nize unskilled workers rather than preserve a protected, privileged status for an aristocracy of white, native-born laborers. Alewitz says he decided to focus on the UPS strike because "what it symbolized about fighting for the most oppressed sections of the workforce, for those who had the least work and the lowest wages, was part and parcel of the same struggle in Mexico."

Lucy and Albert Parsons loom large on each side of the mural, extending giant hands toward each other. Out of their fingers emerge highways with trucks upon them; these roadways curve across the mural, connecting the two. A stream of words also connects them, a compressed quotation from a speech: "If you think that by hanging us, you can stamp out the labor movement . . . from which the downtrodden millions who toil in want and misery expect salvation, then hang us. Here you will tread upon a spark, but there and there, behind you and in front of you, and everywhere, flames blaze up. It is a subterranean fire, you cannot put it out." These words were spoken during the Haymarket trial by one of the accused, August Spies, the brilliant editor and orator who had the power to move audiences in both English and his native German. Lucy made those flaming words blaze up again and again, particularly in her edited collection of *The Famous Speeches of the Eight Chicago Anarchists in Court*, which she self-published in several editions in the decades after the men died. In the mural, the words wind around a blazing orange sky, colored by an ascendant sun as well as by multiple bursts of fire all along the bottom, which spark up among groups of workers who stand along the Chicago skyline, bearing signs saying "Huelga," "Viva la Revolution!" "UPS Tightest Slaveship in the Business," and other slogans.

By including Spanish and Spanglish on these signs, Alewitz and the other artists assert that Spanish-speaking people and immigrants have long been prime movers of the labor movement in the United States, which, as Alewitz insisted in his remarks at the mural's dedication, should aspire to be "a social movement for social justice" more than anything else. Alewitz's reminder that the labor movement must be a social justice movement is necessary because of the long history of racial exclusion, white supremacy, and anti-immigrant sentiment that has all too often weakened it in the United States. The black internationalist Hubert H. Harrison, who is the main focus of much of part III of *Radical Sensations*, struggled against the exclusionary boundaries and white supremacy of Samuel Gompers and the American Federation of Labor as well as other mainstream U.S.

labor organizations for much of his life. By rooting the mural's vision of international solidarity in the Haymarket area, recalling the immigrants and people of color who built the movement in Chicago, and then re-routing it through the 1997 Teamster strike, which depended for its success on transnational and more inclusive models of organizing, Alewitz and his mural team illustrate one of this book's main arguments: that the Haymarket struggle lives on in visual culture and in many other forms throughout the world, animating struggles for social justice and inspiring creative responses from below to state and corporate power.

Lucy and Albert also loom large in the mural Alewitz and Manrique Arias painted in Mexico City, which made the workers there "very happy," according to Alewitz, "because Lucy and Albert Parsons are heroes in Mexico." Alewitz and Manrique Arias created "Sindicalismo Sin Fronteras / Trade Unions without Borders" in response to the efforts of United Electrical Workers (UE) to build cross-border ties with the Frente Auténtico del Trabajo (FAT), a union that was organized as an alternative to the labor federation established by the Mexican state. According to the story of the mural's creation in *Insurgent Images: The Agitprop Murals of Mike Alewitz*, the artist had originally planned to make Che Guevara and Malcolm X the dominant figures in the mural, but FAT members requested that he instead include Lucy and Albert Parsons, and Alewitz "was happy to accommodate their sense of labor history in which anarchist and other movements had lifted the Haymarket victims into martyrs for generations of labor demonstrators."

It makes sense that the Mexican unionists would remember Lucy and Albert Parsons because of the significance and long history of anarchist movements in Mexico, and also because of FAT's struggles against the Mexican state and state-sponsored labor organizations. On the other hand, Alewitz said that back in Chicago, when he asked a room packed with hundreds of "militant, mobilized workers" how many of them had heard of the two Chicago anarchists, only "a couple of hands went up." Alewitz hopes that the mural will contribute to "the process of relearning this history."

As I was growing up, a working-class girl in deindustrializing Iowa, I didn't know who Lucy and Albert Parsons were either, but I always found it disturbing when the forms of forgetting described by Alewitz fueled nostalgic imaginings of the Midwest as an agrarian heartland inhabited almost exclusively by white farm families clad in overalls and cut off from the

rest of the world. These forms of forgetting are colonialist, for the Midwest was Indian land and Indian people still live there. They also disavow the ways black laws and white-supremacist violence restricted the mobility and settlement of people of color, and overlook the long history and presence of black and Mexican miners, meatpackers, auto workers, and other laborers in the rural and industrial Midwest. Finally, they fail to acknowledge how the racial demographics of many Midwestern small towns have changed. In my hometown of Ottumwa, Iowa, for instance, Mexican-origin teens make up almost 20 percent of the high school population, and Spanish-language newspapers and magazines are sold at most grocery store check-out stands.

Since the 1980s, Midwestern meatpacking companies such as Cargill, Iowa Beef Processors, and ConAgra have relocated from big cities such as Chicago, Omaha, and Kansas City to Midwestern small towns near livestock field lots to cut costs. They have also recruited more and more workers from Mexico, as well as from Southeast Asia, Guatemala, and El Salvador. With the expansion of meatpacking in small towns such as Ottumwa, the Latino population in the Midwest has increased by more than 150 percent; by the year 2000, Latinos had become Iowa's largest minority group. This newly visible presence has made some of these workers a target for U.S. Immigration and Customs Enforcement (ICE), perhaps most infamously in an ICE raid, in 2009, at the Agriprocessor slaughterhouse and meatpacking plant in Postville, Iowa. During this raid in the self-proclaimed "Hometown to the World," almost 400 immigrants, mostly Guatemalan and Mexican, were arrested by federal agents who had come up with the novel plan of applying federal identity-theft laws to undocumented workers. Many of the arrested workers were held at a cattle exhibit hall; during the trial they were led out of the courthouse in chains; and more than 260 of them ended up serving five-month prison sentences, after which they were deported. The arrests and convictions provoked critical commentary both nationally and in Postville itself. The Postville Community Schools superintendent David Strudthoff said the sudden incarceration of more than 10 percent of the town's people was "like a natural disaster—only this one is manmade" and predicted that "in the end, it is the greater population that will suffer and the workforce that will be held accountable." His statement proved prophetic since in the aftermath of the raids the meatpacker declared bankruptcy, several other businesses closed, and the town lost half its population.

If Lucy Parsons's story, which I take up at the beginning of *Radical Sensations*, underlines the historical significance of immigrants, Spanish speakers, and people of color in the labor movement in Chicago, the Midwest, and the United States, then the recent history of the region sends one back to the 1920s, which I discuss in my epilogue by analyzing the deportation photos of three famous radicals: Enrique Flores Magón, Marcus Garvey, and Emma Goldman. Reading about the deportation terror in Iowa and throughout the meatpacking Midwest again as I wrote this preface, I was reminded of that other moment of terror in the wake of the First World War, when state officials used deportation as a weapon in a clampdown on immigrant labor organizers that reshaped the U.S. labor movement. But as Alewitz says of his Chicago mural, my book is also "the result of a social process" and among its "authors" are the many who not only mourned but also organized, sometimes by using mourning to organize and fight back, like those who have remembered Haymarket and the deportation terror of the 1920s down through the years. In words and images, they made connections across time and space that help me tell a different story about transnational radical cultural history in this period, and I would first of all like to thank them, although much has been destroyed by the police, state officials, and time.

In reconstructing and analyzing the paper trail left by these radicals, I owe a great deal to other scholars of radical cultural history, especially Carolyn Ashbaugh, Paul Avrich, Michael Denning, Robert A. Hill, Joy James, Winston James, Robin D. G. Kelley, George Lipsitz, Emma Pérez, Cedric Robinson, and Howard Zinn. In the last few years I have been lucky enough to participate on conference panels with Winston James and Emma Pérez, which helped me think through many of the questions I take up in *Radical Sensations*. David Roediger's work, especially *The Haymarket Scrapbook* he compiled with the help of Franklin Rosemont, was an invaluable resource. I also greatly appreciated his generous, helpful reading of an earlier version of this manuscript. My work on Hubert H. Harrison would not have been possible without Jeffrey Perry's groundbreaking scholarship, including the organizing of the Hubert H. Harrison Collection at Columbia University's Butler Library and the writing of his own luminous books on Harrison. Perry was also kind enough to answer some of my questions over email.

I also want to thank the many artists, librarians, and archivists who helped me locate images and other materials over the years and right up

to the end. I was delighted when Mike Alewitz, responding quickly to my inquiry about his Chicago mural, generously gave me permission to use his amazing vision of Lucy Parsons on the cover of *Radical Sensations*. Raquel Aguiñaga-Martinez, the visual arts associate director of the National Museum of Mexican Art, answered my questions and made available to me the Carlos Cortéz linocuts I analyze in the introduction. Kristen Graham, at the Dunn Library at Simpson College in Indianola, Iowa, deserves special mention for going above and beyond the call of duty in providing me with scans of images from some difficult-to-find issues of *Frank Leslie's Illustrated Newspaper*. Jean-Robert Durbin's expert assistance with the images I use from the Huntington Library was also much appreciated. The extensive digitized writings that are now available courtesy of the Archivo Electrónico Ricardo Flores Magón were crucial, especially for chapter 2. Here I must also mention my gratitude to the staff at the Los Angeles Public Library, who helped me with cranky microfilm equipment as I read long runs of radical newspapers there. Kate Hutchens and Julie Herrada at the University of Michigan located some of the illustrations from *Regeneración* for me, and in general the Labadie Collection was an excellent resource, especially in helping me with the discussions of Voltairine de Cleyre and her circle of anarchist comrades. The Ethel Duffy Turner and John Murray Papers at the Bancroft Library at the University of California, Berkeley, provided important material for chapter 3, and I thank Susan Snyder for her assistance with the pictures drawn from those collections. And I first located many of the sources and images for part III at the Schomburg Center for Research in Black Culture, the Tamiment Library at New York University, and the Butler Library at Columbia University, so I want to thank staff at these archives for their assistance. In particular, I appreciated the help of Tara C. Craig at the Butler Library with the images from the Hubert H. Harrison Papers.

During the last few years that I have worked at the University of California, the struggle over its privatization has sharply reminded me of the preciousness of my time in the classroom with students. As administrators plan to shift more teaching online to make money in a time of state disinvestment in public education, I often think about how much more all of us can learn together when we also talk and think together in person. It was a real joy to discuss many of the questions and issues I take up here with the graduate students in my seminars on American Studies Archives; Labor, Memory, and Culture; Projects in American Studies/Cul-

tural Studies; Cultures of Sentiment and Sensation; Transnational Literary Studies; and History and Culture. While writing this book, I learned much from the work of and conversations with the following students, and many more: Neal Ahuja, Aimee Bahng, Benjamin Balthasar, Lauren Berliner, Gabriela Cázares, Josen Díaz, Cutler Edwards, Marta Gonzalez, Lauren Heintz, Melissa Hidalgo, Anita Huizar-Hernandez, Ashvin Kini, Adam Lewis, Chien-Ting Lin, Joo Ok Kim, Jacqueline Mungia, Reece Peck, Chris Perreira, Molly Rhodes, Kyla Schuller, L. Chase Smith, Elizabeth Steeby, Oliver Ting, Stacey Trujillo, Megan Turner, and Niall Twohig. I have also been incredibly lucky in the students with whom I have had the pleasure of working over the years. Desiree Henderson, Grace Hong, Helen Jun, and Randall Williams, who have gone on to write important books, were all enrolled in the very first seminar I ever taught, at the University of California, San Diego (UCSD), and I have continued to learn from them and the other members of their cohort, as well as later arrivals such as Neda Atanasoski, Emily Cheng, Yu-Fang Cho, Omayra Cruz, Heidi Hoechst, Jinah Kim, Hellen Lee-Keller, Esther Lezra, Irene Mata, Jake Mattox, Gabriela Nuñez, and Amie Parry.

I am also fortunate to have great colleagues at UCSD, several of whom generously provided comments and feedback on part or all of this manuscript, including Luis Alvarez, Jody Blanco, Fatima El-Tayeb, Yen Espiritu, Gary Fields, Ross Frank, Rosemary George, Sara Johnson, Jin Lee, Danny Widener, and Nina Zhiri. I also wish to recognize all my colleagues in ethnic studies, literature, communication, visual arts, history, and other departments, who together make up an impressive cluster of people working in American studies broadly conceived on this campus. Beatrice Pita and Rosaura Sánchez inspire me with their own work (most recently *Lunar Braceros*, their bracing sci-fi novella), and I've enjoyed all of our conversations over soup. Working together with Lisa Lowe for almost twenty years was a rare privilege. During that time, she was at the heart of my beloved community, creating and sustaining so much of everything good here. I cherish her friendship and will miss her mightily. To Lisa Yoneyama and Takashi Fujitani, thanks for your help with this book and for everything else. The place won't be the same without you, and I appreciate all you did to try to make it better. The arrival at UCSD of Patrick Anderson, Dennis Childs, Kirstie Dorr, Dayo Gore, Sara Clarke Kaplan, Roshanak Kheshti, Daphne Taylor-Garcia, and Kalindi Vora makes me hopeful and excited about the future here despite all the challenges. I also wish to thank other

members of the UCSD community, including Michael Davidson, Ricardo Domínguez, Page DuBois, Camille Forbes, Brian Goldfarb, Luis Martin-Cabrera, Roddey Reid, Kathryn Shevelow, Nicole Tonkovich, and Meg Wesling. And since I became director of the Clarion Science Fiction and Fantasy Writers Workshop, in 2010, I have greatly enjoyed and learned from all the Clarionauts who come to UCSD each summer to imagine alternate worlds and near futures, an important collective project on campus that has been ably supported by Hadas Blinder, Sheldon Brown, Donald Wesling, Don Wayne, and Kim Stanley Robinson.

I also owe a lot to people at other institutions who have spent time at UCSD on the way. I still miss Jack Halberstam's presence, although luckily he's not too far away. I learned a great deal from teaching and thinking about Stephanie Smallwood's work, and appreciated her comments on mine. I had a breakthrough in my thinking about part III as I was working on the 16th Annual David Noble Lecture, which I delivered at the Historical Society of Minnesota in 2010, so special thanks to Roderick Ferguson for inviting me and for being such a great host, as well as to David Noble and colleagues for being such excellent interlocutors. I also benefited from conversations about part III with American Studies faculty at Carleton College in 2009, and with participants in the Reimagining the Hemispheric South conference at the University of California, Santa Barbara (UCSB), in 2010. Thanks to Nancy J. Cho and Carl Gutiérrez-Jones for organizing these two series of events. I want to thank Carl and the graduate students at UCSB for inviting me to give a keynote at that institution's Racing across Borders conference that became the basis of part III, as well as Hester Blum and colleagues at Penn State University, with whom I had useful conversations about this work in its early stages. The earliest version of part I was a paper I delivered at an *American Literary History* conference on print culture, organized by Gordon Hutner at the University of Illinois, Champaign-Urbana, and I would like to thank Hutner and all the participants for helping me think about this project at its origins.

Parts of chapters 1 and 2 were previously published in different form as "Labor, Memory, and the Boundaries of Culture: From Haymarket to the Mexican Revolution," *American Literary History*, vol. 19, no. 2 (Summer 2007): 406–33 and "Looking at State Violence: Lucy Parsons, José Martí, and Haymarket," in *The Oxford Handbook of Nineteenth-Century American Literature*, edited by Russ Castronovo (Oxford University Press, 2012). Thanks to the publishers for permission to reprint and to the edi-

tors Gordon Hutner and Russ Castronovo, respectively, for their helpful suggestions. I also want to thank Ken Wissoker at Duke University Press for being such a smart and supportive editor, and Jade Brooks for helping me with all of my questions and especially with the illustrations in *Radical Sensations*.

For the last several years, I have enjoyed being a part of the managing editorial board and an associate editor of *American Quarterly*, and I want to thank everyone involved with that collective enterprise over the years for a lot of fun and many edifying conversations, especially Marita Sturken, Curtis Marez, Sarah Banet-Weiser, Tara McPherson, Grace Hong, Kara Keeling, Jack Halberstam, Macarena Gomez-Barris, the late Clyde Woods, John Carlos Rowe, Jim Lee, Fred Moten, Laura Pulido, and Dylan Rodriguez. I have also greatly appreciated contact and conversations with other colleagues working in American Studies, including Jesse Alemán, Jayna Brown, Bruce Burgett, Cindy Franklin, Julie Greene, Susan Gillman, Kirsten Silva Gruesz, Glenn Hendler, Susan Lee Johnson, Amy Kaplan, David Kazanjian, Stephanie LeMenager, George Lipsitz, Jacqueline Shea Murphy, Chandan Reddy, José David Saldívar, Shirley Samuels, Nayan Shah, and Penny Von Eschen.

I owe a lot to my family, and they have been on my mind, especially as I finished this book. I remember coming back from college in the 1980s, another time of labor struggles in my hometown, and talking about what I was reading with my grandmother, Kathryne Clare Gage Traul, who read my college textbooks eagerly after I passed them on to her; she especially liked Harriet Jacobs. She was a telephone operator most of her life and was very highly regarded by all the other women she worked with, who would tell me so when I visited her at work. I also remember her anger about Ronald Reagan breaking the air traffic controllers' strike and her fears about what this would mean for working people, which I have often reflected on during the most recent eruption of attacks on collective bargaining and workers' rights in Wisconsin and throughout the nation.

My mother, Joyce Streeby, shaped this book in more ways than she knows. She took a lot of pleasure in teaching me to read and was patient when I wouldn't let her skip anything. I am also inspired by her work as a stained-glass artist and sustained by our political conversations and our shared values and sense of what's right. She is incredibly strong and has always amazed me by cutting and hauling wood and doing other hard outdoor work that none of the other mothers seemed to be doing. It is really

something to think that my mother and father in their sixties and seventies worked together in the woods to heat the house in this way. She left us much too soon, in November 2011, just as I was finishing this book, and I still can't make myself change all these sentences to past tense.

I also have the greatest respect and love for my dad, Jim Streeby, a truly inspiring person who has coached innumerable kids and turned them into better runners and people, even as he has fought off illness for the last eleven years. I probably would not have finished college had it not been for him, for he drove me halfway across the country to get there back in 1986 and talked me into staying when I wanted to leave. It always made me glad that he took such pride in my intelligence and encouraged my intellectual and scholarly projects at every level; not every father of a daughter feels that way.

I owe special thanks to Patrick and Kim Streeby for being such good friends to me through the years and for always, always being there, for the fun times celebrating and hanging out, and also for all the help with the hard times. My brothers Jimmy, Tony, Victor, and Eric are also part of the matrix that shaped this book. Finally, my aunt Sheila Streeby reentered my life in a fairly dramatic way just as I was finishing it, and it made me remember how she has always represented an alternative pathway for me, a way of living that extends beyond the family in her ideals of justice and service even as she comes through to support the family in ways like no other, especially for me in this last year.

I always say history is more important than blood, and so my long history of being friends with Chris Cunningham definitely makes him family. He was kind and patient enough to read the proliferating versions of all the different parts of this book as I produced or reimagined them at a furious pace in 2010 and 2011, something only one other person (Curtis!) did. For me, entire sections of this book are inextricable from memories of all of us being together during research trips to the Schomburg Center, the Butler Library, the Tamiment, and all those other archival sites where I worked and then later we played in New York City.

And I can never thank Curtis Marez enough for all the ways he makes my life better. Through all those crazy commuting years (fifteen!), when sappy songs like the Pet Shop Boys's "Home and Dry" and George Jones's "Forever's Here to Stay" always seemed so meaningful, I knew that nothing could ever tear us apart. But living and working together now is a real pleasure, no doubt.

Sentiment, Sensation, Visual Culture, and Radical World Movements, 1886–1927

Radical Sensations traces the persistent legacies of sentiment and sensation in U.S. literature, media, and visual culture from 1886, the year of the Haymarket riot in Chicago, through 1927, the year that Marcus Garvey was deported. This half-century witnessed the proliferation of rival world visions and internationalisms, as new media and visual technologies connected people across national boundaries in what the Harlem activist and intellectual Hubert H. Harrison and other radicals called the great "world-movements" of the era. In response to global imperialism, world wars, and state-driven forms of internationalism such as Woodrow Wilson's League of Nations, a variety of anarchist, socialist, and black transnational movements emerged, including the International Working People's Association (IWPA), the Partido Liberal Mexicano (PLM), the Socialist Party of America (SPA), the Industrial Workers of the World (IWW), the Marine Transport Workers (MTW), the African Blood Brotherhood (ABB), the Universal Negro Improvement Association (UNIA), and the International Colored Unity League (ICUL). I analyze adaptations, transformations, and critiques of sentimentalism and sensationalism within these movements in order to understand the connections and disconnections among them.[1]

Although these movements had different ideals and goals, the cultures of sentiment and sensation shaped radicals' debates over violence and direct action; the role of the state and the need to

seize state power or dismantle it; patriotism, nationalism, and internationalism; gender, sexuality, marriage, family, and kinship; race, empire, and anticolonial revolutions; and the significance of new visual media for these movements. Focusing especially on transnational contexts and visual culture, I suggest that after the 1860s and well into the 1920s, the cultures of sentiment and sensation continued to shape the radical movements of the era, remaining primary modalities through which alternate worlds and near futures were envisioned.

During the 1970s and 1980s, the artist-poet-editor Carlos Cortez recalled these earlier visions of alternate worlds and futures when he produced a series of linocuts—prints made from designs carved on linoleum blocks—depicting famous leaders of workers' movements.[2] One of the linocuts, which Cortez designed in 1986 to commemorate the hundredth anniversary of the Chicago Haymarket riot and its aftermath, is a portrait of the Haymarket widow, IWW organizer, and anarchist speaker, writer, and editor Lucy Parsons (see figure 1). An earlier print, from 1978, depicts the Mexican émigré anarchist and co-founder of the revolutionary PLM Ricardo Flores Magón in his prison cell in Leavenworth, Kansas, where he died under mysterious circumstances while serving a twenty-year sentence for obstructing the U.S. war effort, a crime that was defined very broadly under the Espionage Act of 1917 (see figure 2). The final linocut, which Cortez made in 1987, is a portrait of Ben Fletcher, an MTW organizer and the only black defendant among the 101 IWW leaders who, after a mass trial in Chicago, were found guilty of violating the Espionage Act (see figure 3).[3] Imagine each portrait as the lead illustration for the three parts of this book: illuminating the global dimensions of Haymarket; the relationships among anarchists and socialists in the revolutionary U.S.-Mexico borderlands; and black radicals' involvement in the great world movements of the 1910s and 1920s.

Although it may at first glance seem that the movements Cortez reenvisions were widely separated by time and space, his linocuts reveal many of the connections between them, as I have also tried to do in *Radical Sensations*. By engraving the Spanish name "Lucía González de Parsons" at the top of his portrait of the iconic radical, he reminds viewers that she was a mixed-race Spanish speaker who identified herself as Indian and Mexican; the inscription "Texas 1852–Chicago 1942" on the top right recalls her origins in the antebellum U.S.-Mexico borderlands, where she was probably born a slave, as well as her long lifetime of radical activity in

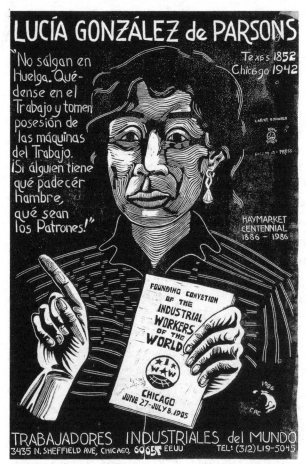

FIGURE 1 Carlos Cortez, *Lucía González de Parsons*, 1986, linocut, N.N., 34″ × 23⅛″ (paper size), National Museum of Mexican Art Permanent Collection, 1990.28, gift of the artist. Photo by Michael Tropea.

Chicago, which extended from the Haymarket era through the 1930s (see figure 1). Cortez also highlights a significant moment in her illustrious history that links her to Fletcher as well as to Flores Magón: her involvement in the formation of the IWW. In her left hand, she holds a booklet entitled "Founding Convention of the Industrial Workers of the World, Chicago, June 27–July 28, 1905," which is inscribed with the IWW globe symbol. With the other hand, she points toward a quotation from a speech she made at the convention, which has been condensed and translated into Spanish: "No salgán en Huelga. Quédense en el Trabajo y tomen posesión

de las máquinas del Trabajo. ¡Si álguien tiene qué padecér hambre qué sean los Patrones!"

This is the philosophy of the general strike, a direct-action tactic embraced by Wobblies and other radicals on both sides of the U.S.-Mexico border. Speaking in English at the convention, Parsons predicted, to applause, that "the land shall belong to the landless, the tools to the toiler, and the products to the producer," before declaring, "My conception of the strike of the future is not to strike and go out and starve, but to strike in and remain in and take possession of the necessary property of production. If any one is to starve—I do not say it is necessary—let it be the capitalist class."[4] By translating this quote into Spanish, Cortez suggests its relevance to movements involving Mexicans, Chicanos, and other Spanish speakers. And at the bottom he inscribes the name of his own organization as "Trabajadores Industriales del Mundo," thereby not only connecting Haymarket to the IWW, but also reminding viewers of the long history of leadership and participation of Spanish speakers in the IWW and other radical world movements of the period.

Direct action was a guiding principle shared by the IWW and Flores Magón's PLM, which was organized in the same year, 1905. The PLM translated Parsons's and others' calls for a general strike and the seizing of the means of production into a revolutionary appeal for "Tierra y Libertad!" in the wake of the overthrow of Porfirio Díaz. Flores Magón was the subject of the 1978 Cortez linocut in which the words "Movimiento Artistico Chicano" appear in the bottom-left corner. Through a labor-intensive process of carving his words into the linoleum block, Cortez extracts two sentences from one of Flores Magón's prison letters in order to claim him as a precursor. Cortez edited the IWW's *Industrial Worker* in the 1970s and 1980s, and contributed editorials, book reviews, and articles as well as cartoons and eventually a wide range of illustrations, many of which were made into posters, including the linocuts I recall here. His Mexican Indian Wobbly father, who came from Sinaloa, as well as his German socialist-pacifist mother shaped his ideas about art and social movements and his decision to spend two years in prison rather than fight in the Second World War.[5] In his linocut Cortez imagines Flores Magón in prison, flourishing a pen and writing a letter, thereby defying both an emergent formalist modernism and the two states and other forces that collaborated to confine and silence him (see figure 2).

The words Cortez carves into the block are a translated passage from

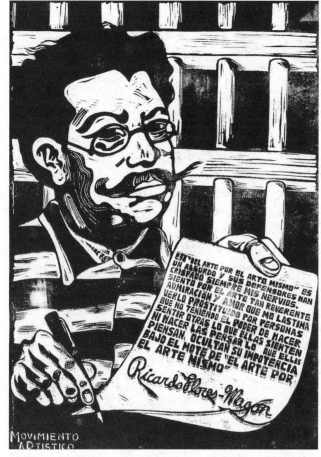

FIGURE 2 Carlos Cortez, *Ricardo Flores-Magón*, 1978, linocut, N.N., 33½″ × 23″ (paper size), National Museum of Mexican Art Permanent Collection, 1990.31, gift of the artist. Photo by Kathleen Culbert-Aguilar.

one of the more than forty letters Flores Magón wrote in the last three years of his life to Ellen White (Lily Sarnow), a young Russian anarchist who was working in New York City.[6] In this extract he ridicules the idea of "Art for Art's sake" as "nonsense" and claims its "advocates" have always "set his nerves on edge" because his own "reverential admiration" and "love" for "Art" means that it "hurts" to "see it prostituted by persons, who having not the power of making others feel what they feel, nor of making [them] think what they think, hide their impotency" under that motto. Even though the black-and-white stripes of Flores Magón's prison uniform and the bars of the cell loom large, his power to make others feel what he

feels and provoke the kinds of direct action most feared by the authorities is underlined by the pen that he holds and the letter that he displays to the viewer in his other hand as he defends a different vision of art, one that aims to inspire feeling, thought, and action. The white bars of the cell frame the space behind Flores Magón's head, positioning the viewer within the "pit wherein souls and flesh rot," where he wrote letters in English to Sarnow about poetry, art, his failing vision, his illnesses, Hope, and his strong desire to be outside with the dreamers who were working together to make the world beautiful, letters that were translated into Spanish soon after he died and published in Mexico.[7] Cortez's rendering of the quotation in Spanish suggests that translation across boundaries of language and nation was a pressing task for Flores Magón and the PLM and that it remained one of the conditions and central problems for art of the Chicano movement. By portraying Flores Magón in this way, Cortez imagines a genealogy for an art connected to world movements that provokes people to feel, think, and act in ways that may put them at odds with state and capitalist power.

Like the Chicago Haymarket anarchists that Lucy Parsons joined and later memorialized, partly through her work on behalf of the IWW and the PLM, the power of Flores Magón's words was deeply feared by those who imprisoned him several times on a variety of charges. While the state claimed that the Chicago anarchists' advocacy of violence and their incendiary words in their speeches and newspaper writings had provoked the bombing at Haymarket that killed a policeman, Flores Magón and other PLM leaders were prosecuted and jailed in the United States not only for fomenting revolution in Mexico and obstructing the U.S. war effort, but also for sending through the mail incendiary and indecent material to incite murder, arson, and treason.[8] This last charge referred to the PLM's newspaper, *Regeneración*, which was for a while published in Los Angeles, circulated in the United States and Mexico, and included an English page. These charges were repeated when Flores Magón was arrested the last time, less than a week after publishing in the PLM's paper a manifesto to the anarchists and workers of the world which predicted that the old society was dying in the conflagration of the First World War, that workers had become aware that the nation did not belong to them but was the property of the rich, and that the future would witness the unfolding of the PLM's ideal, "Tierra y Libertad."[9] The state punished Flores Magón for his direct-action-inspiring words and visions of an alternate near future,

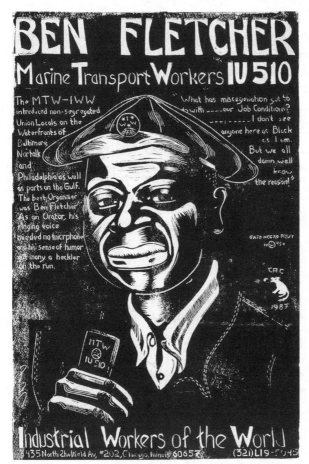

FIGURE 3 Carlos Cortez, *Ben Fletcher*, 1987, linocut, N.N., 35″ × 23″ (paper size), National Museum of Mexican Art Permanent Collection, 1992.118, gift of the artist. Photo by Michael Tropea.

judging them violations of the Espionage Act of 1917 and a threat to the nation and its First World War allies.

Ben Fletcher's powerful speeches, newspaper writings, and ability to move people to act and organize got him into trouble with the law as well. While the Haymarket anarchists and Flores Magón died in prison, however, Fletcher, who is featured in a 1987 Cortez linocut, served three years in Leavenworth before his ten-year sentence was commuted and he was released, in 1922 (see figure 3). U.S. officials later admitted that they had no evidence to support charges against Fletcher and other members of Local 8, an interracial organization of Philadelphia longshoremen affili-

ated with the IWW that actually voted not to strike during the First World War. Nonetheless, they were identified as a "danger" in a government report entitled *Investigation of the Marine Transport Workers and the Alleged Threatened Combination between Them and the Bolsheviki and Sinn Feiners* (1918), and Fletcher and 165 other IWW leaders were arrested and charged in the fall of 1917 with an array of crimes, including violating the Espionage Act. After the longest trial in U.S. history, in 1918 he and one hundred other Wobblies were quickly found guilty, given long sentences, and moved from Chicago's Cook County jail, where the Haymarket anarchists had been detained and then executed, to Leavenworth, where Flores Magón was imprisoned.[10] Fletcher's status as the only black defendant in the IWW trial at Chicago suggests both the often overlooked presence of black people in the IWW and other workers' movements of the era, as well as the color line that continued to divide these movements, as we shall see in part III.

Instead of showing Fletcher, like Flores Magón, wearing prison stripes in his cell, Cortez isolates Fletcher's head, which is covered by a union cap with an IWW pin in the center, and his right hand, which holds a small book with "MTW," "IWW," and "IU 510" inscribed on the front. In these ways, Cortez emphasizes Fletcher's multifaceted activities as an IWW and MTW speaker, organizer, and writer. In 1912 and 1913 Fletcher contributed short pieces about Philadelphia organizing to the IWW weekly *Solidarity*; he attended and spoke often at the 1912 IWW convention; and, as the words that Cortez laboriously carved into the linoleum block suggest, he was "the best Organizer" in the MTW-IWW, which "introduced non-segregated Union locals on the Waterfronts of Baltimore, Norfolk, and Philadelphia as well as ports on the Gulf." Indeed, it was this work that made him the target of the state, as Cortez's monthly paper, the *Industrial Worker*, recalled, in 1981, in a review of an article on Fletcher. This article cited a Justice Department document, dated December 1921, advising against amnesty for Fletcher, as he was "a Negro who had great influence with the colored stevedores and dock workers, firemen, and sailors, and materially assisted in building up the Marine Transport Workers Union, which at the time of his indictment had become so strong that it practically controlled all shipping on the Atlantic Coast."[11] But the MTW's power extended beyond the United States, as one IWW pamphlet of the era proudly claimed as it praised the MTW for taking "part in strikes in Tampico, Mexico, and in other ports" and for having "port delegates in England, Mexico, Chile,

Germany, Panama, Uruguay, and Argentina": "Leave it to the IWW to live up to its name!"[12] Fletcher organized alongside Spanish and Italian long-shoremen, who were a strong presence in the MTW and whose often anar-chist leanings connected them to the worlds of Parsons and Flores Magón.

Cortez's words on the linocut also call attention to Fletcher's power "as an Orator" whose "ringing voice needed no microphone" and whose "sense of humor put many a heckler on the run." He gives three of Fletcher's sen-tences a prominent place: "What has miscegenation got to do with . . . our Job Conditions? . . . I don't see anyone here as Black as I am. But we all damn well know the reason." The text alludes to occasions where Fletcher spoke to large crowds, sometimes in embattled circumstances where he was the only black person present and had to convince his audience that racism limited the workers' movement and that they should build inter-racial organizations. Cortez's reference to Fletcher's humor and also to his sometimes anomalous status in IWW contexts outside the docks is cap-tured by Big Bill Haywood's memory that in Chicago in 1918 Fletcher had joked, "If it wasn't for me, there'd be no color in this trial at all."[13]

In this series of portraits, Cortez makes connections between move-ments that are often imagined as temporally and geographically distinct from each other. By remembering Lucy Parsons as a Spanish speaker and translating into Spanish a quotation from her speech about the general strike delivered at the founding convention of the IWW, he links the Chi-cago Haymarket anarchists to the IWW, to the Mexican Revolution, and to his own moment. On the other hand, his 1978 portrait of Ricardo Flores Magón in prison reminds us of the conscientious objectors to the Vietnam War, whose status was in question when Cortez made this linocut, as well as of Cortez's own two-year sentence for refusing to serve in the Second World War, even as it recalls earlier images of those other migrant anar-chists who were confined and finally executed in Chicago's Cook County jail, as well as all of the radicals who were imprisoned during the First World War era, including Fletcher. Finally, Cortez's portrait of Fletcher in his dockworker clothing and with his IWW and MTU button and book makes Fletcher's organizing of interracial unions a model for his own times and emphasizes the historical presence of black leaders within his own movement, the IWW. The connections Cortez imagined between his mo-ment and Fletcher's are visible in a 1974 poster of a black marine transport worker flanked by four other male and female workers of color that Cortez designed and sold for $2 each in the pages of *Industrial Worker* to support

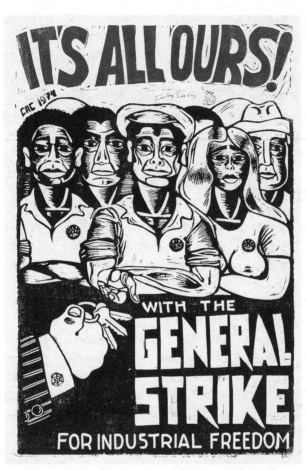

FIGURE 4 Carlos Cortez, *It's All Ours! With the General Strike for Industrial Freedom*, 1974, linocut, N.N., 28″ × 20⅞″ (paper size), National Museum of Mexican Art Permanent Collection, 1990.23, gift of the artist. Photo by Kathleen Culbert-Aguilar.

the IWW's "General Strike for Industrial Freedom" booklet (see figure 4).[14] But even as he made Fletcher's organizing into a model for contemporary workers, he also made a point of reproducing Fletcher's verbal challenge to hecklers who maligned interracial organizations as miscegenation as well as his audience-implicating charge that "we all know damn well the reason" why workers' organizations were historically segregated, in order to raise questions about the persistence of racism within those movements.

Cortez remembers these connections between and among movements partly through words but also through the cultural forms, modalities,

and technologies with which he re-envisions these movements and their leaders. Cortez's linocuts are descendants of the wood engravings of the nineteenth century that were ubiquitous in early mass-circulation periodicals such as *Frank Leslie's Illustrated Newspaper*, where many of the iconic images of the Haymarket anarchists initially appeared, as I suggest in part I.[15] Even in the wake of the incorporation of photographs into newspapers and magazines in the late nineteenth century, engravings continued to be used to illustrate action and were also relatively cheap, an important consideration for publishers of radical literature who were therefore more easily able to reproduce illustrations based on photographs and sketches, such as the many engravings and lithographs of Lucy Parsons and the Haymarket anarchists that have circulated in different forms throughout the world.[16] Cortez's linocut of Parsons remembers and repeats such traffic between different forms of visual culture even in small details: his portrait of her in a dark-striped dress recalls a photograph that she used in her own publications and which was widely copied by engravers in other print culture contexts, in her own time and in later times, as we shall see in part I. In the photograph she holds a scroll, while in Cortez's print she holds a book of the proceedings of the founding convention of the IWW; both this linocut and the one of Ben Fletcher holding his union book recall the frontispiece engravings of former slaves holding books in antislavery literature, such as Olaudah Equiano's *Interesting Narrative* (1793).

In Mexico, as Cortez reminded readers in his introduction to the compilation he edited, *Viva Posada: A Salute to the Great Printmaker of the Mexican Revolution* (2002), there was also a long, rich tradition of engraving and lithography in the popular press. The most famous of Mexico's printmakers, José Guadalupe Posada, Cortez observes, began as an illustrator of crime broadsheets, corridos, and "sensational events in the news" for the publishing house of Vanegas Arroyo, but beginning around 1900 he "also collaborated on many newspapers and magazines openly opposed to the dictatorship of Porfirio Díaz."[17] One of these periodicals was *El Hijo del Ahuizote* (1855–1903), the satirical anti-Díaz paper that Ricardo and his brother, Enrique Flores Magón, briefly edited and to which they contributed in the face of imprisonment and repeated police harassment in 1902 and 1903, just before the Mexican Supreme Court banned the publication of any article by either of the Flores Magóns and the brothers left for the United States.[18] To these and other periodicals of the era, Posada and other Mexican artists contributed cartoons that satirized those in power and

communicated across boundaries of language and literacy, which helps to explain why the editors of the PLM's newspaper *Regeneración*, which was published in Los Angeles from 1910 to 1918, frequently remarked on Mexican cartoons and used cartoons themselves when they could afford to do so.

In the United States, cartoons were strongly associated with the emergence of "yellow journalism" and the sensational mass-circulation press of the William Randolph Hearst era as well as a form of visual culture that was quickly adapted by Wobblies and other radicals who contributed to the newspapers and other periodicals aligned with the world movements of the era.[19] On the one hand, Hearst's Katzenjammer Kids and Happy Hooligan; on the other, the *Industrial Worker*'s Mr. Block, the patriotic, IWW-hating, boss-loving, perpetually obtuse blockhead who starred in a comic strip created by Ernest Riebe, which began running in 1912 and quickly became incredibly popular (see figure 5). Introducing a 1913 book of Mr. Block cartoons, Walker C. Smith observed that in "an age in which pictures play a leading part, an age where the moving picture show has stolen the audiences of the church and where the magazine without illustrations has fallen by the wayside, this little book of cartoons, showing the every-day experiences of Mr. Block — the average worker, is sent out to catch the eye and mould the mind of any Block into whose hands it might fall."[20] Remarking upon photography as a rival form widely viewed as offering a privileged window onto the real, Smith hoped that the Mr. Block cartoons might "enable the readers to see their reflection on a printed page without the air of glass or quicksilver" and thereby persuade them to disidentify with Mr. Block and join workers' movements.

But perhaps the distance between the Katzenjammer Kids and Mr. Block was not so great after all. In an editorial for the *Industrial Worker* entitled "The Funnies Ain't Funny No More" (1980), Cortez reflected on comics as "one of the World's enduring popular arts," tracing comic strips to "the rise of the photo-engraving process at the turn of the century and the facility in the mass reproduction of line drawing."[21] In response to a colleague who complained that the violence in comics had become more "sadistic" since the days of the "old time funnies," Cortez argued that the violence had always been there, but the real difference "that your scribe gazes back at with more than mere nostalgia" was the "proletarian, anti-establishment character" of many of the earlier funnies. He fondly remembered the Katzenjammer Kids setting off rockets under the king's throne and Happy Hooligan waxing "flippantly to royalty and constabulary alike." Such de-

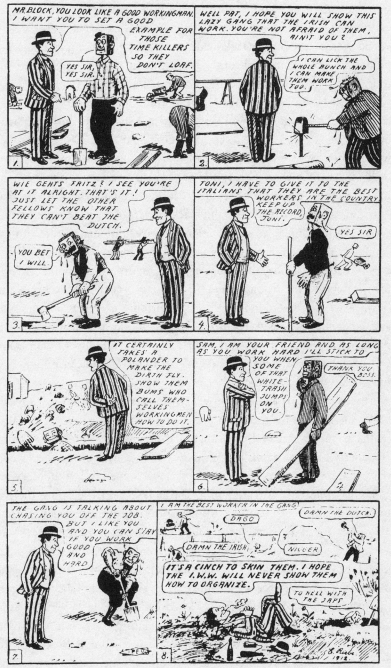

FIGURE 5 Ernest Riebe, episode of *Mr. Block*. Here Riebe shows how the boss promotes ethnic and racial divisions among workers, whom the IWW hoped to organize into "one big union." This cartoon originally appeared in the *Industrial Worker* and was collected in Ernest Riebe's *Twenty-Four Cartoons of Mr. Block*.

fiance was rare, Cortez lamented, in the comics of his own day, in which the villains, whether they were gangsters or communist foreign agents, were the only ones who questioned established authority.[22] The political cartoons that Cortez contributed to the *Industrial Worker* after the Second World War, on the other hand, made capitalists, bosses, imperialists, and politicians into villains and turned those who questioned established authority, such as Parsons, Flores Magón, and Fletcher, into heroes.

Political cartoons were also an important form in early-twentieth-century black newspapers and magazines, as I suggest in part III, partly because they offered a way to critically comment on lynching and other white-supremacist atrocities without reproducing the sensational spectacle of racial violence. Noting the prevalence of cartoons about lynching in African American newspapers, Jacqueline Goldsby suggests that "African American cartoonists and black readers of the papers themselves could control lynching's signification more readily than even the most carefully captioned lynching photograph" by using hyperbole, caricature, captions, and "drawing techniques of line, proportion, and point of view" to call attention, for instance, to the "complicity between state officials and the illegally constituted mob."[23] Political cartoons as well as photographs and other illustrations were also important in black radical periodicals published in New York City in this period, such as A. Philip Randolph and Chandler Owen's *Messenger*, the UNIA's *Negro World*, and Cyril Briggs and the African Blood Brotherhood's *Crusader* magazine.[24]

These periodicals made their own sentimental and sensational appeals to readers, such as the serialized fiction about the Spanish-American War written by the sportswriter, basketball star, and movie programmer Romeo Dougherty that was published in the *Crusader*, as well as the spectacular photographs of Marcus Garvey and other UNIA members in military regalia that appeared in *Negro World*. Throughout part III, I trace the critique of sentimentalism and sensationalism as well as the theories of visual and mass culture that emerge in the scrapbooks of Hubert H. Harrison, a major intellectual, editor, speaker, writer, and activist who was an organizer for the Socialist Party and, like Ben Fletcher, the IWW before moving on to help organize race-based movements such as the Liberty League, the UNIA, and the International Colored Unity League. While Harrison condemned the white-supremacist sensationalism of the Ku Klux Klan and the imperialist sensationalism of William Randolph Hearst, in his scrapbooks he also preserved an archive of mass-mediated images, such

as those clipped from black newspapers and other periodicals, that offered alternative world visions, engaged sentimental and sensational modalities, and mobilized people in support of black radical world movements.

While work on sentimentalism and sensationalism has often focused on antebellum U.S. contexts, in the last decade or so new scholarship has emerged on sentiment and sensation in the Americas and in diverse cultural forms after this period. David Luis Brown, Susan Gillman, Laura Lomas, and others have drawn on a rich body of reflections on sentiment and melodrama in the Americas to make the case for their significance, while Lauren Berlant, Joshua Brown, Christina Klein, Jane Gaines, Jacqueline Goldsby, Franny Nudelman, Laura Wexler, and Linda Williams have all usefully extended the discussion of sentiment, sensation, race, and visual culture after the Civil War.[25] Building on this work, I understand the sentimental and sensational as modalities that exist on a continuum rather than as opposites and which work by provoking affect and emotional responses in readers and viewers and by foregrounding endangered, suffering, and dead bodies and separated families, often in order to make political arguments about races, classes, nations, and international relations. Whereas the sentimental mode in literature tends to emphasize the refinement and transcendence of the body, the sensational mode dwells on outrages done to bodies and often refuses the closure that sentimentalism strives for, where characters are reconciled with society. But both the sentimental and the sensational also move beyond the boundaries of the literary into other cultural realms, including popular performances, songs, political speeches, journalism, and most important for this book, diverse forms of visual culture.[26] I add to this conversation by exploring the significance of new forms of visual culture for radical world movements that took up and transformed discourses of sentiment and sensation in response to problems of violence, especially state violence, in the wake of Emancipation and before the 1930s, a time when the continuities between slavery and freedom and the contradiction between empire and democracy were strikingly apparent and central to struggles over state power.

Between the 1880s and the 1920s, the role of the United States in the world changed dramatically and state violence, as well as its myriad connections to changing configurations of capitalist power, took a variety of forms. In part I, the trial and execution of the Haymarket anarchists represent one such moment of collaboration between the state and local businessmen, such as Marshall Field, George Pullman, and Cyrus McCormick

Jr., with the support of a public stirred up by sensational stories about the anarchists in the mass circulation press, including new visual media such as *Frank Leslie's Illustrated Newspaper*. In part II, the collaboration between state officials in Mexico and the United States to protect the interests of wealthy U.S. investors in Mexico, which involved covering up or idealizing as progress the often genocidal violence and brutal exploitation of Yaquis and other indigenous people, is the main focus. Transnational cooperation between states and capitalists was also evident when PLM members in the United States were arrested, tried, and imprisoned in the United States on charges of criminal libel against Díaz, violating neutrality laws, sedition, sending obscene material (their newspaper) though the mail, and obstructing the war effort. And the deportation of PLM leader Enrique Flores Magón in 1923 after he was released from prison was part of a larger wave of political deportations from the First World War era through the 1920s in which the state also punished and tried to silence Emma Goldman, Alexander Berkman, Marcus Garvey, and many other anarchists, socialists, and dissidents. These deportations and prison sentences comprise the backdrop for part III, which takes up the diverse critiques of U.S. empire and the state's failure to pass federal anti-lynching laws made by black internationalists in New York City during this period, who imagined alternate black worlds and futures in response to these forms of state violence.

All of the radicals in this book called state power into question, whether they hoped to do away with the state entirely, fundamentally change it, or take it over. The anarchists, especially, elaborated theories of state power and of alternatives to it that anticipate later theorists such as Michel Foucault, who sought "to understand Power outside the model of Leviathan, outside the field delineated by juridical sovereignty and the institution of the State."[27] An important part of this theorizing and alternate world building involved the building of "mass movements" that "recognized the centrality of racial oppression," as Joel Olson puts it.[28] Olson suggests that while "the contemporary American anarchist scene still has not analyzed race as a form of power in its own right or as a potential source of solidarity," builders of contemporary mass movements should look "less toward Europe and more toward people of color in their own back yard for historical lessons and inspiration" in doing so. Among these people of color are many of the movement builders I focus on in *Radical Sensations*, including Ben Fletcher, Lucy Parsons, Hubert Harrison, and Ricardo and Enrique Flores Magón.

Several excellent studies of transnational movements of this period have appeared, including work on black internationalism by Kate Baldwin, Brent Hayes Edwards, Robin D. G. Kelley, Cedric Robinson, Nikhil Pal Singh, and Michelle Stephens, and work on transnational literature and print culture in the Americas by Benedict Anderson, Kirsten Silva Gruesz, Anna Brickhouse, and Rodrigo Lazo.[29] I draw on both of these bodies of scholarship, but analyze the conjunctures and disjunctures between world movements in order to understand the changing relationships among them and the ways deportation and other mechanisms of state repression reshaped the Left during this period. Looking at state violence through the lens of visual culture studies and in relation to discourses of sentiment and sensation from 1886 to 1927 makes visible the linkages between and among movements as well as the differences that divided them and that still persist, in many ways, today.[30]

Editors, writers, speakers, and artists made sentimental and sensational appeals to readers when they translated political and economic struggles into melodramatic stories of villains, heroes, and victims; focused on corpses and bodies in pain in order to narrate injustice; and exposed horrors and atrocities in order to move people to act, join movements, and participate in projects of social, political, and economic transformation. Some of their newspapers, pamphlets, and periodicals circulated transnationally: José Martí's contributions to the Buenos Aires newspaper *La Nación*, Ricardo Flores Magón and the PLM's *Regeneración*, and the UNIA paper *Negro World* all reached scores of readers outside the United States. And discourses of republicanism, especially strands that denounced the crimes of tyrants and justified revolution, traveled throughout the Americas, sometimes in sentimental and sensational forms.[31] More elite versions in newspapers, political pamphlets, novels, and speeches imagined solutions to problems of state and nation-building, while more unruly meditations on law, crime, state power, and the police appeared in crime sheets, melodramas, bandit and slave narratives, cartoons, and ballads.

Throughout *Radical Sensations*, I show how the intellectuals and organizers of the radical world movements of the era adapted and transformed discourses of sentiment, sensation, and melodrama: I add José Martí to Glenn Hendler and Mary Chapman's catalogue of "sentimental men," reconstruct Lucy Parsons's negotiations of the sentimental and sensational in visual culture, and analyze Ricardo Flores Magón's melodramatic plays and Romeo Dougherty's sensational fiction.[32] But the fluid category of the

sensational also captures the state's collapsing of a distinction between words and action in charging the radicals with various crimes: radicals were policed, punished, and sometimes even executed for using incendiary and indecent words and images to urge readers to act. And radicals themselves criticized the sentimentalism and sensationalism of mass-circulation dailies, illustrated newspapers, official histories, and emerging media empires such as that of William Randolph Hearst. In these contexts, the words refer to the capture of mass culture by capitalists and states and the use of modern media to criminalize dissent and to build emotional and affective support for war, empire, and white supremacy. The different cultural meanings of sentiment and sensation from the 1880s through the 1920s suggest that both are historically shifting keywords that index struggles over popular literature and new media, visual culture, global capitalism, and state power.[33]

The keywords *sentiment* and *sensation* also illuminate rival world visions, different ways of seeing and imagining the world. One of the main claims of this book is that the changing meanings of sentiment and sensation were powerfully affected by the transformation of visual culture in this period. Although there are earlier antecedents, modern mass media and photography emerged in the mid-nineteenth century and studies of visual culture often begin there. While Marita Sturken and Lisa Cartwright place particular emphasis on "those images that since the mid-nineteenth century have been generated through cameras," other scholars, such as Joshua Brown, have shown how, even after the halftone process was patented, in 1881, and after newspapers, illustrated magazines, and pictorial histories began to use photographs to illustrate articles and stories, they continued to feature a hybrid of pictorial techniques, including photographs alongside wood engravings, process line engravings, halftone wash drawings, and cartoons.[34] Photographs, lithographs, wood engravings, and other images circulated widely in new media, provoking anxieties among the powerful about whether they would incite strong feelings, sentiments, and sensations that might lead to the overturning of existing hierarchies. The pejorative meanings of the keyword *sensational*, then, partly respond to fears that modern media and the shift to the visual might incite mass rebellion or even revolution. On the other hand, while for their part radicals worried that new visual media would be exploited by the wealthy and powerful, they nonetheless tried to use photographs, cartoons, illustrations, and other images to make connections across national and linguistic

boundaries. Since illustrations were expensive, radicals could not always afford to use them, but they intervened in practices of looking in other ways, sometimes by commenting on photographs, cartoons, and other pictures in the mass-circulation press. In doing so, they not only criticized particular images but also made a broader critique of the use of visual culture as a means of domination, by deconstructing the claims to a transparent realism made for images used to vindicate the law and justify state power.

Throughout, I attend to the cultures and movements of people who were at odds with state power and who were punished in ways ranging from police harassment and deportation to imprisonment and execution.[35] I also focus on radical movements that crossed national boundaries and on literary, cultural, and visual forms that do not fit easily into national canons and traditional disciplines. In this way, I emphasize how radicals of this era contributed to fashioning what Rebecca Schreiber calls a "critical transnationalist perspective," one that deliberately and strategically calls "attention to political, economic, and cultural relations that do not take political borders as their ultimate horizon" and that criticizes "the normative and exclusionary functions of nationalism."[36] The many displaced people, migrants, and aliens who comprised a substantial part of these movements thereby called into question the inevitability of the nation as the horizon for utopian hopes for justice, freedom, and revolution, and appealed to sympathies and solidarities that extended beyond it. In both the 1880s and the 1910s and 1920s, these strategies, critiques, and utopian visions made them targets of state power, especially in the era of Woodrow Wilson and World War I, when, as the English immigrant anarchist and editor of *Regeneración*'s English page William C. Owen put it, "Everywhere the State . . . clothed itself with powers previously undreamed of, and the powers so seized" it did not "relinquish in a hurry."[37]

In addition to *transnational* and *world*, *empire* is also a keyword in *Radical Sensations*. Although recent efforts to remap the field of American studies have sometimes involved rejecting a focus on empire in favor of the "transnational" or the "hemispheric," I suggest that we still need the keyword *empire* even as we reflect on its limits as a critical paradigm for American studies.[38] In her 2003 American Studies Association Presidential Address, "Violent Belonging and the Question of Empire Today," Amy Kaplan challenged American studies scholars to move beyond what she called "a methodology of exposure" in order to recast debates about

empire in transnational, historical, and comparative contexts. Many critics of a "U.S. empire" paradigm return to these three challenges: the transnational, the historical, and the comparative. First, the focus on the U.S. imperial nation-state risks making the United States the center of analysis at the expense of the transnational, missing affiliations and alliances below, above, and beyond the level of the nation, as well as multidirectional exchanges. Even a critical U.S.-centered analysis of empire is inadequate if it ignores other parts of the world as well as voices from other places.[39] Second, prominent scholars of empire, such as Melani McAlister, warn of the dangers of turning the story of U.S. empire into a seamless, transhistorical metanarrative instead of vigilantly recognizing difference, contradiction, and disruption.[40] Third, many have rightly insisted that U.S. empire studies should be comparative, not exceptionalist, and multilingual rather than an English-only club. Chicana/o, Latina/o, and Latin American studies scholars, many of whom use the word *empire* in their own scholarship, have been making this point for a very long time.

In other words, many of the scholars who have made *empire* a keyword have also urged us to think about the limits of the category and have reminded us of the need to attend to transnational and comparative contexts and to be vigilant about historical differences and discontinuities. The turn, or return, to questions of empire in traditional academic disciplines such as English and history during the nineties was relatively late in coming and happened in response to historical events and larger projects of public memory-making, such as those that surrounded the centennial of 1898, the sesquicentennial of the U.S.-Mexico War, and the Columbus quincentennial. In many cases, interdisciplinary and problem-based fields such as ethnic studies, cultural studies, and postcolonial studies confronted the category of empire earlier because of their closer connections to social movements that struggled over empire. In our own times, it would be strange to have *empire* recede from our lexicon while U.S. wars in Afghanistan and Iraq and debates over the decline and fall of the "American empire" continue to make it a meaningful word to a broader public and the world.

Radical Sensations is divided into three parts that take up different constellations of movements and struggles over empire, internationalism, violence, sentiment, sensation, and visual culture. This focus on social movements and culture is a crucial part of my method, for I make a point of drawing on what George Lipsitz calls the "'other American Studies,' the

organic grassroots theorizing about culture and power that has informed cultural practice, social movements, and academic work for many years," much of which has "been created by exiles, migrants, and members of other groups that have been displaced and are consequently less likely to take for granted the automatic congruence between culture and place."[41] Part I traces anarchist movements from Haymarket to the Mexican Revolution, beginning with José Martí and Lucy Parsons, who re-envisioned iconic sentimental and sensational Haymarket scenes, especially scenes related to the execution of four of the Chicago anarchists, and thereby raised questions about violence, the visual, and state power that connect world movements across space and time. Part II builds on these connections by turning to anarchists and socialists in the U.S.-Mexico borderlands in the first two decades of the twentieth century, including the Flores Magóns, John Kenneth Turner, Ethel Duffy Turner, and Lázaro Gutiérrez de Lara, who adapted and transformed discourses of sentiment and sensation in response to Mexico's Yaqui Wars, the Mexican Revolution, and U.S. military and economic interventions in the Americas. Finally, part III focuses on black radicals in New York City, especially Hubert H. Harrison, for whom struggles over empire and decolonization in the Americas were central in their imaginings of alternative black worlds that diverged from Woodrow Wilson's internationalism. The dozens of scrapbooks Harrison compiled document and critically comment on the cultures of these movements and thereby open up larger debates about violence, sentiment, sensation, and visual culture in black radical organizations such as the ABB and the UNIA and in their official publications, *The Crusader* and *Negro World*.

PART I: GLOBAL HAYMARKET

Part I traces anarchist movements from Chicago in the 1880s to the revolutionary U.S.-Mexico borderlands in the first two decades of the twentieth century. I begin by comparing Martí's and Lucy E. Parsons's interventions in visual culture in the Haymarket era. Martí's years in the United States and his changing stance on Haymarket have long been a focus for scholars, and in what follows I emphasize how he responded to a changing visual culture and new mass-produced images of Haymarket.[42] In his newspaper writings, Martí works over and re-envisions the images of Haymarket that circulated widely: scenes of the speeches and bombing at Haymarket, the trial, the anarchists' imprisonment, visits from family and friends, their final hours and execution, and their funeral were graphically illustrated in

lithographs, cabinet cards, cartoons, mass-circulation daily newspapers, weekly illustrated papers, pamphlets, and books. Although Martí initially condemned the anarchists and defended the state, after the executions he adapted and altered discourses of sentiment and sensation to mobilize sympathy for the anarchists. In part I, I suggest that Martí's revision of the "escenas extraordinarias" in Chicago illuminates the global significance of Haymarket and the transnational anarchist movement at the end of the long nineteenth century and at the beginning of an era of revolutions in Russia and Mexico.

Twenty-five years later, Lucy E. Parsons issued a special edition of the *Famous Speeches* of the Haymarket anarchists that included an illustration of the execution, one of the most widely reproduced of the Haymarket scenes. This was the era of Parsons's involvement with the IWW, but it was also a time when she gave public lectures about the Mexican Revolution as an example of direct action, and raised money for Mexican anarchists and IWW members who were imprisoned in the United States, including the Flores Magóns. Like Martí, Parsons both drew on and diverged from discourses of sentiment and sensation as she intervened in late nineteenth-century practices of looking. In the two editions of *The Life of Albert R. Parsons* (1889; 1903), the story of her late husband's life that she compiled, she did not include a picture of the executions, but instead emphasized what was obscured by the mass-circulation dailies and the illustrated press, despite their claim to a new graphically illustrated realism in their coverage of Haymarket. More than twenty years would pass before she would decide to include such a picture, and when she finally did she carefully explained that the illustration was an example of tyrannical state power rather than the "vindication of the law," as *Frank Leslie's Illustrated Newspaper* had claimed in a caption to an iconic illustration back in 1887. Parsons makes a sentimental appeal to readers' hearts as she tries to guide their practices of looking, but she does so in hopes of provoking sympathetic action rather than voyeuristic withdrawal into the spectacle.

Next, I analyze how, during the Mexican and Russian Revolutions and the First World War, Haymarket was often remembered by those who imagined alternatives to state power and who were punished by states for doing so, including the Flores Magóns, William C. Owen, Alexander Berkman, Emma Goldman, and many others who were targeted by federal immigration, citizenship, sedition, and obscenity laws. Even as Haymarket memory-makers looked backward by imagining their own struggles as

part of an ongoing war against slavery, they also remembered Haymarket in order to face the revolutionary future. Although the First World War and the Bolshevik Revolution undoubtedly impacted the emergence of the radical world movements of the 1910s and early 1920s, the Mexican Revolution and U.S. military interventions in Mexico and the U.S.-Mexico borderlands during these years also shaped debates about labor, land, race, revolution, and state power. The U.S. bombing and occupation of Veracruz in 1914, the deployment of U.S. soldiers against Pancho Villa in New Mexico in 1916, the repeated threat of another U.S. war in Mexico to protect U.S. investments there, and the harassment and imprisonment of critics of Porfirio Díaz were all important flashpoints. On the other hand, the Mexican Revolution and the forms of direct action it inspired figured prominently in Haymarket memory-makers' visions of "near future," worldwide revolutionary transformations.

PART II: REVOLUTIONARY U.S.-MEXICO BORDERLANDS

While part I situates anarchism as what Benedict Anderson calls a "globe-stretching" and "nation-linking" movement from Haymarket to the Mexican Revolution, part II begins by focusing on the relationships between socialist radicals in the United States and Mexico.[43] In the first issue of the PLM's paper *Regeneración* that was published in Los Angeles, in 1910, two photographs memorialized a hopeful moment of transborder solidarity, when John Kenneth Turner and his wife, Ethel Duffy Turner, the Mexican lawyer Lázaro Gutiérrez de Lara and his wife, and other prominent socialists welcomed PLM leaders to Los Angeles after they were released from an Arizona prison where they had served eighteen months for violating U.S. neutrality laws. Photographs were relatively uncommon in *Regeneración* since the paper operated on a shoestring budget, so their inclusion suggests they showed something that the PLM particularly wished to make visible. After Díaz was overthrown and Madero took power, however, this image of transnational solidarity shattered, for while socialists such as the Turners viewed Madero's presidency, at least at that moment, as an acceptable end to the Mexican Revolution, the PLM pressed for anarchosyndicalist alternatives to centralized state power as well as the redistribution of land and other more radical changes.

In part II, I compare the story told in the pages of *Regeneración* to those that emerge from the archives of Ethel Duffy Turner, who was for a time editor of the paper's English page, as well as from the work of her

then husband, the muckraking journalist John Kenneth Turner, who wrote *Barbarous Mexico*, a sensational exposé of Porfirio Díaz's Mexico that contemporaries compared to Harriet Beecher Stowe's *Uncle Tom's Cabin*. Like Stowe, in *Barbarous Mexico* Turner adapted discourses of sentiment and sensation to expose the evils of what he and the PLM called slavery: the state violence directed at Yaqui Indians in northern Mexico, which became a powerful symbol of the tyranny of the Porfiriato and thereby helped to justify the Mexican Revolution. I emphasize the importance of the illustrations in many of the first extracts, which were originally published in a variety of periodicals, including the *American Magazine*, an illustrated, mass-circulation, family periodical that was a continuation of *Frank Leslie's Popular Monthly* (1875–1906) as well as the *International Socialist Review* and *Regeneración*, which were linked to the radical world movements of the era. The *American Magazine* series was dominated, in both words and pictures, by beating scenes and other sentimental and sensational spectacles of suffering, although Turner repeatedly worried about the dangers of looking at such scenes and about the possibility that they might provoke responses other than sympathetic action. The *International Socialist Review* also included illustrations and drew on discourses of sentiment and sensation, but the photographs as well as the excerpts from Turner's story that appeared there and in *Regeneración* insisted on the role of the "American Partners of Díaz" in the making of modern Mexico.

Barbarous Mexico was shaped by Turner's close connections at that time to the PLM and to Lázaro Gutiérrez de Lara, who collaborated with Turner on this project, and it was part of a body of transnational literature about the Porfirio Díaz regime that was published in the United States in the years leading up to and during the Mexican Revolution. The writers of this literature also made sentimental and sensational appeals to readers, especially in *Regeneración*, and turned the problem of Yaqui "slavery" into a symbol of the horrors of the Porfiriato, but they emphasized the partnership between Mexico and the United States rather than isolating spectacles of suffering to provoke outrage and action. Still, within a year the Turners and Gutiérrez de Lara parted ways with the PLM and left *Regeneración* because of socialist-anarchist disagreements over the goals of the Mexican Revolution, thereby abruptly ending this episode of transnational collaboration between anarchists and socialists in the revolutionary U.S.-Mexico borderlands.

Meanwhile, the parts of Turner's story that were published in the *Ameri-*

can Magazine attracted far more attention and were reproduced far more widely in the United States than any of the other parts of *Barbarous Mexico* or any of the rest of the transnational "horrors of the Porfiriato" literature. I trace the *Barbarous Mexico* story in a host of popular narratives, including the Mexican adventures of Frank Merriwell, the most popular figure in the dime novel's "twilight era." All of these stories call attention to the dispossession and exploitation of the Yaquis and condemn Mexican atrocities by mobilizing sentimental and sensational conventions and structures of feeling, but while *Barbarous Mexico* exposes and renders villainous the "American Partners of Díaz," the U.S. presence in Mexico is forgotten or celebrated in most of the other popular versions.

In my conclusion to part II, I call attention to the mediated memories of Chepa Moreno, a Yaqui woman who was deported to Yucatán, survived years of hard labor, and ultimately returned to Sonora, as a counterpoint to these sentimental and sensational narratives of Yaqui slavery and suffering. Moreno's narrative clarifies the boundaries of the transnational socialist solidarities that were precariously forged in the U.S.-Mexico borderlands during this period. Socialists on both sides of the border privileged the capture of state power and often failed to recognize the significance of indigenous struggles that were not made in behalf of the nation. They also inherited and contributed to a legacy of Asian exclusion, which imagined the Asian migrant as a threat to the nation and to the working classes. These problems persist, troubling the histories of slavery and U.S. imperialism and neocolonialism in Mexico that were remembered and forgotten in sensational radical and mass cultures during the Mexican Revolution.

PART III: BLACK RADICAL NEW YORK CITY

In scholarship on black modernity and the radical internationalisms of the twentieth century, the writings and career of W. E. B. Du Bois have often been central, and for good reasons, since he is one of the major intellectuals and writers of the period. In part III, however, I explore formations of black radical transnational culture which are in dialogue with but diverge from the work of Du Bois, the National Association for the Advancement of Colored People (NAACP), and the *Crisis*, especially in relation to the boundaries of middle-class uplift ideology, the politics of respectability, and the place of the nation in their visions of the future. In doing so, I build on work on black radical internationalisms of this era, especially Michelle Stephens's *Black Empire*, which explores how, in the first half of the nine-

teenth century, "Black male subjects from the English speaking Caribbean attempted to court a chart for the race in the interstices between empire, nation, and state."[44] While Stephens emphasizes how migrant black radicals such as Cyril Briggs responded to the Bolshevik Revolution, something that Kate Baldwin also examines in *Beyond the Color Line and the Iron Curtain*, I suggest that they also looked to the Mexican Revolution and struggles over empire and decolonization throughout the Americas. As well, I focus on the critique of sentiment and sensation as modalities through which to imagine alternative worlds that emerges in the writings and scrapbooks of Hubert Harrison, who came to New York City from the Virgin Islands in 1900 and moved in and out of many of the great world movements of his era, including the Socialist Party, the IWW, and the UNIA.

In *Black Empire* the spectacular and sensational strategies and appeals of Marcus Garvey and the UNIA and of Cyril Briggs and the ABB are central to the story of the "internationalisms" of the New Negro in the 1910s and 1920s. Stephens suggests that "Marcus Garvey's historical significance lay in his ability to imagine and then mobilize the black masses around a spectacular vision of black transnationality," such as the James Van Der Zee photographs of him in the regalia of a black emperor, the massive New York City parades, the international conventions, and the Black Star Line, which he promoted with photographs of the *Phillis Wheatley*, a ship that he did not own, and which led to his conviction on charges of mail fraud and, ultimately, to his deportation. These "spectacles of Black statehood," Stephens argues, "allowed his Black and colonial spectators to envision the impossible—the virtual or imagined fulfillment of their desires for inclusion within the world-order of nation-states in construction after World War I."[45] Stephens also places the sensational fiction of Cyril Briggs within the contexts of world war, revolution, and the League of Nations in her reading of Briggs's *The Ray of Fear: A Thrilling Story of Love, War, Race Patriotism, Revolutionary Inventions, and the Liberation of Africa*, which was serialized in the *Crusader*, a monthly magazine that Briggs edited and which included an eclectic mix of editorials, articles, installments of serialized fiction, recipes, poems, book reviews, pictures, and advertisements.[46] For Stephens, *The Ray of Fear* is an especially revealing example of the black empire narrative, which flourished in the first third of the twentieth century and which "attempted to imagine some version of an internationalist revolutionary Black state," thereby expressing both "impulses toward racial revolution, movement, and freedom" and "impulses towards

militarism, statehood, and empire." And it was the Russian Revolution, Stephens claims, which "became a motivating force for shaping an alternative vision of racial revolution" in these narratives of black empire and longing for a state.[47]

While the example of the Russian Revolution was undoubtedly significant, wars of empire and struggles over decolonization in the Americas also inspired alternative visions and longings, as the editorials, stories, and pictures published in the *Messenger*, *Negro World*, and the *Crusader* reveal: there was considerable material on Mexico, Haiti, Cuba, Brazil, and other sites of anticolonial struggle, revolution, and black settlement in the Americas. One notable example is Romeo Dougherty's "Punta, Revolutionist," a "great thrilling serial story of love, mystery, adventure, revolution, and the renaissance of a race," which first appeared in the December 1918 issue of the *Crusader*. Dougherty, a basketball star, sportswriter, and movie exhibitor, set his story during the Spanish–American War. The story's hero, Harry Lonsdale, is a black war correspondent for a sensational newspaper, the *New York Thunderer*, who is covering the war on the fictional island of Santo Amalia. The story draws the African American hero into an anticolonial, revolutionary world movement and remembers connections between struggles in different parts of the Americas as well as some black U.S. soldiers' disaffiliation from the white nation during the Spanish–American war. At the same time, however, the fantasy solution requires and romanticizes hierarchical relations of race, gender, and sexuality and military counterformations long familiar from the genre of sensational colonial adventure and conquest fiction, which this novel adapts and transforms. In these ways, the sensational form expresses the contradictions of which Stephens writes, turning at once toward revolution and freedom as well as toward militarism and other deeply hierarchical and patriarchal forms of collectivity in this story of inter-American romance and race war and in the story within the story about sensationalism and empire.

While Garvey, Briggs, and Dougherty made sensational appeals to a mass audience through photographs and fiction, Hubert Harrison's interventions into debates over sentiment and sensation, uplift, empire, and black world movements qualifies him, as I argue throughout part III, as a major theorist of race, social movements, modern media, and visual culture. Harrison was an organizer in the Socialist Party in the early 1910s, but he ultimately turned to race-based organizations such as the Liberty

League, the UNIA, and the ICUL to imagine alternatives to official internationalisms after the First World War and the Mexican and Bolshevik Revolutions. The dozens of scrapbooks he compiled and the newspapers and other periodicals to which he contributed reveal much about the complex and changing relationships between movements that have usually been examined separately. In these scrapbooks, using clippings and ephemera and making frequent annotations, Harrison creates stories about his life in these movements as well as narratives about modern science and technology and about many different parts of the world, including Africa, the Caribbean, Central America, and Mexico; alternative histories of the "Negro-American" in the Civil War, Reconstruction, and First World War eras; critical views of the "White Man at Home" and modern race science; and interventions into contemporaneous debates over internationalism, colonialism, and black "world-movements," spaces, and imagined futures. I suggest that Harrison selected fragments and images from newspapers and magazines in order to construct narratives of "Negro American" life that connect the domestic to the foreign, understand race as a world problem, and turn a critical gaze on white mobs, leaders, and national symbols rather than circulating more images of black bodies in pain.

Harrison criticized Du Bois and the NAACP for what he described as their sentimental and sensational antilynching strategies, such as picketing D. W. Griffith's *Birth of a Nation* and publishing photographs of lynching's victims, because he believed they failed to acknowledge the pleasure some whites took in black suffering. And although he was a member of the UNIA for a while and edited and contributed to *Negro World*, Harrison ended up breaking with Garvey, partly because he considered Garvey's schemes for redeeming Africa "sensational": Harrison came to believe that Garvey knew little about Africa, dismissed or was ignorant about what Africans were doing in Africa, and made excessive, fraudulent claims about the Black Star Line. In his scrapbooks, Harrison also exposed how modern media promoted sensational, idealized visions of whiteness in mass-circulation magazines such as *Hearst's Magazine* as well as in newspapers, newsreels, and motion pictures. But Harrison used modern media, popular culture, and images in different ways as well, to build support for the "great world-movements for social betterment" of which he was a part. I thus understand Harrison's diary and scrapbooks as an alternative archive of his life in movements, as he moved beyond the boundaries of the white, heteronormative, middle-class home and the limited and hierarchi-

cal imagined community of the nation into other kinds of spaces where different worlds might be imagined.

It is this imagining of different worlds that I have tried to illuminate in *Radical Sensations*, by turning to the adaptations and critiques of sentiment and sensation and the uses of visual culture made by intellectuals and organizers of radical world movements. In bringing together these different movements, times, and spaces, I also draw on recent work on time, temporality, and the imagining of alternate worlds and futures by queer theorists such as José Esteban Muñoz, Kara Keeling, Jack Halberstam, and Elizabeth Freeman, which helps us to understand queer alternatives to the orderly, unilinear, progressive organization of time and temporality assumed by traditional, discipline-bound, and disciplinary histories. Muñoz defines queerness as "a temporal arrangement in which the past is a field of possibility in which subjects can act in the present in the service of a new futurity," thereby working against "static historicisms" and "empiricist historiography."[48] Muñoz's emphasis on acting in the present to imagine a new futurity is important, for as Tavia Nyong'o reminds us, time-bending and lingering in the past may align with conservative historicism as well as historical materialism. Indeed, Nyong'o suggests that for Tea Party advocates and Civil War re-enactors, time-bending may serve as a "bastion of white male identity politics," promoting the idealization of an historical period prior to black citizenship and foreclosing "a reckoning with black radical strivings that are immanent to but never fully contained by the nation's story."[49]

In what follows, I seek to tell a queer alternate cultural history by mixing up and juxtaposing different times and temporalities, as well as by crossing disciplines and analyzing different cultural forms. But I also, as Nyong'o advises, try to keep track of "how time accumulates—in and as forms of (racial and national) property," even as radical counter-memory exerts a "dispossessive force" against that accumulation.[50] In doing so I build on the efforts of many of the radicals I study to imagine alternate worlds and near futures by disassembling and reordering time and temporality to connect the past as a field of possibility to an action-oriented present. Hubert Harrison's scrapbooks, which rearrange time and space to make unexpected connections that are shaped by his engagement with a queer black radical transnational subculture, are perhaps the most obvious example, but Haymarket memory-makers such as Lucy Parsons, Voltairine de Cleyre, and Enrique Flores Magón, as well as borderlands socialists and

anarchists such as John Kenneth Turner, Lázaro Gutiérrez de Lara, and Ricardo Flores Magón, who called for revolution in Mexico by remembering nineteenth-century civil wars, also disassembled and reordered time in these ways. As well, theories of queer time and alternative forms of kinship and sociality to those of heteropatriarchy are useful in thinking about imaginings of the future in anarchist and free-thought movements, with their critiques of marriage and greater openness to other arrangements of intimacy, kinship, and sociality, as well as in the diasporic black public spheres that pushed Harrison and some other black radical internationalists beyond the bourgeois boundaries and linear, progressive temporality of dominant versions of the uplift movement.[51]

The need to mix and juxtapose different times and spaces, to move backward and forward in time and find points of convergence as well as departure and lines of flight, means that the story I tell does not fit neatly into conventional periodizations of U.S. history, literature, and culture. The persistence of the sentimental and sensational during these years is rarely accounted for in narratives of U.S. literary history that emphasize the 1880s through the 1920s as a time of transition from an antisentimental realism and naturalism to modernism and the proletarian literature of the 1930s. And partly because these radicals often used cultural forms other than fiction and poetry, such as speeches, political pamphlets, journalism, and visual culture, the significance of radical cultural production in these years has often been radically underestimated. When we imagine that the 1930s were the moment in the United States where there was a first flowering of proletarian culture, we miss this earlier efflorescence of radical culture, which often took more international and transnational forms than did the thirties radicalisms of Michael Denning's The Cultural Front (1998). But it is also important to remember, as Denning does, that internationalisms and transnational cultural genealogies were also significant for radical movements in the thirties and after, even though the deportations and other forms of state repression in the wake of the First World War reshaped the U.S. Left and helped to produce the greater emphasis on the ethnic Americanisms that Denning analyzes so powerfully.[52]

By reconstructing intersections, borrowings, tensions, and collaborations between and among world movements that, because of differences of time, place, national origin, and race and ethnicity, have often been studied in isolation from each other, I hope to contribute to a better understanding of the moments of conjuncture and disjuncture that brought them

together and divided them. Each part of this book reveals how sentiment and sensation traveled across temporal and national boundaries as well as the boundaries among different forms and sectors of culture. But each also clarifies the limits of the sentimental and sensational as expressive modes through which to address injustices, as well as the limits to what and who can travel and what can be shared. Throughout, I suggest that the intersection of sentiment and sensation, text and image, with new technologies and forms of visual culture comprised a formative matrix for radical movements that crossed national boundaries, criticized state power, and envisioned alternate worlds from the 1880s through the 1920s.

Part I

GLOBAL HAYMARKET

1 | Looking at State Violence

LUCY PARSONS, JOSÉ MARTÍ, AND HAYMARKET

In late 1887, while he was living in New York City, José Martí wrote about the Chicago anarchists who were hung after being found guilty of inciting the violence at Haymarket Square that led to the death of a police officer on May 4, 1886. Several other people also died and many more were severely injured as a result of the blast of a bomb as well as the bullets that civilians and the police fired into the crowd and, accidentally, at each other. Although the bomb-thrower's identity was never determined, the state claimed that the anarchists were part of a conspiracy to "excite the people, or classes of the people" to "sedition, tumult and riot" in order to "overthrow the existing order of society and to bring about a social revolution by force." As part of that conspiracy, it charged, the anarchists, in their speeches, newspaper writings, pamphlets, and broadsides, used "incendiary," sensational language to provoke the murder of the police.[1]

The "drama" of Haymarket, as Martí called it, which included the anarchists' imprisonment, trial, appeals, and execution in the months that followed, was crucially mediated and shaped by the late-nineteenth-century expansion of the pictorial marketplace and the transformation of visual culture. In the wake of the removal of state-sponsored executions from public spaces, an emergent mass visual culture promised access to forbidden scenes of punishment, while the state and the police tried to use new visual technologies and cultural forms to turn Haymarket

into a spectacle, enforce their own interpretations, and regulate the responses of viewers and readers.[2] José Martí and Lucy E. Parsons, on the other hand, intervened in late-nineteenth-century practices of looking by re-envisioning iconic sentimental and sensational Haymarket scenes and raising questions about violence, the visual, and state power that connect world movements across space and time.

Many scholars of Martí's years in the United States have suggested that Haymarket coincided with a larger transformation in his thinking: I build on this work by emphasizing how he responded to a changing visual culture and new mass-produced images of Haymarket. Although in an earlier piece Martí harshly criticized the anarchists and defended the state, after the executions he adapted and altered discourses of sentiment and sensation in order to reimagine iconic Haymarket scenes and mobilize sympathy for the anarchists. Martí's chronicles, which were written for the Buenos Aires newspaper *La Nación*, reached readers in Argentina, Mexico, Cuba, the United States, and other parts of the Americas, for whom debates about violence and the state in visions of future revolutionary and anticolonial transformation were both relevant and pressing.[3] By the late 1880s, as Benedict Anderson has observed, globe-stretching and nation-linking networks connected anarchists in many different parts of the world, notably including Cuba, Mexico, the Philippines, Spain, the United States, China, France, England, and Japan, and anarchism had become "the dominant element in the self-consciously internationalist radical Left."[4] As a writer for a Spanish-language newspaper with a transnational circulation, Martí participated in just such a network, but as an anticolonial, revolutionary nationalist, he was alarmed by anarchist objections to the nation-state, although he ambivalently admired their passion for social justice and sympathized with their desire to change the world. Martí's anxieties about working-class violence and his commitment to the ideal of a utopian, fraternal, and anticolonial nation shaped his perspective on "la guerra social" in Chicago, despite his outrage at the police violence and the legal injustice that followed. Even so, Martí's chronicle of the "escenas extraordinarias" in Chicago suggests the global significance of the Haymarket drama, as he called it, as well as the challenges posed by anarchist world movements to nations and nationalisms at the end of a long century of anticolonial wars and nation- and empire-building in the Americas.[5]

In representing Haymarket as a global drama to a world audience, Martí's chronicles also respond to significant transformations in visual cul-

ture. He repeatedly refers to or re-envisions in words the images of Hay-market scenes that were disseminated by means of new technologies such as the telegraph and the camera and in illustrations based on photographs and eyewitness sketches (see figure 6). Scenes of the speeches and bomb-ing at Haymarket, the trial, the anarchists' imprisonment, the visits made by family and friends, the anarchists' final hours and execution, along with the massive public funeral that followed, were graphically illustrated in lithographs, cabinet cards, cartoons, albums, mass-circulation daily news-papers, weekly illustrated papers, pamphlets, and books.[6] Many of Martí's elaborately rendered "escenas" suggestively evoke the most iconic images of the conflict, including line drawings of the explosion of the bomb at Haymarket Square, photographs of the anarchists, and illustrations of the suicide in his prison cell of the youngest of the anarchists, Louis Lingg (see figure 7), a German immigrant youth who, Martí marveled, wanted to "desventrar la ley inglesa / eviscerate English law" and did not even speak English![7] Martí was not alone in reworking such visual material, for the anarchists and their allies also struggled to make use of newly ubiquitous images by reproducing and reimagining iconic ones. The struggle over the meaning of Haymarket, then, was also a struggle over the images of state violence and anarchist world movements that circulated in the popular press and through the transnational networks of which Anderson writes.

Martí's modernist newspaper chronicle recasts a wide range of such popular images and narratives of the Haymarket drama: he responds to the events of the day by assimilating, revising, and stylizing the represen-tations of an emergent mass visual culture. As Julio Ramos suggests, the Latin American chronicler at the fin de siècle struggled to "dominate in the very process of representation" a "conjunction of materials, tied to jour-nalism."[8] In this way, Martí seeks to "overwrite" (107) inscriptions of U.S. newspapers, anarchist literature and culture, and other sources with his own interpretation of the events.[9] But although Martí cites anarchist litera-ture as he criticizes the state's case and the representations of Haymarket purveyed in mass culture, he ultimately draws back in horror from the an-archists' denial of the patria, for he remained committed to the ideal of the nation and to republican institutions even as he was forced to confront the question of whether violence against the state was necessary in anticolonial contexts.

Twenty-five years after Martí wrote his chronicle, Lucy E. Parsons self-published a memorial edition of the *Famous Speeches* of the Haymarket

NEWSPAPER

—Vol. LXV.] NEW YORK—FOR THE WEEK ENDING NOVEMBER 19, 1887. [Price, 10 Cents.

NINA VAN ZANDT SPIES REFUSED ADMISSION TO THE JAIL.

IS.—THE DOOM OF ANARCHY—SUICIDE OF LINGG, ONE OF THE CONDEMNED, BY MEANS OF A DYNAMITE CAP.
FROM A SKETCH BY WILL E. CHAPIN. SEE PAGE 219.

FIGURE 6 "The Doom of Anarchy—Suicide of Lingg, One of the Condemned, by Means of a Dynamite Cap." *Frank Leslie's Illustrated Newspaper*, November 19, 1887. Dunn Library, Simpson College, Indianola, Iowa.

anarchists that gave a prominent place to an illustration of the gallows scene, one of the most widely reproduced of the scenes associated with Haymarket. During this era, Parsons was one of the founding members of the IWW, the "one big" U.S. union that organized immigrants and women, and one whose official publication declared that workers had "no country" and frequently criticized the sentiment of patriotism. Parsons also made speeches and raised money for Mexican anarchists who were imprisoned in the United States, such as Enrique and Ricardo Flores Magón, two of the

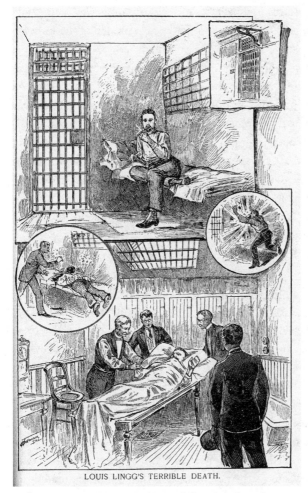

LOUIS LINGG'S TERRIBLE DEATH.

FIGURE 7 "Louis Lingg's Terrible Death." In *Anarchy and Anarchists* (1889), by Michael J. Schaack.

leaders of the revolutionary PLM, a transnational movement that initially helped to overthrow Porfirio Díaz and eventually tried to push the Mexican Revolution in an anarchist, rather than liberal reformist, direction.[10]

In his second Haymarket chronicle Martí referred to her as "la mestiza Lucy Parsons" and declared that her tempestuous eloquence and heroic efforts to wrest the bodies of the anarchists from the gallows amazed him. She may have been a former slave and was described in the popular press as a "mulatto" although she claimed to be solely of Mexican and Indian descent. She played an active role in the events surrounding Haymarket,

for she was an important organizer, writer, and orator as well as the wife of Albert Parsons, one of the leaders of the Chicago branch of the International Working People's Association (IWPA) and the editor of the anarchist newspaper the *Alarm*, who was hung along with three of the other Chicago anarchists. In the years after the executions, Lucy Parsons continued to write, speak, and organize, and compiled the *Life of Albert R. Parsons* (1889; 1903) as well as the *Famous Speeches* of the Haymarket anarchists, which went through many editions and translations and traveled all over the world. This last text was eventually illustrated with a few prominent images, most notably an illustration of the gallows scene that Parsons instructed her reader to "look at" while swearing "in your heart" to work for the overthrow of the "accursed system" that was responsible for the "awful murder of our comrades."

In bringing Lucy Parsons and José Martí together, I combine insights from nineteenth-century visual-culture studies with methodologies in literary studies that look below, above, and beyond the nation and the state, unsettling both as the primary horizons of analysis. As the Martí scholar Laura Lomas suggests, much of the recent revisionary American studies work on transnational literature in the Americas has focused on "the multilingual and deterritorialized routes and roots of Latino or transamerican writing in the work of mainly light-skinned Creole elites of early to mid-nineteenth century Cuba." By the 1880s, in the wake of "truncated wars of independence and after the gradual abolition of slavery began," the "numbers of islanders and other Latino Americans in multiracial barrios, especially Florida, swelled to the thousands."[11] Many were anarchists who questioned what they saw as the narrowness of the idea of national independence championed by the previous generation of exiles and émigrés as well as by wealthy businessmen prominent in the independence movement of their own time.[12] Martí's perspective on Haymarket, which betrays anxieties about anarchism as a rival worldview as well as sympathy for the Chicago anarchists, was thus shaped by his complex relationships with Cuban anarchists and by debates over state power, violence, direct action, and political reform within and around the independence movement.

For Haymarket was an epochal event that provoked responses not only in Chicago and the United States, but also in Cuba, Mexico, Spain, Russia, Germany, England, and other places where anarchism flourished. And despite his ambivalence about the Chicago anarchists, Martí, like Lucy Parsons, was part of a larger world of migrants, writers, and organizers at odds

with or openly critical of states and state power, including anticolonial revolutionists, socialists, and anarchists. In the United States, many anarchists, like most of the men on trial at Haymarket, were immigrants. Lucy Parsons and her husband, Albert, were both born in the United States, but they cast their lot with the German immigrant workers who led the Chicago labor movement when they joined the IWPA, whose Pittsburgh Manifesto insisted that "political structures (States), which are completely in the hands of the propertied, have no other purpose than the upholding of the present order of exploitation."[13] As a woman of color whose marriage was not recognized by the state and who may well have been a former slave and thereby legally classified as property, it is not surprising that Lucy Parsons had a strong critique of the state, legal institutions, and the limits of political reform. In the early twentieth century, during the Mexican and Russian Revolutions and the First World War, Haymarket continued to be remembered by others who imagined alternatives to state power and who were punished by states for doing so, including the Flores Magóns, Emma Goldman, and Alexander Berkman, all of whom were targeted by federal immigration, citizenship, sedition, and obscenity laws.

The changing meanings of the Haymarket archive in transnational contexts suggest that debates about state violence and state power responded to what Joshua Brown has called the "vast expansion of the pictorial marketplace" in this era.[14] Recent work in nineteenth-century visual-culture studies, especially American studies scholarship on violence, photography, and discourses of sentiment and sensation, is helpful in making these connections. Some of this work emphasizes how the visual cultures of sentiment and sensation disappear evidence of violence: in *Tender Violence* Laura Wexler traces "the constitutive sentimental functions of the innocent eye" in white women's photographs that erase "the violence of colonial encounters in the very act of portraying them," as she argues for the connections between literary sentimentalism and a broader visual culture of sentiment at the end of the nineteenth century.[15] But if sentimental literature and visual culture may hide evidence of the violence of white supremacy and imperialism, showing that violence can cause other problems, as scholars such as Saidiya Hartman, Shawn Michelle Smith, and Jacqueline Goldsby suggest.[16] These theorists of literature and visual culture warn that the spectacles of death and suffering in sentimental and sensational representations of violence may reproduce or extend that violence.

In what follows, I argue for the importance of new forms of sentimental and sensational visual culture in struggles over Haymarket, violence, and the mass-mediated spectacle of state power. Sentimental and sensational images of the dead and wounded bodies of the police were used to mobilize public sentiment against the anarchists, while newspapers and illustrated magazines tried to turn the imprisonment, execution, and funeral of the anarchists into a spectacle. On the other hand, the anarchists and their allies disrupted the spectacle by critically commenting on such scenes as well as by reproducing them, along with other images of the anarchists' trial and punishment, as evidence of unjust state violence. In the decades after Haymarket, writers and artists would reproduce and critically reframe many of these very Haymarket icons in order to inspire participation in the great world movements of the era. Although it is often said that the fallout from the Haymarket tragedy was a huge setback for the labor movement and that alternative voices were quickly overwhelmed by dominant media, Haymarket's long afterlife looks different if we widen our perspective to trace its reemergence as a powerful image in the decades to come throughout the world.

THE SCAFFOLD AS BATTLEGROUND: HAYMARKET IN VISUAL CULTURE

A key source that Martí used and that he sought to "overwrite" in his Haymarket chronicle was the *New York Sun*, one of the mass-circulation daily newspapers of the period. An evening edition of the *Sun* began to appear just before the executions took place, filled with news that the paper boasted came over "our own private wire from the jail." In this way, the *Sun* purveyed a glimpse of that which was out of bounds to the crowd: the execution of white criminals. Although witnessing the execution scene in person was proscribed for all but a few, the *Sun* promised access to readers, claiming it was "the first time in the journalistic history of the world" that the telegraph or "electric current had been introduced right into the very corridor of death itself, for the purpose of chronicling the final movements" of the anarchists. The men were imprisoned in a "cage" that "was so located that every movement . . . could be discerned," while the "finger of the operator" made the "click, click" of the "telegraph instrument" echo through the corridor of the prison. As the operator watched the men walk to the gallows, the paper reported, their white linen shrouds "rubbed against the wires of the outside of the cage," and before they as-

cended the stairs, "the fact that the final moment was at hand was flashing over the United Press wires in all directions." The operator sat motionless, his eyes "riveted" on the sentry box, where the executioner awaited the signal, heard the crack on the chisel that severed the rope, pressed his finger on the key, "and even before the bodies had fallen in the full length of their ropes it was known in tens and hundreds of cities throughout the country that the sentence of the law had been fulfilled." Never before, the *Sun* writer commented, "had realism in the distribution of news been more graphically illustrated, and never before had the echo of the hammer and chisel of the executioner been flashed over the wires to the outer world."[17]

[margin handwriting: But that's the difference, this violenced[?] real news.]

This "graphically illustrated" realism, spurred by the telegraph and new mass-circulation daily newspapers, partly responded to the incomplete withdrawal of scenes of state-sponsored execution from U.S. public spaces in the nineteenth century. As Foucault's analysis would lead us to expect, in Chicago in November 1887 the machinery of state executions was "placed inside prison walls and made inaccessible to the public . . . by blocking the streets leading to the prison" (15).[18] The Chicago police captain Michael Schaack reported in his mammoth, illustrated *Anarchy and Anarchists* (1889) that on the morning of the executions three hundred police were deployed "to preserve order and keep away from the immediate vicinity of the building all persons not having proper credentials or not properly vouched for."[19] As the time of the execution neared, the crowd pushed to get closer to the scene as "the streets beyond the ropes became crowded with people of all grades and descriptions," but they were "kept moving by policemen scattered along the thoroughfares . . . so that no groups might gather and under the excitement of the moment precipitate a row or riot" (643). Schaack even observed that Lucy Parsons, "dressed in mourning and accompanied by her children, presented herself at the ropes and demanded admittance to see her husband, 'murdered by law,'" but instead police took her to the police station and "detained her until after the execution" (644). All of these measures would seem to confirm Foucault's claim that by the 1840s the "punishment" of (white) criminals became "the most hidden part of the penal process" (9) and that execution scenes were increasingly removed from public view.

[margin handwriting: are they all white]

Such scenes were hidden, Foucault suggests, in order to prevent "the intervention of the people in the spectacle of the executions," as sometimes happened in these "ambiguous rituals," which risked evoking a longer history of "struggles and confrontations" and thereby becoming a "battle-

ground around the crime, its punishment, and its memory" (67). But the punishment of the Haymarket anarchists was not really hidden, even though it took place behind prison walls and even though police kept the crowd away from the scene. After all, the men were placed in cages where their every movement was visible to the journalists who visited the prison in order to cover the unfolding story; the telegraph was even brought inside the prison to chronicle the "final movements" of the men to the "outer world." While the telegraph, newspapers, books, and images mediated the "visible intensity" of the Haymarket executions in new and different ways, scenes of their punishment were also disseminated to wide networks of people and thereby became a battleground of competing meanings and memories in U.S. mass culture and all over the world.

Although Jeffory Clymer persuasively argues that mass cultural representations of the Haymarket executions provided a political spectacle that served the dominant social, political, and symbolic order, Haymarket scenes, as well as the anarchists' life stories, speeches in court, and final words circulated in multiple cultural forms and languages, often creating new conversations and affiliations as they were translated into new contexts, especially in Spain, Italy, and throughout much of Latin America.[20] Martí's Haymarket chronicle exemplifies how the circulation of Haymarket scenes in transnational contexts could generate new meanings that clashed with those of the dominant U.S. order, for his engagement with mass-circulation newspapers and the ubiquitous images of an emergent mass culture provoked him to ask unsettling questions about attributions of crime and criminality and the role of violence in maintaining state power.

Often Martí drew on discourses of sentiment, sensation, and melodrama to raise such questions. Isn't it criminal, Martí asks, for "la república" to take advantage of a crime that was born as much from its own crimes as from the criminals' "fanatismo / fanaticism" (334)? Here the "republic"— the United States—becomes the villain, a tyrant that makes the accused anarchists into "víctimas del terror social / victims of social terror" (334) within a melodramatic narrative that exposes injustice, recognizes injured victims, and upsets or inverts social hierarchies.[21] A sentimental and melodramatic crime narrative runs through Martí's recasting of the Haymarket drama as one in which a "wrathful nation" fights the efforts of a benevolent lawyer, a young girl ("una niña") who has fallen in love with one of the anarchists, and an "Indian and Spanish mestiza, who is the wife of another" (334) to seize the anarchists' bodies from the gallows. The law-

yer was Captain William Black, who defended the anarchists in court and delivered a eulogy in which he compared their execution to the hanging of Jesus and insisted that the men were moved to act by a gracious tenderness of heart. The "young girl" was Nina Van Zandt, the daughter of a rich Chicago chemist, who became enamored of August Spies, whom she thought had a "good face" when she attended the trial and whom she married by proxy before he was executed. Their cross-class romance became a media sensation as well as a source of fascination for Martí, who found the girl's loyal misery moving and implied that Spies was too cold, too busy redeeming mankind, to love her properly (see figure 8).[22] Finally, the "Indian and Spanish mestiza" was Lucy Parsons, who became a fantasy figure of racial mixture for Martí who, unlike the U.S. popular press, accepted her own account of her racial genealogy, one that was almost certainly altered to shield her from the racism of those around her.

Martí's vision of Parsons as an impassioned mestiza whose heart responds to the suffering of the abject classes is saturated with keywords of sentiment and sensation. Recent work on Martí by Lomas, Brown, Gillman, and others helps us to see him as a "sentimental man" and to understand his sentimentalism as part of a broader transnational cultural matrix, one that is inseparable from what Anderson calls "the universalist currents of liberalism and republicanism" that nourished the "Spanish American nationalist independence movements" (2).[23] Throughout the Americas, melodramatic stories of national race romance, with their villains, heroes, and virtuous victims, provided a grammar for nineteenth-century nation-building and anticolonial struggles. Such narratives modeled relationships between classes, races, and nations for readers, and Martí's translation of the Haymarket events into a cross-class and cross-racial romantic melodrama is one sign among many of his engagement with transnational literary and visual cultures of sentiment and sensation, as is his focus on bodies in pain and corpses in order to narrate injustices.

In their speeches and writings, the Haymarket anarchists, especially Samuel Fielden, also drew on nineteenth-century discourses of sentiment and sensation when they emphasized their own passionate empathy and their strong feelings for other people, as well as how witnessing the suffering of others had moved them to act. In his chronicle, Martí echoes these explanations as he suggests that the compassion provoked by the witnessing of social misery in the United States motivated the "crime" of the Haymarket anarchists: their loss of faith in the triumph of justice through

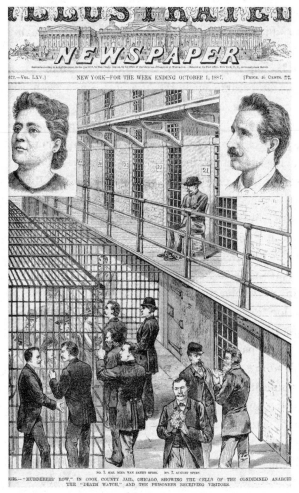

ILLUSTRATED
NEWSPAPER

672.—Vol. LXV.] NEW YORK—FOR THE WEEK ENDING OCTOBER 1, 1887. [Price. 16 Cents.

NO. 1. MRS. NINA VAN ZANDT SPIES. NO. 2. AUGUST SPIES.
...RS.—"MURDERERS' ROW," IN COOK COUNTY JAIL, CHICAGO, SHOWING THE CELLS OF THE CONDEMNED ANARCHI
THE "DEATH WATCH," AND THE PRISONERS RECEIVING VISITORS.

FIGURE 8 Nina Van Zandt, August Spies, and Cook County jail interior on the cover of *Frank Leslie's Illustrated Newspaper,* October 1, 1887. Dunn Library, Simpson College, Indianola, Iowa.

peaceful means and through democratic institutions and procedures. Even though he disapproves of this response, he judges the "fervor of their compassion" and "love" for the workers' cause to be natural and admirable, if excessive. He finds their compassion natural and admirable because in the sentimental universe a well-regulated sympathy is necessary in order to bind people together in the absence of traditional, more coercive forms of social authority. A sentimental psychology also presumes that witnessing suffering should ideally move people of feeling, people with a heart, to act

to change the world and remove the source of that suffering, for the good of the republic and the health of the state.

But Martí is also concerned with how bearing witness to scenes of irremediable misery in industrial society may make the mind "lose its bearings," pushing the compassionate witness into a kind of "lunacy" (205). It is this excessive sympathy and sensitivity, Martí suggests, that provoked the anarchists to advocate a violent response to the "bloodfests of the police" (205). Because of their rage that was fueled by witnessing painful scenes, Martí claims that the anarchists exemplify how "human life is concentrated in the spinal cord and the life of the earth in the volcanic masses," and he imagines them as hellish beings who have arisen from the enraged multitude: "their speeches, even when read in silence, send off sparks, billowing smoke, half-digested meals, reddish fumes" (200). In other words, Martí aligns the anarchists' speeches, writings, and acts with the body and with excessive emotions that provoke unruly mobs in ways that are unregulated by the sentimental love of patria that he considered essential. To Martí, the Chicago anarchists' speeches and writings, especially those of August Spies, are too sensational, beyond the pale of nationalist sentiment, touching nerves and sending off sparks that threaten to ignite the angry multitude.

But Martí both drew on and dissented from the newspaper reports, "from San Francisco to New York," which, he charged, misrepresented the trial, "depicting the seven accused men as noxious beasts, putting the image of the policemen ripped apart by the bomb on every breakfast table, describing their empty homes, their golden-haired children, their grieving widows" (212). Martí emphasized how in an emergent mass U.S. culture the wide circulation of images of the injured bodies of the policemen and stories about their homes and their families initially inspired sympathy for the police and the state. Such observations, along with Martí's rendering of the trial, the gallows scene, and the anarchists' funeral, open up questions about state power and state violence that are not put to rest by his horror over the anarchists' rejection of the patria and their emotional synergy with tumultuous multitudes. In this sense, despite his discomfort with the anarchists' critiques of patriotism and the state, his chronicle resembles accounts of Haymarket in anarchist newspapers, pamphlets, speeches, and other literature that also return to iconic Haymarket scenes in order to question or overturn official interpretations of their meaning as well as those that circulated in mass culture.

Many of these iconic Haymarket scenes appeared in *Frank Leslie's Illustrated Newspaper*, the most popular of all the illustrated papers that contributed to the expansion of the pictorial marketplace in the late nineteenth century. *Leslie's* first Haymarket cover, which appeared on May 15, 1886, consisted of two images. On top was a small illustration of policemen who are either felled by the bomb or hurled backward by the explosion's force, two of them implicitly toward the viewer in a mini-assault on the latter's perspective. Below that image, a larger illustration depicts a priest giving last rites to a dying policeman who is lying in the foreground of the sketch, bloodied and in the "shadow of death," as the caption explains, surrounded by other injured police but closest to the reader, who is offered a relatively intimate proximity to the deathbed scene. In the same issue, a huge two-page illustration featured seven stern police portraits, including one of Captain Michael Schaack, across the top, along with a giant picture of "the police charging the murderous rioters" at the bottom (see figure 9). This illustration is somewhat more multi-accented than others in this issue, as the reader's point of view is aligned with the crowd that is being charged by the police, but the dark, bearded visages of most of the anarchists may have diminished readers' sympathies for those who were being criminalized as foreign, disheveled "rioters." Finally, a full-page illustration toward the end of the issue offered a view of "a police patrol wagon attacked by a mob of 12,000 rioters," a wild exaggeration since the small, rain-soaked crowd that remained had not attacked the police (see figure 10). In this illustration the retreating police are under assault by a rowdy crowd of "rioters" who are wielding guns and knives and throwing objects that threaten the police and implicitly assault the reader. All of these illustrations focus on the bodies of the police in ways that encourage sympathy for their vulnerability, pain, and losses, except for the one where the police charge the crowd, which risks positioning the viewer with the crowd in order to display police power.

On the other hand, *Leslie's* depicted the Chicago anarchists as "beasts" with out-of-control, monstrous bodies that had to be subdued by the police, with the help of the relatively new tool of photography, which was increasingly deployed as part of the emerging social science of criminology during these years.[24] And the reemergence of physiognomic codes that Joshua Brown traces in *Leslie's* in the wake of Haymarket, which highlight "hirsute, foreign physiognomies," is clearly visible in an illustration of "the police capturing leading anarchists at one of their dens" (May 22,

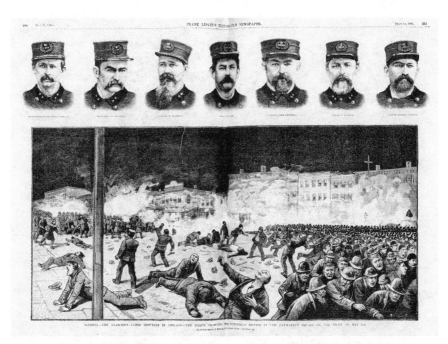

FIGURE 9 "Illinois—The Anarchist-Labor Troubles in Chicago—The Police Charging the Murderous Rioters on the Night of May 4th." *Frank Leslie's Illustrated Newspaper*, May 15, 1886. Huntington Library, Art Collections, and Botanical Gardens.

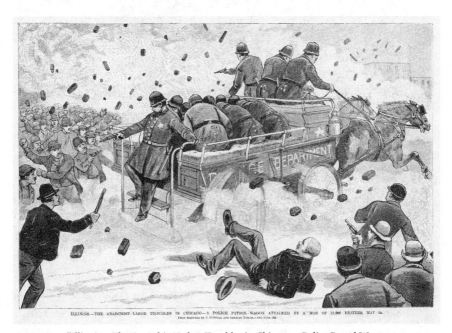

FIGURE 10 "Illinois—The Anarchist-Labor Troubles in Chicago—Police Patrol Wagon Attacked by a Mob of 12,000 Rioters, May 3d." *Frank Leslie's Illustrated Newspaper*, May 15, 1886. Huntington Library, Art Collections, and Botanical Gardens.

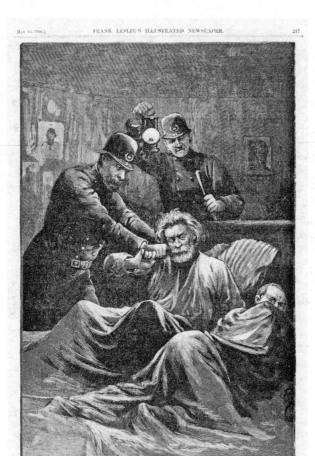

ILLINOIS.—THE RECENT TROUBLES IN CHICAGO—THE POLICE CAPTURING LEADING ANARCHISTS AT ONE OF THEIR DENS, No. 616 CENTRE AVENUE.
FROM A SKETCH BY G. FUNNELL.—SEE PAGE 210.

FIGURE 11 "Illinois—The Recent Troubles in Chicago—The Police Capturing Leading Anarchists at One of their Dens, No. 616 Centre Avenue." *Frank Leslie's Illustrated Newspaper*, May 22, 1886. Huntington Library, Art Collections, and Botanical Gardens.

217).[25] In this image a nighttime raid is depicted: as one policeman shines a lantern on a bearded, wild-eyed anarchist, another roughly shakes the latter to wake him up as he lies in bed with another man, whose backside is emphasized as he turns away from the glare of the policeman's lantern (see figure 11). By picturing the anarchists in a sleeping arrangement that was increasingly being viewed as a perverse and unnatural inversion of heterosexual domesticity, *Leslie's* multiplied ways of seeing the anarchists as dangerously alien. And just two months later, a July cover engraving that

FRANK LESLIE'S ILLUSTRATED NEWSPAPER

No. 1,604.—Vol. LXII.] NEW YORK—FOR THE WEEK ENDING JULY 31, 1886. [Price, 10 Cents.

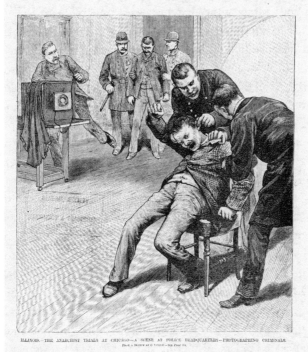

ILLINOIS—THE ANARCHIST TRIALS AT CHICAGO—A SCENE AT POLICE HEADQUARTERS—PHOTOGRAPHING CRIMINALS.
FROM A SKETCH BY C. UPHUE—SEE PAGE 84.

FIGURE 12 "Illinois—The Anarchist Trials at Chicago—A Scene at Police Headquarters—Photographing Criminals." *Frank Leslie's Illustrated Newspaper*, July 31, 1886. Huntington Library, Art Collections, and Botanical Gardens.

appeared during the anarchists' trial featured two policemen struggling to subdue a frenzied anarchist who is resisting being photographed by the police (see figure 12). By substituting this image for coverage of the actual trial, the paper supported, as Joshua Brown suggests, the "negative view of anarchists that would have been belied by a rendering of the accused conspirators' dignified demeanor in the courtroom."[26]

This *Leslie's* cover also reveals that the anarchist trials involved a struggle over representation, specifically over the use of photographs to

assign criminal identities to the men. A few pages into the July issue, an anonymous writer explained that "portraits of all of these wretched conspirators appear in the Rogues Gallery," a gigantic album holding up to 2,500 photographs that the Chicago police department constructed, in a variation on the Bertillon system in France, "to keep perfect track of and identify every criminal who has come into contact with the authorities, and also to have him punished under the Habitual criminals act." In other words, the photographs of the anarchists were integrated into what Alan Sekula in "The Body and the Archive" calls a "bureaucratic-clerical-statistical system" of police "intelligence" (16) that criminalized the anarchists. Inspector Bonfield released copies of these police photographs to *Leslie's*, which used three of them, depicting Spies, Schwab, and Fielden, in the May 15 issue to illustrate an article on the "Anarchist leaders who are responsible for the Chicago outbreak," thereby judging the men guilty of murder before the trial had even transpired.[27]

Although *Leslie's* did not cover the trial, in the fall of 1887 the paper prominently featured many large, eye-catching illustrations of scenes of Cook County jail and the policemen who guarded it, the anarchists in prison, their final days, the execution, and the funeral. These illustrations emphasized the power of the law, the state, the police, and the prison to contain and control the threat posed by the anarchists, who refused to recognize the authority of those institutions. The day after the executions, *Leslie's* published a full-page picture of the gallows, over the captions "the shadow of death" and "preparations for the execution of the condemned anarchists." This illustration is yet another example of how *Leslie's*, like the *Sun*, tried to appeal to readers by offering views of scenes that were increasingly being removed from public sight: the execution of white criminals. But while the production of a degree of sentimental sympathy for the men in the wake of the spectacle of their punishment often involved emphasizing their whiteness, Albert Parsons's marriage to Lucy associated him with people of color. In other words, whiteness is not only a solution, but also a problem in sentimental and sensational Haymarket literature and visual culture, which raise questions about the boundaries of whiteness and the relationship of the anarchists to that category. In the same issue of *Leslie's*, a cover illustration depicted an "affecting interview between Parsons and his little daughter" in which Lucy is rendered a slightly whitened, almost ghostly presence in the background, drawn in lighter shades of ink and difficult to see behind prison bars (see figure 13). This

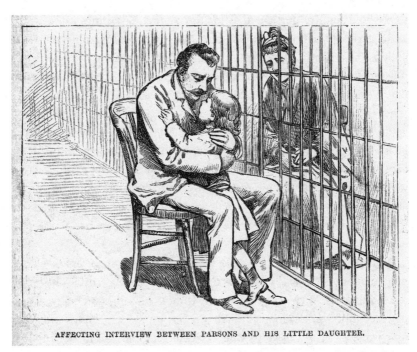

AFFECTING INTERVIEW BETWEEN PARSONS AND HIS LITTLE DAUGHTER.

FIGURE 13 "Affecting Interview between Parsons and His Little Daughter." *Frank Leslie's Illustrated Newspaper*, November 12, 1887. Dunn Library, Simpson College, Indianola, Iowa.

drawing was one part of a tripartite cover that also featured a picture of Fielden and a larger one of the prison guarded by police. It is notable that the two anarchists who were singled out for a measure of sympathy were of English descent: Fielden was an English immigrant while Parsons was a native-born Southerner. Along with their Anglo-Saxon whiteness, their easy eloquence in their native language provoked admiring responses from many readers of their speeches and testimony. The sentimentality on display in *Leslie's* seemed to require ghosting Lucy, however, whose presence is written out of the picture's caption even as her face is whitened and made a part of the blurry background. The viewer is positioned inside the cell with Parsons and the child, looking out at Lucy: along with the prison bars, then, the color line also divides the space, further whitening those on the inside.

But if the production of sentimentality about the executions depended on whitening the anarchists and foregrounding the family, it also relied on properly regulating the feelings provoked by the spectacle of their death. In an issue published the week after the executions, *Leslie's* claimed that

the "whole country participated" in "the conflicting feelings of awe, pity, and a stern satisfaction at the final operation of justice inspired by the executions" as it continued to focus on "the doom of anarchy."[28] The issue's most striking feature was a three-part pictorial narrative of the execution day: a drawing of Parsons defiantly singing in his cell (see figure 14); another of the "march to the scaffold" of the white-clad anarchists, whose white faces also stand out in contrast with the black clothing worn by the guards (see figure 15); and finally, a picture of the executioner "drawing the caps over the prisoners' faces" as the hooded men stand before the gallows with ropes tied around their necks, along with several witnesses, including at least two rows of observers (see figure 16). The space is represented as a theater in which the anarchists stand on an elevated stage before the gaze of an array of spectators.

Martí lingers on many of these iconic scenes but he alters or elaborates on them and thereby changes their meanings. He retells, for instance, the sentimental story of the final visits from the families the night before the execution, remarking especially on "las mujeres sublimes / the sublime women" (350): Fischer's wife's "terrible embrace," Engel's daughter, Spies's mother, who extends her arms as she is dragged away from her son, and especially, the "terrible joy" of Nina's and Spies's final kiss. He also emphasizes the stark contrast in the way Nina and Lucy are treated by officials: while Nina passes easily by the prison guards, who hold their hands out to her respectfully, Lucy is prevented from seeing her husband. Like *Leslie's* and the *Sun*, Martí extensively narrates the story of the anarchists' last night in their cells, and even remarks that the final strokes of the carpenter's hammer were audible above "el golpeo incesante del telégrafo que el *Sun* de Nueva York tenía en el mismo corredor establecido / the chatter of the telegraph that the *New York Sun* set up in the same corridor" (351). Martí follows the men as they walk to the gallows and as the head of each is covered with a "mortaja blanca / white shroud" that resembles the "túnica de los catecúmenos cristianos / tunic of neophyte Christians" while down below the "concurrencia / audience" sits in rows in front of the scaffold "como en un teatro! / as if in a theater!" (354). While whiteness subtly shadows *Leslie's* pictorial narrative, in Martí's chronicle it enables a comparison that turns the men into martyrs devoted to a sacred cause and associates the punishing state with imperial Rome. Martí vividly imagines the body, face, and voice of each of the men in ways that resonate with anarchist literature that tried to disrupt the execution as spectacle,

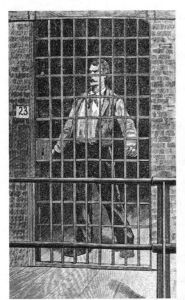
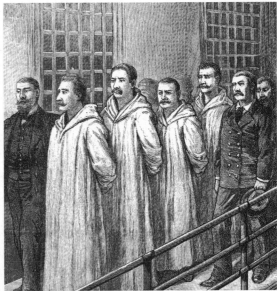
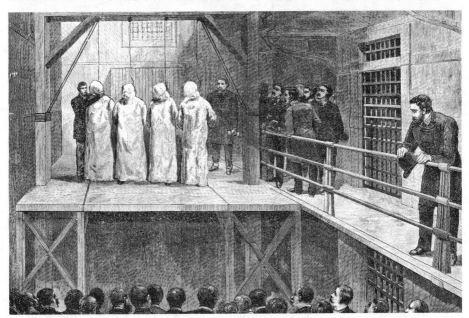

FIGURES 14, 15, AND 16 "The Law Vindicated—Four of the Chicago Anarchists Pay the Penalty of their Crime—Scenes in the Cook County Jail before and at the Moment of Execution." *Frank Leslie's Illustrated Newspaper*, November 19, 1887. Dunn Library, Simpson College, Indianola, Iowa.

and he records the final words of each, which were reported in the papers and would be echoed around the world for decades to come. In giving the men a voice and by drawing on sentimental discourses to give them faces and bodies, Martí reimagines the execution scene as something other than a "satisfying" spectacle of state power. Both the *Sun* and Martí also emphasized the "horror" of the scene, since all but Parsons died slowly and painfully of strangulation. Martí narrates how each responded to the giving way of the trap door, concluding with Spies's protracted "danza espantable / terrible dance" of death, ending with his broken neck and head facing forward, saluting the "espectadores / spectators" (355). In this way, Martí draws on sentimental, sensational, and melodramatic modalities to foreground forms of state violence hidden from all but a chosen audience of witnesses.

After revising the execution scene, Martí ends his chronicle with an account of the funeral rites that is also saturated with keywords and signifiers of sentimentalism and that privileges cultural memories of the meaning of the execution rather than the execution itself as a spectacle of state power.[29] He lingers on the funeral scene, a privileged locus of sentimentality, and on the display of the bruised corpses, the caskets containing the bodies, and the parade of workers' associations that marched mournfully that day. Twenty-five thousand "almas amigas / friendly souls," Martí writes, listened to Black declare in his eulogy that the men were not criminals but instead resembled Christ, a comparison that *Leslie's* characterized as "somewhat blasphemous" and that Martí emphasizes through translated quotation (see figure 17).

Finally, Martí imagines a voice emerging as the men are lowered into their graves, an angry voice that accuses the workers of Chicago of allowing five of their noblest friends to be executed. Here, Martí's swerve away from what can be seen and shown, this "gesturing with flourishes to what it cannot represent in the mode of a photographic reproduction or copy" breaks with "the dominant ideology of realism in the United States in the 1880s," by "pushing available forms of representation," such as journalism, "to their limit."[30] The spectral voice that Martí imagines suggests that the crowd may still participate in what Foucault calls the "small but innumerable disturbances around the scaffold" (60) that took place before state-sponsored executions were removed from public spaces. But the possibility of overturning the ritual of state violence is quickly set aside, as the defense attorney consoles the unquiet soul and the crowd quietly returns to their

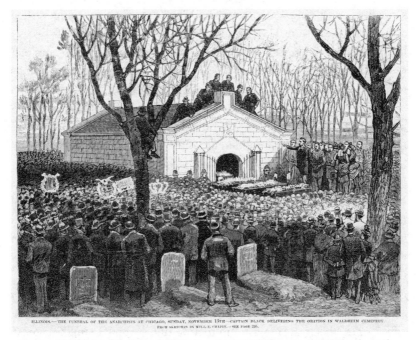

FIGURE 17 "Illinois—The Funeral of the Anarchists at Chicago, Sunday, November 13th—Captain Black Delivering the Oration in Waldheim Cemetery." *Frank Leslie's Illustrated Newspaper*, November 26, 1887. Dunn Library, Simpson College, Indianola, Iowa.

homes. Martí concludes with a translated quotation from the next morning's edition of the *Arbeiter-Zeitung*, the German-language workers' newspaper Spies edited, advising its readers to be wise as serpents and harmless as doves, for although they had lost the battle, they would "veremos al fin el mundo ordenado conforme a la justicia / see a just world order in the end" (356). At the end, then, republican institutions, though damaged, still survive: the lawyer comforts the man, thereby quieting his reproachful voice, and the next morning the workers' voice, the newspaper, is not suppressed, but instead appears in the public sphere to counsel caution and peaceful waiting for a just world order "al fin," whenever that may come.

LUCY PARSONS, RACE, AND THE VISUAL CULTURES OF SENTIMENT AND SENSATION

Like Martí, Lucy Parsons adapted and transformed discourses of sentiment and sensation as she intervened in late-nineteenth-century practices of looking, as she tried to "pintar al mundo el horror" (348) of the unhappy classes in her oratory, in her newspaper writings, and in the books

she edited, including *The Life of Albert R. Parsons*, which she published at her own expense in 1889. In this book there is no picture of the gallows scene, though Parsons returns to other iconic Haymarket scenes that Martí, illustrated newspapers, and new mass-circulation daily newspapers reproduced and re-envisioned. The book compiles diverse kinds of writings loosely organized around the life and writings of Parsons, the Haymarket riot, and the trial, imprisonment, execution, and funeral of the men, and it includes many different voices and cultural forms, ranging from speeches and newspaper editorials to interviews and letters.

Instead of picturing the gallows scene or the funeral, the illustrations that frame the 1889 edition depict Albert in the honorific, sentimental mode of the portrait rather than the repressive one of the mug shot and imagine him as a sentimental husband and father. The engraving of Albert that serves as the frontispiece circulated (and still does) widely, reaching viewers all over the world in a variety of forms (see figure 18). Engraved portraits in this era were "governed by conventions developed by commercial photography during the 1840s," according to Joshua Brown, and despite "their transmogrification into a different medium, the engravings preserved the approved qualities of the emulatory photographs" that presented idealized faces.[31] The engraving of Albert's head and shoulders offers such an idealized, white face: it is not a frontal image or profile, as criminal mug shots often were; instead, he looks off in the distance, rather than directly at the viewer. Instead of representing Albert through physiognomic and phrenological codes associated with criminal types, this engraving adapts classical, racialized codes of portraiture borrowed from commercial photography to suggest that he is an intelligent individual with a complex interiority. With its oval framing, the portrait resembles those that families placed on their walls or in other places within the home during this era.

In the 1889 edition, Lucy included engravings of her daughter, Lulu, and her son, Albert Jr., as well as a reproduction of the last letter Albert wrote to their children before he died, which he begins by noting the tears that blot their names as he writes (see figures 19, 20, and 21). However, the sentimental tropes of family ties and separation suggested by these illustrations were fundamentally transformed in the second edition, which Lucy published in 1903, for she removed the illustrations of the couple's children, though she kept the reproduction of the letter. Perhaps the pictures were painful reminders of what Lucy had lost: Lulu died two years after

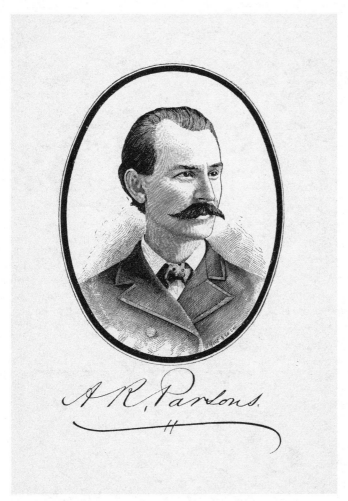

FIGURE 18 Frontispiece. In *Life of Albert R. Parsons* (1889), by Lucy Parsons. Huntington Library, Art Collections, and Botanical Gardens.

Albert was executed, and in 1899 she asked a judge to commit her son to a hospital for the insane, where he would die in 1919.[32] The alteration also, however, deemphasizes Albert's role as husband and father, and thereby makes the visual focus less on sentimental domesticity and more on the two Parsonses' roles in the public world.

Lucy altered her own image as well, replacing the engraving of her head and shoulders with a photograph. Versions of both of these images circulated widely, both at the time and in the years that followed. The engraving in the 1889 edition (see figure 22) is similar to one that appeared in 1886 in

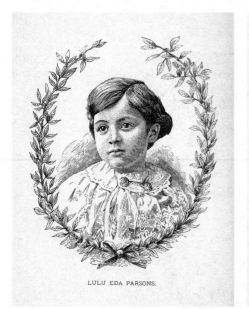

LULU EDA PARSONS.

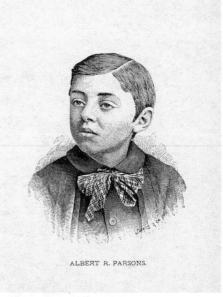

ALBERT R. PARSONS.

FIGURE 19 Portrait of Lulu Eda Parsons. In *Life of Albert R. Parsons* (1889), by Lucy Parsons. Huntington Library, Art Collections, and Botanical Gardens.

FIGURE 20 Portrait of Albert Parsons Jr. In *Life of Albert R. Parsons* (1889), by Lucy Parsons. Huntington Library, Art Collections, and Botanical Gardens.

FIGURE 21 Illustration of letter Parsons wrote to his children. In *Life of Albert R. Parsons* (1903), by Lucy Parsons. Huntington Library, Art Collections, and Botanical Gardens.

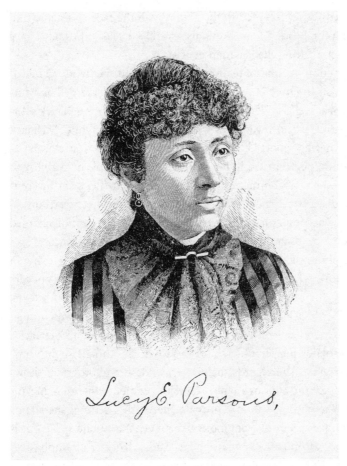

Lucy E. Parsons,

FIGURE 22 Portrait of Lucy Parsons. In *Life of Albert R. Parsons* (1903), by
Lucy Parsons. Huntington Library, Art Collections, and Botanical Gardens.

the Chicago newspaper *Knights of Labor*, which sympathized with the an-
archists, as well as one in George McLean's "profusely illustrated" screed,
The Rise and Fall of Anarchy in America (1888), a defense of the police
and the state. This engraving does not rely on the harsh physiognomic
codes and the ethnic and racial typing that Joshua Brown argues were re-
invigorated during the Haymarket era. In an excerpt from the newspaper
Women's World that Lucy placed in an appendix, the writer Helen Wil-
mans denounced the many images that did rely on such codes and typing
when she charged that "Distorted and outrageous pictures, purporting to
be portraits of these men, appeared; wherever a socialist is represented
in print the head of a baboon is given him."[33] Wilmans's comment that

"Mrs. Parsons was represented in the dailies with the face of a negro and the retreating forehead of a monkey" also starkly reveals how Lucy's race became an issue during the Haymarket crisis.[34]

The production of a measure of mass cultural sentimentality on behalf of the anarchists in *Frank Leslie's Illustrated Newspaper* depended on whitening the men as well as Lucy. In anti-anarchist texts such as Schaack's *Anarchy and Anarchists*, however, Lucy was described as a "mulatto." Schaack questioned what he reported as Lucy's claim that "she is of Mexican extraction with no negro blood in her veins," boasting of his own ability to accurately read physiognomic codes and insisting that "her swarthy complexion and distinctively negro features do not bear out her assertions."[35] These remarks accompanied an illustration of Lucy that a caption claimed was based on a photograph (see figure 23). Despite key differences, it resembles the photograph of Lucy that was substituted for the engraving in the 1903 edition of *The Life of Albert R. Parsons* (see figure 24). She appears to be wearing the same elegant, striped dress and jewelry in both texts, and in both her hair is curly and dark and she looks at the viewer, though not in the directly head-on way typical of criminal mug shots. Schaack's illustration isolates her shoulders and head, which is tilted slightly upward at an angle as she regards the viewer, while the photograph shows more of her body and captures a more level and cooler, rather than melancholy, gaze. The photograph also provides her with a setting: she stands holding a scroll in front of what looks like an elegant public space but is probably a backdrop in a photographer's studio. The scroll emphasizes her roles as a writer and public speaker and implicitly, as a leader of movements. Schaack's text, on the other hand, removes both scroll and setting as it claims physiognomic racial knowledge that is partly based on photographic evidence.

In the 1889 edition of *The Life of Albert R. Parsons*, the issue of Lucy's race is raised at least twice: in the *Women's World* article and in a brief autobiography narrated in the first person, in which Albert recalled his first meeting with the "charming young Spanish-Indian maiden who, three years later, would become his wife" (9). In the 1903 edition, Lucy added further testimony from Albert's brother, William, who in a newspaper interview made a point of noting his own family's "pilgrim-father parentage" as he characterized Lucy as a "Mexican lady of youth, beauty, and genius" whom Albert married in 1871 in Austin, Texas, "where miscegenation is a crime." William's insistence that Lucy was of Mexican descent re-

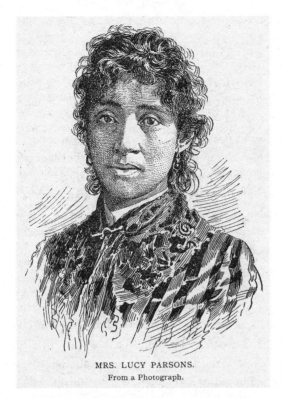

MRS. LUCY PARSONS.
From a Photograph.

FIGURE 23 Picture of Lucy Parsons "from a Photograph." In *Anarchy and Anarchists* (1889), by Michael Schaack.

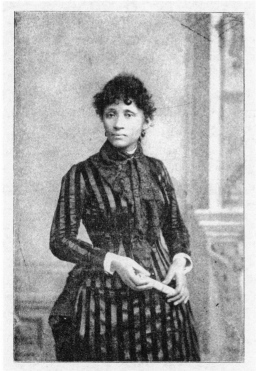

Lucy E. Parsons

FIGURE 24 Lucy Parsons. In *Life of Albert R. Parsons* (1903), by Lucy Parsons.

sponds to Schaack and others who claimed that she was "mulatto": he even adds that her "Spanish and Aztec blood were then never questioned" (3), making it clear that in the wake of Haymarket, questions about her race and "blood" were indeed often raised as a way of "blackening" the anarchists.

Although the testimony of the Parsons brothers and the *Women's World* editor marked Lucy as Mexican and Indian in response to claims that she was a "negro" or a "mulatto," the 1903 edition of *The Life of Albert R. Parsons*, especially, emphasizes how she was treated differently than the white families of the other accused anarchists. This racialized difference emerges especially as Lucy returns to an iconic scene that both *Leslie's* and Martí also re-envision: the final meeting between Albert Parsons and his family. While the illustrated newspapers raved about Nina Van Zandt's beauty and Martí reported that the prison guards held out their hands respectfully to her as she left the jail after her final visit the night before the executions, in a chapter entitled "Arrest of Mrs. Parsons and Children" in *The Life of Albert R. Parsons*, Lucy's friend Lizzie Holmes tells a very different story about Lucy's experiences with the police. Lucy was not allowed to see Albert that night and was told to return early the next day, which she did, bringing her children along with her to seek "a last sad interview" (249). Instead, they were arrested, strip-searched, and confined in cells until the executions were over. There are also other key differences among the three versions of this scene in *Leslie's*, Martí's, and Lucy Parsons's texts. *Leslie's*, as I have suggested, focused on the "affecting interview between Parsons and his little daughter," ignoring Lucy in the caption and both whitening her and relegating her to the background, on the other side of prison bars, in a sentimental cover illustration. The "Arrest of Mrs. Parsons and Children" chapter, on the other hand, foregrounds questions of looking and power as it describes how the police sent Lucy from one corner to another near the closely guarded jail, suggesting each time that perhaps at the next she might be admitted. According to Holmes, Lucy "besought the officers" to allow the children, at least, "one last look that the image of that noble father might dwell forever in their heart of hearts," but they denied her the consolation of "the sacred rite of a last goodbye" (250). The *Leslie's* cover illustration therefore depicts a scene that, if it took place at all, happened days before the executions, and thereby provides a sentimental closure that did not actually occur. In showing this scene, it hides the "shameful deeds" done "in the name of law and order," which "passed almost un-

noticed" in the "veil" of "gloom, so dense that the close of the century will scarcely see it lightened" (249). Holmes perhaps alludes to the sentimental displacements of such Haymarket pictures when, in her account of Lucy's arrest, she inquires, in a direct address to the reader, "Who can picture her agony?" (250).

In representing the execution, Holmes and Parsons suggest, such Haymarket pictures disappeared some scenes even as they made others visible. In these ways, the representational strategies of the illustrated papers and the mass-circulation dailies converged with those of the police and the state: "Thus it was," Holmes charged, "that while organized authority was judicially murdering the husband and strangling 'the voice of the people,' the wife and children were locked up in a dungeon, that no unpleasant scene might mar the smoothness of the proceedings" (252–53).[36] Instead of reproducing pictures of the gallows scene in the two editions of *The Life of Albert R. Parsons*, Lucy Parsons used both words and pictures to make visible what was obscured by the mass-circulation dailies and the illustrated press in ways that challenged the claims to smooth transparency of a "graphically illustrated realism."

Holmes and Parsons focus on what the sentimental pictures and "the extras of Friday, Nov. 11" hide, partly, like Martí, by themselves drawing on discourses of sentiment and sensation. Parsons adapts the moral polarities of melodrama, typified by villains, heroes, and victims, to stage other scenes of the recognition of virtue and the upheaval and inversion of social hierarchies. In an author's note near the beginning of the 1889 edition of *The Life of Albert R. Parsons*, Parsons announces her intention to show not only that her husband was neither "aider, nor abettor, nor counselor of crime in any sense," but also that "the proud State of Illinois murdered him under the guise of law and order" (viii). In Lucy's melodrama of crime and punishment the state is the villain and Albert is a victim whose exemplary virtue is made manifest in scenes of sacrifice and suffering such as "Parsons' self-surrender," as William Black called it. In a letter, the defense lawyer wrote admiringly of Albert's voluntary surrender to the court: when "prompted by his own sense of right and of loyalty to his comrades in labor, from a place of absolute security" he submitted himself to the imprisonment from which he was liberated on the scaffold (102). In a lithograph of this scene entitled *Surrender of Parsons* (1887), Black and Parsons are rendered tiny figures at the bar of justice, while the cavernous courtroom, with rows and rows of spectators as in a theater, looms large, dwarf-

ing them in scale: in this illustration, Parsons's surrender is noble, but the majesty and sheer massiveness of the institutions of the law dominate the scene.

In her own representations of the imprisonment and execution scenes in *The Life of Albert R. Parsons*, rather than "vindicating the law" Lucy Parsons charges the law, the courts, and the state with injustice. Echoing Martí, she argues that, instead of being a model republic, "with this atrocious, five-fold murder, America stands today in the vanguard as the most bloodthirsty of all the despotisms of so-called civilized Governments," despotic because the state "erected a scaffold and attempted to murder thought" (210). But instead of showing a picture of the scaffold or the "murder," the rest of her illustrations situate Albert's life within social movements, emphasize his ingenuity in eluding detectives and his selfless virtue in turning himself in, and document his activities while imprisoned. The only "gallows picture" (222) that Lucy reproduced was an account of the "final scenes copied from the city press" (210), which identified Albert as "the one American" among the anarchists as it narrated, in a classic sentimental move, his transcendence of his body and his "transfiguration" (222). While Lucy isolates this sentimental scene, she does so in order to contest mass cultural efforts to affirm the verdict and sentimentalize the state.

Many of the other extracts, especially in the 1903 edition of *The Life of Albert R. Parsons*, make the state the villain in a melodrama of crime and punishment that recalls the popular crime literature of which Foucault writes. Parsons reproduced, for instance, the last words of the men, including Albert's final truncated sentences, before "the officers of the State performed their mission by strangling both speakers and speech" (247). Lizzie Holmes's piece also echoes this emphasis on the state's "strangling" of "the voice of the people," and adds the judgment: "Only in the State where dying men are forbidden to speak a few last words can such a scene be possible" (253). Such extracts resonate with the multiform and transnational, sentimental and sensational literature on crime and punishment that Foucault suggests registered a long history of struggles around the scaffold over state power.

While Lucy did not include a gallows picture in either of the two editions of *The Life of Albert R. Parsons*, in 1912 she finally added one to the Twenty-Fifth Anniversary Souvenir edition of her compilation of the anarchists' courtroom speeches. The engraving of the gallows scene appeared

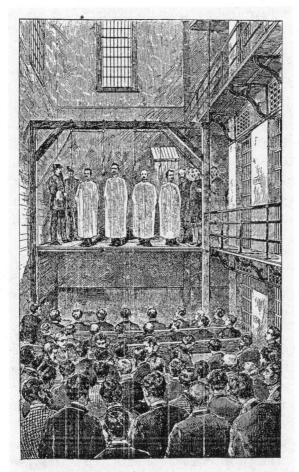

Reading from left to right. A. Spies, A. Fischer, G. Engel, A. R. Parsons.
Louis Lingg, had died the day before. The police said he committed suicide.

FIGURE 25 Scaffold scene. In *Eleventh of November Memorial
Edition of the Famous Speeches of Our Martyrs* (1910), by Lucy
Parsons.

on the second page of this text, following an ad for *The Life of Albert R.
Parsons* on the inside cover and a first page featuring engraved portraits
of all of the men, including the oval portrait of Albert that appears in the
mediated autobiography (see figure 25). The gallows scene is a full-page
engraving that resembles *Leslie's* "Vindication of the Law" illustration, but
with key differences: the dominating figure of the prison guard in the fore-
ground of *Leslie's* picture disappears and the space seems even more like a
theater, with a higher ceiling and more vertical space.

In an adaptation that reveals much about the creative and promiscuous circulation of images among different cultural and political agents and movements at the turn of the long nineteenth century, the very same picture, just cropped a little differently, occupies a full page in Schaack's *Anarchy and Anarchists*, where he used it to illustrate the "tragedy" (644) of the execution, witnessed by "two hundred spectators" (646), in ways that are at times at odds with his stated purpose of helping the assistant state's attorney "vindicate" the "outcome" as a "victory for outraged law" (vi) (see figure 26). The viewer's eye is drawn to the white shrouds of the men in the center, whose faces are not hooded. Instead, the men who are about to die look out at the audience, returning the gaze. On the opposite page, Parsons instructed readers to "read the poem; then look at the gallows scene," and then "in looking upon the awful murder of our comrades, swear within your own heart never to cease your work until this accursed system of capitalism is overthrown."[37] In doing so, she tried to guide her readers' practices of looking, so that when they viewed the gallows scene, they would see state violence in concert with capitalism rather than the vindication of the law or a spectacle of state power. While Parsons's appeal to the reader's heart is a sentimental one, she calls for action rather than voyeuristic withdrawal into the spectacle or even the watchful waiting Martí's narrator advises.

Indeed, the poem that Parsons chooses models, in the process of its composition, the very breaking with the spectacle and the embrace of action that she hopes to teach her readers. She frames the poem by claiming that one of the spectators of the execution scene wrote it and then gave it to Captain Black, who read it at the funeral. Extracting the poem from Black's eulogy and making it part of the book's introductory material, Parsons emphasizes the anonymous poet's exemplary response; rather than being mesmerized by the spectacle of state power, he is moved to write a poetic elegy that situates the execution scene within a long history of "the gallows old disgraced" by state "tyranny." Like Martí, the poet envisions the men "Wearing their robes of white / As saints or martyrs might," and looking back, as they did in the picture, at the spectators as they "faced" the "world" in "conscious right." Like Martí also, the poet sentimentally wonders how to "judge a heart" whose "throbbing valves" were torn asunder by witnessing "wrong and suffering." Ultimately, however, the poem represents the anarchists' struggle against the state as a struggle for justice, rather than affirming the resilience of republican institutions, as Martí's ending does.

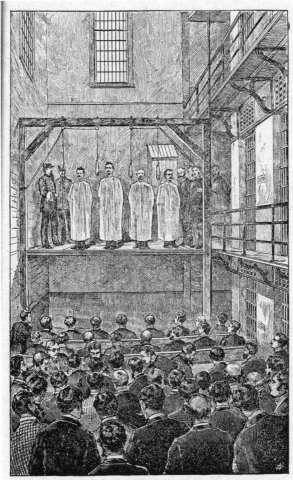

THE EXECUTION.

FIGURE 26 "The Execution." In *Anarchy and Anarchists* (1889), by Michael Schaack.

But despite their different conclusions, the poet, Martí, and Lucy Parsons all use discourses of sentiment, sensation, and melodrama to insist that looking at the gallows scene means understanding that, in Black's words, "the ruthless taking of human life under the forms and by the machinery of the law is a dagger thrust into the heart of justice."[38] While Martí still hoped republican institutions and the "machinery of law" might prevail in a truly just state, Parsons and the anarchists believed that state power was intrinsically violent. Visual culture became a site of struggle for all of these writers, as well as for the world movements of which they were

part, precisely because all of them challenged the state's efforts to use new forms of media and visual culture to both withdraw and intensify spectacles of violence, punishment, and the vindication of the law. In looking above, below, and beyond the nation and the state, then, we also need to attend to practices of looking and to struggles over the transformation of sentimental and sensational visual cultures at the end of the long nineteenth century.

2

From Haymarket to the Mexican Revolution

ANARCHISTS, SOCIALISTS, WOBBLIES, AND MAGONISTAS

In the April 15, 1916, issue of the anarchist PLM's bilingual news-paper *Regeneración*, which was published in Los Angeles from 1910 to 1918, William C. Owen, the editor of the English-language page, called attention to an announcement, in the Chicago anarchist newspaper the *Alarm*, that Lucy Parsons was contemplating a tour of the East Coast to "raise money for the defense of our Comrades, the Magón brothers." Owen was an English anarchist who came to the United States in the late 1880s, became a naturalized citizen, took over the editorship of the English page of *Regeneración* in 1911, wrote a pamphlet on the Mexican Revolution that was published in Los Angeles in 1912, briefly edited a newspaper called *Land and Liberty*, and in early 1916 escaped back to England, where he became the editor of the anarchist journal *Freedom*, after he and the Magóns were indicted by a grand jury on charges of sending incendiary material through the mail. In the April 15, 1916, issue of the PLM's paper, under the headline "Lucy Parsons to Take Tour," Owen reproduced a letter she had written and circulated to East Coast comrades asking them to arrange meetings so she could assist the Magóns as well as "discuss the Mexican situation from 'the other side,' showing that there is an economic question." Parsons asserted that since she "read Spanish," she thought she could "show what has been accomplished in Mexico." Owen applauded this project, adding that "our old and true comrade Lucy E. Parsons has our full confidence and any aid we may be able to offer."

The network of linkages between the anarchist newspapers the *Alarm* and *Regeneración* and among Lucy Parsons, William C. Owen, Ricardo and Enrique Flores Magón, and world movements such as the IWPA, the PLM, and the IWW also connect the trial and execution of the Chicago anarchists to the Mexican Revolution and the long history of U.S. intervention in Mexico and collaboration in the persecution of the political opponents of Porfirio Díaz. Underneath Owen's story about Lucy Parsons, in a letter to the paper entitled "The State Attacks Free Speech and Free Press," which was signed "'Industrial Worker' (Seattle, Wash.)," the letter's author explained why the Magóns and *Regeneración* required Parsons's help. On February 18, in Los Angeles, the Magóns had been arrested, and they, along with Owen, had been indicted for "using the mails to incite murder, arson, and treason, thru [*sic*] the columns of *Regeneración*." This *Industrial Worker* article also reported that Enrique was "severely beaten by the arresting deputies," while Owen, who had been visiting the anarchist Home Colony, Washington, was "still at liberty." Their only "crime," the writer sarcastically added, was "in showing the direct connection between the political rulers of the United States and the plunderers of Mexico." Because "resistance to tyranny is an I.W.W. duty," the paper declared the "the duty of the workers" was "plain": they would be fighting "for their own self interests" by "resisting every attempt to suppress freedom of speech and press." In this way, the *Industrial Worker* writer drew on discourses of sentiment, sensation, and republicanism to understand the arrest of the PLM leaders as yet another example of state "tyranny," the result of a collaboration between Mexico and the United States that criminalized those who criticized state power by exposing connections between political leaders and "plunderers of Mexico" in both nations. He also insisted that it was the duty of members of the IWW to support the PLM and the Flores Magón brothers in their common struggle against state efforts to suppress freedom of speech and the press.

The urgent imperative to connect movements in Mexico and the United States is strikingly visible throughout this entire issue of *Regeneración*, as the various contributors appealed to readers to take action in a case that reminded many radicals of the Haymarket drama. In their efforts to make these connections, radical appeals often included visual elements, such as photographs, sketches, and, especially, political cartoons, which communicated meanings across boundaries of language more readily than did many other cultural forms. But illustrations were relatively expensive and

during these years in the columns of *Regeneración* the editors frequently commented on the paper's precarious status, asked for financial support, and at times were unable to publish the paper on a weekly basis. In the wake of the indictments, other PLM members with little experience in publishing a newspaper had to take over the jobs of those who had been arrested. As R. B. Garcia, who stepped in to help out with the English page after Owen was indicted, had put it a few weeks earlier, "Some of us remaining to continue the work have laid aside the pick and shovel to push a pencil" (February 19, 1916). In this context, it is not surprising that many issues of *Regeneración* included no illustrations at all.

In the May 15 issue, the translation of articles and the addition of some new material in English was the main strategy the paper's editors used in their efforts to forge transborder sympathies. At times there were notable disparities between the Spanish and English versions of the same article, however, as well as different content in the Spanish and English pages, which reveals much about how the paper's editors imagined their transnational audience, including the differences and divisions among them. A good example of the strategy of translation is a coupon of protest that appeared on the English page, translated from the Spanish of the previous page: the paper's editors asked readers to cut out these coupons and send them to Woodrow Wilson to protest the persecution of the Flores Magón brothers and to demand "their immediate release from jail." Arguing that this case could set a precedent that would "be used to persecute all the labor papers" and "suppress freedom of thought and freedom of the press," the PLM appealed to "comrades, sympathizers, and liberty-loving people" to denounce this "crime," which "shall drag North America back to chattel slavery."

While on the English page, the appeal to sympathizers to act in the present was underscored by the threat of a return to chattel slavery, in the Spanish pages the authors of the coupon accused Wilson not only of helping to reinstate "el reinado del terror de la época porfiriana / the reign of terror of the Díaz period," but also of exposing the Mexican people to "la rapacidad de la plutocracia de ambos países / the rapacity of the plutocracy in both countries," a distinctly modern formation of capitalism based on the collaboration of capitalists and the state in the United States and Mexico. These writers also adapted and altered discourses of sentiment and sensation as they attacked plutocrats for rapaciously victimizing the Mexican people and declared that Wilson's support of Carranza's efforts

"to reestablish the Díaz regime" was creating among the Mexicans "un sentimiento hostil contra el pueblo Americano / ill feelings against the American people" that should not exist.

While the coupon published in Spanish and English appealed to readers in both the United States and Mexico to come together in support of the Flores Magóns, an article written by Juanita Arteaga, who wrote many articles for *Regeneración* while the Flores Magóns and other editors were in prison, explored some of the obstacles to the forging of such transborder solidarities in an April 15, 1916, piece entitled "Be on Your Guard, You Labor Papers!" While in the Haymarket case, nativist sentiment directed at European immigrant workers divided the Chicago labor movement, in the period of the Mexican Revolution, Arteaga suggested, the "racial prejudice" of the U.S. masses, who she claimed viewed the Magóns as "despised greasers," meant that they "would be glad to see our prisoners convicted and even hung." Thus Arteaga concluded that "Wilson and his minions" had "aimed well the blow" by persecuting the Magóns. But she also astutely predicted that although "*Regeneración* and its editors" would be the first "victims" of this "muzzle," it would eventually be applied to "all the labor papers of this American Russia." Comparing the United States to Russia just before the Bolshevik Revolution, she thereby called attention to the beginnings of the Red Scare of the First World War era, which echoed the earlier one that followed Haymarket, when the police arrested many anarchists and other radicals and clamped down on their newspapers, writings, and speeches. The persecution of the Magóns and *Regeneración* in 1916 was indeed one of the first blows in this new Red Scare, as Arteaga suggests and as illustrations in that paper and others would also ask viewers to imagine.

Just below Arteaga's piece, an article about the suppression of two issues of the anarchist Alexander Berkman's weekly newspaper the *Blast* (San Francisco) supported her prediction: two issues had been "denied admission to the mails" because of articles on birth control, a piece entitled "Villa or Wilson—Which Is the Bandit?," and, especially, a front-page cartoon that William C. Owen described as depicting "Uncle Sam's army crossing into Mexico under the stars and stripes emblazoned with the inseparable dollar mark and going to the rescue of the plunderbund who is in imminent danger of a peon who is in the act of breaking his chains." Although no such figure actually appears in the cartoon, the plunderbund (a term with Dutch origins and links to piracy and imperialism) was a keyword in radical circles in the 1910s as well as a stock figure frequently

mocked in IWW cartoons and the radical press. By suggesting that the U.S. army was invading Mexico to "rescue" the plunderbund, the editor of the English page of *Regeneración* supplied an explanation for U.S. intervention in Mexico that would have resonated with U.S. radicals, for whom the plunderbund was a major nemesis. The peon struggling to break his chains was another iconic figure in radical literature and in cartoons on both sides of the border that could be easily understood even by readers who struggled with Spanish or English. Perhaps this is why the postal authorities found the illustration so threatening. Indeed, Owen suggested in his article about the crackdown that "what caused the real crack was the pertinent cartoon" on the front page of the number 10 issue of the *Blast* (see figure 27).

The crackdown that threatened and eventually led to the demise of both *Regeneración* and the *Blast* and the use of political cartoons to create solidarities across boundaries of language and literacy are only two of the many connections between these newspapers as well as the larger world of movements and struggles in which they played important roles. Like the Flores Magóns and all of the Chicago Haymarket anarchists except Albert Parsons and Samuel Fielden, Berkman and his friend and comrade Emma Goldman, with whom he worked on the leading U.S. anarchist monthly *Mother Earth* from 1907 to 1914, were immigrant radicals whose first language was not English. Nonetheless, Berkman, like August Spies, Goldman, and Enrique Flores Magón, became an eloquent orator and writer in English, and worked hard to appeal to readers and viewers in multilingual, migrant contexts.

One of the ways Berkman did this was by frequently mentioning the trial, punishment, and execution of the Chicago anarchists in his speeches, journalism, and writing, and by participating in Haymarket commemorations, such as the one that took place in San Francisco on November 12, 1916, in which Berkman, Enrique Flores Magón, the IWW cartoonist Robert Minor, and other speakers led an "international mass meeting" to commemorate the twenty-ninth anniversary of the "martyrdom of the Chicago anarchists." Like the Haymarket anarchists and the Magóns, Berkman was also repeatedly at odds with the state and was imprisoned for long periods of time. His early classic of prison literature, *Prison Memoirs of an Anarchist* (1912), which is remarkably open about and affirming of erotic relationships between male prisoners, chronicles his fourteen-year confinement after he tried to kill Henry Frick, the manager of Carnegie Steel

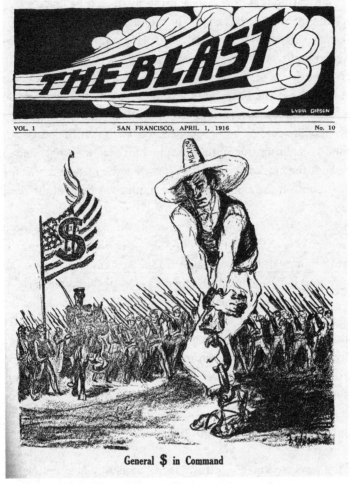

FIGURE 27 "General $ in Command." *Blast*, April 1, 1916.

Company, during the Homestead steel strike, as part of an effort to inspire the working class to rise up in revolt.[1]

Berkman's trajectory resembled those of the Chicago anarchists as well as Goldman and the Flores Magóns, since all were migrants who were at odds with states and were targets of state power. Within a year of the 1916 crackdown on the *Blast* and *Regeneración*, Berkman, along with Emma Goldman, would be arrested again and sentenced to two years in jail for violating the Espionage Act of 1917 by participating in a "conspiracy to induce persons not to register" for the draft. After they were released, Berkman and Goldman were deported to Russia under the 1918 Anarchist

Exclusion Act, which dramatically expanded the definition of anarchist activities and punishments and made it much easier to deport immigrant anarchists. On the brink of U.S. involvement in the First World War and as, in Owen's words, "everywhere the State . . . clothed itself with powers previously undreamed of," the federal government increasingly tried to silence the anarchists' critiques of the state by suppressing anarchist newspapers and imprisoning anarchist writers, speakers, artists, and organizers (January 1, 1916).

The 1916 case was not the first time the United States had collaborated with Mexico in criminalizing the Flores Magóns and the PLM, nor would it be the last. Not only had the men been accused, at Díaz's prompting, of criminal libel in 1905, but in 1907 they were charged with violating U.S. neutrality laws and were extradited to Arizona, where beginning in 1909 they served eighteen months in the state penitentiary at Yuma. Then, having returned to Los Angeles in 1910, they were sentenced in 1912 to twenty-three months in prison, again for violating U.S. neutrality laws, after several of the state's witnesses committed perjury and falsely claimed the PLM had given them money to go to Mexico to fight. Just a year later, several of the witnesses from the 1912 trial signed affidavits admitting that they had committed perjury, and in the months that followed, the editors of *Regeneración* reproduced, "at great expense," these affidavits in their paper, urged other papers to notice them, and appealed to Wilson to pardon the men (April 19, 1913). While the PLM did not deny that "they assisted in the publication of a newspaper in the United States which published news of the Mexican Revolution and advocated that the people of Mexico should fight for their rights," they insisted that they had never "actually paid soldiers to go from the United States to fight personally against the Mexican government." Wilson did not find it expedient to recognize such a distinction, however, and refused to pardon them. Finally, after they had served full sentences and in the wake of the 1916 charges of sending incendiary material through the mail, when the men were out on bail pending an appeal, Ricardo was arrested again and charged with sedition under the Espionage Act. This time he was given a twenty-year sentence, and in 1922 he was found dead in his cell in Leavenworth prison in Kansas.[2]

The charges brought in 1916 were supported in the indictment by several quotations from *Regeneración*, fragments that were extracted from four articles in Spanish. In the ensuing months, the editors translated the

articles into English so that readers could judge for themselves whether the accused men were guilty of inciting murder, arson, and treason through their newspaper articles ("The Articles in Question," March 25, 1916). The first piece, written by Ricardo, called on Mexican soldiers to turn their arms against their superior officers if they were told the revolution had ended. On the English page of April 1, 1916, in an article entitled "The Prosecution of *Regeneración*," Celso Marquina insisted that this was a "figure of speech, a literary way to express the idea that carrancista soldiers rally to the banner of the Mexican Liberal Party." The second article, also by Ricardo, was about violent depredations on innocent people committed by the Texas Rangers and included a passage suggesting that the Rangers were the real criminals and were therefore the ones who should be shot. The paper claimed that, far from committing treason against the United States—a charge that Marquina found especially "ridiculous" since Ricardo and Enrique were not U.S. citizens, but rather "internationalists"—in this essay Ricardo had simply made a "very strong appeal for justice." A third piece by Ricardo addressed the Carranza reforms and advised revolutionaries not to put down their arms until private property ceased to exist. Comparing the struggle of different factions in Mexico to the U.S. Civil War, Marquina argued that quotation was poor evidence that Ricardo was guilty of inciting murder, since at the time Mexico was at war, and pointedly asked, "Would not those from the North, during the secession war, have liked that the soldiers from the South kill their chiefs and Officials, and, reciprocally, those from the South would not [they] have felt satisfaction if the soldiers from the North had done any similar thing?" Finally, the fourth article, which was written by Enrique, accused Wilson of being in connivance with Carranza because the latter had promised to favor U.S. capitalists in Mexico. In this case, rather than inciting treason, Marquina countered, Enrique simply told the truth, since "the conditions on which the carrancista government was recognized by the U.S., and which are known by everybody implicate the restoration of the Porfirio Díaz system and all that it had of spoliator and tyrannical" (March 4, 1916). Marquina concluded by charging the state with dishonoring the American people by serving a foreign tyrant and "locking up in jail" Carranza's enemies.

Along with translating the articles into English and arguing against the charges, *Regeneración* also attacked the hypocrisy of the state and made accusations of "discrimination" because the Magóns were charged with in-

citing violence through the mails, while despite "the continuous murderous scream of the daily press and especially the Hearst organs" that urged Wilson to go to war against Mexico, Hearst, Otis, and other publishers with significant investments in Mexico were left alone (May 13, 1916). In an April 6, 1916, piece about the case, R. G. Cox suggested that as "in former times," it was the "cause" that was "at issue" rather than the newspaper writings of the Magóns. Cox found it maddening that the "capitalist and yellow sheets" were "absolutely immune from all this," and that the Hearst papers carried a "continuous scream urging and inciting people to fly at each others' throats, but they are not molested." Even though Hearst was "working day and night to force the people of this country into a bloodfest with the Mexican people," Cox objected, "we don't see screaming headlines announcing that Hearst has been arrested for 'using the mails to circulate matter that tends to incite to murder, arson, and assassination.'"[3]

To make matters worse, the very next week the postmaster revoked the paper's second-class mailing privileges on grounds that *Regeneración* was "not a newspaper that can be considered as such, because it professes incendiary and destructive methods" (April 13, 1916). Notifying readers that the paper would now have to bear twice the expense to keep publishing, on June 7, 1916, the editors announced that they would no longer be able to produce it on a weekly basis and hoped to put out a new issue every other week. For the next two years, *Regeneración* appeared sporadically, and only rarely at biweekly intervals, before it expired in March 1918.

Even before the paper's second-class mailing privileges were revoked, the editors of *Regeneración* could only infrequently afford to reproduce images, but at times they strategically used photographs, illustrations, and especially cartoons to make connections between world movements. A good example is a large illustration (see figure 28) that appeared on the first page of the April 29, 1916, issue, which included the words "18 de Febrero 1916 Regeneración" at the top and two portraits, based on photographs, of Ricardo and Enrique, along with a picture of a "monstruo (Capital, Autoridad y Cléro) / monster (Capital, Authority, and Clergy)," adorned with bullets, dollars, and stars like those on the U.S. flag, snorting smoky blasts at doves with the names of workers' newspapers written on their wings, in front of the Statue of Liberty. The newspapers under attack included *Mother Earth*, the *Blast*, *Regeneración*, and the *Alarm*, and the same issue of the paper informed readers that the post office had held up another issue of the *Blast* and that Emma Goldman had been imprisoned

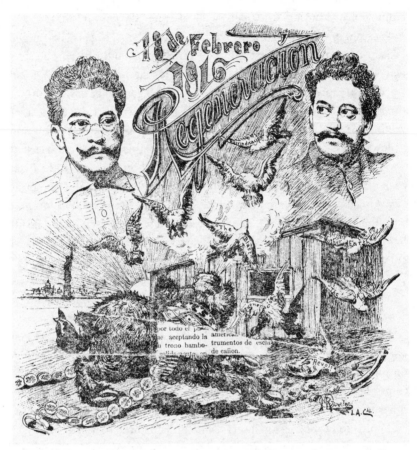

FIGURE 28 "18 de Febrero de 1916 Regeneración." *Regeneración*, April 29, 1916. Labadie Collection, University of Michigan.

for two weeks for advocating birth control. Visually connecting all these struggles, the artist, Nicolas Reveles, re-envisioned the day the Magóns were arrested, in a sensational scenario, as a monstrous crime scene which "dar al golpe de muerte a la prensa Obrera" (gave a death blow to the workers' press).

All of these workers' papers were connected to anarchist movements; all were threatened or killed, in the picture, by the monster that embodied the merging of the state, the military, and transnational capitalism; and all participated in Haymarket memory-making by connecting the Haymarket trial and executions to the present. Among them was the *Alarm*, the monthly Chicago newspaper in which Lucy Parsons's letter announcing her intention to lecture on the Mexican Revolution on behalf of the

Magóns, which was reproduced in *Regeneración*, had originally appeared. The first version of this paper (October 1884–April 1886) was edited by Albert R. Parsons; the second series (November 1887–February 1889) was a short-lived effort to revive the paper in the wake of the executions; and the last issue of the third series (October 1915–August 1916) appeared just a few months after this illustration depicting the paper as a wounded, reeling bird victimized by the monstrous synergy of capitalism and the war state was published in the pages of *Regeneración*. Along with this network of connections, the legal persecution, trials, convictions, appeals, punishment, and media coverage of Ricardo and Enrique Flores Magón and other PLM members must have reminded Lucy Parsons and other Haymarket memory-makers of the Haymarket anarchists, who were found guilty of murder, partly because of the sensational, violently compelling force of their "incendiary," revolutionary words in speeches and newspapers, and who were quickly convicted, then either imprisoned or executed.

Lucy Parsons called the Haymarket trial a "farce" in 1910, in the first issue of the bimonthly anarchist journal the *Agitator*, which was affiliated with the Home Colony in Washington. The editor, Jay Fox, was a veteran of the Haymarket struggles in Chicago who filled the short-lived, initially pro-IWW paper with drawings, articles, and poems about Haymarket as well as news of the Mexican Revolution.[4] The paper, which first appeared on November 15, 1910, aimed to commemorate, according to Fox, "the twenty-fifth anniversary of the Chicago martyrdom by the publication of a paper that stands for the freedom throttled by [Judge] Gary and his co-conspirators Nov. 11, 1887." The first issue included an extract from the November 19, 1887, issue of Parsons's paper, the *Alarm*, which contained an account of the execution and of the anarchists' last words, as well as an article that enjoined readers to "hail the memories and influences of the heroes of Chicago — not of war! Victims of the class war!" And in her article, entitled "The Trial a Farce," Lucy Parsons once again, more than two decades later, concluded by connecting the past to the present: "Our comrades sleep the sleep which knows no awakening, but the grand cause for which they died is not asleep nor dead!" Parsons warned that it would be useless for "the ruling class" to try to suppress the "swelling tide" of revolutionary transformation, for "though they should erect gallows all along the highways and byways, build prisons, and increase armies, the tide will continue to rise until it overwhelms them in a worldwide revolution." In these ways, she connected cultural memories of Haymarket to the

revolutionary struggles of the 1910s, including those involving the PLM, anarchists, and socialists who were caught up in the unfolding events of the Mexican Revolution.

During this period, Lucy Parsons worked relentlessly, especially by publishing and promoting editions of the lives of the anarchists and their famous speeches, to ensure that they lived on in radical cultural memory to inspire future world movements. Her efforts are visible on the bottom of the first page of the November 15, 1910, issue of the *Agitator*, which advertised an edition of *The Chicago Martyrs: The Famous Speeches* for sale for thirty cents. In the ad, Fox opined that the speeches are "masterpieces of their kind, and have traveled around the world and given hope and courage to hundreds and thousands of toilers, in a dozen languages." The mediated autobiographies of the anarchists as well as the *Famous Speeches* served as sourcebooks for early-twentieth-century writers, orators, and artists who remembered Haymarket.[5] Again and again, they quoted the anarchists' words in poems, essays, newspaper articles, and speeches of their own. From the 1890s through the early decades of the twentieth century, Parsons sold both these books and others on the street, by mail through notices in radical periodicals, and at labor events, including Haymarket memorials, where she usually lectured, not only in Chicago but also in many other parts of the United States, including New York City, Seattle, Los Angeles, and San Francisco, as well as in Canada.[6]

Despite her public-sphere persistence, however, it wasn't always easy for Parsons. On many occasions, she was prevented from speaking or from selling literature. Under the headline "Lucy Parsons Arrested," in the April 19, 1913, issue of *Regeneración*, for instance, Owen reported that Parsons and her companion, George Markstall, had been arrested and charged with "selling copies of the Celebrated Chicago speeches on the streets of Los Angeles without a license." Owen complained of the "discrimination exhibited in her case," since "literature is sold freely at street meetings in this city," and also deemed her treatment by the police "outrageous, a ring that had never left her finger since her husband placed it there having been removed forcibly against her protest." On the same page, under the headline "Come and Hear Her," Owen promoted her "afternoon and evening speeches" on "The Haymarket Tragedy" and "Direct Action, as Exhibited in Mexico and throughout the Labor Movement," and predicted that the fact "that the Los Angeles police have fallen foul of her will not keep the public from attending."[7] Although these charges were later dropped, in

January of the next year she was arrested in San Francisco and charged with "inciting to riot" when around a thousand angry demonstrators followed her and the police to the station after she was arrested while speaking from a curbstone, having been turned away from a lecture hall where she was scheduled to speak. While these charges didn't stick, either, these events are only two of many cases in which Parsons was hassled by police and public officials who wanted to prevent her from speaking or circulating literature.[8] And although over the course of her lifetime she contributed to and edited many different periodicals, including the *Socialist*, a few different incarnations of the *Alarm*, *Freedom*, the *Rebel*, *Free Society*, the *Liberator*, *Industrial Worker*, the *Agitator*, the *Syndicalist*, and others, these publications were generally short-lived, often short of funds, and were sometimes suppressed: the *Alarm* was shut down for a while after the Haymarket bombing, and in Chicago police destroyed the *Free Society* press after McKinley was assassinated, in 1901. Parsons was rarely able to include illustrations in these ephemeral, short-lived, and cash-starved publications, though she continued to intervene in practices of looking in other ways.

Parsons was also a vocal opponent of U.S. empire who criticized the imperialist wars of the turn of the twentieth century, led anti-recruitment protests in 1899, and made a speech appealing to potential recruits to "refuse to enlist and go to those far-off islands for the purpose of riveting the chains of a new slavery on the limbs of the Filipinos."[9] Many of those in her expansive network of radicals understood the relationship of the United States to Mexico to be an imperialist one, citing U.S. capitalists' large-scale acquisition of Mexican land and other resources, such as oil, pressures on the state to protect their interests, and Taft's and Wilson's interventions in Mexico as part of a continuum of recent U.S. empire-building.[10] In the lead article in the April 1, 1911, issue of the *Agitator*, Fox even declared that "if the government of this country may step into Mexico and restore the power of the cruel Díaz regime without a word of protest from the great body of American toilers, the degeneracy of [the] American labor movement is well proven, and the plutocratic owners of the country may use the army and navy with impunity to carry out their dream of empire." Like Fox and other contributors to the *Agitator* from 1910 to 1912, Parsons probably connected U.S. efforts to contain and reshape the Mexican Revolution to an ongoing U.S. "dream of empire," one that for Parsons notably included the wars of 1898 and the long war in the

Philippines. In an address before the Socialist League in London as part of a Haymarket commemoration event in 1888, Parsons described herself as "one whose ancestors are indigenous to the soil of America. When Columbus first came in sight of the Western continent, my ancestors were there to give them a native greeting. When the conquering hosts of Cortez moved upon Mexico, my mother's ancestors were there to repel the invader; so that I represent the genuine American. I don't say this from any national feeling of boundary-lines; I simply say this to show the tenor of the times and the different peoples who are here tonight."[11] While Parsons's emphasis on her indigenous American-ness may respond to charges that the Haymarket anarchists were foreigners whose values were therefore alien to republican America, her allusion to the "invasion" of Mexico reminds her listeners of the long history of empire-building in Mexico and the Americas.

In her compilations and writings, Parsons also emphasized parallels between rich capitalists and Southern slaveholders, the continuities between slavery and so-called freedom after the Civil War, and the need to make fundamental changes in "existing social and industrial arrangements." During the decades that followed Albert's death, she continued to envision workers' struggles as a new front in an ongoing civil war and only occasionally, although then with outrage and sympathy, did she refer specifically to the struggles of black people in the wake of the failure of Reconstruction.[12] Thus she did not specifically address the grim situation of black people in the post-Emancipation period when she contributed to the *Liberator* a front-page article entitled "Americans Arouse Yourselves" (September 14, 1905). Reminding her readers of the fiftieth anniversary of the end of the Civil War, she claimed that "50 Years Ago You Drew Your Sword to Save the Black Slave" and posed the question "What will you do now?" Parsons compared "the wage slave, as a class" with the "black slaves" of "the Southern slaveholders" as she argued for the inadequacy of mere political solutions:

It's not quite so bad in the North to-day, it is true, but how many of the wage class, as a class, are there who can avoid obeying the commands of the master (employing) class as a class? Not many are there? Then are you not slaves to the money power as much as were the black slaves to the Southern slaveholders? Then we ask you again, What are you going to do about it? You had the ballot then. Could you have voted away black slavery? You know you could not for the slave holders would not

hear to such a thing, for the same reason you can't vote yourselves out of wage slavery.

Here, by using the wage-slavery metaphor Parsons emphasizes the continuities between the position of workers after the Civil War, who are "slaves to the money power," and that of the "black slaves" of the "Southern slaveholders" before the Civil War. By naming her short-lived weekly newspaper the *Liberator* (1905–6), moreover, she implicitly compared Garrison's abolitionism to the post–Civil War project of emancipating the "wage slave." In all of these ways, she continued to draw on antebellum languages of labor and race as she critically addressed the incomplete project of emancipation in the decades after the Civil War and Haymarket.

As her conflation of these two forms of "slavery" suggests, Parsons sometimes relegated issues of race to secondary status, subordinating them within an economic framework, such as when she argued in an April 3, 1886, issue of the *Alarm* that "outrages were heaped upon the negro" because he was "poor" rather than because he was "black." At other times, however, she emphasized race as a factor in her analysis of the new but uncannily familiar forms of violence and inequality that followed the Civil War. In a newspaper article on "Southern Lynchings" (1892), for instance, she denounced the "brutality" of the "war" being "perpetrated upon the Negro in the south," which she described as a "scene of horrors" in which "bloodthirsty mobs" were "lashing and lynching" citizens. She also hoped that "another John Brown" would rise up from among the "colored" race and suggested that "peaceful citizens" were being lynched "simply because they are Negroes."[13] The April 1, 1906, issue of the *Liberator* devoted several columns to the first meeting of the Georgia Equal Rights Association, which was attended by "two hundred colored delegates," including W. E. B. Du Bois, who attacked the idea that labor contracts were free and cited debt peonage and vagrancy laws as examples of the near reduction of farm labor "to slavery in many parts of the State," as he would later document in *Black Reconstruction in America*. The group reminded "the world" that "the accumulated wealth of this great State has been built upon our bowed backs, and its present prosperity depends largely on us," and yet, they objected, "we are not receiving just wages for our toil," chiefly because of the injustices enforced by the labor contract. Although Parsons herself put little faith in political solutions, her paper reprinted the group's statement that "Voiceless workingmen are slaves" as well as their angry request that the nation "enforce the fourteenth and fifteenth amendments." In-

deed, she undoubtedly shared the group's position on the inequalities of contracts after formal emancipation, for in an editorial published in the *Liberator* on October 29, 1905, she argued that "contracts are only good between equals; but as the laborer is never on equal footing with capital, the contract is a fraud and will react to his detriment."[14]

Since Lucy Parsons also shared the belief that, as Albert put it, "access to the means of production" was a natural right and that all people had an "equal right to the use of the soil and other natural opportunities," she also supported Flores Magón's view that the PLM and the Mexican people were involved in a fight against "slavery" and that through direct action they should take back the land and the means of production.[15] This emphasis on direct action, which comes through clearly in the title of her lecture "Direct Action, as Exhibited in Mexico and throughout the Labor Movement" (1913), was one of the defining principles of the IWW, but within a few years it would lead to a split with socialists and others within the organization who contended that political reform was the best path to economic and social transformation.[16] Members of the IWW from the U.S. West, such as Big Bill Haywood, especially, criticized the focus on political action at the ballot box rather than on revolutionary tools such as the general strike and sabotage, two strategies of direct action. In his IWW pamphlet *Direct Action and Sabotage* (1912), William Trautmann explained that the strategy of direct action emerged as workers became conscious of their importance in "workshops, mines, farms, and transportation" and realized that their labor was "indispensable," and therefore that the "withdrawal from the job, the suspension of operation, the withdrawal of efficiency" might be effective weapons in "curtailing the economic power of the capitalist class."[17] The term could also refer to the expropriation of land and to revolution, as in a 1923 IWW pamphlet that proudly recalled the period "when the Mexicans overthrew Díaz" and "the IWWs rushed over the Southern border and took part in the work of liberation" as exemplary of direct action and IWW internationalism.[18]

Members of the IWW, Mexican revolutionists, and Haymarket memory-makers looked backward to the past as they defended direct action, for they often cited John Brown's efforts at Harper's Ferry, as well as other antislavery actions of the Civil War era, along with the events surrounding the Haymarket drama, as important precursors to the struggles of their own era. But they also faced the future by remembering Haymarket and connecting it to state violence in Mexico, the United States, and Europe as well as to the revolutions in Mexico and Russia.[19]

Although the First World War and the Bolshevik Revolution have more often been credited with provoking and inspiring early-twentieth-century radical internationalisms, the series of wars, interventions, uprisings, and other conflicts in Mexico and the U.S.-Mexico borderlands during these years also shaped debates about state power, transnational capitalism, and revolutionary world movements within and beyond the United States and Mexico. The U.S. bombing and occupation of Veracruz in 1914, the deployment of U.S. soldiers against Pancho Villa in New Mexico in 1916, the recurring possibility of further U.S. military intervention in Mexico before the United States entered the First World War, and the collusion between Mexico and the United States in the harassment and imprisonment of émigré revolutionaries were especially controversial. The revolutionary agenda of the PLM was also a flashpoint for debates over radical strategies and tactics, for Flores Magón and the PLM were dedicated not only to the overthrowing of the Díaz regime, but also to the expropriation of land and the means of production, and many U.S. labor organizers and socialists had problems with this revolutionary agenda.

It is perhaps not surprising that Samuel Gompers, the president of the American Federation of Labor (AFL), distanced his organization from the more radical aims of the revolutionaries and refused to condemn U.S. military interventions in Mexico. In 1911 Flores Magón appealed to Gompers to urge "workingmen of the United States [to] speak out" in support of PLM efforts to fight "the slavery, forced on us and supported by the American money power. The Standard Oil Company, the Guggenheims, the Southern Pacific railway, the Sugar Trust—all that Wall Street autocracy against which you and the great masses of your nation are making such vigorous protest—are the powers against which we of Mexico are in revolt."[20] Although Gompers did publicly defend Flores Magón after he and two others were arrested for violating U.S. neutrality laws in 1907, the PLM would soon find out, according to the labor historian Gregg Andrews, that Gompers was not a reliable ally, for despite the opposition of numerous local unions to U.S. intervention in Mexico, Gompers worried about the possible "influence of a dynamic IWW internationalism in radicalizing the revolution." Furthermore, Gompers sought to integrate the AFL "into a national foreign policy agenda which would nurture a more progressive United States-led economic expansion into Latin America," and he ultimately subordinated labor internationalism to that agenda.[21]

Even the socialist John Kenneth Turner, whose sensational exposé *Barbarous Mexico* helped to arouse sympathy for the revolt against Díaz, broke with the Magóns and the PLM after they criticized Madero and pushed for land redistribution and more radical changes in the wake of Díaz's overthrow.[22] Although just a little later Turner would change his mind, he initially called for the end to the revolution once Madero, whom he supported, became president of Mexico, and he believed, according to Owen, that Flores Magón had "killed" Madero's "party" by criticizing him. This was especially disappointing because Turner had been one of the PLM's biggest supporters when Ricardo and the others first came to Los Angeles. In the years that followed, in the pages of *Regeneración* Owen frequently expressed "admiration" for Turner's "services" as a "bold and faithful chronicler of facts," but claimed to "cross swords with Mr. Turner" over the latter's claim that Mexico remained in a stage of "feudalism" beyond which the United States had passed. Owen insisted, on the other hand, that "Mexico is not suffering because it is a century behind us," but rather that "Díaz, under the influence of Limantour and the 'Científicos,' was modern capitalism incarnate" (May 3, 1913).

Many U.S. socialists endorsed such a "modes of production" master narrative, which often depended on an "evolutionism" that, in Barbara Foley's words, "insisted that all peoples and nations must go through full capitalist development, thereby creating a proletariat exclusively empowered to carry forward the torch of history."[23] These socialists also had a "formalistic view of the state as a neutral site" that might, "through political education and organization of the workers, evolve into an institution serving all of the people" (89), and they were thus critical of the PLM's pessimistic, if not dystopian, view of state power, even though many of them would soon feel the punishing hand of the state in all its intensity during the "Red Scare" that followed.

In an article called "The Crisis in Mexico" published in the *International Socialist Review*, Eugene Debs, for instance, who would soon be imprisoned for thirty-two months for giving an antiwar speech, criticized the PLM for their anarchist tendencies as he compared them to the Haymarket martyrs.[24] While Debs hoped that the ouster of Díaz would ultimately inspire the Mexican people to "overthrow not merely their political dictators, but their economic exploiters" in order to achieve true "emancipation," he worried that the "direct action" tactics of the Mexican Liberal Party would end "in a series of Haymarket sacrifices and the useless shedding of their

noblest blood" ("The Crisis in Mexico," 22–23). Instead of inspiring rebel-lion, in this case the Haymarket analogy served a cautionary function. And despite his sympathy for the revolt against Díaz, Debs also argued that "the masses of Mexican workers and producers, like those in other countries, are ignorant, superstitious, unorganized, and all but helpless in their slavish subjugation," so much so that "in their present demoral-ized state economic emancipation is simply out of the question" (22). It is important to recognize that Debs spoke out, more often than many of his peers, on behalf of racial justice, and the differences between socialists and anarchists should not be overstated, since there were many political and institutional connections between them. Yet Debs's statement reveals the implicit narrative of progress and development, with its emphasis on stages of revolutionary transformation, which framed many socialist dis-cussions of the Mexican Revolution and limited their imaginings of radical transborder movements.

But anarchists such as Lucy Parsons were much more likely to sym-pathize with what Debs condemned as the "direct action" tactics of the Mexican revolutionists. In an editorial published in *Regeneración*, Owen insisted on the significance of the Mexican Revolution for the U.S. labor movement, arguing that the AFL and other labor unions should not ignore "the vast army of Mexicans now working in the United States" or "the great struggle going on across the Rio Grande and involving issues which affect most deeply the whole body of labor, white, black, mahogany, colored, and what not. The old policy of ostracism, from its neglect of the Mexi-can and negro, to its persecution of the Oriental, is a relic of aristocratic barbarism and should be flung upon the scrap heap" (December 6, 1913). Here, instead of warning of the "slavish subjugation" of the Mexican "masses," as Debs did, Owen urged "the whole body of labor" to attend to the "great struggle" going on in Mexico, where Mexicans had taken the lead in actively addressing "issues which affect [them] most deeply." [25] One of Owen's replies to Debs, "What Mexico's Struggle Means," was published in the May 1912 issue of *International Socialist Review*, shortly after Debs's own article appeared, and in an article called "Mexico and Socialism" pub-lished in *Mother Earth* in September 1911, Owen criticized the Socialist Party, deeming it the "enemy" of what he called a "revolutionary situation of extraordinary vehemence" in Mexico and part of the reason that events in Mexico commanded "so little sympathy" (202) among U.S. workers. Later, in an article entitled "Magón Is Marx' Natural Ally," Owen insisted

that "Magón is the man" with whom the author of *The Communist Manifesto* would have sided, rather than with Debs or Victor Berger, the prominent socialist who represented "the respectability Milwaukee has sent to Congress to fight all revolutionary movements" (January 6, 1912) and who infamously referred to the PLM as "bandits."

For the next few years, in the columns of the English page of *Regeneración*, Owen continued to attack the socialists for failing to understand that the crisis in Mexico was precipitated by modern global capitalism rather than by an anachronistic feudalism, even as he himself continued to use the language of "slavery." On May 10, 1913, he insisted that "the operations of such men as Guggenheim embrace the globe" and that since international capitalists are attracted to "rich natural resources" and "cheap labor," whatever "flag they may profess to fly, their actual country is the world." Only "the wage slave," he charged, "is duped by the patriotism bauble," since capitalists such as Guggenheim, Hearst, and Otis know that "steam and electricity have put frontiers out of date; in Chili [*sic*], Mexico, South Africa, wherever wealth is stored and native labor can be bought cheapest, there is their home." This helps to explain why the Mexican crisis was so important to Owen: he believed that "capitalism in this country must either advance toward the South and become infinitely stronger, or be turned back and receive a mortal blow." Two years after Debs had written "The Crisis in Mexico," Owen was still angry, charging that Debs "spares no pains to alienate sympathy" from "the Mexican disinherited," despite the significance of their struggle against forms of slavery that were reanimated by modern imperialism and capitalism.

Another of Owen's ripostes appeared in the *Agitator*. In the August 1, 1911, issue, Fox reprinted Owen's article "Debs Sides with the Reactionists," in which Owen castigated Debs for arguing "as slave-owners have argued since slavery began." Owen asked Debs: "What will you do after you have organized [Mexicans] according to your superior wisdom? What COULD you do with them except urge them to get back their land—the very thing they have been doing most effectively NOW, and without your aid!" (2). In the November 15, 1911, issue of the *Agitator*, in an editorial called "Greatest Figure in History," Fox echoed Owen's criticisms of the socialists as he sarcastically noted that "the 'ignorant' peons will not trade their guns for socialist tracts." Arguing that "the Mexican" is "the most important figure in history, not excepting the French Revolutionists," Fox predicted that "the 'illiterate' Mexican across the line is engaged in the first battles of the

world-wide revolution which will sweep capitalism from its base and enable industrial and political freedom." Fox concluded, "All hail to you, my gallant Mexican fellow workers! I bow before your superiority. You know, you do, I merely talk" (4). Here, Fox identifies the Mexican revolutionists as models for workers in other countries precisely because of their direct-action tactics, rather than declaring them unready for "economic emancipation."

Looking backward, Fox remembered being present at the McCormick riot in Chicago in May 1886, as part of his finger was severed by a bullet that proceeded to kill someone next to him. Looking forward, he saw the Mexican Revolution as the beginning of a "world wide revolution" for "industrial and political freedom." Both Fox and Owen viewed the Mexican Revolution and worldwide labor struggles as rebellions against "slavery," and both thereby connected the U.S. Civil War, wars on workers, and the Mexican Revolution in their editorials and pamphlets. Both also criticized socialists for not supporting the direct-action tactics of the Mexican revolutionists, which they saw as the rightful effort of the proletariat, in Owen's words, "to get back by force what has been taken from it by force, or fraud backed by force."[26]

Such connections were also made by prominent anarchist women, including Lucy Parsons and Voltairine de Cleyre, who remembered Haymarket, reacted to events in Mexico, and also addressed the issue of women's place in these struggles as well as questions about whether marriage was a form of slavery. De Cleyre was a poet and writer of essays who delivered powerful November 11 speeches commemorating the Haymarket executions and whose final poem, "Written in Red," which is dedicated to "Our Living Dead in Mexico's Struggle," was published in *Regeneración*.[27]

De Cleyre was born in poverty in 1866, a year after the Civil War ended, in a small town in Michigan. Her mother was from a family of New England abolitionists, and her French father was an itinerant tailor and free-thinker who named her after Voltaire and gained U.S. citizenship by fighting for the North during the Civil War. As a young woman, she began to write essays and poems as part of the free-thought movement, editing a small weekly, *The Progressive Age*, lecturing throughout the East and Midwest, and contributing to publications such as the *Boston Investigator*, the *Freethinkers Magazine*, the *Truth Seeker*, and *Freethought*.[28] The execution of the Haymarket anarchists in 1887 was a transformative event that she later credited with converting her to anarchism. After that, she started

writing for Benjamin Tucker's *Liberty* and moved to Philadelphia, where she began teaching English to Jewish immigrants and learning Yiddish, in which she became so fluent that she could enthusiastically follow discussions in Jewish anarchist newspapers and could translate the Yiddish of Z. Libin and I. L. Peretz for *Mother Earth*.[29] Between 1890 and her death, in 1912, she contributed to a variety of radical and anarchist journals, including some that Lucy Parsons was involved with, such as *Freedom*, the *Rebel*, *Solidarity*, the *Firebrand*, and the *Agitator*. She also gave many speeches, including at least one alongside Parsons at a Haymarket memorial in Chicago in 1906. From 1906 to 1912, she contributed to *Mother Earth* on a regular basis, and during the last year of her short life, she became a contributor to *Regeneración* and organized the Chicago Mexican Defense League to support the PLM.[30]

For de Cleyre, the Mexican Revolution was, like the Haymarket executions, a world-transforming event, one that she hailed as "a genuine awakening of a people" who have "struck for Land and Liberty" and one that she predicted would achieve "as important a place in the present disruption and reconstruction of economic institutions as the great revolution of France held in the eighteenth-century movement."[31] The Haymarket speeches that de Cleyre delivered between 1895 and 1910 help explain the intensity of her response to the Mexican Revolution. Some of these speeches were published in movement periodicals, usually shortly after the event, but sometimes many years later, as part of an ongoing cycle of commemoration in which radicals responded to the present by remembering Haymarket. Like Parsons and other radical memory-makers, de Cleyre looked both backward to the past and forward to the future when she remembered Haymarket. In *The First Mayday*, she imagined Haymarket as an "unhealing wound whence blood still issues" (1), one which was productive rather than an "uncompensated loss" (2), since there were "so many things to gather" from the "grave" (1), especially the words of the martyrs, sent "on wings of flame in many tongues and many lands" (4), so that "though there is nothing but ashes in the five-fold grave, there are flaming memories from world's end to world's end tonight" (32). In all of her speeches, she frequently cites the anarchists' words, especially those from Parsons's *Famous Speeches*.[32] And in a Haymarket oration delivered in Philadelphia in November 1900, in language that foreshadows the words of her final poem, "Written in Red," she insisted that the Haymarket anarchists had a message to deliver, "a burning message, red at the heart, and

leaping in flames" (18). Looking backward to the Civil War, she claimed that the Haymarket martyrs "believed that Lincoln and Grant were right, when they predicted further uprisings of the people, wild convulsions, in the effort to reestablish some equilibrium in possessions" (18). In this way, she situated the Haymarket tragedy as a continuation of the Civil War and as part of an ongoing history of "slavery" that opened up onto a future of "further uprisings."

At least by the end of the nineteenth century, discussions of lingering forms of slavery could also provoke challenging questions about married women's legal status and women's work in the home, in the labor market, and within radical movements. At times anarchists and other radicals criticized marriage as a form of "Sex Slavery," as the title of one of de Cleyre's pamphlets put it. Calling the "married woman" a "bonded slave" who "takes her master's name, her master's bread, her master's commands, and the throes of travail at his dictation—not at her desire," de Cleyre protested that "only through the marriage law is such tyranny possible."[33] In viewing marriage as a form of slavery, de Cleyre contributed to what Amy Dru Stanley has shown was a lively post–Civil War debate about whether "principles of contract freedom should apply to marriage," whether marriage was an "equal contract," and whether the wife lost "sovereignty" in her "self" when she married and was thereby effectively enslaved. As Stanley makes clear, the "lessons of slave emancipation implicitly informed the understanding of the wife's contract freedom" that was at stake in these debates.[34]

Instead of calling marriage a form of slavery, Lucy Parsons took a somewhat different position, idealizing, in one issue of the *Liberator*, the "home" even as she argued that the domestic ideal was "rarely achieved under the present system of capitalism" (September 10, 1905). In the very next issue, however, she wrote an editorial about women who are "happier while unmarried" in which she defended divorce and blamed churches "for meddling with the marriage relation," since, she argued, "the people are generally trying to find the best way to save their bodies while in this world, and obtain any happiness they can" (September 17, 1905). According to her biographer Carolyn Ashbaugh, Parsons tried to separate out the question of "variety in sex relations" from the question of "economic freedom," arguing that venereal disease and the mother's responsibility in case of pregnancy were perils of "free love."[35] But while Parsons's complex and sometimes contradictory views of marriage may have been shaped by

her mixed-race status, her specific concern for the problems of poor and working-class women, and by the historical failure of the state to respect and uphold the marriages of many people of color, the distinction she tried to establish between questions of "sex" and questions of "economic freedom" was one that many other anarchists, including de Cleyre, would not have accepted.

Indeed, de Cleyre argued that in the wake of industrial capitalism different economies would arise and that, "with free contract, that form of sexual association will survive which is best adapted to time and place.... Whether that shall be monogamy, variety, or promiscuity matters naught to us; it is the business of the future, to which we dare not dictate."[36] Her theory of such an open-ended future, one which would engender diverse forms of economy and sexual association, was informed by her interest in "anarchism without adjectives," a more inclusive, less prescriptive conception of anarchism endorsed by the Spanish and Cuban anarchists Ricardo Mella and Fernando Tarrida del Mármol.[37] In 1910, when *Regeneración* was published in Los Angeles with a new English-language section, the editors included an illustration of Tarrida del Mármol on a poster that accompanied the first issue. Flores Magón's writings for *Regeneración* embrace Tarrida del Mármol's views, and the historian James Sandos imagines that the paper's "emphasis upon sex equality, Modern Schools, the opposition to every form of tyranny, and direct action" must have particularly resonated with de Cleyre.[38]

The message de Cleyre attributed to the Haymarket martyrs, moreover, was one that was at the heart of PLM efforts in Mexico: to tell the people to "learn what their rights on this earth were—freedom to use the land and all within it and all the tools of production—and then to stand together and take them, themselves, and not to appeal to the jugglers of the law."[39] As de Cleyre tried to persuade her audience of the significance of the PLM's struggle to radicalize the revolution, she drew on antebellum languages of labor and land, comparing Mexico's "great estates" to plantations and recasting the revolution as a war in which the "Slaves of Our Times . . . have smitten the Beast of Property in Land" (168).

But even as she looked backward to the antebellum era, in her lecture on the Mexican Revolution she anticipated some of the issues of our own times as she questioned an emergent discourse of development which promised that "developing" mineral resources and "modern industries" and granting land concessions would "civilize" Mexico." Instead of view-

ing development as the key to progress, de Cleyre emphasized its destructiveness: how "Indian life has been broken up, violated with as ruthless a hand as ever tore up a people by the roots and cast them out as weeds to wither in the sun" (305). Ultimately, she hoped that "freedom in land" would "become an actual fact" in Mexico, which would mean "the death-knell of great landholding in this country also," she argued, since "what people is going to see its neighbor enjoy so great a triumph, and sit on tamely itself under landlordism?" (274). But she was also concerned that U.S. citizens might fail to learn what they needed to know about Mexico because they were too "egotistic" about "their own big country" and especially because "they do not read Spanish" and were taught "that whatever happened in Mexico was a joke." Finally, she complained, "the majority of our people do not know that a revolution means a fundamental change in social life, and not a spectacular display of armies" (274). For these reasons, she worried that U.S. observers might not understand that some Mexican revolutionists were trying to bring about the sort of "fundamental change in social life" that the Haymarket martyrs had called for. In all of these ways, de Cleyre's speeches, essays, and poetry reveal how ideas about Mexico and the Mexican Revolution figured prominently in Haymarket memory-makers' backward-looking visions of "near future" revolutionary transformations.

FROM HAYMARKET TO THE MEXICAN REVOLUTION AND BEYOND: THE EAR AND THE EYE

De Cleyre's concern that people in the United States might not understand the significance of the Mexican Revolution and the PLM's struggle because "they do not read Spanish" was shared by the Flores Magóns and William C. Owen, who worried that "it is often hard to see clearly, especially when a movement is being conducted in a tongue with which most are unacquainted."[40] To be sure, bridging differences of language had been a challenge for U.S. radicals at other moments as well, notably in Chicago in the years leading up to Haymarket. In his "History of the Chicago Labor Movement," published in *The Life of Albert R. Parsons*, George Schilling observed that "A. R. Parsons for a long time was practically the only public English speaker we had," and he recalled that "we had no English literature on socioeconomic subjects" (xxii). The radical labor paper with the highest circulation in Chicago before Haymarket was, after all, the German-language *Arbeiter-Zeitung*, not Albert Parsons's English-language *Alarm*,

and several of the other important movement papers were in German and Bohemian.[41] Because many involved in the movement were immigrants and fluent in languages other than English, the Haymarket anarchists were often represented in an emergent mass culture as an unwelcome, alien presence in republican America. Parsons and his comrades, notably Spies, the editor of the *Arbeiter-Zeitung*, on the other hand, worked to bridge such differences and to build solidarity between German- and English-speaking labor activists by holding rallies where speeches were made in both German and English and by publishing some important texts, such as the famous circular announcing the May 4 Haymarket meeting, in both languages.

The contributors to *Regeneración* faced the same problem in the 1910s, and they experimented with a variety of strategies to address it, including translation, teaching Spanish and English to monolingual radicals, and using photographs, illustrations, and cartoons to communicate meanings across boundaries of language and literacy. Remembering Haymarket was apparently one activity that had the potential to bring together radicals from different nations who spoke different languages, for in the October 28, 1911, issue of *Regeneración*, in an article in the Spanish pages entitled "Los Martires de Chicago," the editors drew readers' attention to an upcoming mass meeting at Burbank Hall to commemorate the execution of the Chicago anarchists. And in the November 4, 1911, issue, the paper invited "todos los mexicanos / all Mexicans" who wanted to learn the history of this "crimen de la burguesía y del gobierno / crime of the bourgeoisie and the government" to attend the meeting and listen to Ricardo Flores Magón's and William C. Owen's speeches as well as a poetic composition on the subject by a "niña / little girl." In the English section, Owen declared that "no event in American history ever carried more important lessons for the world's disinherited, and we of Los Angeles, in particular, should not allow [the Haymarket anarchists] to be forgotten."

Especially after his release from prison in 1913, Enrique Flores Magón made key contributions to these efforts to bring together English- and Spanish-speaking radicals. Beginning in 1914, he wrote several articles for the English page and translated important pieces from the Spanish pages. In the January 31, 1914, issue of *Regeneración*, for instance, he translated an article that appeared on the English page under the title "Back Again to Our Post." In this article, the former prisoner rejoiced that "we have found our beloved paper still alive" but worried that "its debts have been piling

up week after week." In another article on the same page, Enrique apologized for his "poor English," adding that he was strongly motivated to "go now after the English language" and promising to "struggle like a Titan to make myself understood in a tongue that is not my own." In the weeks that followed, he covered other labor conflicts in the United States in both Spanish and English, notably the struggles involving hop pickers from Wheatland, California. In a piece entitled "Our Brothers from Wheatland" (February 7, 1914), he explained that he felt "great indignation and rage" when he read about their battle while he was imprisoned at McNeil's Island and suggested that if Mexico, "because of the intolerable conditions to which the proletariat had been cornered, deserved the name 'Barbarous Mexico,'" the hop pickers' case proved that the "so-called Model Republic, United States of America, deserves the name of barbarous, too."

Enrique also participated in efforts to build transborder coalitions by remembering Haymarket. In the November 1916 issue of *Mother Earth*, which contained many reflections on Haymarket's significance, he recalled that when he heard his parents talk about the execution of the Chicago anarchists, he wondered "how the bodies of the hanged men must have looked, dangling to and fro from the ends of ropes fastened to the branches of a tall, leafy oak, as men are hanged in Mexico" (674–75).[42] And in an article in the Spanish pages of *Regeneración* (January 8, 1916), Enrique responded to a contemporary's claim that Albert Parsons was "un socialista gubernativo / socialist who believed in government" by calling the author a liar and insisting that Parsons was an anarchist. To prove his point, Enrique cited the speeches of the eight Chicago anarchists "publicado por nuestra camerada Lucy Parsons / published by our comrade Lucy Parsons," Albert's "compañera de vida / life companion" and told readers that if they wanted to judge for themselves, they should send twenty-five cents to her in Chicago in order to receive a copy of the book; he added, "Se le puede escribir en espanol, idioma que ella entiende / You can write in Spanish, a language she understands." He also cited passages that showed Albert was an anarchist, and translated one that supported his point that Parsons had considered the state an "odiosa institución" and criticized the centralization of power.

In addition to these strategies, the editors of *Regeneración* used photographs, engravings, and cartoons, when they could afford them, to try to make connections between movements. They also critically commented on practices of looking by reproducing or informing readers about images

in other radical publications, including some published in Mexico. In an article that appeared on the English page on December 9, 1911, for example, Owen reflected on the financial constraints that limited what the PLM's paper could do with pictures when he wrote, "One wishes . . . that one could reproduce the illustrations with which the Mexican comic papers swarm, as they never swarmed before" and called attention to several cartoons in *El Ahuizote*, in particular, as examples of "the great literature" of revolution, which gives voice to the "underlying thoughts and emotions that are habitually suppressed in times of peace." The very next week, he once again applauded "the well known comic weekly" for its "front-page colored cartoon" that reproduced the story of Lazarus and Dives "with Madero and the Mexican people in the title roles," as well as for a central, sensational cartoon showing Madero as a gravedigger disinterring the dictatorship of Porfirio Díaz. Owen continued to comment on and translate the captions of Mexican cartoons throughout his editorship, observing on June 27, 1914, that in his columns he had "alluded time and again, to the ferocious caricatures in which Latin cartoonists hold up to ridicule and hatred" the "United States governing class," representing "our labor and capital conflicts as the ruthless wars they are" and relentlessly satirizing "our longings to gobble up the property of others." Owen found these cartoons important because, "just or unjust, they reflect current thought" and he warned of the perils of "pretending to virtues we do not possess and assuming a racial superiority which has no root in fact."

Another way the editors of *Regeneración* intervened in practices of looking was by reprinting cartoons from the English-language press and translating the captions into Spanish. But the meaning of the cartoons could often be understood even without the captions, for they incorporated iconic elements, such as a ball and chain representing peonage, that were shared across a wide range of visual representations on both sides of the border. The cartoons of an artist named Barnett, which were originally published in the progressive, one-cent daily newspaper the *Los Angeles Tribune* (1911–16), frequently appeared on the front page of the Spanish section of *Regeneración*. The March 1, 1913, issue, for instance, featured one of Barnett's cartoons, which depicts a male worker in ragged clothes, holding a tool in one hand and shackled to a ball and chain with the word *peonage* inscribed on it (see figure 29).[43] In the foreground a woman with downcast eyes kneels to collect the rocks the man is breaking, as he looks off in the distance at what the Spanish headline ("Mexico es un Ciclon Revolució-

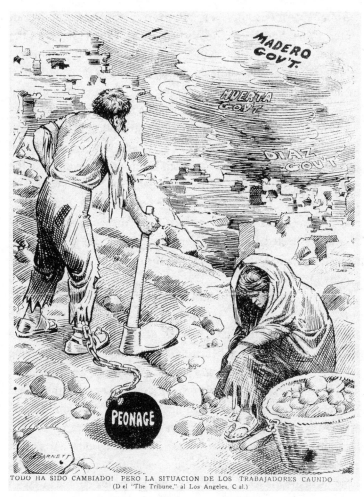

TODO HA SIDO CAMBIADO! PERO LA SITUACION DE LOS TRABAJADORES CAUNDO...?
(Del "The Tribune," al Los Angeles, Cal.)

FIGURE 29 "Toda ha sido cambiado! Pero la situacion de los trabajadores caundo [*sic*]." Cartoon from *Los Angeles Tribune* reprinted in *Regeneración*. Courtesy Bancroft Library, University of California, Berkeley.

nario") suggests are three cyclones, labeled "Diaz Gov't," "Madero Gov't," and "Huerta Gov't." The cartoon can be understood even without its new Spanish caption, which emphasizes that everything has changed except the situation of Mexican workers. And on the English page, the lead headline repeats the theme of the cartoon and the entire issue: "Rulers Change but Conditions Remain."

In addition to adapting and commenting on cartoons published in the United States and Mexico, from 1912 to 1914 the editors of *Regeneración*

reproduced many cartoons and illustrations by Ludovico Caminita, an Italian printer, writer, and artist who also edited an Italian section of the paper that appeared from July through October 1911.[44] Caminita's illustrations for the paper included political cartoons, engravings of the Flores Magón brothers, and several pictures for a special edition that appeared on June 13, 1914, including a full-page cover illustration of a giant breaking the chains of clergy, class, and government and holding a banner with the PLM's rallying cry, "Tierra y Libertad / Land and Liberty" (see figure 30).[45] These were some of the last illustrations Caminita contributed to the paper, however. An earlier announcement entitled "Too Valuable to Lose," which appeared on the English page of *Regeneración* (July 26, 1913), explained that Caminita had "worked in the mines," that "one of his lungs" was "now severely affected," and that he and his family were "in dire want," and it appealed to readers to send money to the editor of the English section or directly to Caminita.

Two months later, two of Caminita's final illustrations for the PLM appeared in their English-language pamphlet *Land and Liberty* (1913). The first, inside the pamphlet, depicted a Mexican worker shackled to the iconic "peonage" ball and chain, bearing on his shoulders the staggering weight of a priest, soldier, and capitalist who are plucking money from a tree, while in the background rays of light shoot out across the desert from the faraway Statue of Liberty (see figure 31). In the second image, which appeared on the back of the pamphlet, Caminita once again used the Statue of Liberty to anchor a visual narrative about tyranny and the remoteness and inaccessibility of democratic ideals of liberty and freedom, but this time he made the United States, rather than Mexico, the target of his critique by contrasting the Statue of Liberty and the date "1776" with a statue of a skeleton holding a small gallows in one hand and a crucifix in the other, with a dollar sign dangling from a chain, standing atop a pedestal labeled "penitentiary" (see figure 32). In the wake of the sentencing of the Flores Magón brothers to eighteen-month jail sentences after they were declared guilty, on the basis of perjured evidence, of violating U.S. neutrality laws, Caminita suggested that the United States was no longer a beacon of hope for exploited Mexicans and that the prison had replaced the Statue of Liberty as a symbol of the immigrant encounter with U.S. America.

Another artist who contributed pictures to *Regeneración* was Nicolás Reveles, a Mexican engraver and illustrator who worked in Los Angeles

and was affiliated with the PLM. Many of his illustrations were reproduced in the paper in 1915, including one entitled "Acción Directa / Direct Action" (October 16, 1915), in which two male workers stand on a base with an inscription reading "Manifiesto de 23 de Septiembre de 1911," a reference to the document in which the PLM openly declared their anarchist principles and advised workers to appropriate the land and other resources as part of their war on authority, clergy, and capitalism (see figure 33). A paragraph in Spanish underneath the picture explains what it shows: the giants represent the "pueblo/people," who have freed themselves from political leaders and warlords and are in the process of emancipating themselves through direct action, the strategy that Lucy Parsons also endorsed in her lecture on the Mexican Revolution. Their efforts to crush scepters, crowns, military trappings, and other signs of an oppressive order illustrate the lesson, according to the caption, that political action is not capable of redeeming humanity and that only direct action can accomplish that task.

An engraving by Reveles that appeared in the newspaper a week earlier made a similar point. In "The Triunfo de la Revolución," a shining, refulgent female figure has toppled the capitalist system from its throne and keeps it down using workers' tools—an axe and a shovel—which signify the PLM's advocacy of expropriation as the form of direct action that would overturn the unjust hierarchies of the present in order to benefit "la familía humana." While humanity was presently divided into classes, everyone would happily fraternize in the future, when everyone's children had enough to eat, as Reveles suggests with his line drawings of happy, mingling, eating children who are illuminated by the rays of light emanating from the salvific female figure.

These two engravings were unusually utopian, however, for most of Reveles's engravings offered grimmer views of the present and near future, such as his October 23, 1915, cartoon "En Nombre de La Patria," which depicts a smug millionaire with dead bodies all around him. According to *Regeneración*, the picture showed what happens when workers from one nation agree to fight the workers of another. Another cartoon addressed to the "proletarios patriotas," entitled "El Militarismo Prepotente," featured a monstrous skeleton fused with an airplane and wearing a military helmet attacking a naked farmer (see figure 34). The cartoon was accompanied by a dialogue, in Spanish between the worker and "el militarismo," who invites the worker to come with him to the battlefields to fight for the dream of "la patria." The worker replies that the poor have no country and that

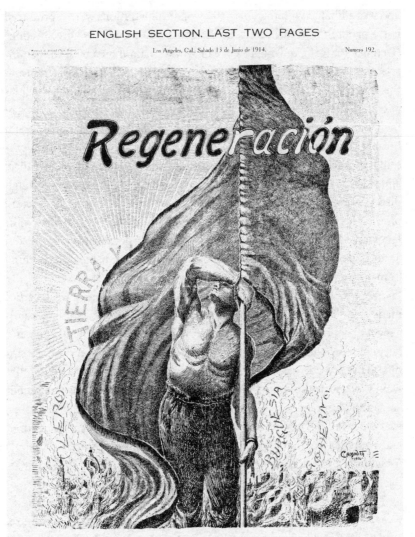

Los Angeles, Cal., Sabado 13 de Junio de 1914. Numero 192.

FIGURE 30 Ludovico Caminita cover with giant and banner. *Regeneración*, June 13, 1914. Labadie Collection, University of Michigan.

wars are fought for the benefit of the rich. On the English page of the next issue of the paper, William C. Owen extended the lesson by calling "attention to the cartoon (in free translation, 'Militarism on Top')" that had appeared the previous week, adding his own editorial gloss for readers of English: "There is the real origin of the war, and militarism is essentially the creation of the State."

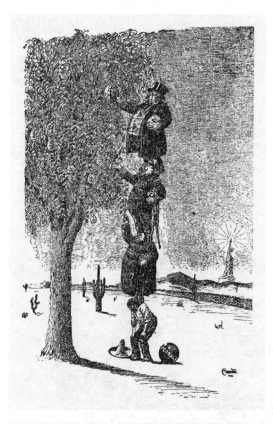

FIGURE 31 Ludovico
Caminita illustration in
Land and Liberty (1913).
Huntington Library, Art
Collections, and Botanical
Gardens.

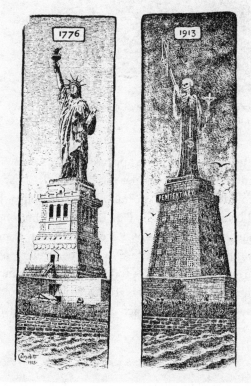

FIGURE 32 Ludovico
Caminita illustration on
the back cover of *Land and
Liberty* (1913).

FIGURE 33 "Accion Directa." *Regeneración*, October 16, 1915. Courtesy of the Labadie Collection, University of Michigan.

But although several of Reveles's illustrations appeared in *Regeneración* in the fall of 1915, by the end of that year the paper was in such dire financial straits that the editors could not afford to use them. In the December 18 issue, in an article entitled "Nuestra Grabado / Our Engraving," Enrique Flores Magón observed that another picture by Reveles would have appeared in the same issue, but they could not afford to pay the printers the five-and-a-half dollars that was required to reproduce it. And on January 15, 1916, Enrique informed the paper's readers that three other engravings by Reveles could not be published due to lack of funds. He suggested

FIGURE 34 "El Militarismo Prepotente." *Regeneración*, October 30, 1915. Courtesy of the Labadie Collection, University of Michigan.

that this was especially unfortunate and that the pictures deserved to be widely disseminated because each contained a lesson for the proletariat and provided a good opportunity, through pictorial art, to extend anarchist propaganda with "todo el brío y todo el fuego / all the energy and all the fire" of their "corazones rebeldes y indomables / rebellious and indomitable hearts."

And yet, although the paper could no longer afford to use Reveles's engravings, his visions of revolutionary transformation animated the movement in other ways, especially when he designed the scenery for Ricardo's

play "Tierra y Libertad / Land and Liberty" (1916), a sensational melodrama of direct action that was performed in Los Angeles in 1917. The play was the main focus of a "grand meeting" in support of the PLM and their newspaper, which began with a Mexican orchestra and a speech in Spanish by Ricardo and concluded with the performance of the "gripping revolutionary drama in four acts." Although the play was in Spanish, *Regeneración* promised readers that it was "so realistic and thoro [sic], that a knowledge of the language is not necessary to understand its meaning" as it invited readers of the English page to attend (February 10, 1917).

The moral polarities of melodrama are soon established in this sensational play, partly through visual cues, as the tyrannical villain Don Julian tries to assert a master's right to the body of Marta, who is the wife of Juan, a peasant who works on his hacienda. The play opens in a forest, on a path where villains, victims, and heroes encounter each other and where their virtue and villainy are exposed and recognized. Don Julian lies and claims that Juan has stolen a steer, has Juan thrown into prison, and threatens him with military service. The stage settings, which include a work camp and a prison, suggestively evoke the bodily sufferings of the virtuous victims of tyrannical villainy and support an opposition between legal right and true justice, a familiar trope of popular sensational crime literature, which is further embodied by the police, the soldiers, and priests who aid the villain-tyrant and support the false charges of crime.

Changes in the settings designed by Reveles help to visually anchor the play's hierarchies and moral polarities. The scene that illustrates the virtues of direct action is set in a peasant's plantation hut to which thirty men, women, children, and old people of the working class are eventually admitted, along with the evil *hacendado* and his minions. When Juan's and Marta's friends suggest that they petition the government for aid and redress, a worker named Marcos replies that all government is bad for the poor and urges the people to open their eyes and take justice into their own hands. But just as Marta prepares to sacrifice her body for Juan's sake, the revolution erupts: Marcos stabs an official and announces that the time for the liberation of the slaves has come, thereby initiating the overturning of the old order and leading the people, who in turn rescue her from the villain and preserve her virtue. The magical simultaneity of these actions is typical of popular sensational melodrama and one of its main attractions.[46]

Next, the scene shifts from the wretched interior of the plantation hut to an open field of peasants rejoicing, recalling Reveles's utopian illustra-

[handwritten margin note: But what is this liberation imagined from—what makes it possible?]

tion, in the pages of *Regeneración*, of the triumph of the revolution: men, women, and children of many different ages mingle amicably and happily eat, drink, and rejoice as the banner of "Tierra y Libertad" waves over the people and their mingled weapons and farm instruments. But although the people have learned the happy lesson of direct action, in the end they are still threatened by the tyrannical villainy of state power in league with capitalism and the Church, and the play ends with a war scene illustrated by a landscape filled with the dead bodies of peasants of both sexes and many ages, which are stripped for ammunition by roving children, while all the heroic characters die in a dystopian image of militarism as grotesquely grim as any of Reveles's 1915 *Regeneración* engravings.

These are just a few of the ways that the ideal of direct action was translated and re-envisioned by anarchists in the era of the Mexican Revolution. The PLM slogan and the title of Ricardo's melodrama, "Tierra y Libertad," were also reproduced in many of *Regeneración*'s illustrations, while *Land and Liberty* was the title of another newspaper that was briefly edited by Owen as well as of an English-language pamphlet issued by the PLM in Los Angeles in 1913; the subtitle of the pamphlet was "Mexico's Battle for Economic Freedom and Its Relation to Labor's World-Wide Struggle." Along with the Caminita cartoon of the worker shackled to the peonage ball and chain, the pamphlet included translated excerpts of PLM literature as well as short pieces in English written by Owen. Many of these extracts illustrated the lesson of direct action by connecting it to a longer "history of anarchism in this country," which the pamphlet claimed had "honeycombed the entire social structure and is today ten thousand times stronger than when Authority sought to strangle it out of existence in Chicago, less than twenty-six years ago" (31). Linking the "Economic Revolution" in Mexico to the "honeycombing" of anarchism in the United States in the years following Haymarket, the PLM pamphlet *Land and Liberty* thereby exposed relationships between and among movements that have too often been imagined, in the years that followed, as isolated from each other. Following their paper trail, I have traced translations, adaptations, and critical views of sentiment, sensation, and melodrama, especially in new forms of visual culture, which connected world movements across boundaries of space, time, and language, from Haymarket to the Mexican Revolution.

REVOLUTIONARY
U.S.-MEXICO
BORDERLANDS

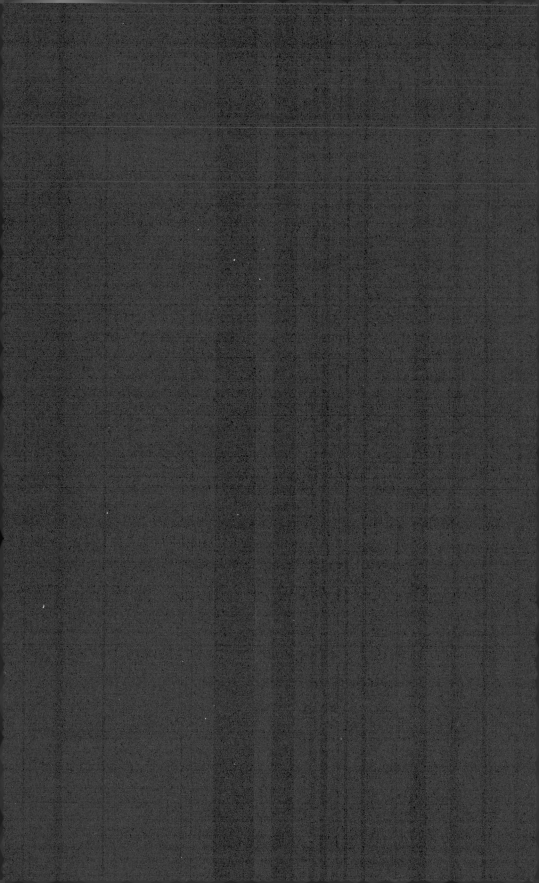

3 | Sensational Socialism, the Horrors of the Porfiriato, and Mexico's Civil Wars

In the very first issue of the Partido Liberal Mexicano's *Regeneración* that was published in Los Angeles, on September 3, 1910, the newspaper reproduced photographs of Ricardo Flores Magón and fellow PLM leaders Antonio Villareal and Librado Rivera, who were welcomed to that city by John Kenneth Turner, Lázaro Gutiérrez de Lara, and other prominent socialists after they were released from an Arizona prison, where each had served an eighteen-month prison sentence for violating U.S. neutrality laws. Fearing that Porfirio Díaz's agents might ambush the PLM leaders once they were released, Turner and a crowd of Mexican workers met them and escorted them to Los Angeles; two photographs captured the crowd at the train station as well as Ricardo reaching out to take the hand of "la señora de Lara," while her husband Lázaro, who led the demonstration, "y se la vé, en uno de los fotograbados que publicamos hoy / as is shown here, in one of the photographs we publish today," shook hands with Villareal. Gutiérrez de Lara also translated Turner's remarks for the crowd, which gave the latter "una ovación de la cualquier hombre se sentiría orgulloso / an ovation that would make any man feel proud" (see figures 35 and 36). In the same issue, the paper included a notice for Turner's sensational series "Mexico Bárbaro," which the editors referred to as "el grito de guerra de la campaña / the battle cry of the war campaign" that their own periodical would continue. And on the English page, the paper called Turner "an

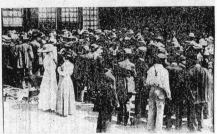

FIGURES 35 AND 36
"En Libertad" and "Bienvenida a los Liberales Mexicanos en Arcade Station, Los Angeles, Cal." *Regeneración*, September 3, 1910.

indefatigable worker on our behalf" as it inaugurated a specific appeal to friends "who desire to help our cause along but are not acquainted with the Spanish language." The PLM promised that "Americans who wish to take up the study of Spanish will find our paper a weekly stimulus" as it extended its transnational "campaign for the abolition of slavery, peonage, and every form of political oppression that exists in Mexico" by offering a bilingual newspaper as a "vehicle of our agitation," in order to fortify the "sentiment" that had been "aroused in our behalf."

The photographs were unusual because *Regeneración* had barely enough financial support to keep publishing, let alone pay for relatively expensive illustrations. Their inclusion in the first Los Angeles issue of the paper therefore highlights a hopeful moment of solidarity between U.S. and Mexican radicals upon which the PLM clearly hoped to build. The framing of these images also reveals how these solidarities were often imagined in sentimental and sensational modalities. In an article entitled "To All Americans Who Cherish the Ideal of Liberty," the PLM thanked the Socialist Party in Los Angeles for its "magnificent demonstration in our honor" as well as for the "agitation" that helped to arouse the "sentiment" that was "feared" by "those who afflict us." While the men confessed that the "American People can never reimburse us for the sufferings to which we have been unjustly subjected" during years in prison, they claimed that those sufferings "tempered our character like a blade of steel," honing their exemplary virtue and clarifying their own roles as victims of the villainous Díaz. The men also emphasized that they had been imprisoned because of a "plot entered into between the bloody tyrant who rules our nation and the Captains of Industry who prey alike upon yours and ours," thereby narrating the relationships between Díaz and wealthy U.S. capitalists as a transamerican melodrama in which both "yours and ours" are imperiled by the tyranny of state power and the voraciousness of a capitalism that reached beyond the U.S.-Mexico border. Finally, the paper insisted that sensational mass media such as William Randolph Hearst's newspaper empire were significant weapons in this "war" when it observed that James Creelman, who became famous as a writer for Hearst, had been employed by "the powers that be in Mexico" to write articles countering those written by Turner. After 1898, the pejorative meanings of the word *sensationalism* were reinforced by its connections to the yellow press of that era, but sentiment and sensation continued to be important modalities through which radicals imagined alternate worlds and transborder alliances.

These shared legacies of sentiment and sensation are especially evident in *Barbarous Mexico*, the result of this alliance between anarchists and socialists in the revolutionary U.S.-Mexico borderlands. In the November 5, 1910, issue of *Regeneración*, the paper reported having received advance proofs of Turner's book, which narrated what he observed in "los campos de esclavitud / the fields of slavery" in Yucatán and other parts of Mexico in "el estilo emociónante que tanto conmovió al pueblos de los Estados Unidos / an emotional style that shocked the people of the United States." Praising Turner for proving that slavery really existed in Mexico, the writer called attention to the sixteen pages of illustrations included in *Barbarous Mexico* as he deemed it the best account yet of conditions in "la llamada República de México / the so-called Republic of Mexico." And on the English page, the paper included a large ad for the book along with extracts from the chapter entitled "The American Partners of Díaz" and reflections on what it called the "five slave chapters" of the book, which retained "the terrible vividness which so aroused the decent people of this country a year ago" when they were published in the *American Magazine*, a popular illustrated periodical that was a continuation of *Frank Leslie's Popular Monthly* (1875–1906). Although these chapters, which were profusely illustrated with photographs and other images, had played an important role in "arousing" the people, *Regeneración* insisted on December 3, 1910, that they were only part of the story, for it "remained to show that this slavery is only made possible by the military despotism of Díaz, and that this despotism is kept in power by the aid of American capitalists and the US government." Only Turner's book, the paper claimed, contained "the whole story with many vivid photographs." For a while the PLM even offered a free copy of *Barbarous Mexico* to new subscribers to *Regeneración*.

While part I examined the possibilities and limits of anarchism as what Benedict Anderson calls a "globe-stretching" and "nation-linking" movement from Haymarket to the Mexican Revolution, part II focuses especially on the connections and disconnections between socialist and anarchist radicals in the United States and Mexico.[1] As a way of exploring these linkages and the vernacular modes in which they were often expressed, I turn to *Barbarous Mexico* as a particularly popular and revealing example of transnational collaboration and sensational socialism.[2] I trace the persistence of sentimentalism and sensationalism in this narrative's melodramatic structure, its emphasis on spectacular scenes of suffering, its reifications of race and class, and its reiteration of nineteenth-century tropes of

empire, slavery, and freedom. I also compare the book version of the text to the excerpts and illustrations that were originally published in a variety of periodicals that ranged from the muckraking but relatively mainstream *American Magazine* to the much more radical and marginal *International Socialist Review*. Finally, I explore how the sensational scenes represented in *Barbarous Mexico* were remembered and forgotten in dime novels and other narratives of the horrors of the Porfiriato in the years that followed. I conclude by focusing on the memories of Chepa Moreno, a Yaqui woman who was deported to Yucatán, survived years of hard labor, and ultimately returned to Sonora, as a counterpoint to these sentimental and sensational narratives of Yaqui slavery and suffering.

THE HORRORS OF THE PORFIRIATO

During the 1960s, a decade when Ethel Duffy Turner was interviewed for an oral history project, wrote a book about Ricardo Flores Magón that was published in Mexico, and donated her papers to the University of California, Berkeley, she remembered how her former husband, John Kenneth Turner, first became involved in investigating the "slavery" of Yaquis in Porfirio Díaz's Mexico. In 1908 the *Los Angeles Record* sent John to the Los Angeles county jail to interview Flores Magón and other PLM members, who were accused of violating U.S. neutrality laws because of their efforts to help overthrow Díaz. Ethel recalled that "Ricardo told John about the atrocities of Porfirio Díaz" and that in the course of John's work as a "newspaper man," he decided to go to Mexico to see those "atrocities for himself."[3] Accompanied by Lázaro Gutiérrez de Lara, who was another political opponent of Díaz and the target of many efforts by the Mexican state to punish him for it, in August John "left secretly for Mexico, riding the vestibule of a passenger train from Los Angeles to El Paso, a practice of the more daring 'hoboes.'" When John and Gutiérrez de Lara arrived in El Paso, "they shaved, bathed, changed clothes and stepped out of the hobo role to become a buyer for a large exporting and importing house in New York and his interpreter."[4] Disguised in their way, their plan, according to Ethel, "was to penetrate into the worst area—into the Yucatán plantations of henequen, from which they make hemp, and into the tobacco fields of Valle Nacional." There, Flores Magón had insisted, workers were treated no better than chattel slaves, and the fate of the Yaqui Indians, who, as Ethel recalled, "were taken away from Sonora and forced to march all the way down into Yucatán," where they often died within six months, was

especially harsh.[5] By exposing these horrors, John and Gutiérrez de Lara hoped to document the complicity between the Díaz regime and U.S. capitalists and politicians and to build U.S. support for what John would later call "a revolution the justice of which there can be no question."[6]

Barbarous Mexico, the book that resulted from this investigative journey, was part of a transnational body of literature about the "horrors" of the Porfirio Díaz regime that was published in the United States in the years leading up to and during the Mexican Revolution. I call this subgenre of literature transnational because the writers, who were of diverse national origin, moved between nations, though not without barriers and repercussions, and made appeals to readers in both the United States and Mexico. They include Ricardo and Enrique Flores Magón and other members of the PLM, who left Mexico under duress because of their opposition to Díaz and issued their newspaper, *Regeneración*, from Texas, St. Louis, and later Los Angeles; Ethel Duffy Turner and the English migrant William C. Owen, both of whom edited and contributed to *Regeneración*'s English page; and Lázaro Gutiérrez de Lara, who delivered speeches throughout the United States about Mexico under Díaz and coauthored a book, *The Mexican People: Their Struggle For Freedom* (1914), about the special relationship between the Díaz regime and U.S. "Big Business."[7] Another author of anti-Díaz literature was the Italian artist Carlo de Fornaro, who lived for a few years in Mexico City, where he edited a daily newspaper, and then went to New York City and published a pamphlet called *Díaz, Czar of Mexico* (1909), for which he served a year in the New York Tombs for criminal libel.

Most of these writers faced efforts in the United States and Mexico to censor or suppress their writings or to imprison them for what they wrote or said. Each had close ties to newspapers and worked as editors or journalists, and this multifaceted literary activity, as well as these writers' transnational trajectories, resist easy incorporation into nationalist literary canons on either side of the border. Certainly their trajectories were different: the fact that the Turners were white, native-born U.S. citizens undoubtedly protected them at times, for the others were far more vulnerable to the punishing hand of the state, whether in Mexico or the United States. But despite the differences, each of these writers responded to early-twentieth-century forms of empire-building and labor exploitation by remembering older ones, especially those of the 1840s through the 1860s, a period marked by U.S. war with and expansion into Mexico, the

Mexican Wars of Reform, the French occupation of Mexico, and the U.S. Civil War. Throughout part II, I analyze how these borderlands socialists and anarchists connected this nineteenth-century history to the so-called New Empire of their era, which depended on the control of foreign markets, resources, trade routes, and military bases rather than on continental expansion and the annexation and incorporation of new lands.[8]

During this period and in the years that followed, U.S. involvement in Mexico took a range of forms, including massive U.S. investment in Mexican land and resources, the U.S. bombing and occupation of Veracruz in 1914, the deployment of U.S. soldiers as part of the Punitive Expedition against Pancho Villa in 1916, and the recurring threat of further U.S. military intervention in Mexico. And through the early 1920s, John Kenneth Turner became especially committed to critically analyzing U.S. neocolonialism in Mexico and what he called the "Wilson Imperialism" of the First World War era. In *Hands Off Mexico!* (1920) and *Shall It Be Again?* (1922), which brought together and expanded arguments Turner made in the 1910s in the socialist newspapers *International Socialist Review* and *Appeal to Reason*, he identified a "new imperialism," which he traced to the 1850s and defined as the collaboration of the state and big business to shape economic and political policies, exploit cheap labor, and gain mining, lumber, railroad, and oil concessions in "weak" nations by extending loans and threatening or launching armed interventions.[9] In *The Mexican People*, Gutiérrez de Lara also underscored the symbiotic relationship between capitalism and the state in the new empire as he insisted that Díaz ruled Mexico "by the grace of American Big Business" and "as a direct result of the national fear of United States intervention" (297). Like Turner, Gutiérrez de Lara located the roots of the new empire in the mid-nineteenth century, although he told a deeper and more complicated story about the intersecting interests of ruling classes in the U.S. South and the clerical party in Mexico during the U.S.-Mexico War and about debt as an instrument of U.S. imperialist coercion in Mexico beginning especially in the 1860s. Although U.S. wars in Cuba and the Philippines in the 1898 era were more often viewed as paradigmatic and exceptional instances of U.S. imperialism, Turner and Gutiérrez de Lara both understood dollar diplomacy and the threat of U.S. intervention in Mexico in this period as elements of the new empire that were nonetheless inseparable from a longer history of U.S. empire-building in the Americas.[10]

The literature that John Kenneth Turner and Lázaro Gutiérrez de Lara

authored, both together and separately, struggles to map new configurations of globalization and empire in Mexico, often by trying to understand these problems in terms of older literary and political-economic paradigms. Gutiérrez de Lara was a prominent figure in this tumultuous era in his own right, both before and after going on the road with Turner to Mexico. In an interview with a socialist newspaper in 1910, he told of how, as a younger man, he had gone to Sonora to begin the practice of law, where his clients were mostly poor miners employed by the U.S. mining king, Colonel William C. Greene, who paid his Mexican workers in the mining town of Cananea substantially less than he did his U.S. employees and also denied Mexicans opportunities for advancement.[11] Gutiérrez de Lara became the leader of the Club Liberal de Cananea, and when a strike broke out there, in June 1906, after a reduction in the Mexican workers' wages and in support of an eight-hour day, he "spoke for the men and with 200 was arrested, charged with being an agitator, and was sentenced to be shot."[12] He managed to escape, however, and fled to the United States where, after returning from his trip to Mexico with Turner in 1909, he testified, along with Turner, Mother Jones, and others, before the House Rules Committee about the persecution of Mexican opponents of Díaz within the United States.

Then, in October 1909, the same month that an announcement for the forthcoming "Barbarous Mexico" series appeared in the *American Magazine*, while Gutiérrez de Lara was in the middle of delivering a speech in Spanish in Los Angeles, he was arrested by police officers who did not understand Spanish and who charged him with being an anarchist and with threatening the lives of Díaz and Theodore Roosevelt. His case was widely publicized throughout the United States, and there was an outpouring of support for him in the socialist and anarchist press and among labor organizations (see figure 37). During the ensuing trial, the defense focused on proving that Gutiérrez de Lara was not an anarchist, since anarchists could legally be deported.[13] In an interview with the socialist paper the *New York Call* at this time, Turner compared the arrest to the persecution of anarchists and the execution of Francisco Ferrer in Spain as he warned, "If De Lara is taken across the Mexican border he will be killed as Ferrer was in Spain." But Turner also added that Gutiérrez de Lara had "frequently expressed himself . . . as being opposed to the theories of anarchism" and that he was "unalterably opposed to violence and bloodshed."[14] Eventually the charges against him were dropped. He worked as

a labor organizer and a speaker for the Socialist Party in Mexico and the United States until his death in Mexico, in 1917, when he was apparently murdered by his political opponents (see figure 38).

Much of what we know about the collaboration between John Kenneth Turner and Lázaro Gutiérrez de Lara is the result of the activism, writing, and collecting of Ethel Duffy Turner. She was, like Gutiérrez de Lara, in other words, an important figure in her own right as well as a mediator of John Kenneth Turner's story. As the daughter of a warden, she grew up in San Quentin prison and met her future husband when both of them were students at the University of California, Berkeley. After they married, they moved to Los Angeles, where, in 1908, John was working as a newspaper writer when he first encountered Ricardo Flores Magón. Later, both John and Ethel would become close friends with Manuel Sarabia, another PLM leader, who was arrested soon thereafter. Ethel also became close to Elizabeth Trowbridge, a wealthy heiress from the East Coast, who became involved in the PLM's cause, ended up marrying Sarabia, and funded Turner's and Gutiérrez de Lara's trip to Mexico. During the early days of their friendship, Ethel, John, and Elizabeth felt "handicapped" because they did "not know the Spanish language," and so they took lessons from Gutiérrez de Lara at his home, partly to prepare for the different collaborative projects in which each of them became involved. While John and Gutiérrez de Lara were away in Mexico, Ethel, Elizabeth, and the socialist John Murray (later secretary of the Pan-American Federation of Labor) went to Tucson, Arizona, and started a monthly magazine called the *Border*. The real purpose of this magazine was to undermine Díaz, but "as a come-on," Ethel recalled, "it would run Southwest Allure articles—desert magic and so on." Although the *Border* never drew a substantial readership and only a few issues were published, it did attract the attention of what Ethel called "the Díaz-American spy machine" and as a result, she remembered, spies followed her all over town, and eventually, right before the first issue was published, the printing shop that published the magazine was "completely wrecked."[15]

When John and Gutiérrez de Lara returned from Mexico, he and Ethel traveled to New York to meet with the editors of the *American Magazine*, who in January 1909 sent John and Ethel back to Mexico to obtain more information about the political end of things. After the magazine published the first articles, which Ethel remembers came as "a tremendous shock to the American people," and then quickly dropped the series be-

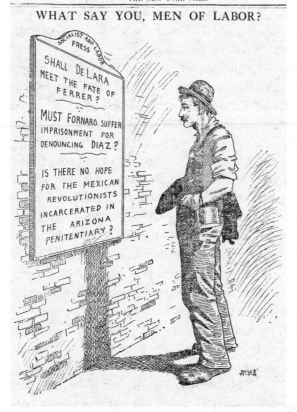

WHAT SAY YOU, MEN OF LABOR?

SOCIALIST AND LABOR
PRESS

SHALL DE LARA
MEET THE FATE OF
FERRER?

MUST FORNARO SUFFER
IMPRISONMENT FOR
DENOUNCING DIAZ?

IS THERE NO HOPE
FOR THE MEXICAN
REVOLUTIONISTS
INCARCERATED IN
THE ARIZONA
PENITENTIARY?

FIGURE 37 "What Say You, Men of Labor?" *New York Call* cartoon (1910). Courtesy of the Bancroft Library, University of California, Berkeley.

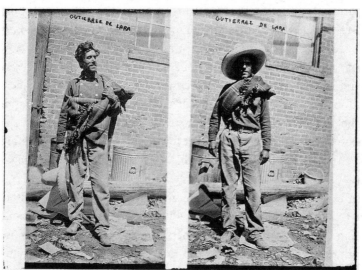

FIGURE 38 Lázaro Gutiérrez de Lara. Bain News Service: Press Photograph from the George Grantham Bain Collection, purchased by the Library of Congress in 1948. Unknown date. Wikipedia Commons: http://commons.wikimedia.org/wiki /File:Lazaro_gutierrez de lara.jpg#filelinks.

cause of the political fallout, they returned to Los Angeles, where John worked on finishing his book and where both of them became intimately involved in the world of the Mexican political refugees, who had renewed publication of their newspaper, *Regeneración*, in Los Angeles after it had been "smashed" in St. Louis, Missouri, and "attacked" in San Antonio, Texas.

These connections to the PLM, to the network of anarchists, socialists, and other radicals who affiliated with them in Los Angeles, and to the print communities they fostered through newspapers and other publications encouraged Ethel to become deeply immersed in the revolutionary plans of the Mexican political refugees, so much so that she became, for a few months, the editor of the English-language page of *Regeneración*. In the December 31, 1910, issue, the paper announced that she had taken over the editorship by assuring readers that "there is no American woman who has more knowledge of and sympathy for the Mexican cause." As she remembered in 1966, "I had always wanted to write, and I was writing, and I was full of fire. It made me so angry when it was later said that John wrote everything! He didn't. I had guidance from everybody, but I wrote most of the articles myself. That gives me prestige in Mexico today, that I was on that paper. My name was on the masthead." During this period, she and John used to "go to the newspaper office all the time and got to know" the PLM leaders very well, often sharing meals with them at the newspaper office, while John lectured on their behalf and "bought up all the guns he could find" to send to PLM revolutionists in Baja California.[16]

Ethel also remembered and frequently remarked on the complicated and sometimes vexed relationships between anarchists and socialists that she observed during these years. The distinctions between socialists and anarchists were sharpened by U.S. immigration laws that enabled the deportation of anarchists as well as by socialist conceptions of the revolutionary subject that privileged the industrial proletariat over peasants and agricultural workers. At the same time, however, radical movements of the era still often brought together anarchists and socialists despite their differences, as the common concerns and intersecting discussions in anarchist and socialist periodicals and other publications reveal.

The transnational collaboration between anarchists and socialists, as well as the differences that divided them, shaped the history of *Regeneración* during the years that it was published in Los Angeles. Ethel recalled that Gutiérrez de Lara was a member of the editorial staff for a while, but

he left before long due to "Anarchist-Socialist differences." On the other hand, she claimed that Ricardo Flores Magón "had a friendly tolerance at that time for non-anarchists like ourselves. He and Enrique put gentle anarchist pressure on me, in an effort to obtain a convert, but it was all done in a good-humored way." For her part, she claimed to always have been "on the best of terms" with the PLM leaders and considered her brief editorship of the English-language page of their newspaper "the most satisfying experience in my life." Although she "could not accept anarchism, the goal," she "did accept revolution, the road," and for her, "the goal was socialism."[17]

The socialist understanding of revolution as a transformation in government, however, made John initially hopeful that the resignation of Díaz, in 1911, would solve Mexico's problems, while the PLM's frank declaration of its anarchist principles around this time caused many socialists to break with or criticize the PLM. In any case, by April 1911, "something had gone wrong," as Ethel put it, in John's "relationship to the situation as a whole," and just before Díaz resigned, John told a writer for the *San Francisco Bulletin* that "his share in the revolution was over" and that he was leaving Los Angeles to live in the artists' and writers' colony, Carmel. In the April 8, 1911, issue of *Regeneración*, the new editor of the English page, William C. Owen, informed readers that "owing to the pressure of many duties," Mrs. Turner found it impossible to continue her work on the newspaper. Later, Owen revealed that he had actually "assumed Mrs. Turner's position" at the "insistent urging" of John Kenneth Turner, after a committee from the Socialist Party of Los Angeles visited Ricardo, insisted that he clarify whether or not he was an anarchist, and witnessed his reply that the PLM "wanted to restore the land to the people" (October 7, 1911). Although, as Ethel insisted, just a few years later John would "play his part again, at a time of the highest stress,"[18] their move to Carmel effectively removed her from the transborder network of political radicals who had surrounded her in Los Angeles.

Shortly thereafter, while Ethel remained in Carmel, John returned to Mexico, became actively involved in covering events there, and for the next decade continued to produce a large body of journalism and other literature opposing U.S. intervention in Mexico and critically analyzing U.S. investors' efforts to secure access to Mexican oil, labor, and other resources (see figure 39).[19] In a typical statement against U.S. intervention in the *Appeal to Reason*, for instance, in 1915 Turner warned that the "plotted

RSA

MEXICO.

DE 1921.

Reg[i]
clas[e]
Adm

Desde mañana comenzará a
aparecer en EL UNIVER-
SAL una serie de artículos
del conocido periodista ame-
ricano John Kenneth Tur-
ner, bajo el título general de
MEXICO Y LA POLITICA
INTERVENCIONISTA DE
LOS ESTADOS UNIDOS.

FIGURE 39 Clipping of John Kenneth Turner
from an issue of the Mexican newspaper *El
Universal* (1921). Courtesy of the Bancroft
Library, University of California, Berkeley.

American invasion would be disastrous alike to the democratic movement in the US and the democratic movement in Mexico," that it "would be a calamity to world progress," and that he considered "Mexico distinctly an American issue—an American working-class issue—THE American working-class issue of the day."[20] And in the pamphlet *Hands off Mexico!* (1920), Turner deplored Wilson's and Wall Street's efforts to "manufacture and mobilize public opinion" (4) in behalf of intervention by circulating reports in which "Americans figure as sufferers" (11) and by trying to identify the interests of the "people" with those of the "oil corporations" (73). Turner argued that it was "more to the interests of the American people that their neighbors should have decent homes, decent wages, public education, and progressive institutions of their own making, than that American oil gamblers should carry out their schemes" (74), even as he acknowledged that "there has been an important merger of British, Dutch, French, and American oil interests" (68).

Barbarous Mexico anticipates John Kenneth Turner's later interest in exposing the emerging parameters of the new empire, but it also looks backward to the nineteenth century as it draws on the conventions of the antebellum cultures of sentiment and sensation to expose the "crimes" of Porfirio Díaz and to condemn Mexican "slavery." Indeed, many of Díaz's émigré opponents engaged, in different ways and to different degrees, the sensational mode, which is closely linked to melodrama in its emphasis on bodies, feelings, and the polarization of the social field, but which focuses on bodies under duress, on the thrilling and the lurid, and on persistent social injustices more than on the refinement and redemption of the body and the happy resolution of social conflicts. Since at least the mid-nineteenth century, sentiment and sensation have been important modalities through which members of social movements have struggled over land, labor, and empire. In the wake of the print revolution of the 1840s, cheap sensational story-papers, pamphlets, and novels, often linked to labor, land reform, abolitionist, and nativist movements, were issued in larger editions and reached more readers than ever before. The sensational mode also shaped discourses of republicanism that traveled throughout the Americas, especially those strands that denounced the crimes of tyrants who abuse the people.[21] Turner and all of these émigré writers made sensational appeals to readers as they translated political and economic struggles into melodramatic stories of villains, heroes, and victims; focused on dead bodies and bodies in pain in order to narrate injus-

tices; and expressed the hope that exposing horrors and atrocities might move readers to act, join movements, and participate in projects of social, political, and economic transformation.

The authors of anti-Díaz literature both drew on and departed from these discourses in their sensational appeals to readers, which are especially apparent in articles that appeared in movement periodicals. In a manifesto to the workers of the world, for example, the Los Angeles Organizing Junta of the PLM imagined that reading movement literature and participating in its political culture could be a moving, exciting, and potentially transformative act as they urged workers to agitate for change through letters, manifestoes, conferences, and meetings, because the tremendous drama of conflict in Mexico should "move all hearts" and "intensely excite the nerves of all of the dispossessed of the Earth."[22] A conception of movement literature working on the body to provoke a collective political response also animates an advertisement entitled "Turner Series Exposing War Lies Thrills and Enthuses Appeal Army" (see figure 40) that appeared in the *Appeal to Reason* and was accompanied by a coupon readers could cut out to add the names of new subscribers for the "sensational series," so that the latter could learn about "the inside plotting of our militarists and imperialists."[23] These examples show how sentiment and sensation traveled across national boundaries as well as boundaries between elite and popular culture. But they also reveal some of the limits to what and who can travel and what can be shared.

Language is one of those limits. That most of these texts were written in English underscores the facts that it was more perilous to publish anything critical of Díaz in Mexico and that, in light of the power relations linking Mexico to the United States in the new empire, these writers all believed that an appeal had to be made to U.S. readers who, it was hoped, could still act as a brake on U.S. capitalists and the state. In his preface to the third edition of *Barbarous Mexico* (1911), Turner declared that the book was written to "inform the American people" in order that they might prevent "American intervention against a revolution the justice of which there can be no question."[24] Believing that "the majority yet may protest, and if the protest be long and loud enough, it is still capable of making . . . rulers tremble," Turner concluded that if it became necessary "to raise that protest to the threat of revolution here, so be it." Ricardo Flores Magón and the members of the PLM addressed readers in both Spanish and English in their speeches, pamphlets, and bilingual newspaper, but although build-

Turner Series Exposing War Lies
Thrills and Enthuses Appeal Army

The Turner series exposing the lies of our war propaganda is already a sensational success. Although the announcement of the publication of this notable series of articles was first made two weeks ago, the Appeal has received thousands of letters from its readers expressing deep appreciation of our plan to make public the secret history of the war. The greatest interest and enthusiasm is shown.

I, John Kenneth Turner, Appeal correspondent for many years, have made a complete study of the secret and public documents of the great world war. For four years I have been gathering my material for the Appeal's great army of readers. My material is ready. I am now ready to prove:

The lie that the American people wanted war.
The lie that America was in danger.
The lie as to how the war began.
The lie of Germany's "broken submarine promises."
The lie of "the German-Mexican plot to attack the United States."
The lie that we had to go to war to protect American commerce.
The lie that we had to go to war to preserve American lives.
The lie that we had to go to war to maintain international law.
The lie that we had to go to war to uphold American honor.
The lie that we went to war to "make the world safe for democracy."

Best of all the Appeal Army is now in the midst of a glorious offensive. Every mail brings thousands of subscriptions of men and women who are anxious to read this remarkable exposure by John Kenneth Turner, the Appeal's famous correspondent. And every mail brings the good news the work has only begun—that the Army is still on the firing line enrolling American citizens on our mailing list so that they may know the truth of the inside plottings of our militarists and imperialists.

To meet this extraordinary demand for this great series and to see that no one misses the first articles the Appeal has decided to postpone the publication of the introductory article for two weeks. This will give everybody time to roll up a large subscription list for the Turner series before the first article is published. Remember this is exactly what you have been waiting for—the other side of the war propaganda. At last the truth is going to be told. You owe it to humanity to see that the truth becomes known to our fellow citizens. You can spread the truth by using the following subscription blank. The rate is only 25 cents for six months of the Appeal if you send us a list of four or more:

Use This Subscription Blank to Get Readers for Sensational Series Exposing Lies of Our War Propaganda!

Appeal to Reason, Girard, Kans.

I want the people of my community to get the truth at last about the lies of our war propaganda. I want them to read the facts and evidence that John Kenneth Turner will present in the Appeal. For the enclosed

$............ put the following names on the Appeal mailing list for six months each at the rate of 25 cents per subscription.

NAME	ADDRESS	CITY	STATE

FIGURE 40 "Turner Series Exposing War Lies Thrills and Enthuses Appeal Army." *Appeal to Reason* (July 3, 1915). Courtesy of the Bancroft Library, University of California, Berkeley.

ing support for the overthrow of Díaz among Spanish-speakers in Mexico and the U.S. Southwest was definitely a priority for them, they also shared Turner's conviction that appeals had to be made to the English-speaking U.S. public in order to prevent the U.S. government from stepping in to prop up Díaz once the revolution was under way. They were clearly disappointed in the results of their efforts to build a transnational coalition among working people, however. In a letter to his brother Enrique in 1908, Ricardo wondered whether U.S. audiences could be reached by agitation, especially since their own domestic miseries did not seem to move them to

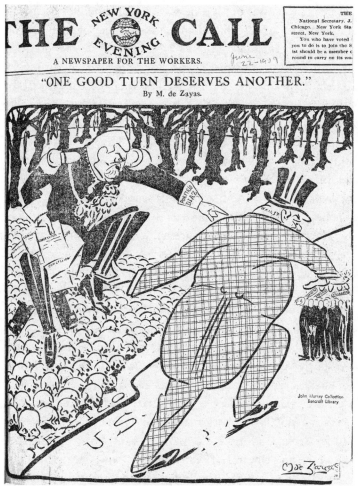

FIGURE 41 "One Good Turn Deserves Another." *New York Evening Call*, June 22, 1909. Courtesy of the Bancroft Library, University of California, Berkeley.

action ("Si con sus miserias domésticas no se agitan los americanos, podemos esperar que les importan las nuestras?"), and hoped that their eagerness for "noticias de sensación / sensational news" might make them pay attention and oppose U.S. intervention in support of Díaz if a revolution broke out in Mexico.[25]

Cartoonists such as the Mexican artist Marius de Zayas circumvented barriers of language and literacy to reach U.S. audiences by using illustrations, such as a cartoon, published in the socialist *New York Call* in 1909 (see figure 41) that pictured Díaz in front of trees laden with the corpses

of lynched men, sitting on top of a field of skulls, handing off conces-
sions to a Wall Street fat cat while pointing menacingly at small figures
of de Fornaro, Flores Magón, and other Díaz opponents, who are dan-
gling precariously from Wall Street's hand. According to Roberto Tejada,
as a young man in Mexico, de Zayas worked as a political caricaturist for
newspapers his father published in Veracruz as well as for the Mexico City
newspaper *El Diario*, but in 1907 his family was forced to leave Mexico
because of their newspapers' "calls for democracy" as well as "the anti-
dictatorial positions against Díaz." In New York City, de Zayas became a
cartoonist for the *New York Evening World*, learned English, and contrib-
uted essays on photography to Alfred Stieglitz's modernist journal *Camera
Work*, where he defended a vision of art as the representation of an idea,
inspired by nature, "in order to produce emotions"—an aim shared by
sentimental and sensational art. While de Zayas's drawings would later be
exhibited in art galleries by Stieglitz and others, this 1909 political cartoon
reached a broader audience of readers of this popular "newspaper for the
workers" and vividly illustrated the point about the transnational collabo-
ration between Díaz and Wall Street in criminalizing and silencing critics
by adapting sensational, iconic images, such as the large pile of skulls upon
which Díaz sits, that could be easily understood with little explanation.[26]

Mexican liberals, socialists, and anarchists increasingly felt it was their
task to "educate the American people," as Gutiérrez de Lara put it, in order
to "forestall the possibility of American intervention in Mexico," especially
because of the partnership of the U.S. state, U.S. investors, and the Díaz
government in the new empire.[27] The new empire, however, was haunted
by the old one, and especially by ideas about race, government, and inter-
national relations that were among the many legacies of the U.S.-Mexico
War and the sensational literature that responded to it. Gutiérrez de Lara
repeatedly argued against the notion that the Mexican people were unfit
for democratic government and that Anglo-Saxons had a special racial
talent for democracy, ideas which circulated widely in sensational U.S.-
Mexico war literature. In a preface to *The Mexican People*, Gutiérrez de
Lara and his coauthor, Edgcumb Pinchon, observed that to most people
"Mexico and Freedom seem almost antithetical items," and in the first sen-
tence of chapter 1 they attack the "popular superstition" that "the Mexican
race is made up of degraded half-castes" (3) and is therefore incapable of
democracy. Indeed, pressure to perform the part of the civilized political
subject affected the modality of Gutiérrez de Lara's appeal, as he tried to

model an enlightened, progressive civility that might touch the "hearts" of U.S. readers, awaken a spirit of "brotherhood," and convince them that the Mexican proletariat was the heroic subject of a national history that deserved international support. The most sensational passages of *The Mexican People* are those that condemn the Spanish and mixed Spanish "master class" as "the most bloodthirsty and depraved . . . the world has ever witnessed" (6) and that connect a long history of class struggle in Mexico to the massacres and other atrocities of the Díaz regime, for which Gutiérrez de Lara insists that U.S. capitalists and the state are partly responsible.

But Gutiérrez de Lara's investment in a Mexican civilization that he opposed to the "barbarous Mexico" of Díaz and the Spanish colonizers led him to construct his own racial hierarchies, which Turner echoes and alters in his writings on Mexico (see figure 42). This Mexican discourse of democracy, civilization, and nation-building depended on contrasts with excluded others who were external to the nation, such as "the real Indians" who Gutiérrez de Lara locates "in the hills and mountains and entirely outside of the main currents of Mexican politics," whom he claims form only a "small proportion of the population of Mexico" and whom he distinguishes from the "native races," the ancestors of the working class of his own era, who enjoyed a "civilization" superior to Spain and Teutonic Europe.[28] The facts about his own family's background are somewhat murky, and Ethel Duffy Turner's comment that he "repudiated even a trace of alien blood" and claimed to be of "pure Aztec origin" does not provide any definitive clarification.[29] Whatever that background may have been, however, his commitment to socialist politics encouraged him to privilege the capture of state power and the national, collective administration of "the means of wealth production" as the most important horizon of social struggle and to diminish indigenous struggles that were not made in behalf of the nation.[30] On the other hand, the anarchist PLM defended indigenous peoples' right to the land and some of its leaders were Indians, notably Fernando Palomárez, a trilingual Mayo Indian from Sinoloa who, according to Devra Weber, spoke English, Spanish, and the indigenous language Yoeme; organized miners "in Yaqui and Mayo labor camps"; and served "as a bridge between Magonistas and monolingual English-speaking allies" in the IWW, an organization to which he also belonged.[31]

John Kenneth Turner's participation in transnational socialist and anarchist networks fundamentally shaped his ideas about the new U.S. empire's connections to and differences from the older one, but his appeals

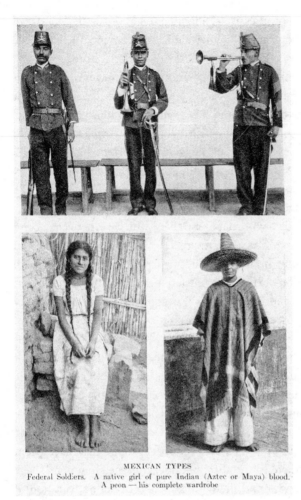

MEXICAN TYPES

Federal Soldiers. A native girl of pure Indian (Aztec or Maya) blood.
A peon — his complete wardrobe

FIGURE 42 "Mexican Types." In *The Mexican People* (1914; 1917), by Lázaro Gutiérrez de Lara and Edgcumb Pinchon.

to the U.S. public proved to be much more popular than any of the other literature written in English by the opponents of Díaz. The first five chapters of *Barbarous Mexico* provoked an intense and dramatic response when they appeared in 1909 in the *American Magazine*, and after 1910, when all of the articles were published as a book by Charles H. Kerr, a socialist publishing house, it quickly went through multiple editions and inspired many other versions of the story, from dime novels to early films. The popularity of Turner's narrative can be attributed in no small part to his skill at adapting popular sensational and sentimental tropes and genres to tell the story of the incipient Mexican Revolution. Despite its debt to popular nineteenth-century U.S. narratives of empire, slavery, and freedom, how-

ever, Turner's book was also the result of his close connections to many of the important émigré Mexican radicals of the era. Since Turner's Spanish was rudimentary at this time, Gutiérrez de Lara's skills as a translator and collaborator were especially crucial.[32] Indeed, *Barbarous Mexico* is a mediated narrative in many ways: the voices of the Yaquis and Mexicans who are quoted at length were translated by Gutiérrez de Lara for Turner, who then selectively incorporated and translated this material into a sentimental and sensational story about the horrors of slavery under Díaz.

The result is a text that must be understood through an analytic of collaborative authorship that recognizes the national and linguistic hierarchies and inequalities, as well as the political urgencies, that motivated and shaped their shared project. Gutiérrez de Lara's name does not appear on the title page of *Barbarous Mexico*, although Turner gratefully acknowledged his help, but after his untimely death, in 1917, some of his relatives told a Mexican newspaper reporter that he had actually written the book and that Turner had merely translated it. These family members claimed that Gutiérrez de Lara feared reprisals, and so had not wanted authorship of the book to be attributed to him. Although this account does not consider the collaborative project that engendered the book or the complicated and creative work of translation, it has the virtue of underlining the significance of Gutiérrez de Lara's contributions to *Barbarous Mexico*, which have been forgotten by most scholars who have written about the narrative. It seems likely that if Turner had only been a translator of the material, he would have given his friend even more of the credit after the end of the Diáz regime made it safer for critics to speak out. The sensational style and substance of *Barbarous Mexico* also resonate with Turner's later writings on Mexico for the *Appeal to Reason*. Finally, although Gutiérrez de Lara accompanied Turner on his first trip to Mexico, which provided the basis for the first five chapters of the narrative, he was not with him during the later trip, where John learned more about the political system in Mexico and made it the foundation of the middle chapters of the book. Most of the concluding chapters on U.S. responsibility for conditions in Díaz's Mexico also appear to derive largely from Turner's later research, and they were published after the period when Turner and Gutiérrez de Lara were close associates. But establishing authorship in the sense of deciding who was responsible for what is an impossible endeavor anyway, and furthermore, judging this text in terms of romantic-modernist conceptions of authorship and the literary fails to appreciate how the sensational, collaborative

aesthetics on which the narrative depends was enmeshed with transnational movement cultures and larger collective struggles.

Like the nineteenth-century sensational literature to which many of its conventions may be traced, *Barbarous Mexico* was closely connected to the periodicals and movements in which it was embedded. The initial context of its serialized publication clarify its fragmented narrative structure; the rhetoric of exposure, of bringing hidden horrors into the light of day, and the strategy of piling horror on horror to provoke emotional responses in readers and to make them want to keep reading, are all familiar from the "mysteries of the city" and U.S.-Mexico War narratives of the previous century, which were also authored by newspaper writers and social reformers. The muckrakers of the Progressive era, including Turner, were in many significant ways the literary and cultural heirs of mid-nineteenth-century journalists and sensational authors such as George Lippard and Ned Buntline, who also wrote about U.S. class conflicts and the U.S.-Mexico War. The links among newspapers and other serials, sensational literature, and social and political movements are also as significant for understanding *Barbarous Mexico* as they are for interpreting mid-nineteenth-century urban gothic and imperial adventure literature. Indeed, the labor, land reform, and antislavery movements of the earlier era were important precursors of the socialist movement that Turner and Gutiérrez de Lara championed in the first two decades of the twentieth century, and rhetorical strategies and ways of thinking about race, labor, land, and government from this earlier period of U.S. intervention in Mexico returned to haunt the era of the "New Empire."

BARBAROUS MEXICO, UNCLE TOM'S CABIN, AND MEXICO'S CIVIL WAR(S)

Gutiérrez de Lara's collaboration on the chapters of *Barbarous Mexico* that focus on the dispossession, deportation, and virtual enslavement of Yaqui Indians was especially important, for in addition to his skills as an interpreter and guide, his time in Sonora had taught him much about the long history of the Yaqui Wars in northern Mexico. The latest conflicts had been sparked by Mexican efforts to take possession of Yaqui lands, and they were marked by what the narrative rightly calls "horrible atrocities," including a massacre in Mazocoba where over a thousand Yaquis were mowed down by Mexican soldiers armed with Mauser rifles, and more recently, by Díaz's "sweeping order decreeing that every Yaqui, wherever

found, men, women, and children, should be gathered up by the War Department and deported to Yucatan."[33] According to Ethel Duffy Turner, Gutiérrez de Lara had "spent some time in the Yaqui country handling law cases for the dispossessed Indians," and his contact with the Yaquis had left him eager to do something to help improve their situation. In 1906, while he was standing on a wharf in Mexico, a Yaqui woman had shouted his name and implored him to help her and her fellow Yaquis, who were being abused by Mexican troops and sent "to Yucatán to be worked to death." Powerfully affected by the cruel scene, Gutiérrez de Lara brought the Yaquis some food and tried to alleviate their suffering, but remained frustrated that "there was nothing else that he could do." The scene remained burned in his memory, however, and he went on to play an active role in "exposing the whole ghastly system of slavery and Yaqui extermination."[34]

The comparison of Yaqui servitude to slavery has more extensive implications, however, and *Barbarous Mexico* has roots in both the cultures of sentiment and sensation, for the nineteenth-century narrative to which the narrative was most often compared was Harriet Beecher Stowe's *Uncle Tom's Cabin*, another text with strong links to a larger social movement, in this case the antislavery movement. Indeed, the narrative was credited in England with causing a Mexican "Civil War." As Linda Williams and others have observed, Stowe's novel alternates between sentimental scenes of pathos and sensational scenes of action and horror. Like *Uncle Tom's Cabin*, *Barbarous Mexico* tells a sentimental and sensational story of slavery that aims to move readers to feel for exploited workers by foregrounding sympathetic acts of witnessing; by focusing on abject bodies, bodies in pain, and the separation of families; by establishing strong moral and political polarities; and by dividing the social field into categories of heroes, villains, and victims.[35] As Turner compares Yaquis and other workers in Mexico to slaves in the United States before the Civil War, a host of other comparisons are suggested: that the horrors of the Porfiriato are like the horrors of the U.S. Southern slaveocracy; that Mexican rubber and henequen plantations (see figure 43) are similar to antebellum plantations such as Simon Legree's hellish establishment; and that the conflicts between Díaz and his opponents should be understood as another version of the U.S. Civil War. The developmental narrative that is implicit here—which suggests that Mexico under Díaz is like the United States at an earlier moment in time—is another legacy of the U.S.-Mexico War, since

THE TOILERS

"In the fields toiled the peons, still tilling the land from dawn till dark, under the lash of the master, still enduring the pangs of hunger and the darkness of ignorance" (See page 60)

FIGURE 43 "Cultivation of Hennequin, Yucatán." In *The Mexican People* (1914; 1917), by Lázaro Gutiérrez de Lara and Edgcumb Pinchon.

the war literature of 1848 often imagined Mexico as a premodern Other to the modernizing nation to the North. It resonates uneasily, moreover, with contemporaneous socialist statements, like those of Eugene Debs, which suggested that Mexico was not yet ready for revolution because so many of its people were peasants rather than members of an industrial proletariat. But *Barbarous Mexico* also confronts the question of the complicity of the "North" in "Southern" slavery as the text repeatedly insists on the role of U.S. investors in the exploitation of Mexican workers and on the intimate connections between the Díaz and Taft administrations.

When *Barbarous Mexico* was published in parts and then as a whole, it created a sensation. In Mexico, copies of the articles and book were suppressed, while the negative responses of Díaz supporters and other critics apparently affected the text's U.S. publication history. But *Barbarous Mexico* was sensational in other ways as well. The early chapters are dominated by graphic renderings of the horrors of what the text names slavery, including beatings of workers and other punishments as well as scenes of arduous labor and of the bodily suffering and deaths of Yaquis who were being transported to Yucatán and forced to toil in the henequen fields. Accompanied by photographs of a "slave mother and child," "Yaquis hanged in Sonora," and "a typical Mexican military execution," to name a few,

Barbarous Mexico begins with a sweeping exposé of the transportation and extermination of the Yaquis and of debt peonage as a form of slavery on Mexican plantations, then shifts to a critical dissection of the "Díaz system," "the repressive elements of the Díaz regime," "the crushing of opposition parties," and the violent suppression of Mexican labor strikes, before finally turning to a harsh critique of the "Díaz-American Press Conspiracy," "The American Partners of Díaz," and "American Persecution of the Enemies of Díaz" (see figures 44 and 45). While some critics regretted what one called "the sensational, rhetorical, and feverish methods employed," the exposé generally received favorable reviews and helped to provoke a strong interest in the Yaquis' plight and the Mexican Revolution among many U.S. Americans.[36]

The most sensational and the most widely repeated and adapted parts of *Barbarous Mexico* were the opening chapters on the transportation of Yaquis to plantations in Yucatán and on debt peonage there and in the Valle Nacional. The first installment of *Barbarous Mexico*, "The Slaves of Yucatan," appeared in the October 1909 issue of the *American Magazine*, which was the "first number" of a "larger and greater" version of this publication, which increased from 100 to 144 pages and which included "scores of illustrations" and a "new series of startling articles." Boasting that no authors had contributed more "to needed knowledge, or more frequently stimulated the government of the United States, or of the separate states, or individuals and associations to right action" than had the contributors to the *American Magazine*, in this issue the editor, John Phillips, predicted that Turner's "bitter stories from real life" would "thrill the reader and rouse his righteous indignation."[37] In other words, Phillips voiced the sentimental hope, made newly relevant in this muckraking, Progressive era, that literature that stimulated strong feelings could also "stimulate" political transformations. Although the articles were quite popular, however, by the spring of 1910 the magazine had stopped publishing them. In the book version of *Barbarous Mexico*, Turner claimed that the publishers had succumbed to "skillfully applied influence," and while there is no hard evidence to prove that this was the case, it provides an otherwise unavailable explanation for why the magazine dropped the series after publishing "enthusiastic comments" from editors on the "interest aroused by the series," statements about its "jumping circulation," and favorable letters from subscribers (239).

According to Ethel Duffy Turner, Phillips chose the title for the series,

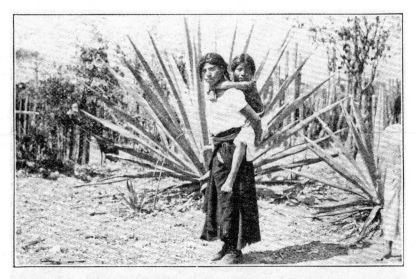

SLAVE MOTHER AND CHILD; ALSO HENEQUEN PLANT

FIGURE 44 "Slave Mother and Child; Also Henequen Plant." In *Barbarous Mexico* (1910), by John Kenneth Turner.

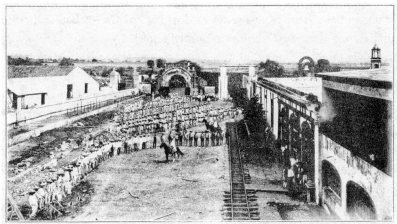

CALLING THE ROLL AT SUNRISE ON A SLAVE PLANTATION

FIGURE 45 "Calling the Roll at Sunrise on a Slave Plantation" In *Barbarous Mexico* (1910), by John Kenneth Turner.

which "proved embarrassing," she remembered years later, "as many Mexicans believed it was the typical gringo slander of themselves as a people. The real intent had to be explained over and over, and what must be frequently explained is not so good."[38] Although in Turner's preface to the first edition of his exposé, he was careful to say that the word _barbarous_ in his title was meant to "apply to Mexico's form of government rather than to its people" a form of government, he insisted, for which the United States was partly responsible, the title resonates with sensational U.S.-Mexico War–era formulations of Mexican savagery and unfitness for democratic self-governance.[39]

Along with the title, the illustrations for the series, which isolated spectacles of bodily suffering and Mexican cruelty, also contributed to such a master narrative of Mexican barbarity. These installments of _Barbarous Mexico_ were accompanied by photographs as well as line drawings by George Varian, a prominent magazine artist of the era. Such a mixture of pictorial techniques was typical in the magazines of the period, according to the visual-culture scholar Joshua Brown, who suggests that "even as the photographic half-tone was victorious" after the late nineteenth century, "illustration continued to serve as the medium for conveying action" with "continued reliance on the familiar conventions of extended narrative."[40] In the _American Magazine_ series, illustrations are used, especially, to represent beating scenes and other Mexican atrocities, while the text's photographs include a portrait of Díaz taken by the North American photographer C. B. Waite, one of the most prolific producers of early-twentieth-century Mexican postcards, as well as portraits of other Mexican politicians, Díaz's wife, and officials and managers of plantations in the Valle Nacional; views of Yaqui deportation, the execution of Yaqui "renegades," and the signing of a peace treaty between Mexicans and Yaquis; a flashlight photograph taken by Turner of a mass of bodies in a cheap Mexican lodging house (see figure 46); and long shots of the plantation, plantation houses, and workers of the Valle Nacional. Many of these images, like the illustrations, also relied on familiar conventions of sentimentalism and sensationalism as the photographers labored to capture views of wealthy and prominent Mexicans, dramatic current events, Mexican "underworlds," and Mexican plantations.

Turner's and Gutièrrez de Lara's masquerade was another sensational part of the _Barbarous Mexico_ story, one that recalls the ubiquity of cross-dressing, racial masquerade, and secret identities in the story papers and

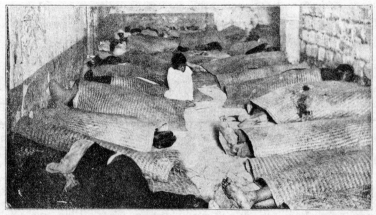

MIDNIGHT IN A MEXICO CITY "MESON", CHEAP LODGING HOUSE OF THE POOR. ONE PAYS THREE CENTAVOS FOR A GRASS MAT AND HUNTS A PLACE TO LIE DOWN IN THE ENCLOSURE. FROM A FLASHLIGHT BY THE AUTHOR

FIGURE 46 "Midnight in a Mexico City 'Meson.'" In *Barbarous Mexico* (1910), by John Kenneth Turner.

dime novels of the U.S.-Mexico War period. The two men left Los Angeles by riding the rails disguised as tramps, and they continued their masquerade in Mexico, where Turner posed as "an American investor with an itch for profits his only spur" and Gutiérrez de Lara pretended to be his interpreter and guide.[41] This masquerade opened up possibilities for sympathetic witnessing even as it foreclosed others. From the beginning of the narrative, Turner emphasizes his ability to penetrate into hidden spaces, claiming that although other "foreign investigators" had been "bought or blinded," his masquerade enabled him to observe "thousands of slaves under their normal conditions."[42] As Ethel Duffy Turner recalled years later, "They were glad to show the buyer for a rich Eastern firm all over the place. Exploit human flesh to the limit? Why not? Was not the American buyer's class angle identical with theirs? Let him see everything."[43] As a result, Turner was able to confirm the charges of the jailed members of the PLM who insisted that chattel slavery still existed in Mexico: "Slavery in America! Yes, I found it," he insisted as he assured his readers that in Mexico "peonage is the rule for the great mass" and "actual chattel slavery obtains for hundreds of thousands." According to Turner's definition, "Slavery is the ownership of the body of a man, an ownership so absolute that the body can be transferred to another, an ownership that gives to the owner the right to take the products of that body, to starve it, to chastise it at will, to kill it with impunity. Such is slavery in the extreme

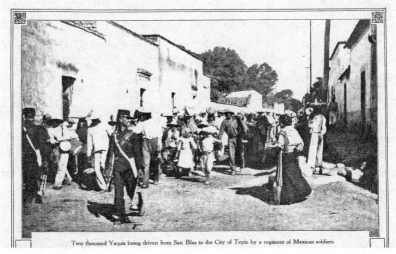

Two thousand Yaquis being driven from San Blas to the City of Tepic by a regiment of Mexican soldiers

FIGURE 47 "Two thousand Yaquis being driven from San Blas to the city of Tepic by a regiment of Mexican soldiers." *American Magazine*, vol. 69, no. 1 (November 1909).

sense. Such is slavery as I found it in Yucatan."[44] And just as Turner's defi-nition of slavery focuses on the ownership, exploitation, and punishment of the body, so does *Barbarous Mexico* repeatedly dwell on endangered and ravaged bodies as privileged symbols of the horrors of slavery in Díaz's Mexico.

Again and again *Barbarous Mexico* suggests that sympathetic acts of witnessing the atrocities inflicted on Yaqui bodies can make a difference as Turner draws on the conventions of nineteenth-century antislavery and sensational "mysteries of the city" literature to expose hidden hor-rors. After the Yaquis left Veracruz, Turner claimed, "the curtain dropped upon them," so that even "well-informed Mexicans" didn't know what "fate was waiting them there at the end of that exile road."[45] But Turner and Gutiérrez de Lara succeeded in following that road and "saw gangs of Yaqui exiles, saw them in the 'bull pens' in the midst of the army barracks in Mexico City; finally [they] joined a party of them in Vera Cruz and trav-eled with them on ship from Vera Cruz to Progreso."[46] By "penetrating" into parts of Mexico that were usually unseen by foreigners without invest-ments there and by witnessing the Yaquis's journey down the exile road, Turner and Gutiérrez de Lara hoped to call the attention of U.S. readers to what they feared was the "extermination" of the Yaquis (see figure 47).[47]

But *Barbarous Mexico* also suggests some of the constraints of masquer-

ade, the vicariousness involved in witnessing, and the limits of sympathy. Turner's and Gutiérrez de Lara's masquerade forced them to pretend that their loyalties were with the exploiters, for instance, and prevented them from directly intervening to help those who were suffering, a dilemma that is especially troubling when the men watch as workers are beaten or listen in anguish to the "heartbreaking sobs" of workers who are locked into a densely packed plantation "dormitory" at night.[48] After talking with Yaqui women on a Yucatán plantation about the separation of Yaqui families and the beatings that had been inflicted on them, Turner noted, "I looked into the face of my companion; the tears were trickling down his cheeks. As for me, I did not cry. I am ashamed now that I did not cry!"[49] The different ways the two men responded to these atrocities are notable, and Turner's inability to cry in response to his witnessing of these cruelties raises a disturbing possibility that haunted sentimental narratives of humanitarian reform: that being repeatedly exposed to shocking scenes might weaken the powers of sympathy rather than stimulating an affective response that would lead to political transformation.[50] While the absence of tears in this case is no doubt tied to changing, early-twentieth-century norms of U.S. manhood, especially of the muckraking variety, it also signals the absence of appropriate affect within the sentimental discourses with which *Barbarous Mexico* is entangled and therefore raises larger questions about the emotional and political effects of exposing scenes of suffering.

The chapters from the *American Magazine* series drew on sentimentalism and sensationalism in other ways as well. Like nineteenth-century antislavery novels and other abolitionist literature, *Barbarous Mexico* focuses on the separation of families as key evidence of the horrors of Yaqui slavery: Yaqui families are systematically "broken up on the way" to the plantations after deportation, with husbands and wives "torn apart" and "babes . . . taken from their mother's breast." One Yaqui exile testified that "They take our children from us and give us the children of strangers," recalling the separation of families under slavery in the antebellum U.S. South. One of the few photographs in this series, captioned "Hundreds of families being gathered up monthly and sent away into exile," reinforced this sentimental strategy of representing endangered, vulnerable families as objects of sympathy.[51] Another photograph (see figure 48), captioned "A young Yaqui boy on the morning of his execution," provided visual evidence of another of Turner's and Gutiérrez de Lara's themes, that of the Mexican state's and the plantation system's cruelty toward children.[52] A

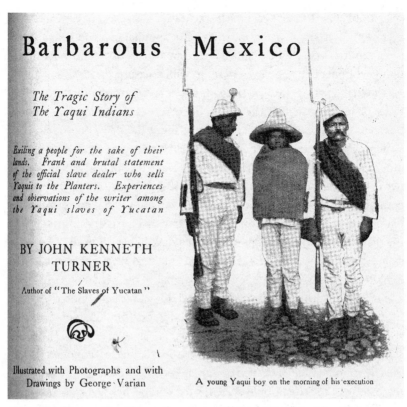

Barbarous Mexico

*The Tragic Story of
The Yaqui Indians*

*Exiling a people for the sake of their
lands. Frank and brutal statement
of the official slave dealer who sells
Yaquis to the Planters. Experiences
and observations of the writer among
the Yaqui slaves of Yucatan*

BY JOHN KENNETH
TURNER

Author of "The Slaves of Yucatan"

Illustrated with Photographs and with
Drawings by George·Varian

A young Yaqui boy on the morning of his·execution

FIGURE 48 "A young Yaqui boy on the morning of his execution." *American Magazine*,
vol. 69, no. 1 (November 1909).

small figure wrapped in a serape, the boy is guarded on each side by armed
soldiers whose long rifles menacingly frame him, underlining the point
that in Díaz's Mexico even children's bodies are not safe from the cruel-
ties and depredations of capitalism and the state. The text also emphasizes
the sexual dangers that imperil young girls on plantations, such as in the
case of a girl of twelve who, along with the other women, is "left to the
mercy of the men" when the workers are locked into small, closely packed,
prison-like sleeping dormitories at night.[53] Turner never sees such scenes
of sexual violation, though he fears the worst when he hears the women
crying, but the responses of others show how witnessing threatens to slide
into voyeurism. Turner mentions, for example, that "the son of the presi-
dente, when I was visiting his father's plantation, told me of how fiercely
the women sometimes fought and how he had at times peeked through a
crack and watched these tragic encounters of the night."[54] At moments

such as this one, the sentimental and sensational strategy of exposing ravaged bodies as signs of the injustice of economic and political systems threatens to become indistinguishable from a voyeurism that looks at suffering without acting and even perhaps with pleasure.

The chapters from the *American Magazine* series are dominated by spectacles of suffering that clearly aim to move readers to outrage and action, but they also repeatedly betray anxieties about the dangers of looking at such scenes and about the possibility that they might provoke responses other than sympathetic action. This is especially true of the beating scenes, five of which are accompanied by George Varian's illustrations. In the first episode, "The Slaves of Yucatan," the largest and most dramatic picture (see figure 49) is a full-page halftone reproduction of a wash drawing of "one of the richest planters in Yucatan" watching a slave being whipped. A "professional man of Merida" told Turner about "planters who took a special delight in personally superintending the beating of their chattels," including one whose "favorite pastime" was to watch his slaves being punished: "He would strike a match to light his cigar. At the first puff of smoke the first stroke of the wet rope would fall on the bare back of his victim. He would smoke on leisurely, contentedly, as the blows fell, one after another. When the entertainment finally palled on him he would throw away the cigar and the man with the rope would stop, for the end of the cigar was the signal for the end of the beating."[55] The tonal contrasts in the wash drawing isolate in the lighter foreground the planter, seated on a horse looking down on the raised whip ready to strike the back of the worker as another Mexican looks on, while in the shadowed background a crowd of workers are forced to watch the disciplinary spectacle. Turner's caption raises the dangerous possibility that some viewers, like the planter, would see such a spectacle of suffering as "entertainment" even as the illustration implicitly draws the reader's gaze to the planter's gaze and invites the reader to look at the same violent scene in the pages of an illustrated magazine, another form of entertainment, albeit one ostensibly devoted to stimulating "right action."

The second installment of Turner's series included another drawing of a beating that was so memorable that he wrote about it twice, briefly in the first episode and then rendering it as a long extended scene in the second. "One of the first things that I saw on a Yucatan plantation," Turner writes, "was the beating of a Yaqui." Turner emphasizes how the "act, though not intentionally so, perhaps, was theatrically staged," thereby calling attention to how relations of looking are implicated in regimes of terror and

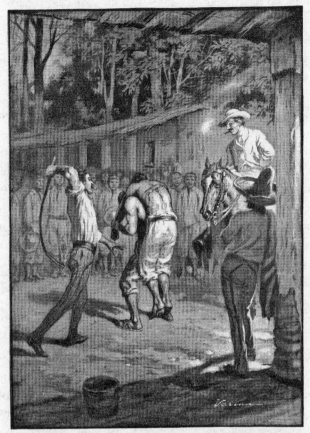

"A favorite pastime of——was to sit on his horse and watch the 'cleaning up' (the punishment) of his slaves. He would strike a match to light his cigar. At the first puff of smoke the first stroke of the wet rope would fall on the bare back of the victim. He would smoke on, leisurely, contentedly, as the blows fell, one after another. When the entertainment finally palled on him he would throw away the cigar and the man with the rope would stop, for the end of the cigar was the signal for the end of the beating."

FIGURE 49 "A favorite pastime of ———— was to sit on his horse and watch the 'cleaning up' (the punishment) of his slaves." George Varian illustration in *American Magazine*, vol. 68, no. 6 (October 1909).

labor exploitation, while at the same time, perhaps, reminding readers of their comfortable distance from the scene.[56] After the roll-call of the slaves at 3:45 in the morning, the slave gang was called together in front of the plantation store, the "fitful rays" of their lanterns "playing uncertainly over their dusky faces and dirty white forms."[57] Here, Turner seems to imagine the scene as a wash drawing, with shadings of dark and light, and he repeatedly describes it as a disciplinary spectacle that seizes hold of the gazes and bodies of the workers even as it invites the sadistic gazes of the

planters and plantation functionaries. Along with the manager, superintendent, and various bosses of the plantation, the slaves are summoned to witness the punishment of a young Yaqui man, who is first forced to take off his shirt and expose his body, while waiting slaves "look on" as "a giant Chinese" places the Yaqui on his back. Suddenly the scene transforms into one of horror, and the Chinese worker becomes transformed into a thing, a means of displaying the ravaged Yaqui's body, as he "[squares] off with the naked body of the victim to the gaze of his fellow bondsmen."[58] Turner gathers that this "drama" must have been so old to the assembled workers "that their eyes must have ached many times at the sight," but he speculates that it continued to "fascinate" since each worker knew "his own time was coming, if it had not already come, and not one possessed the physical power to turn his back upon the spectacle."[59] They do not possess that power because their bodies are not their own and because viewing the spectacle is part of plantation discipline.

Turner's next four sentences serve as the caption for another halftone reproduction of a Varian wash drawing that depicts another beating scene (see figure 50), but this time one more tightly focused on a close-up view of the *majocal* raising the whip to strike the back of the Yaqui, who is stretched across the Chinese worker's back and gazed at by the plantation *administrador*, the *mayordomo*, and a group of slaves: "Every eye was riveted tight upon that scene."[60] Many gazes are in play here: those of readers/viewers of the story and its pictures, that of the author, an autobiographical "I" who repeatedly calls attention to his own presence as an anxious witness, as well as, within the story, the approving gazes of the plantation owner and the terrified gazes of the slaves. Turner introduces this scene by refuting what "some people" might say, "that Yaquis are Indians" and for that reason "do not feel their troubles as you or I would feel the same thing."[61] Although Turner's purpose is to make his readers feel what the Yaquis feel by exposing scenes of ravaged bodies, however, the extended, drawn-out descriptions and the illustration also mimic the strategies of the torture scene even as they suggest that different readers and viewers might experience more troubling sentiments and sensations rather than being provoked to sympathetic action as a result of witnessing the horrors of slavery in Mexico.

The rendering of the Chinese worker as a thing and as a mediator for plantation labor discipline also exposes the limits of Turner's socialist sympathies and the way the sentimental and sensational construction of social

Every eye was riveted tight upon that scene in the uncertain dimness of the early morning—the giant Chinaman, bending slightly forward now, the naked body upon his shoulders, the long, uneven, livid welt that marked the visit of the wet rope, the deliberate, the agonizingly deliberate *majocol*, the *administrador*, watch in hand, nodding endorsement, the grinning *mayordomo*, the absorbed *capataces*. All held their breath for the second blow. I held my breath with the rest, held it for ages, until I thought the rope would never fall. And not until it was all over did I know that, in order to multiply the torture, six seconds are allowed to intervene between each stroke

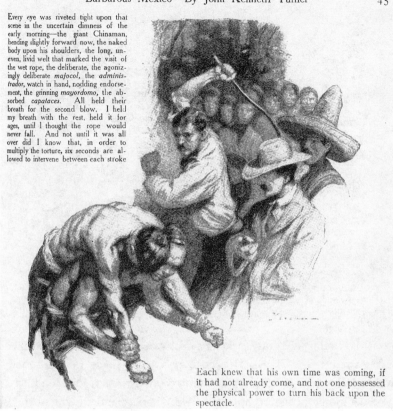

Each knew that his own time was coming, if it had not already come, and not one possessed the physical power to turn his back upon the spectacle.

FIGURE 50 "Every eye was riveted upon that scene." George Varian illustration in *American Magazine*, vol. 69, no. 1 (November 1909).

types could converge with naturalist reifications of personhood and race. While Turner observes that Chinese and Mayan workers are part of the watching crowd of workers, his sympathies are squarely with the Yaquis, and he imagines the Chinese in ways that are reminiscent of the foundational exclusions of the white working-class politics of the Progressive era, which, as Alexander Saxton suggests, was at many points inseparable from the politics of Asian exclusion.[62] Another Varian illustration, this time a process line engraving of a pen-and-ink sketch of a plantation functionary "making the Yaqui women choose Chinamen for husbands" (see figure 51) also provides a visual anchor for this externalization of the Chinese worker, marking his ineligibility for sympathy as it suggests that sexual liaisons with Chinese men are uniquely degrading and "abhorrent" to the

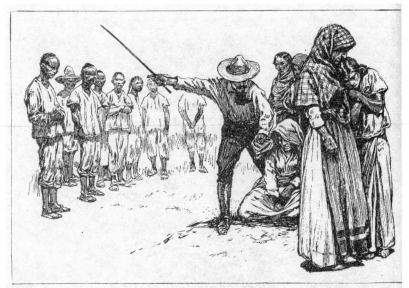

Making the Yaqui women choose Chinamen for husbands

FIGURE 51 "Making the Yaqui women choose Chinamen for husbands." *American Magazine*, vol. 69, no. 1 (November 1909).

women.[63] In this way, both Turner's narrative and the accompanying illustrations reduce the Chinese worker to an abject type defined by a mediating relationship to the slave plantation economy. This reduction further reveals another form of complicity between Mexico and the United States, one that Turner does not expressly acknowledge: shared histories of Asian exclusion and anti-Chinese violence in the United States and Mexico. Even the anarchist PLM advocated ending Chinese immigration to Mexico in order to protect other workers from competition in their 1906 Program and Manifesto.

If Turner externalizes the Chinese in ways that are typical of U.S. West Coast socialist and trade-union politics, he constructs Mayan and especially Yaqui Indians as exemplary workers by distinguishing them from the Indians of the United States. Indeed, he introduces the Yaquis to U.S. readers with the curious claim that "in the United States we would not call them Indians, for they are workers."[64] Turner repeats the testimony he gathered from Sonoran employers that Yaquis are the "best workmen" around, and he describes Yaqui male bodies in ways that suggest both identification and desire: he notes that Yaquis have an "an admirable physical development"; he learns to "pick [the Yaqui worker] out at a glance by his broad shoulders, his deep chest, his rugged face"; he suggests that the

"typical Yaqui is almost a giant, the race a race of athletes," and so on. Turner asserts that the Yaqui "have never been savages" and admires the Yaqui's refusal to bend "his head in submission to the will of the masters of Mexico," thereby explicitly distinguishing Yaquis from U.S. Indians and implicitly identifying them with white U.S. working-class ideals of manly self-reliance and resistance.[65] What is more, Turner claims that Yaquis have always shown "regard for the property of Americans and other foreigners" and have "never attacked Americans nor any people but Mexicans" (35). At this point, he returns to a path that later popular writers and cultural producers would follow, by casting Yaquis as friends of the U.S. Americans and enemies of the Mexicans in ways that both let the United States off the hook for its own genocidal Indian policies and perpetuate long-standing U.S. imperialist views of Mexico as a failed state, fatally marred by corruption and cruelty.

Turner would go on to insist on U.S. complicity in Mexican atrocities in the later parts of the *Barbarous Mexico* series, and through the early 1920s he would continue to be a persistent and vocal critic of U.S. imperialism in Mexico. In this part of the series, however, his exposé of the dispossession, deportation, and enslavement of the Yaquis both provokes and displaces comparisons with U.S. policies toward Indians and blacks. The main force of his exposé depends on raising the specter of slavery that, in the United States, was indelibly associated with chattel slavery before the Civil War. Yet this comparison could have ambiguous effects in both the antebellum and postbellum discourses of race and labor that Turner inherited.

At the same time, Turner's graphic account of the Mexican state's war on the Yaquis parallels contemporaneous, rather than antebellum, forms of white cruelty and torture directed at black people in the United States. Turner documents several episodes of lynching involving the Mexican army and the Yaquis, and he refers to "a photograph showing a lot of Yaquis hanging from a tree in Sonora."[66] These episodes recall the lynchings of black people that took place in the United States in the late nineteenth and early twentieth centuries; the Mexican soldiers who cut off the ears of imprisoned Yaquis and committed other atrocities resembled the participants in U.S. lynch mobs, who often took similar "trophies." Turner, however, never explicitly makes these connections in his narrative, which relies for much of its emotional force on the comparison between antebellum U.S. slaves and the Yaquis who are "held as chattel, bought and sold . . . beaten, sometimes beaten to death" and "worked from dawn until night in the hot sun" so that "two-thirds . . . die off within the first year

of their arrival."[67] In this way, Turner's text can indeed be aligned with antebellum sentimental novels such as Stowe's *Uncle Tom's Cabin*, which lingered on scenes of suffering in order to mobilize readers' sympathies in behalf of the enslaved. At the same time, the displacement of the comparison to black people into the U.S. past facilitates the disappearance of the black people of the present from Turner's narrative of modern white-supremacist atrocities and the state's collaboration in extreme forms of labor exploitation.

So how did readers respond to the chapters of *Barbarous Mexico* that appeared in the *American Magazine*? In the November 1909 issue, the editor made the unusual move of leading the issue with a discussion of the intensity of the response to Turner's sensational story. As soon as the series had been announced and before any of Turner's words had even appeared in the magazine, the editor charged, a "so-called Committee of the American Colony in Mexico City" had sent a telegram to President Taft asking him to prohibit the use of U.S. mails to the periodical. After news of this telegram reached the "South and Southwest and Mexico" and in the wake of the publication of the first excerpt from the series, the editor claimed, the magazine had received "hundreds of letters." While a few of the letters admitted that slavery existed in Mexico but worried that the publication of the series would do no good or would be bad for business, the vast majority of letters from U.S. Americans in Mexico confirmed the article's details. The "mass of letters," according to the editor, came from "people who know," "people who sympathize," and from "those whose humane sense is outraged by what they have heard of Mexico, and all urging us for humanity's sake to go on and show conditions as they are, in order that they may be remedied" (13). In this sense, they echoed Turner's hopes that exposing these scenes of horror might lead to change, although just what form that "remedy" would take was unspecified.

At times, however, these letters made disturbing comparisons between black slavery in the United States and Indian slavery in Mexico. One letter writer, for instance, argued that "the American slave prior to his emancipation lived in luxury and comparative freedom compared to the conditions under which the Mexican peon is compelled to exist" (11). An article in *Collier's Weekly* similarly tried to make historical violence sanctioned by the U.S. state disappear by condemning Mexican atrocities; this writer claimed that "probably nothing as brutally disgraceful has ever been done in the United States as the handling of Yaqui question by the Mexican

government" (13). Although Turner would probably not have gone that far, he did assert that he did "not believe that the conditions of the black slaves of our South were nearly as miserable as the lives of those people I saw in Yucatan." Echoing the troubling comparisons often made by white workers before the Civil War, he even maintained that black slaves were "usually well-fed, as a rule they were not over-worked, on many plantations they were rarely beaten, and it was usual to give them a little spending money now and then." He concluded that "the lives of our black men were not so hard that they could not laugh, sometimes, and sing. But the slaves of Yucatan do not sing."[68] Here Turner's comparison diminishes the horror of antebellum U.S. slavery and fails to see the singing on plantations as a response to the "deep sorrows" of the slave's "heart," as Frederick Douglass put it, who was "astonished" at the idea that some people in the North interpreted singing among slaves as "evidence of their contentment and happiness."[69]

And yet, while Turner rearticulated nineteenth-century white working-class comparisons of black and white slavery that diminished the former in order to emphasize the special pathos of white suffering and the exploitation of white workers, some radicals took different lessons from such comparisons. Responding to Turner's series in *Mother Earth*, Alexander Berkman and Emma Goldman repeated the claim that the Yaquis had been "decimated and driven into the most atrocious chattel slavery" and even commended Turner for proving "conclusively that at this moment American capitalists are engaged in buying and selling Mexican slaves, just as the Southerners bought and sold them before the civil war." But instead of making light of antebellum slavery, they drew the very different conclusion that "thus the people of this country face the fact that their war was fought in vain, and that their government is today conniving actively in the perpetration of the very crime they shed oceans of blood to make impossible." *Mother Earth* therefore advised the "people of this country" to form bonds of solidarity with "Mexican slaves" against states that connived "actively" to perpetrate a "crime" that was not truly abolished despite the "oceans of blood" shed during the Civil War.[70] As anarchists, Berkman and Goldman had developed a critique of the state that was not shared by the socialists Turner and Gutiérrez de Lara, despite their problems with the U.S. and Mexican governments. How the absence of such a critique shaped the boundaries of revolutionary internationalism in the U.S.-Mexico borderlands is the subject of the next chapter.

4 The End(s) of *Barbarous Mexico* and the
Boundaries of Revolutionary Internationalism

Despite the contradictions and ambiguities of *Barbarous Mexico*'s appeal, the intensity of some readers' responses to the series was apparently alarming enough to cause the *American Magazine* to stop publishing it. Although John Kenneth Turner was able to place some of the rest of his articles in newspapers aimed at working-class readers, the parts of *Barbarous Mexico* that focused on what he called the "American Partners of Díaz" came toward the end of the book and initially appeared in socialist and radical journals, such as the *Appeal to Reason*, the Partido Liberal Mexicano's bilingual newspaper *Regeneración*, and the *International Socialist Review*, a ten-cent monthly magazine published in Chicago and edited by Mary Marcy, which in 1910 had 27,000 subscribers (see figure 52).[1] Under Marcy's editorship the *International Socialist Review*'s circulation had increased 300 percent, as the journal's format changed to "that of the popular illustrated magazines of the day" and adopted a "militant" position in the U.S. socialist movement, but it had a much smaller circulation than did the *American Magazine*, which was a major Progressive publication venue with millions of readers.[2]

While Turner mentioned U.S. involvement in Mexico throughout the series, his emphasis on U.S. interests and investments in Mexico became much more forceful and explicit in the parts of *Barbarous Mexico* that were published in the *International Socialist Review*. In these sections of the narrative, Turner insists that

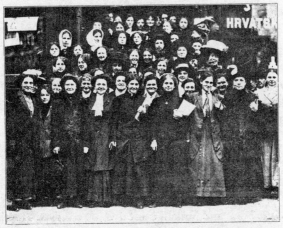

DECEMBER, 1910 **The** PRICE TEN CENTS

INTERNATIONAL
SOCIALIST REVIEW

The Fighting Magazine
of the Working Class

THE STRIKE OF THE GARMENT WORKERS
Robert Dvorak

THE AMERICAN PARTNERS OF DIAZ
John Kenneth Turner

FIGURE 52 Cover of December 1910 issue of the *International Socialist Review*, "The Fighting Magazine of the Working Class."

the "United States is responsible in part for the extension of slavery in Mexico; second, it is responsible as the determining force in the continuation of that slavery; third, it is responsible knowingly for these things." He also argues that "through its business partnership, its press conspiracy and its police and military alliance, the United States has virtually reduced Díaz to a political dependency, and by so doing has virtually transformed Mexico into a slave colony of the United States." Finally, he implicates U.S. capitalists in the "Yaqui atrocities" by declaring that "American capitalists bought the [mining and agricultural] lands while the Yaquis were still on

them, then stimulated the war of extermination and finally instigated the scheme to deport them into slavery in Yucatan."[3]

Instead of using wash drawings, engravings, and other sketches as illustrations, the pages of the *International Socialist Review* were lavishly illustrated with photographs, which perhaps suggest a more documentary impulse in keeping with Turner's and Gutiérrez de Lara's muckraking project. Many of the photographs in the *International Socialist Review* were not that different, however, from those in the *American Magazine*: they included photographs of Yaqui men on the exile road (see figure 53) and of Yaqui families huddled together in "bull pens" along the way (see figure 54), together with photographs bearing melodramatic captions such as "In Mexico women are cheaper than grist mills" (see figure 55).

The *International Socialist Review* illustrations do depart from the *American Magazine* illustrations in at least two ways, however. First, two photographs in the *International Socialist Review* connect the Yaqui wars to revolutionary struggles against Díaz as they show rebellious Mexican "insurrectos," who are also identified as "workers," taking up arms to fight for "freedom" (see figure 56). Instead of representing the opponents of Díaz simply as passive victims, the *International Socialist Review* implicitly endorses the armed revolutionary struggles of the Mexican people against Díaz as the "remedy" for the atrocities that Turner documents. Second, the *International Socialist Review* makes the U.S. presence in Mexico visible in the illustrations by prominently featuring a photograph of William Howard Taft with Díaz at the top of the first page of "The American Partners of Díaz" section of Turner's series (see figure 57). As Turner reminded his readers, Taft repeatedly sent troops to the U.S.-Mexico border "to aid Díaz in wreaking vengeance upon his enemies" and collaborated with him in a variety of other ways as well.[4]

By using this photograph to illustrate U.S. complicity in Díaz's policies, the *International Socialist Review* was inverting the meanings officials had hoped to give to the series of photographs of which it was a part, which were taken in Ciudad Juárez, Chihuahua, and El Paso, Texas, on October 16, 1909, to mark the first meeting ever between a U.S. president and a president of Mexico. As Roberto Tejada suggests, the Díaz camp had proposed such a meeting in hopes that, as Taft put it in a letter to his wife, "the knowledge throughout his country of the friendship of the United States for him and his Government will strengthen him with his own people, and tend to discourage revolutionists' efforts to establish a different gov-

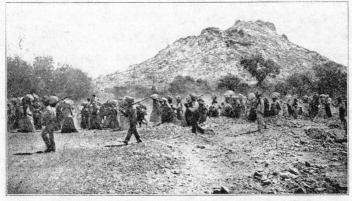

BAND OF YAQUIS ON THE EXILE ROAD.

FIGURE 53
"Band of Yaquis
on the Exile Road."
*International
Socialist Review*,
vol. 11, no. 6
(December 1910).

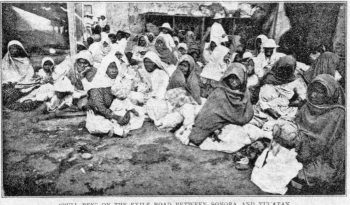

"BULL PEN" ON THE EXILE ROAD BETWEEN SONORA AND YUCATAN.

FIGURE 54
"'Bull Pen' on
the Exile Road
between Sonora
and Yucatan."
*International
Socialist Review*,
vol. 11, no. 6
(December 1910).

"IN MEXICO WOMEN ARE CHEAPER THAN GRIST MILLS."

FIGURE 55
"In Mexico Women
Are Cheaper
Than Grist Mills."
*International
Socialist Review*,
vol. 11, no. 6
(December 1910).

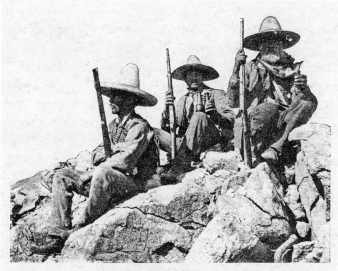

FIGHTING FOR FREEDOM.
EXTREME OUTPOST INSURRECTO CAMP OVERLOOKING JUAREZ.

WHY MEXICAN WORKERS REBEL

BY

JOHN KENNETH TURNER

FIGURE 56 "Why Mexican Workers Rebel." *International Socialist Review,* vol. 11, no. 6 (December 1910).

The
INTERNATIONAL
SOCIALIST REVIEW

Vol. XI DECEMBER, 1910 No. 6

TAFT AND DIAZ AT EL PASO, TEXAS.

THE AMERICAN PARTNERS OF DIAZ

BY

JOHN KENNETH TURNER

(FROM ADVANCE SHEETS OF "BARBAROUS MEXICO.")

FIGURE 57 "Taft and Díaz at El Paso, Texas." *International Socialist Review,* vol. 11, no. 6 (December 1910).

ernment." Taft was eager to comply since, as he put it, "Americans have about [$]2,000,000 of capital invested in the country," making it "inevitable that in case of a revolution or internecine strife we should interfere."[5] In the United States, many labor newspapers derided this photo opportunity even before it took place. The *Houston Labor Journal*, for instance, claimed that the Taft visit found its "inspiration in the secret cloisters of those who are plotting the destruction of liberty here and in Mexico," while the *San Antonio Light and Gazette* explained "Why Taft Will Shake Díaz' Paw: His Brother Runs Ranch in Texas Where Nothing but Mexicans Are Hired" and a *Chicago Evening Post* headline screamed "Mexico Denounced as Land of Slaves: Conditions Described as Worse than in Russia on the Eve of President Taft's Meeting with Díaz." The *Chicago Daily Socialist* even ran a story about the arrest of the Turners' old friend, John Murray, on charges of conspiring to start an armed insurrection in Mexico, on the eve of what the paper sarcastically called "Taft's visit and love fest with Díaz of Mexico."[6]

Other radicals across the southwestern United States were also arrested before the visit since U.S. officials apparently feared that they might spoil the party. But although the stagers of the photographs aimed to document what in *National Camera* Tejada calls Díaz's "neighborly performance" (1) and to support "an image of Mexico as a site of unwavering progress and a dependable place to do business" (20), in the *International Socialist Review* the use of the photograph of the two presidents to put a U.S. face on Mexican atrocities supports the interpretations made by other radical periodicals that implicated both states in the perpetuation of "slavery," as the parts of Turner's text that surround the image emphasize. As the photograph is placed in a different context, the official publicity portrait suggests alternate meanings: the spectacular display of state power, underlined by the pomp of the occasion, the formal attire of the two men, and the uniforms, crests, and raised bayonets of the officers who stand beside them morphs into something else, an illustration of transnational collaboration in the crime of the perpetuation of slavery. Tejada perhaps alludes to these sorts of transnational transformations in meaning when he insists on a photograph's "potential for prompting action" and criticizes the critical move of "dooming the photograph" to "the category of aesthetic positivism, to a descriptive function" (49).

Some of these photographs were also included in the book version of *Barbarous Mexico* that was issued by the socialist publisher Charles Kerr

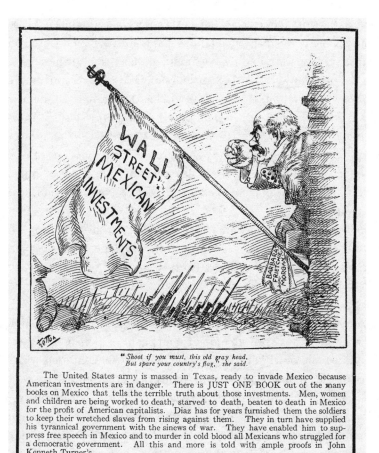

"*Shoot if you must, this old gray head,*
But spare your country's flag," she said.

The United States army is massed in Texas, ready to invade Mexico because American investments are in danger. There is JUST ONE BOOK out of the many books on Mexico that tells the terrible truth about those investments. Men, women and children are being worked to death, starved to death, beaten to death in Mexico for the profit of American capitalists. Diaz has for years furnished them the soldiers to keep their wretched slaves from rising against them. They in turn have supplied his tyrannical government with the sinews of war. They have enabled him to suppress free speech in Mexico and to murder in cold blood all Mexicans who struggled for a democratic government. All this and more is told with ample proofs in John Kenneth Turner's

Barbarous Mexico

Handsomely printed and bound: 340 large pages, with 20 engravings from photographs, many of them taken by the author when traveling through Mexico to gather materials for his work. If the American people knew a tenth this book contains, they would insist that the army be used not to protect slavery but to end it. Extra cloth, $1.50 postpaid.

CHARLES H. KERR COMPANY, Publishers
118 West Kinzie Street, CHICAGO

FIGURE 58 Ad for *Barbarous Mexico* (Chicago: Charles H. Kerr, 1910).
International Socialist Review, vol. 11, no. 6 (December 1910).

(see figure 58); Turner had not been able to interest any more mainstream publishing house in the project.[7] Although the book definitely created a debate about the Díaz regime, however, the parts of the text that were most explicit about U.S. collaboration in Díaz's Mexico came at the end and were initially published in periodicals, like *Regeneración* and the *International Socialist Review*, that reached a smaller, more radical readership.

The parts of the story that reached the most readers in its original publication contexts and in the many adaptations that followed, then, focused on Mexican slavery, tyranny, and the corruption of democracy, tropes made familiar in nineteenth-century U.S. melodramas and war literature, more than on the collaboration between Díaz and his U.S. partners in the new empire. In addition to the vexed politics of its publication history, however, perhaps *Barbarous Mexico*'s melodramatic structure, its reiteration of nineteenth-century tropes of slavery and freedom, its reifications of race and class, and its emphasis on spectacular scenes of suffering also limited the force of this critique of the new empire in Mexico even as it connected it to the "old" empire.

Turner's and Gutiérrez de Lara's "sensational socialism" reveals much about the changing boundaries and borders of radical internationalism in this period. According to Ira Kipnis, between 1910 and 1912 the Socialist Party in the United States "reached the zenith of its power, prestige, and influence" (335), but it was divided between conservative, reformist Socialists, who endorsed electoral politics as a means of socialist transformation and a mixed economy of private property and public, nationalized ownership of utilities and other key resources, on the one hand, and "left-wing" socialists, on the other, who believed in "industrial socialism" and the general strike, were suspicious of the right-wingers' emphasis on legislative reforms, and often had close ties to the Industrial Workers of the World and the anarchist movements of the era.[8] The *International Socialist Review* was "the national organ of the Left wing" of the U.S. socialist movement, and Turner's expulsion from the pages of the mainstream *American Magazine* and his affiliation with the *International Socialist Review* reveal how the revolutionary internationalism and the critical view of the new empire that Turner and Gutiérrez de Lara endorsed was increasingly confined to a relatively marginalized and policed sector of Left publications, while more mainstream versions of socialism championed Americanism and found the "relation of the state to foreign policy" to be of little concern (297).

The *International Socialist Review*, on the other hand, covered anarchist and anti-imperialist struggles in Japan, Spain, Cuba, Nicaragua, and Guatemala, and carried Turner's articles about Mexico as well as those of the anarchist William C. Owen, who replaced Ethel Duffy Turner as the editor of the English-language page of the PLM's newspaper, of the PLM leader Manuel Sarabia, and of others (see figure 59). Writing of the impending revolution against Díaz in an editorial, the editor Mary Marcy

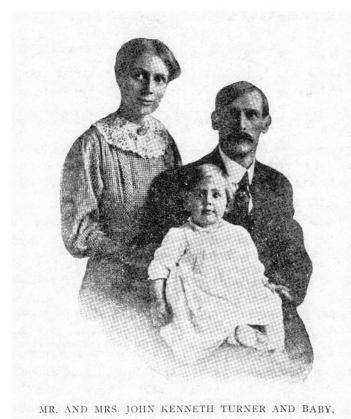

MR. AND MRS. JOHN KENNETH TURNER AND BABY.

FIGURE 59 "Mr. and Mrs. John Kenneth Turner and Baby." *International Socialist Review*, vol. 11, no. 6 (December 1910).

insisted that "their fight, is our fight," arguing that since the "capitalists of North America are a unit on all class questions . . . a close union and a perfect organization of the entire working class of this continent is absolutely necessary.[9] This international vision of working-class struggle against the new empire of international capitalism was a significant departure from the Americanism of the conservative wing of the U.S. Socialist Party as well as that of socialist writers such as Jack London, who justified the U.S. bombing and occupation of Veracruz in 1914 on grounds that the United States was a "big brother" who could more ably "police, organize, and manage Mexico" than could the Mexicans.[10] Mexican émigré anarchists and socialists such as Gutiérrez de Lara, the Flores Magóns, and many others undoubtedly contributed to this more capacious understanding of

international class struggle through their participation in radical U.S. public spheres.

At the same time, the limits of even a more radical socialist internationalism and this more trenchant analysis of the permutations of U.S. empire and globalization are evident in the racial hierarchies, and especially the figuration of Asian workers, in Turner's and Gutiérrez de Lara's texts. Writing in *The Mexican People* of the Yaquis who were rounded up and deported to Yucatán to work on henequen plantations, Gutiérrez de Lara also remarked that the women "who survived the lust of the planters, and the toil of the plantation, were thrown to sate the Chinamen" (324), thereby externalizing the Chinese worker in a way that recalls the representations in *Barbarous Mexico*. The prominence of the Asian worker as a scapegoat for "the social costs of unbridled capitalism" and as "that which marks the limits of socialist solidarity" in all of these texts reveals how, as Colleen Lye suggests, "a genealogy of Asian-American stereotypes reveals the historical failures of class critique."[11] The anarchists of the Americas would ultimately go much farther than the socialists in imagining international and transnational solidarities, perhaps because of their problems with the state form, and they would also be policed, deported, imprisoned, censored, and punished much more. All of the writers in this transnational cluster remembered the U.S.-Mexico War and an earlier history of U.S. empire that was being forgotten as they confronted the complicity of U.S. investors and the state in the horrors of the Porfiriato. Yet U.S. socialist literature, especially, persistently returned to ideas about race, labor, land, government, and national belonging that were partly the result of that history and that were disseminated through sentimental and sensational tropes and genres, making the latter a very ambiguous tool indeed for the forging of world movements in response to the new empire.

BARBAROUS MEXICO REANIMATED: FRANK MERRIWELL AND THE DIME NOVEL IN MEXICO

In the years after it was published, the *Barbarous Mexico* story had a long afterlife in popular culture, inspiring several dime novels, literary Westerns, and early films. The sentimental and sensational modes traverse, in different ways, all of these cultural forms, including dime novels featuring Frank Merriwell, who was the most popular figure in the dime novel's "twilight era" and a host of narratives that served as the basis for early motion pictures, such as the California socialist Herman Whitaker's *The*

Planter (1909), Dane Coolidge's "The Land of Broken Promises" (1913), and Zane Grey's *Desert Gold* (1913), which was made into a movie in 1919, 1926, and 1936. All of these narratives call attention to the dispossession and exploitation of Yaqui Indians and condemn Mexican atrocities by mobilizing sentimental and sensational conventions and structures of feeling. But such a sentimental and sensational focus on bodies, feelings, powerful images, and memories of empire had multiple, contradictory effects and provoked debates and conflicts rather than defusing them. Although all of these texts foreground sentimental and sensational scenes of bodily suffering, *Barbarous Mexico* fully implicates U.S. capitalists and political leaders, while the U.S. presence in Mexico is erased or idealized in most of the narratives that incorporate parts of Turner's and Gutiérrez de Lara's story. And while Turner and Gutiérrez de Lara sympathized with the world movements that participated in Mexico's revolutionary upheavals, early-twentieth-century dime novels, literary Westerns, and motion pictures struggled to contain the impact of those upheavals and movements even as they recorded their traces in sensational stories of imperial manhood and adventure.

I begin by focusing on two stories, written by Gilbert Patten, under the pseudonym Burt Standish, about the boy hero Frank Merriwell in Mexico, that appeared in Street and Smith's magazine *Tip Top Weekly* only months after Turner's *American Magazine* stories were published.[12] Although most of Merriwell's exploits in the long-running series involved sports and running a school for boys, these stories were basically recoded Westerns, as Bill Brown has suggested.[13] Throughout the series Frank and his brother, Dick, frequently traveled to different parts of the world, including the U.S. West, Mexico, and Latin America, and in January 1910 two numbers of *Tip Top Weekly* featured stories about Frank Merriwell among the Yaquis in Mexico and visiting the plantations of Yucatán.

The focus on the opening parts of the *Barbarous Mexico* narrative, especially the spectacles of bodily suffering, in other popular versions of the story is made strikingly visible by the brightly colored illustrated covers of the two *Tip Top Weekly* numbers in which Frank Merriwell retraces Turner's and Gutiérrez de Lara's steps: *Frank Merriwell's Fairness; or, the Crime of a Nation* (no. 716, January 1, 1910) and *The Slaves of Yucatan; or, Frank Merriwell's Pledge* (no. 717, January 8, 1910). (The second title directly echoes the title of the first excerpt published in the *American Magazine*, "Slaves of Yucatan.") On the first cover, Merriwell clenches his fists as he stands

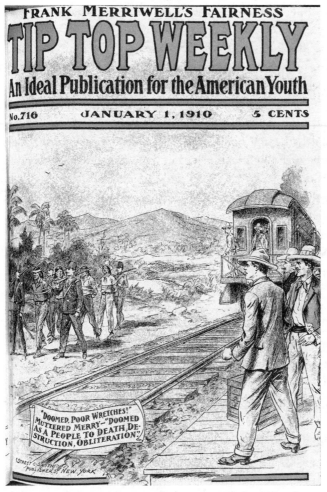

FIGURE 60 Cover of *Frank Merriwell's Fairness. Tip Top Weekly*, no. 716, January 1, 1910. Courtesy of the Huntington Library, Art Collections, and Botanical Gardens.

by the train tracks and watches Yaqui rebels march off to be executed by Mexican soldiers (see figure 60). This image recalls *Barbarous Mexico*'s images of Yaquis on the "exile road" from Sonora to Yucatán, but in this case the Street and Smith artist isolates a group of male insurgents rather than representing a mixed group of men, women, and children; he depicts the guards as soldiers wearing elaborate military uniforms that clearly identify them with the Mexican state; and he also, interestingly, chooses to represent Mexican railroads, three-fourths of which were, according to

Barbarous Mexico, owned or controlled by the U.S.-based Southern Pacific Railroad. However, far from criticizing U.S. business interests in Mexico, Patten works hard to absolve them of complicity in what he represents as the "crime" of the Mexican "nation." Here, the railroad, which, Patten immediately informs us, was "built and owned by American capitalists" (1), becomes a sign of U.S. modernity and progress that is implicitly contrasted with the savage brutality and primitive nature of the Mexican "nation," whose representatives are willing to participate in this "criminal outrage" (4). Merry's statement that the Yaquis are "doomed as a people to death, destruction, obliteration," moreover, repeats the ubiquitous nineteenth-century U.S. trope of the "Vanishing American" while shifting the blame for Indian genocide wholly onto Mexicans.

The second cover similarly focuses on a scene of Mexican tyranny, but this time the illustration captures Merriwell in action, rather than rendering him a passive bystander (see figure 61). As a "brutal" Mexican overseer is about to lash a worker, Frank shouts "Stop" as he springs forward to intervene. Here Merriwell, an allegorically "ideal" American with links to U.S. mining interests, rescues the worker from the Mexican tyrant rather than participating in the worker's subordination, as *Barbarous Mexico* would have it.

As is usually the case with dime novels, the covers reveal much about the stories inside, thereby reproducing the strategy of nineteenth-century theatrical melodramas, which, as Linda Williams suggests, "found a powerful emotional emphasis" in the "freezing" of metaphorical pictures into "still tableaux of the narrative's most intense moments."[14] Here, those "intense moments" are the spectacles of bodily suffering that have always played a prominent role in sentimental and sensational literature, going at least as far back as Stowe's *Uncle Tom's Cabin*. In *Frank Merriwell's Fairness*, the Yaqui execution scene, which is described at great length, and in *The Slaves of Yucatan*, the plantation whipping scene, which comes at the climax, work to make legible a moral truth, as the theorist Peter Brooks would put it.[15] As in Stowe's novel and other race melodramas, in the Merriwell stories that moral truth is revealed in the very alternation between sentiment and sensation, between spectacles of pathos and action. In the first novel, Frank decides to observe the execution scene even though he "had no relish for such a spectacle," for he "was suddenly seized by a desire to witness, with his own eyes, the extremity of brutal persecution to which a nation might proceed against naturally peaceful and harmless people

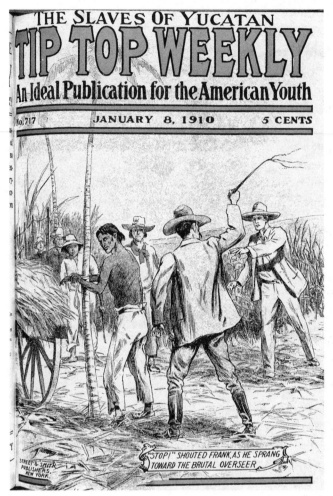

THE SLAVES OF YUCATAN

TIP TOP WEEKLY

An Ideal Publication for the American Youth

No. 717 JANUARY 8, 1910 5 CENTS

"STOP!" SHOUTED FRANK AS HE SPRANG TOWARD THE BRUTAL OVERSEER

STREET & SMITH PUBLISHERS, NEW YORK.

FIGURE 61 Cover of *The Slaves of Yucatan. Tip Top Weekly*, no. 717, January 8, 1910. Courtesy of the Huntington Library, Art Collections, and Botanical Gardens.

whose destruction had been decreed" (6). His response to this scene manifests his own "chivalrous nature" and makes legible the moral opposition between sympathetic U.S. American and tyrannical, unfeeling Mexican.

The Slaves of Yucatan hints that Merriwell's ability to feel right might lead to some sort of action, for one of the Yaqui rebels hopes that "your sympathy may lead you to tell your people how this government has treated its peaceful citizens whose land and property were coveted by greedy, murderous men" (23). But in the novel sympathy ultimately seems to displace,

rather than provoke, action. In a move that recalls Lauren Berlant's characterization of the "paradoxes of liberal sentiment," the stories "render scenes and stories of structural injustice in the terms of a putatively pre-ideological nexus of overwhelming feeling," climaxing with moral tableaux in which sympathy is offered as the only real remedy.[16] At the end of *The Slaves of Yucatan*, Merriwell manages to save one worker by buying and freeing him, but the larger structural problem of U.S. complicity in these "horrors" remains invisible. Indeed, since it is precisely Merriwell's capacity for feeling sympathy that distinguishes him from the brutal Mexicans and makes manifest the moral superiority of the U.S. Americans, Merriwell's sympathetic acts of witnessing actively contribute to the disappearance of the evidence of structural injustice and U.S. complicity that is so important in *Barbarous Mexico*.

In other ways as well, the Merriwell novels actively seek to extricate U.S. business interests from an otherwise damning indictment of the treatment of the Yaquis and other Mexican workers. But the series tracks the U.S. footprint in Mexico even as it labors to characterize that presence as wholly positive. In earlier episodes of the Merriwell story, we are reminded, the Merriwell brothers had to make a "brave fight" to "open and develop" the mines they had inherited from their father in the Mexican state of Sonora. While Frank turned over the management of the mines to a syndicate, in *Frank Merriwell's Fairness* he goes to Mexico on its behalf in order to check out some mines which had been "long abandoned and left idle on account of Indian troubles and the natural sloth of a people who were inclined to put off an arduous labor until to-morrow" (1). When Merriwell visits some of the syndicate's other mines in the region, he notes "with great satisfaction the tremendous development of the mines since the construction of the Central Sonora Railroad" (1). He also tours the workers' quarters and expresses "satisfaction in the manner in which they were sheltered and fed and kept sanitary and healthy by the restrictions and rules which the camp physician insisted upon" (1). In all of these ways, he suggests that the U.S. presence in Mexico has produced wonderful results and implicitly counters *Barbarous Mexico*'s harsh assessment of U.S. responsibility for Mexican atrocities.

Perhaps the most dramatic and explicit attempt to do this, however, comes in the second dime novel, *The Slaves of Yucatan*. Toward the end, Patten introduces an American character, Jim Boardman, who was formerly the superintendent on a tobacco plantation owned by a Mexican.

While many of *Barbarous Mexico*'s claims about the mistreatment of workers are verified by this character, he also claims that "slave-driving and whipping human beings to death" are "too much" for him, and by extension, for Merriwell, who is posing as a potential plantation owner, because they are "Yank" and "could never run one of those plantations as they're run down here," by "squeezing the blood out of human beings" (20). It is hard to imagine any representation more antithetical to *Barbarous Mexico*'s claim that "Americans work the slaves—buy them, drive them, lock them up at night, beat them, kill them, exactly as do other employers of labor in Mexico."[17]

Similarly, the long history of U.S. empire-building in Mexico is both registered and obscured in the Merriwell novels. Many of the plot conventions and character types from U.S.-Mexico War–era sensational novels return to haunt these texts. One of these character types is the "Yankee" who speaks in a marked dialect and acts as a sidekick to the main hero. In *The Slaves of Yucatan*, the Yankee in Mexico is Joshua Crane, Merriwell's buddy. While U.S.-Mexico War dime novels were often international romances in which a soldier-hero courted an elite Mexican woman, in the Merriwell novels Crane falls in love with Conchita, a laborer's sister, and ultimately saves her from a Mexican soldier who is trying to force the girl to marry him by telling officials that she is a Yaqui and by threatening to transport her to Yucatán. This vicious Mexican soldier recalls the many Mexican libertines and tyrants who tried to rape and seduce women in sensational U.S.-Mexico War novels, and here, too, the Mexican's lack of reverence for the principle of consent proves that he is both unmanly and unfit to govern himself or participate in a democracy. At one point in the text Crane even implicitly alludes to the U.S.-Mexico War, when he warns the Mexicans that if they fire on him, "You'll hear the eagle scream, by gum! You'll feel the claws, same as you did once upon a time" (14). And drawing a familiar lesson from this history, Crane concludes, "We've jest got to take persession of Mexico and run it ourselves. These barbarous varmints ain't fit to govern a hen-coop" (17). While in Turner's preface to the first edition of *Barbarous Mexico*, he was careful to say that the word *barbarous* in his title was meant to "apply to Mexico's form of government rather than to its people," a form of government, he emphasizes, for which the United States is partly responsible, in the Merriwell novels the deficiencies of government are precisely blamed on the Mexican people.[18] Again, this understanding of barbarity inverts that provided by Turner, who ends

by explicitly refuting the charge that "the Spanish-American character is somehow incapable of democracy and therefore needs the strong hand of a dictator."[19] Since Mexicans "have never had a fair trial at democracy," he concludes, "and since those who are asserting that they are incapable of democracy are just the ones who are trying hardest to prevent them from having a trial at democracy, the suspicion naturally arises that those persons have an ulterior motive in spreading such an impression. That motive has been pretty well elucidated in previous chapters of this book, especially in the one on the American partners of Díaz."[20]

The mass cultural adapters of the *Barbarous Mexico* narrative did not find it difficult, however, to extract the critique of the U.S.-American partners of Díaz from a sensational narrative comprised of spectacles of bodily suffering and an alternation between pathos and action. I have suggested that the Frank Merriwell stories and other mass cultural versions of Turner's narrative jettison *Barbarous Mexico*'s focus on structural injustice in order to tell a sensational story, which has deep roots in the U.S.-Mexico War period, of tyrannical Mexicans and virtuous U.S. Americans, of Mexican cruelty trumped by right feeling and sympathy. In conclusion, however, I want to suggest that we should understand the Merriwell stories not simply as a reduction or a distortion of Turner's and Gutiérrez de Lara's narrative, but also perhaps as an illuminating amplification of the limits of their text, whether in parts or as a whole. For while in *Barbarous Mexico* the sentimental and sensational modes enable the articulation of a strong critique of the structural connections between Díaz and his U.S. American partners, that very melodramatic structure and the emphasis on spectacular scenes of suffering limited the force of that critique and rendered the text vulnerable to highly selective excisions and revisions. In these and many other ways, sentimentalism and sensationalism shaped the boundaries of the socialist sympathy and internationalism that was precariously forged by U.S. American and Mexican radicals in this period, as the story of Chepa Moreno, which follows, also reveals.

"THE SECRET BASEMENT ROOM": YAQUI-CHINESE
ALLIANCES IN THE SHADOW OF STATE VIOLENCE

In the late 1960s and 1970s, Chepa Moreno, a Yaqui woman who was deported from Sonora to Yucatán, narrated her life story to the anthropologist Jane Holden Kelley. In ending part II with her story, I do not simply propose to offer these memories as the truth by which we can judge the

distortions and gaps in Turner's and Gutiérrez de Lara's sensational story of Yaqui suffering. Moreno's memories are certainly not unmediated windows into the reality of Yaqui experiences during the Porfiriato, although they do indeed both confirm and complicate many of the details of the *Barbarous Mexico* narrative. But Moreno's mediated memories also offer a different perspective on these events, one that is not primarily expressed in sentimental and sensational modalities and one that recalls alliances, rather than antagonisms, between Yaquis and Chinese immigrants. Her story also starkly exposes the boundaries, racial hierarchies, and privileged subjects of the state-centered framework of Gutiérrez de Lara's and Turner's sensational socialism in ways that resonate with the story of Hubert Harrison, the black, immigrant, New York City radical whose shift from organizing for the Socialist Party of America to building race-based transnational movements is a major focus of part III.

It is important to recognize at the outset that Moreno's narrative is, like Turner's and Gutiérrez de Lara's, the result of another relationship of collaborative authorship, one that was structured by hierarchies of power and shaped by problems of translation. In her preface and introduction to *Yaqui Women*, which presents four women's life stories, Kelley spends a good deal of time discussing these hierarchies and problems. Kelley claims that while "she wanted to intervene as little as possible between the Yaqui women and the reading audience," she also didn't want to promote "a false sense of objectivity."[21] Hoping that "the next step will be for Yaqui women to write in their own voices according to their own agendas," Kelley tried to scrupulously elaborate on her own "role and its effects on the published narrative" (vii–viii). One of the forms of mediation involves language and translation, for while the Yaqui women were fluent in Yoeme, the language of the Yaqui people, and Spanish, Kelley did not know Yoeme, so she conducted the interviews in Spanish, then translated and reshaped them in English. She also observed that the Yaqui women perhaps saw her as "occupying the fringes" of a "patrona role," which can be defined as a "boss, implying past or present employment of one or more family members" (11). Kelley confessed that if she had been choosing roles, the patrona image was not the one she would have chosen, since it "carried connotations of a social hierarchy, of inequality, and of exploitation, all connotations that a middle-class white anthropologist might well feel uncomfortable with" (12). At the same time, she understood that in some ways she fit that role because she was a "non-Yaqui" who "provided resources," including

a small amount of pay for the interviews that was funded by a grant from the Canadian government, and mobility, for she often took the women on automobile trips to the beach, to nearby villages, and to visit family members living at a distance. She also fit the role because she "represented a long-term relationship," since she and her father, William Holden Kelley, had collaborated on a previous life story with Rosalio Moisés, a Yaqui man who was kin to many of the women who were interviewed. But Kelley also claims that in other ways her relationship with the women was on a more "egalitarian" footing, since the interviews occurred on "Yaqui ground rather than in the setting of the patron" and since she was asking for "information" rather than "domestic services" (12). Ultimately, however, it is Kelley, and not the Yaqui women, who is credited with the authorship of the text, and the narratives are shaped by her agenda more than by those of the women she interviewed.

This is not to say that the women did not have agendas of their own, agendas that also no doubt shaped these narratives. Kelley notes that Chepa Moreno was "the most difficult of the women to work with": "Not infrequently she was in a fractious mood, losing her temper when I did not know as much as she thought I should, or if I asked her to repeat something, or if she thought I was writing too slowly" (23). But at the same time, Moreno's life was radically affected by her relationship with Kelley. When Kelley first met her Moreno told her she was dying, and indeed she was, since she was disabled by arthritis, could no longer support herself, had no surviving family members who could help her out, and was starving. Kelley admits that "the resources I provided radically changed her life, temporarily" (23). As a result of their relationship, Moreno was able to eat meat and buy other food, to get medical attention and eyeglasses, and to be mobile and see "places she thought she had seen for the last time" (23). While Kelley observed that Moreno placed her "in a more pronounced patrona role than did the other informants," she claimed that "the age dominance factor" applied at other times, when Moreno would take on the role of "an elder instructing a younger woman," leading the conversation, refusing to cooperate with Kelley, and instructing her on correct behavior (129). In other words, while the relationship between Moreno and Kelley was shaped by Moreno's desperate need of the resources that Kelley could supply, this does not mean that she was a pliable subject who simply followed Kelley's agenda.

Moreno's story, as it emerges here, both converges with and departs

from the sentimental and sensational stories told by U.S. Americans and Mexicans about the plight of the Yaquis during the Porfiriato. As a teenager, shortly after her arranged marriage, Moreno was deported from Sonora to Yucatán. According to Kelley, "the deportation itself, the hardships she endured, her life as a 'slave' in Yucatán, the deaths of her seven babies, and the dissolution of her marriage, which left her alone in war-torn Yucatán, were bitter memories" (126). Moreno's grim account of her deportation experience resonates with the photographs and descriptions by Turner and Gutiérrez de Lara documenting the suffering of deportees and the separation of family members. While imprisoned and awaiting deportation, Moreno and her baby were separated from her husband, Pedro, and they experienced "drastic hunger" when they were "crushed into a small cell" in which there was not enough room for everyone to lie down, and where they had to eat their small rations and "perform their necessities" (134). Later, Moreno and over three hundred other Yaquis were "herded into railroad cars—'just stuffed in like goats'"—and when they arrived in San Blas they had to march to Tepic, where Moreno's baby died. This was one of the most traumatic events in Moreno's narrative, and it is unusual because her grief and anger are so evident, whereas she narrates other traumas in a less emotional, more matter-of-fact manner: "She begged to be allowed to bury her baby, but they dragged her out and at bayonet point forced her to return to the army post, crying all the way. She was convinced that they threw the baby to the dogs since they would not let her bury him" (135). After two more train rides to Guadalajara and Mexico City, Moreno was finally sent to Yucatán after being bought by a patron ("the Yaquis were sold like so many goats" [136]). While Pedro labored in the henequen fields, Moreno made tortillas in a communal kitchen for the workers.

Shortly after they arrived, she and Pedro went to visit some Yaquis on another plantation and they were caught and "publicly punished" in a scene that recalls the representations of beatings in *Barbarous Mexico*: "Pedro was given fifty lashes across the lower back, and she (now in an advanced state of pregnancy) was given twenty-five" (136). While *Barbarous Mexico* focuses extensively on such scenes, however, in Moreno's narrative only one sentence is devoted to an account of this punishment. Perhaps since it was such a bitter memory she did not wish to dwell on it. Or perhaps such painful experiences were so common for Moreno that she did not feel that they demanded extensive narration. Another key difference is what while *Barbarous Mexico* foregrounds the pained bodies of

male workers, in ways that aim especially to elicit sympathy and identification in U.S. and Mexican laboring men, Moreno's story emphasizes that women also endured such punishment. The trauma faced by a laboring mother in Yucatán is also clarified in Moreno's narrative. She gave birth to seven children, all of whom died as infants. Kelley observes, "The births and deaths at Hacienda Nokak became part of a blurred, repetitive picture, and Chepa had difficulty in distinguishing one tragic episode from another in her recollections" (138).

While *Barbarous Mexico* emphasizes the short lives of the enslaved Yaquis and fails to narrate the lives of any who survived this brutal experience, Moreno's story diverges from this pattern since she was freed when the Mexican Revolution reached Yucatán. At this point, Pedro deserted her, and so for several months she cut henequen in the fields. The work "cut the flesh like a knife but her raw hands were eventually toughened," she told Kelley (139). Later, she was told that she and many of the other Yaquis were going to be shipped to Veracruz and then sent on a train to Mexico City. After she arrived, she met a Mayo Indian and soldier named Salvador, who was a Carrancista, and she "formed an alliance" with him and became a *soldadera*. Kelley noted that "much has been written on the hard life of the Mexican soldaderas," but "for Chepa the period was a tremendous improvement" over the years in Yucatán, and she had "vivid memories" of it, partly because for the first time she "enjoyed a role in which her being a Yaqui was not the key factor in other peoples' reactions to her" (140–41). Unfortunately, though, Salvador ended up leaving her, and so in the end she returned to Hermosillo in Sonora, where she eked out a living for over forty years by working as a washerwoman.

Her life in Hermosillo was harsh, and one of her few sources of happiness was her long friendship with another washerwoman, Victoria Soto. Kelley observes that while most people thought of Moreno as a melancholy loner, "Victoria's daughters described the two women as constantly talking, joking, laughing, and giggling, and both could perform devastating imitations of other people, something they did only in the river or at their own homes" (146). Moreno's narration of her friendship with Soto also provides a very different story about the relationships between Yaqui women and Chinese men than the ones told by Turner and Gutiérrez de Lara. Moreno remembered that Victoria and her mother had moved to Hermosillo "at the time of the Yaqui roundups and deportations," and while they were there, they became friends with Antonio Wong, "a Chinese

who ran a little shop" (146). During the years of Yaqui persecution, Victoria and her mother would "hide in a secret basement room in Antonio's shops when the Mexican soldiers were searching for Yaquis to deport. Eventually Victoria began living with Antonio, and they had three children" (146). But about 1930 the Chinese in Sonora were themselves rounded up and deported to China. "Antonio Wong was among the 'deported' and he was never heard of again" (146).

Part III

BLACK RADICAL
NEW YORK CITY

5 | Sensational Counter-Sensationalisms

BLACK RADICALS STRUGGLE OVER MASS CULTURE

Here, on the eve of the celebration of the Nation's birthday of freedom and equality, the white people, who are denouncing the Germans as Huns and barbarians, break loose in an orgy of unprovoked and villainous barbarism which neither Germans nor any other civilized people have ever equaled.

How can America hold up its hands in hypocritical horror at foreign barbarism while the red blood of the Negro is clinging to those hands?
— HUBERT HARRISON, "THE EAST ST. LOUIS HORROR," *VOICE*, JULY 4, 1917

During the 1910s, a decade of revolutions and world war, several radical movements that sought to connect black people in different parts of the world emerged in New York City. The Harlem intellectual Hubert Harrison, a brilliant orator, editor, writer, and critic who came to the United States from the Virgin Islands after his mother died in 1900, organized and influenced many of these movements after he stopped working for the Socialist Party of America (SPA) because of its compromises with its Southern wing over white supremacy.[1] Like Marine Transport Union organizer and intellectual Ben Fletcher, Harrison initially found the Industrial Workers of the World (IWW) more congenial. When he turned away from the Socialist Party sometime around 1914, he explained in a letter to a socialist paper that he was instead "throwing in" his "lot" with the IWW because of its "success" in

opposing "race prejudice," as "in Louisiana, where it organized 14,000 Black timber workers, together with 18,000 white timber workers, with 'mixed' locals too, in spite of Southern sentiment."[2] During this period in his life, Harrison joined the IWW leaders Elizabeth Gurley Flynn and William (Big Bill) Haywood to support striking silk workers in Paterson, New Jersey, and also participated in IWW rallies as part of an effort to push the "great world movements" of the era beyond the "veil of the color line."

But East St. Louis was a turning point for Harrison. After the American Federation of Labor (AFL) president Samuel Gompers defended white rioters who viciously attacked black people in East St. Louis in 1917, Harrison lost faith in building interracial movements. Since Gompers and the AFL chose "to put Race before Class," Harrison concluded in an article called "The Negro and the Labor Unions," "let us return the compliment."[3] Instead, he organized black people into groups such as the Liberty League, which protested lynching and disfranchisement, and advocated in the league's paper, the *Voice*, "a breaking away of the Negro masses from the grip of the old-time leaders."[4] In the pages of the *Voice*, he also criticized W. E. B. Du Bois's 1918 *Crisis* editorial calling on Negroes to "forget our special grievances and close . . . ranks" with "our white fellow citizens and the allied nations that are fighting for democracy." Harrison had a different understanding of the significance of the world war for the "Negroes of America." He argued that black people could not be said to have a "political life" as long as the "special grievances" of "lynching, segregation, and disfranchisement" existed, that "life, liberty, and manhood" depended on addressing those grievances, and that "instead of the war making these things less necessary, it makes them more so." In other words, for Harrison, Wilson's war to "make the world safe for democracy" further exposed the home front as a war front and revealed the contradictions between democratic ideals and the violent evisceration of political life experienced by black people in the United States.[5]

Around this time, Harrison first encountered Marcus Garvey, who had already traveled from Jamaica to Central America and England before he arrived in New York City, participated in Liberty League events, and borrowed from Harrison many ideas for promoting the Universal Negro Improvement Association (UNIA), the organization that he had cofounded with his first wife, Amy Ashwood. For a while, Harrison edited the *Negro World* (1918–33), the UNIA's weekly newspaper, which the masthead claimed was "Devoted Solely to the Interests of the Negro Race,"

and helped turn it into a newspaper that could boast that it reached "the Mass of Negroes." During the 1920s, *Negro World* circulated to hundreds of thousands of readers despite official efforts to suppress it in many places, and it reported on "The News and Views of UNIA Divisions" throughout the world, especially Cuba, Nicaragua, Mexico, the Virgin Islands, Costa Rica, Panama, Jamaica, and other parts of the Americas as the UNIA grew into the largest mass movement of black people in history. But in the early 1920s Harrison broke with Garvey and founded the International Colored Unity League (ICUL) as an alternative to the UNIA; he also edited its monthly magazine, the *Voice of the Negro*. The program and principles of the ICUL included serving the "great masses of our people" by offering scholarships, organizing cooperative enterprises, and pressing for a "homeland in America," rather than in Africa, where black people from around the world could demonstrate "to the rest of the nation that they are as capable of democratic self-government under American institutions as any other racial element in this country of ours."[6] The ICUL never enjoyed anything like the popularity of the UNIA, however. Thanks in no small part to the hard work of Amy Jacques Garvey, the UNIA leader's second wife, the UNIA continued to attract a large international membership even during the years when Garvey was investigated by the state, charged with mail fraud, tried and imprisoned, and then deported from New Orleans to Jamaica on December 2, 1927, just two weeks before Harrison's untimely death from appendicitis.[7]

While Harrison and Amy Ashwood, Amy Jacques, and Marcus Garvey had a major impact on black radicalism in the 1910s and 1920s, the Liberty League, the ICUL, and the UNIA and their official publications were not the only significant black radical movements and periodicals in New York City at this time. In August 1917 Chandler Owen and A. Philip Randolph cofounded the *Messenger* (1917–28), a magazine that initially strongly supported the SPA and harshly criticized the United States for its hypocrisy, persistent racism, and role in the First World War.[8] The magazine also endorsed the IWW, urging black people to engage in "direct action" and join the IWW because it was "the only labor organization in the United States which draws no race or color line" and deals "chiefly with unskilled labor."[9] The *Messenger* ran articles about the Marine Transport Workers as well as about Ben Fletcher's IWW work and imprisonment, and it singled out "the face of darker hue," "Ben Fletcher, a cool, intelligent, and able Negro organizer," in an August 1921 photo of "A Group of I.W.W. Class

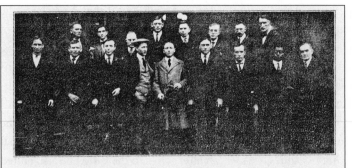

A GROUP OF I. W. W. CLASS WAR PRISONERS
Picture taken just before they returned to Leavenworth Penitentiary.

Top row, left to right:—Ralph Chaplin, Wm. Weyh, Joe Gordon, Walter T. Nef, J. Graber, Francis Miller, E. F. Doree, Thomas McKinnon.
Bottom row, left to right:—Jack Walsh, Wm. Lewis, Harrison George, Jack Law, Chas. Ashleigh, John M. Foss, Pietro Nigra, Ben Fletcher, M. J. Smith.

Do these men look like bomb throwers? Look into their faces. See what an intelligent, serious group they are. Their only crime was the organization of their fellow-workers with a view to raising their standard of living and finally ushering in peacefully a new order of society.

No race or color line is recognized by these men. Note the face of darker hue; it is Ben Fletcher, a cool, intelligent and able Negro organizer.

Let every man who reads this sit right down and write your Congressman and Senator to "Let our people go!" Wont you?

FIGURE 62 *Messenger* photo of IWW prisoners, December 1921.

Prisoners" that was taken just before the men were sent to Leavenworth (see figure 62).[10]

By 1919, the *Messenger* had achieved a monthly circulation of 150,000, despite official threats to crack down on it during the war years, when A. Mitchell Palmer called the magazine "the most able and dangerous of all the negro publications" and J. Edgar Hoover imagined it as "the headquarters of revolutionary thought."[11] The magazine's vivid cover art and graphic images, which Barbara Foley suggests "powerfully reinforced its political message" and "conveyed fairly complex arguments," enhanced its appeal but also provoked the ire of the state: New York's Lusk Com-

mittee used as the frontispiece to a volume of their proceedings a July 1919 *Messenger* image that accompanied the poem, "The Mob Victim" and which "linked lynching and Americanism through the image of a Black man being roasted alive in the flames of a burning US flag."[12]

While Owen and Randolph remained loyal to the Socialist Party despite their critique of the persistence of white supremacy, Cyril Briggs, a prominent writer for the *Amsterdam News* and editor of the *Crusader* magazine (1918–22) who came to New York from St. Kitts-Nevis, shifted instead toward black internationalism and organized the African Blood Brotherhood (ABB), a transnational movement that was for a while affiliated with the Communist Party. Boosted by funding from immigrant businessman Anthony Crawford, Briggs originally aimed to publish "authoritative articles about Africa" and possibilities for black nation-building and enterprise in "the South American and West Indian republics," but he soon turned his attention to using the *Crusader* to "wake up the masses," promote the ABB, and turn the latter into a "world-wide Negro Federation."[13] As a part of this effort, the *Crusader* featured many images, including many covers of beautiful black women (see figure 63) and scores of illustrations and photographs, and claimed to be alone in "making a specialty of entertaining fiction, informing articles and other purely magazine features," adding that "fiction must be appropriately illustrated."[14] As in the cases of Owen and Randolph, Briggs's appeals to the black masses also drew the attention of the state. An editorial Briggs wrote on the League of Nations for the *Amsterdam News*, a newspaper that postal authorities considered unpatriotic and "to exist principally for the purpose of stirring up race feeling," was held up and scrutinized under the terms of the Espionage Act. Briggs also claimed he was summoned for an interview by postal officials after the April 1919 issue of the *Crusader* exposed the "ill treatment suffered by black soldiers at the hands of their white officers in France."[15] Although the ABB and the *Crusader* were never as popular as the UNIA and *Negro World*, for a while there existed branch organizations throughout the Americas.

All of these organizations and publications used literature as well as photographs and other images to appeal to the black masses in sentimental and sensational modalities, but each also struggled with and against the white-supremacist sentimentalism and sensationalism of mass culture and the revitalized Ku Klux Klan. The parades, huge public meetings, international conventions, elaborate official regalia, and other aspects of UNIA

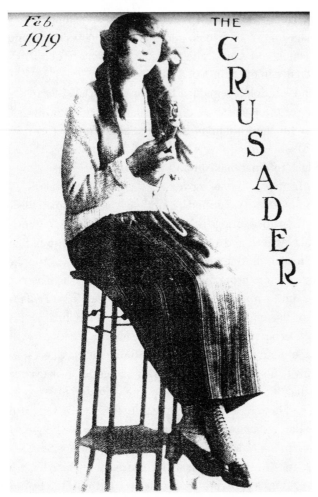

FIGURE 63 *Crusader* cover featuring telephone operator, February 1919.

culture that are famously captured in James Van Der Zee's photographs helped to make Garvey into what the *Chicago Defender* (December 3, 1927) called, on the eve of his deportation, "the colorful figure who caused a sensation with his gigantic program of a 'Back to Africa' movement." The sensational aspects of Garvey's "gigantic program" for the UNIA had important political dimensions: Michelle Stephens, building on Robert Hill's work, argues that Garvey's "popular performances" aimed precisely "to capture the hearts and minds of his worldwide popular black audience" and that his "historical significance lay in his ability to imagine and then mobilize the black masses around a spectacular vision of black trans-

nationality."[16] But Harrison, Owen, Randolph, Briggs, and other radicals who became disillusioned with Garvey also worried that his sensational appeal undercut the aims of the movement. These leaders of black radical New York City connected this sensational appeal to the hierarchical, authoritarian structure Garvey tried to impose on the UNIA and worried that the financial mismanagement of the UNIA's Black Star Line threatened poor and working-class black investors.

In an article called "Marcus Garvey at the Bar of United States Justice," which was distributed to black newspapers by a wire service after Garvey was convicted of mail fraud, Harrison accused Garvey of borrowing all that was best in the UNIA from his own Liberty League, charging that the crucial difference was "an intensive propaganda more shrewdly adopted to the cruder psychology of the less intelligent masses, the sensationalism, self-glorification, and African liberation—although [Garvey] knew next to nothing of Africa. But since Africa was far away and wild statements about its '400 millions' could not be disproved in New York that feature of it was a money-getter always." In claiming that Garvey's sensationalism targeted the "less intelligent masses," Harrison articulated an ambivalence about mass culture that was shared by many other leaders of black radical New York City, despite their own hopes of appealing to those "masses." To Harrison, the "pictures" of the ship the *Phillis Wheatley* that were badly "faked in the office of the B.S.L. [Black Star Line] and printed in the *Negro World*, each picture showing a different type of ship," exposed the dangerously amnesiac, imperialist, and capitalist limits of Garvey's sensational and spectacular performances of black transnationality.[17]

Brochures and advertisements in *Negro World* used these "fake" pictures to promote the Black Star Line, hailing black male readers in utopian terms: "Colored Men! Would you like to be Shipmasters? Engineers? Wireless operators? Would you be proud to have a great line of steam ships owned and controlled by MEN of your RACE?" In a promotional letter to stockholders, Garvey even claimed that the Black Star Line was "the embodiment of the commercial sentiment of the Negro."[18] Briggs observed that "the spectacular feature of the enterprise—Negro ships on all of the seas, Negro ships to run between all Negro lands—won the attention of the people and this happens."[19] Unfortunately, however, the Black Star Line was a spectacular failure and the brochures with pictures of the *Phillis Wheatley* were ultimately used as evidence in the state's case against Garvey, which concluded with a five-year prison sentence.

Most of the leaders of black radical New York City turned against

Garvey in the end, but in the process of making the case against him, Owen and Randolph pressed for his deportation in ways that created tensions with other radicals and revealed some of the fault lines over internationalism and Americanism within radical movements at this moment. Alarmed by the direction in which they believed the UNIA was headed, in December 1920 Owen and Randolph began running a series of articles critical of Garvey. In the first article, "The Garvey Movement: A Promise or a Menace," they explained that while they had previously shared the same platform with Garvey, "The Black Star Line was" then "no part of [the movement's] effects," nor "were the slogans 'Negro First,' an 'African empire,' 'back to Africa,' and extreme race-baiting prominent in its program."[20] But the magazine still remained basically respectful of Garvey, criticizing the *Chicago Defender* as late as April 1922 for "unfairly" attacking him "because he is a West Indian." The *Messenger* insisted that along with the "harm" he had done, "Garvey has done much good work," especially in stressing "the international aspect of the Negro problem."[21] All of this changed, however, in the summer of 1922, after Garvey met with the Ku Klux Klan leader Kleagle Edward Young Clarke in Atlanta and then, in a speech at New Orleans, said, "This is a white man's country" and "I am not vexed with the white man of the South for Jim Crowing me because I am black." In the July 1922 issue, the *Messenger* responded by serving notice that it was "firing the opening gun in a campaign to drive Garvey and Garveyism in all its sinister viciousness from the American soil."[22] Meanwhile, the back cover of this issue of the *Messenger* consisted of a full-page ad for a set of public lectures at the Shuffle Inn Music Parlors in Harlem, entitled "How Marcus Garvey Betrayed the Negroes to a Georgia Negro Hater," which were to be delivered by Randolph and Owen and which they promised would be "told in plain words which burn in letters that blister!"

Although previously the magazine had criticized the *Chicago Defender* for attacking Garvey because he was West Indian, and although two years earlier the editors had objected to the deportation of Emma Goldman, Alexander Berkman, and two hundred other radicals to Russia, reminding state officials that "you cannot deport true ideas and principles by deporting persons," as Owen and Randolph made the case for Garvey's deportation the *Messenger* increasingly began to make distinctions between natives and foreigners and to mark Garvey as a West Indian.[23] An editorial entitled "Time to Go," which appeared in August 1922, noted

in italics that this was the first recorded case of "a foreigner coming to a country and entering into a compact to deport the citizens of that country," and insisted that when "a Negro leader leagues with Negro lynchers as did Marcus Garvey in his alliance with the Ku Klux Klan, then it is time for all decent, self-respecting Negroes to league together for the purpose of driving out that Negro."[24] The next month, in the article "Should Marcus Garvey Be Deported?," Chandler Owen declared that he favored "the conviction and imprisonment of Marcus Garvey and his deportation immediately after he shall have served his sentence," adding that Garvey was "an anarchist in the truest sense of the word and his deportation as an anarchist in thought and advocacy would be in accordance with a true and non-strained interpretation of the law." Owen also contrasted "we intelligent and honest American and West Indian Negroes" with Garvey's "motley crew of Negro ignoramuses," called Garvey himself "the nefarious Negro lizard" making "a report to his universally ignorant Negro savages for his imperial boss, the infamous white wizard," and sneeringly remarked that there was "hardly a citizen among them."[25]

All of this was too much for the contributing editor W. A. Domingo, the former editor of *Negro World* and the *Emancipator*, who was himself an immigrant from Jamaica and who in March 1923 left the *Messenger* after writing a scathing letter that was published, along with Owen's reply, in an "Open Forum." Domingo made it clear at the beginning of his letter that he had been one of the first to raise his voice in protest against "the execrable exaggerations, blundering bombast and abominable assininities of our Black Barnum," but still objected to the abundance of *Messenger* articles stressing "Mr. Garvey's nationality." Domingo went on to advise Owen that "it is incompatible with your Socialist faith for you to initiate an agitation for deportation or to emphasize the nationality of anyone as a subtle means of generating opposition against him," and he charged that "certainly the people you hope to rouse against this monstrous thing are sufficiently intelligent as to be entitled to a higher form of propaganda!"[26]

While in a letter published in the *Negro World* on April 3, 1926, the former *Crusader* editor and ABB co-founder Briggs claimed that he, along with Domingo and Richard Moore, had attacked the "infamous petition engineered by Chandler Owen for the deportation of Marcus Garvey sans trial and conviction," Michelle Stephens suggests that in 1924 Briggs played "a leading role in the US government's deportation case against Garvey."[27] Certainly Briggs aided the state's efforts to convict Garvey of mail fraud

after officials abandoned plans to build a case around income tax evasion. Briggs and Garvey became antagonists after the ABB was expelled from the UNIA's annual convention in 1921, when representatives of the ABB challenged UNIA rules and procedures, and Briggs devoted the rest of the *Crusader*'s brief remaining life to criticizing Garvey's leadership of the movement. For his part, Garvey accused Briggs, who was sometimes called "the blond Negro," of actually being a white man. It is not surprising, then, that Briggs was glad to witness Garvey's downfall. The first page of the *Crusader*'s final issue, of January–December 1921, featured a jubilant story entitled "Marcus Garvey Arrested," and in an article called "On with the Liberation Struggle," the "Supreme Executive Council" of the ABB took credit for trying to "force reforms" in the "management" of the UNIA's "schemes," because "we saw that their spectacular nature had appealed to the imagination of some of our people," whom the ABB wished to "save" from "disappointment and financial loss" (6). On the editorial page, under the headline "The Inevitable," Briggs reminded readers that he had warned them that Garvey was heading for a fall and argued that the arrest proved his point that it was wrong to pledge a "blind, fanatical obedience to the individual above the Cause." In another editorial in the same issue, entitled "Crusader Warned Its Readers against Marcus Garvey," Briggs also took credit for "the exposure of the non-existence of the ghost ship Phyliss Wheatley [*sic*]" and for forcing Garvey to give a "long overdue" accounting of his "collections and expenditures" (8).

Ten years later, in an article entitled "The Decline of the Garvey Movement" which appeared in the *Communist*, Briggs had a more charitable interpretation of Garveyism, attributing its success in its heyday to "the wave of discontent and revolutionary ferment which swept the capitalist world as a result of the post-war crisis" and which brought to the surface the aspirations of the "Negro masses." Briggs suggested that "from the beginning there were two sides inherent to the movement: a democratic side and a reactionary side"; while the democratic side dominated the movement's early stages because "the pressure of the militant masses" forced the adoption of "progressive slogans," later the "reformist leadership" betrayed "the toiling masses" in both the United States and the West Indies. After this, Briggs argued, "the masses began to drop away from the movement" and it "began to assert more and more its reactionary and anti-democratic side." Still, the movement was "historically significant," he insisted, because it "helped to crystallize the national aspirations of the

Negro masses." He concluded by pointing out that the situation in 1931 afforded "considerable opportunity for the winning of the Negro masses away" from Garvey and the "reformers."[28]

Briggs's envy of Garvey's more successful appeals to the "Negro masses" was still strikingly apparent even ten years after Briggs had helped to bring about Garvey's arrest and four years after Garvey had been deported to Jamaica, when the influence of the UNIA in the United States was waning. This was true of all the black New York City radical leaders who played prominent roles in the opposition to Garvey: Briggs, Owen, Randolph, and Harrison all hoped to capture the terrain of black mass culture for their own movements, and all of them envied Garvey's ability to build a movement that attracted "Negro masses" all over the world. This pushed some of them, especially Harrison, to develop a critique of the sensational aspects of Garvey's appeal, even as Harrison and other radicals struggled to imagine a sensational counter-sensationalism that would appeal to the masses while avoiding the pitfalls of Garvey's sensationalism, including the amnesia about Africa and other parts of the world, the imperial ambitions, the authoritarian tendencies, and the falsely utopian vision of black capitalism that came crashing down with the failure of the Black Star Line. This was more easily said than done, however. Harrison devoted the rest of his short life to this difficult project, while Owen's and Randolph's distinctions between citizens and foreigners limited their appeals to the world's masses, and the *Messenger* soon became more focused on literature and the arts than on politics and revolution, anyway. But for a few years the *Crusader* made the imagining of a sensational counter-sensationalism that might appeal to the masses one of its major goals, with mixed results.

Throughout part III, I analyze the diverse appeals to the masses made by black radicals in New York City during this period, with a particular focus on Briggs, Dougherty, and Harrison. In the work of these radicals we see the emergence of a critique of mass culture and worries over its convergence with politics even before the Frankfurt School intellectuals made their more famous critiques of the dangers of mass-mediated fascisms. Marcus Garvey was the figure around which many of these earlier debates revolved, since other radicals' concerns about the antidemocratic, authoritarian tendencies in Garveyism provoked them to raise questions about the consequences of the sensational spectacularization of a charismatic leader and the uses of modern mass media for world political movements. The rest of part III explores how Briggs, Dougherty, and Harrison all struggled

to model a sensational counter-sensationalism that used modern media and popular culture to build black world movements without reproducing the antidemocratic and imperialist elements of Garveyism. Briggs and Dougherty ended up romanticizing hierarchical relations of race, gender, and sexuality and secret, quasi-military counter-formations as they tried to use sensational fiction to reach the masses. On the other hand, Harrison's contact with Harlem's queer black masses and transnational immigrant public spheres pushed him to elaborate a version of sensational counter-sensationalism that sometimes questioned such hierarchies and counter-formations as he imagined alternate worlds and near futures that exceeded the narrow boundaries of heteronormativity and middle-class uplift. Another central argument of part III is that Briggs, Dougherty, Harrison, and other black radicals in New York City during these years were all responding to decolonizing, revolutionary struggles throughout the Americas as well as in Russia.

VISIONS OF BLACK REVOLUTION AND WHITE WORLD EMPIRE IN THE *CRUSADER*

Before it folded, in 1922, the *Crusader* used sensational fiction, hard-hitting editorials by Briggs, and photographs and other pictures to hail black readers in different parts of the world, while the ABB, which lasted until 1924, when it was dissolved into the Communist Party, was centered in New York City but established branch organizations in the U.S. South, Central America, and the Caribbean.[29] Although initially Owen and Randolph supported Briggs and promoted the *Crusader*, by the early 1920s there were more tensions and differences between the two groups of black radicals, particularly over their respective allegiances to socialism and communism. In an editorial entitled "The Socialist Surrender," which appeared in August 1921, Briggs accused the Socialist Party of America of selling its honor, deserting its principles, rejecting "not only the Third International, but all international affiliations as well," and casting aside "the banner of International Labor" in favor of that of "One Hundred Per Cent Americanism." Briggs was averse to making invidious distinctions between foreigners and "Americans" in the movement: the program of the ABB, formulated at their 1920 convention, insisted that the "Negroes in the United States—both native and foreign-born—are destined to play a vital part in the powerful world movement for Negro liberation."[30] Briggs opposed Garvey because Garvey had "treacherously repudiated Social

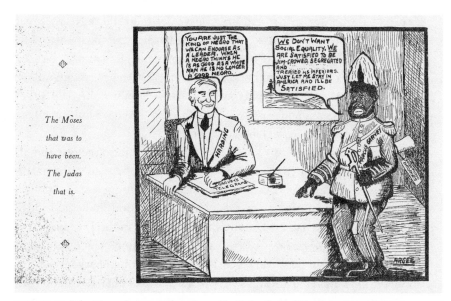

The Moses
that was to
have been.
The Judas
that is.

FIGURE 64 "The Moses that was to have been. The Judas that is." *Crusader*, December 1921.

Equality for the Negro and appealed to all the worst passions of the white race" and refused to "denounce the presence and murderous acts of United States marines in the island of Haiti," not because Garvey was an "anarchist," as Owen put it, whose followers included many noncitizens.[31]

Many of Briggs's criticisms of Garvey connected Garvey's sensational rhetoric and spectacular appeal to antidemocratic tendencies in the movement. Briggs explained that, unlike Garvey, he did not "look upon the task of freeing Africa as exclusive to himself by right of some mysterious 'Divine Decree.'" Instead, he advocated a worldwide federation of allied organizations. Nor did he believe that "the Negro World Movement" could be "organized by vain indulgence in mock-heroics, empty phrases, and unearned decorations and titles, and other tomfoolery."[32] In a cartoon published in the December 1921 issue alongside the caption "The Moses that was to have been. The Judas that is," *Crusader* magazine mocked Garvey by depicting him dressed in the regalia of a black emperor, like the uniform he wore in the ubiquitous photographs that circulated widely in popular culture (see figure 64). In the cartoon, Garvey promises President Harding he will sacrifice the ideal of "social equality" as long as he can stay in "America," to which Harding replies, "You are just the kind of Negro that we can endorse as a leader." In the final issue of the *Crusader*, which

coincided with Garvey's arrest, Briggs gave notice to "those Negroes that insist on following such fakes" that "we have hardly anything more to say." On the other hand, to "those Negroes who have enough stamina to face the hard realities of struggle" rather than resorting to "demagogy, tomfoolery, blatant threats, etc.," he offered the ABB as "a medium to unite with" either "as individuals or as bodies," promising it would "stand for unity of all the truly militant forces in the Liberation struggle."[33]

Despite Briggs's criticisms of Garvey for his sensational rhetoric and his spectacular appeals to the imagination, Briggs also appealed to the imaginations of the black masses in a host of ways, from the secret, "underground" nature of aspects of the ABB's organization and activities to the sensational, serialized literature that appeared in the *Crusader*. Several sensational stories ran in the magazine, including "The Ray of Fear: A Thrilling Story of Love War, Race, Patriotism, Revolutionary Inventions, and the Liberation of Africa," "Secret Service," and "Punta, Revolutionist," a "Great Thrilling Serial Story of Love, Mystery, Adventure, Revolution, and the Renaissance of a Race," which was published in a series of "gripping installments" before trailing off without a conclusion. While Briggs himself authored the first two under the pseudonym "C. Valentine," the last and longest was written by Romeo Dougherty (see figure 65), who was also intimately involved with early-twentieth-century popular and mass culture as a movie programmer, as the sports editor of the *New York News*, and as a member of a prominent New York City basketball team. Dougherty understood the *Crusader*'s purpose to be the "intelligent agitation for a real true and unvarnished democracy for the darker peoples of the world" and both he and Briggs tried to use sensational stories of adventure, inventions, and political intrigue modeled on dime novels to agitate for anticolonial struggle and worldwide revolutionary transformations.[34] The sensational form of the stories resonate not only with the dime novels of an earlier era, moreover, but also with an emergent genre of black militant near-future fiction that Kali Tal defines as "science fictions that feature a secret society of dedicated revolutionaries, a charismatic leader or genius, [and] a face-off between those Blacks who advocate violence and those who cannot bring themselves to do so."[35]

In their sensational stories, Briggs and Dougherty adapted and transformed popular genres and forms, but their fiction reveals some of the contradictions and impasses of mass culture at this moment as well as its uses for radicals. Dougherty's "Punta, Revolutionist," which was serial-

Behind the Scenes in Basketball

By Romeo L. Dougherty

Sporting Editor of New York News (Whose Photo Appears at Right), Relates Inside Facts of Fight to Keep Sport Clean.

FIGURE 65 Portrait of Romeo Dougherty. *Crusader*, January 1921.

ized in the *Crusader* in 1918 and 1919, is especially noteworthy because of its explicit reflections on the culture of sensation and its efforts to connect anticolonial struggles of the Spanish–American War era with black radical movements in Dougherty's present. In the beginning, the reader is introduced to Harry Lonsdale, who has migrated from Savannah, Georgia, to New York City and is passing for white as he works first as a newsboy and then as a reporter for the "sensational" newspaper the *New York Thunderer*. Londsdale educates himself by reading books of the "blood and thunder variety," such as Old Sleuth, Jesse James, and Nick Carter dime novels, and he eventually "graduates" to "stories of love and adventure" by Laura Jean Libbey, E. D. E. N. Southworth, Eugene Sue, Alexandre Dumas, and others. This crash course in sensational novel reading prepares him to give his "imagination full play" as a newspaper writer, to make up "wonderful tales," and to "draw sensational pictures" of the Rough Riders that help to "swing public opinion" in support of the war.[36]

But once Lonsdale is sent to a fictional island called Santo Amalia as a war correspondent to write stories about the activities of the troops in Cuba, he falls in with a crowd of "young Spanish-West Indians" and soon becomes a part of "the most drastic plan for Negro freedom ever conceived." Even though he is passing as white, "deep down" in his "heart" is the "pride of race," and he is inspired to reveal his true identity after he gets to know Punta and Maria Hernandez, the children of wealthy parents, "whose refinement was handed down to them from ancestors, Spanish grandees on the one side, Carib Indian and Negro on the other." Following the conventions of sentimental and sensational international romance, Lonsdale falls in love with the sister, joins in the fraternal fellowship of the brother, and imagines Santa Amalia, where "black, white, yellow, and brown" join together "with locked arms" and "in the best of spirit," as a utopian alternative to the white-supremacist nation at home, "a land where it is almost an offense to be other than white."[37]

These experiences motivate Lonsdale to join Punta's plot, when he discloses it, to perfect an aerial bomb, which will be "the most deadly weapon known to mankind" and make it possible to control space.[38] By developing a secret weapon and building a giant wireless station "to communicate with far-off Africa," the revolutionaries hope to "launch the 'Black Revolution'" twenty years in the future. In the final chapter, Lonsdale recruits Caribbean men to the movement, persuades Maria to agree to marry him in Paris, and then retreats to a "powerful plant hidden in the tall timbers" of an island just off the Florida coast to perfect a powerful communication device to reach Africa once the revolution begins. Just as Lonsdale enters "the fight for justice for my people," however, the novel abruptly ends, despite the "to be continued" notice that followed the final excerpt.[39] But Dougherty still articulates a powerful critique of the connections between sensational literature and U.S. empire-building even as he tries to adapt the codes and conventions of the dime novel and sensational fiction to make connections between past and present, and agitate for anticolonial struggle and black world revolution.

Dougherty's "Punta, Revolutionist" exemplifies what Michelle Stephens calls the genre of "Black empire narratives," which attempt to "imagine some version of an international revolutionary Black state" and thereby reveal "the tension of a cultural politics constituted by both radical and reactionary impulses—impulses toward racial revolution, movement, and freedom, and impulses toward militarism, statehood, and empire."[40]

That "Punta, Revolutionist" breaks off without ever concluding is another symptom of the tensions and paradoxes at the heart of such a project. Imagining an international revolutionary black state was both imperative, because in the postwar world rights and international recognition depended on the nation form, but also almost impossible because of persistent racial-imperial hierarchies. Because the story has no ending, it is difficult to say whether the black revolution that is envisioned in "Punta, Revolutionist" will result in a state. We learn only that the plan is to "call the attention of the world to the injustices heaped upon the colored races." But it is important to recognize that Dougherty's vision of black world revolution connects such an enduring revolutionary struggle to uprisings and decolonizing movements in the Americas, not the revolution in Russia or the new Soviet state. Punta, the young revolutionist who inspires the sensational newspaperman Harry Lonsdale and converts him to the cause, is, after all, a "Spanish West Indian" colonial subject who decides to "hatch a real revolution" after "tasting of that damnable color prejudice" in the United States. Looking backward to the Spanish–American War era, Dougherty thereby imagines in the anti-imperial struggles of the trans-American past a legacy that black people around the world might reclaim in the revolutionary present.

For readers of the *Crusader*, these kinds of connections would have been difficult to miss, since the magazine published many stories and editorials about anticolonial struggles around the world, but particularly in the Americas. Briggs published several pieces, for instance, about independence movements in Santo Domingo and Haiti in response to U.S. occupation. In an editorial called "Partners in Frightfulness," which appeared in January 1920, Briggs reacted with disgust to reports of U.S. marines in Haiti terrorizing so-called bandits in what he called "Wilson's undeclared and private war upon the people of Haiti." Briggs explained sarcastically that although "it is the custom to designate as bandits all those who oppose an occupation of their country by alien forces," the "bandits" were really "Haitian patriots" who were "fighting for the principle of self-determination against the foremost 'champion' of that principle, Woodrow Wilson."[41] And in a later piece, Briggs encouraged "the American Negro" to "recognize his duty towards the Negro republics of Haiti and Santo Domingo and the extent to which his destinies are bound up with those of the Negro people of these two republics," recalling Dougherty's Harry Lonsdale's recognition, in "Punta, Revolutionist," that his destiny and the

future of black world revolution were bound up with the young Spanish West Indians on the fictional island of Santo Amalia.[42]

The Virgin Islands was another site of U.S. empire where an independence movement emerged, and an article about anti-imperial resistance there and in the British West Indies, entitled "The Fight for Freedom," appeared just beneath one of the final installments of "Punta, Revolutionist." This article told about a mass meeting that took place in July 1927 in New York City "under the auspices of the Virgin Island Protective League, to protest against American atrocities and the American regime" there. "Falling in line with the world-wide sweep of the Negro movement for national existence and freedom from the white heel," Briggs reported in this article, "residents of Dominica, B.W.I. have started a movement for an independent federation of the West Indies on the principle of national freedom."[43] These anti-imperial struggles and independence movements shaped the vision of revolution in Dougherty's "Punta, Revolutionist," with its militant, anticolonial West Indians who are plotting a worldwide black revolution against the imperialism of the "white heel," as well as in Briggs's sensational stories in the *Crusader*.

Along with the Virgin Islands and the "Black republics of Haiti and Santa Domingo," Mexico, which Briggs referred to as "the colored republic to the South," also interested these radicals, both because of the Mexican Revolution and Mexico's long history of anticolonial revolutionary struggle and because of the possibility of U.S. intervention there during the 1910s and early 1920s. Sensationalism was also a part of the battle over U.S. intervention, since William Randolph Hearst and other wealthy and influential U.S. investors in Mexico promoted intervention by publicizing Mexican "atrocities." In a March 1920 editorial, Briggs called Hearst "one of the chief engineers of a war with Mexico for the annexation of that coveted country in which he has extensive property holdings," and he deplored the "double page argument for annexation" in one of Hearst's newspapers, the *New York American*, which "dish[ed] up Mexican horrors" by using a photograph of the lynching of a thirteen-year-old Mexican boy to make the case for war. Reminding Hearst of the eighty-four people who had been lynched in the United States in 1919, including a nine-year-old boy, Briggs suggested that the United States "would seem to supply far more cause than Mexico for the entry of some strong power bent upon preserving 'law and order' and suppressing American horrors."[44] Briggs argued that Hearst's sensational "dish" of Mexican horrors invited U.S.

readers to see the violence of a ruined republic in Mexico rather than at home as he astutely analyzed how mass-circulation dailies used photographs and other images to provoke emotional responses in viewers in support of the aims of white empire-building. But at a time when picture postcards of U.S. lynchings still circulated widely as a form of popular entertainment, despite being officially banned in 1908, the very ubiquity of such images in the U.S. public sphere meant that Hearst's and others' efforts to use them to promote intervention in Mexico were vulnerable to alternate visions of "American horrors" such as Briggs's.

In response to such imperialist forms of sensationalism, Briggs encouraged his audience to repudiate "the white plutes' war of aggression on Mexican soil, oil, and national rights," especially since Mexicans "seem quite able to live together without engaging in race wars, mob violence and the fiendish torture of human beings, which are so freely and heartily indulged in on this side of the Rio Grande," as he put it in another editorial, "Gathering War Clouds." Here and elsewhere, Briggs also objected that black soldiers were always sent in to fight the Mexicans and predicted that "in a war of aggression against Mexico," the "American Negro will without a doubt be called upon to shoulder his share of the white man's burden of keeping colored races in their place!" He urged readers not to fight in such a war, but "rather to fill the prisons and dungeons of the white man (or to face his firing squads) than to shoulder arms against other members of the darker races."[45] In editorials such as these, Briggs's vision of mixed-race Mexico as an alternative to the white-supremacist United States recalls Dougherty's picture of Santo Amalia in "Punta, Revolutionist," while Briggs's mocking analysis of Hearst's sensationalism in behalf of U.S. intervention in Mexico resonates with Dougherty's critique of sensationalism in the service of white empire-building during the Spanish-American War era in his sensational novel.

Although Briggs and Dougherty offered trenchant critiques of the narratives of race, empire, and internationalism that circulated in mass-circulation daily newspapers such as those of Hearst, and although Briggs worried over Garvey's sensational appeal, the *Crusader*'s efforts to imagine a sensational counter-sensationalism also involved forgetting as well as re-membering and reproduced some of the problems identified by Briggs in his analysis of Garvey's and Hearst's appeals to mass audiences. In "Punta, Revolutionist," for instance, the cadre of revolutionists follows a charismatic leader who is the mastermind of the black revolution, even though

Briggs argued that Garvey's spectacular attempts to focus the UNIA on his own person and to control the movement were dangerous and anti-democratic. The secret machinations of Dougherty's revolutionists and Briggs's ABB also both threaten to reproduce those antidemocratic tendencies. Since Dougherty's Punta is a wealthy colonial aristocrat, while Garvey was a working-class migrant, Dougherty's novel even arguably reinforces some forms of hierarchy, such as class, more than the UNIA did with its celebration of black property-owning and black capitalism. There is also a fuzziness about Dougherty's representations of the Caribbean and the fictional island of Santo Amalia that recalls Harrison's and Briggs's charges that Garvey knew almost nothing about Africa. Finally, Dougherty's sensational vision of a "near future" black world revolution leaves intact the middle-class, patriarchal ideals of gender and sexuality that were central to the uplift movement, much as Marcus Garvey appealed to such regulatory ideals in his vision of the UNIA's future in Africa and despite the ways Amy Ashwood, Amy Jacques, and Garvey himself departed from them.

Like the *Crusader* magazine writers, Hubert Harrison also made ambivalent appeals to the black masses and tried to imagine a sensational counter-sensationalism, but in doing so he pushed back against the boundaries of bourgeois norms of sexuality, morality, and uplift more than most of his contemporaries did. Like Briggs, Harrison also criticized Hearst's imperialist and Garvey's Afrocentric sensationalisms. Rather than writing sensational fiction or organizing a secret society, however, Harrison worked for a variety of movements as a teacher, speaker, writer, and editor at the same time that he compiled dozens of scrapbooks in which he critically analyzed different forms of sensationalism and struggled to invent different ways of appealing to the black masses through modern media and popular culture. In doing so, Harrison was a significant archivist of black transnational modernity and an important early-twentieth-century theorist and historian of race, modern media, and visual culture. His scrapbooks bring this into sharp focus, as Harrison excavates a variety of sources, from rare black periodicals to mass-circulation daily newspapers, in order to imagine alternative histories of black transnational modernity, respond to sensational white-supremacist and imperialist uses of modern media, trace connections between the United States and the world, and envision an internationalism other than Woodrow Wilson's or Marcus Garvey's.

6 Archiving Black Transnational Modernity

SCRAPBOOKS, STEREOPTICONS, AND SOCIAL MOVEMENTS

[Then I had to leave for] the Renaissance Casino, where the Virgin Islands' Congressional Council was giving its dance and where I was engaged to speak in explanation of the stereopticon pictures of Africa and the Virgin Islands which preceded the dance—whereof I got $10 from Mr. Holstein, president of the Council. . . . The dance is degenerating more and more into a tribade's annual: for about a third or more of the dancers on the floor are made up of female couples.

—HUBERT H. HARRISON, DIARY, NOVEMBER 1926

During the 1920s, Hubert H. Harrison had good reason to mention the Renaissance Casino several times in the diary that he kept from 1907 until his death, in 1927.[1] Designed in the early 1920s and built by Caribbean immigrant businessmen who supported the UNIA, the Renaissance was a Harlem complex comprised of a theater, ballroom, shops, a pool parlor, and a Chinese restaurant.[2] Soon after it opened, the ballroom became a popular venue for mass meetings, dances, parties, basketball games, and prize fights, while the theater featured silent movies and vaudeville performances. In May 1924 Harrison wrote about attending "the first mass-meeting of the recently formed West Indian Association" at the casino, and in November 1926 he reported that when the Virgin Islands' Congressional Council held a dance there, he was paid ten dollars to "speak in explanation of the stereopticon pictures of Africa and the Virgin Islands which preceded the dance."

The stereopticon was a slide projector or "magic lantern" with two lenses that created a dissolve between images. Stereopticon displays, usually accompanied by a lecturer's narrative, were a form of popular instruction and entertainment that had flourished since the 1850s and that persisted even as moving pictures began to replace them.[3] Although we will never know exactly what Harrison said during the narration that accompanied the stereopticon slides, the dozens of scrapbooks that he created during the first three decades of the twentieth century, which contain scores of clippings about Africa and the Virgin Islands, probably inspired some of his remarks.

In his scrapbooks, Harrison juxtaposes and layers ephemera, newspaper stories, photographs, cartoons, and advertisements from different times and places in order to revise and comment on narratives of race, empire, and internationalism in official histories, glossy mass-circulation magazines, the daily newspapers of the big cities, the black press, radical periodicals, and other sources. The tickets, promotional circulars, dance programs, broadsides, newspaper clippings, and other items that he pasted over the pages of periodicals such as *Hearst's Magazine* and *Literary Digest* document his life as an organizer and participant in some of the "great world-movements" of his time, including free thought, the Socialist Party, the IWW, and the UNIA. In these scrapbooks, using clippings and ephemera and making frequent annotations, Harrison creates stories about his life in these movements; narratives about modern science and technology and about many different parts of the world, including Africa, the Caribbean, Central America, and Mexico; alternative histories of the "Negro-American" in the Civil War, Reconstruction, and the First World War eras; critical views of the "White Man at Home" and modern race science; and interventions into contemporaneous debates over imperialism and internationalism as well as black world movements, spaces, and imagined futures.

Harrison was part of what Michelle Stephens calls a "specifically transnational formation of intellectuals" in early-twentieth-century Harlem, a generation of "Black male subjects from the English-speaking Caribbean" who "attempted to chart a course for the race somewhere in the interstices of empire, nation, and state," advocating a "paradoxical mixture of nationalism and internationalism" as they "searched for ways to represent a multiply national global Black community."[4] Although Stephens does not mention Harrison in *Black Empire: The Masculine Global Imaginary of*

Caribbean Intellectuals in the United States, 1914–1962 (2005), and although Harrison makes only a brief, if memorable, appearance in Brent Hayes Edwards's remarkable book *The Practice of Diaspora: Literature, Translation, and the Rise of Black Internationalism* (2003), Harrison was a major shaper, producer, and organizer of the cultures of black internationalism in the 1910s and 1920s.[5] While he does not figure in Cedric Robinson's *Black Marxism* (1983), he was also a key contributor to the black radical tradition that Robinson traces from the "Black rebellions of the previous century" to the "first articulations of a world revolutionary Black theory" in the early twentieth century, through the work of W. E. B. Du Bois, C. L. R. James, and Richard Wright.[6] Now that Jeffrey Perry has published, as editor, *A Hubert Harrison Reader* (2001), a wide-ranging collection of Harrison's writings, as well as the biography *Hubert Harrison: The Voice of Harlem Radicalism, 1883–1918* (2009), Harrison's contributions to many of the major political, cultural, and literary movements of his time are easier to comprehend, since Perry reproduces many of Harrison's most important writings in his anthology and also draws on an extensive archive of Harrison's papers, including correspondence, manuscripts, documents, newspaper clippings, diaries, scrapbooks, memorabilia, photographs, and books. I also draw on Harrison's wide-ranging body of work, but I focus especially on his scrapbooks as "memory books" that create alternative narratives of black internationalism, black history, and black futures as well as an autobiographical story of his own life in movement(s). These scrapbooks, like Harrison's engagement at the Renaissance Casino speaking in explanation of stereopticon slides, reveal how promoters of "world movements for social betterment" used modern forms of media, visual culture, and popular entertainment in ways that sometimes challenged, confused, or even refused the boundaries of normative, middle-class, racial-uplift projects in the wake of the First World War.[7]

In the United States, black elites' emphasis on uplifting the masses in the wake of Emancipation, as Kevin Gaines has shown, often involved distinguishing themselves from the black majority as agents of civilization, thereby supporting a politics of respectability based on bourgeois conceptions of class, sexuality, and gender. Gaines explains that the meaning of uplift was contested and that there was a "historical tension" between a "broader vision" of uplift as "collective social aspiration, advancement, and struggle" and a narrower vision of "a racialized elite identity claiming Negro improvement through class stratification as race progress, which

entailed an attenuated conception of bourgeois qualifications for rights and citizenship." In Gaines's *Uplifting the Race*, Harrison emerges as a key figure who significantly challenged the parameters of this narrower vision of uplift, in which black elites "sought to rehabilitate the race's image by embodying respectability, enacted through an ethos of service to the masses." Instead, Gaines suggests, Harrison redefined "uplift as agitation" and was part of a generation of black intellectuals who were more willing to "represent the masses instead of dissociating themselves from them" and who espoused "more internationalist and radical views."[8]

I build on Kevin Gaines's and Jeffrey Perry's work by focusing on how Harrison ambivalently engaged ideologies of racial uplift as he sought to align himself with the black masses. He did so partly, I suggest, by using modern forms of media and popular culture in his efforts to build black world movements. But Harrison also feared the growing dominance of what he defined in 1919, in the wake of First World War propaganda, the clampdown on radical newspapers and organizations, and the popularity among whites of lynching and the revived Ku Klux Klan, as a kind of media sensationalism that involved not only the "pampering of diseased imaginations" but also "the pandering to a disordered social conscience." Whenever "justice and truth, the sense of rectitude and fair-play are sacrificed by any section of the press upon the altar of popular approval," Harrison wrote in an introduction to a book he never published, "I reckon it a loss to true democracy and a triumph for sensationalism," in which "facts" are "suppressed, distorted, falsified" by the "public press" in order to attack those "who are allied to unpopular causes," including "socialists, suffragettes, vivisectionists, and pacifists," but especially the most "unpopular race," the "American Negro."[9]

Harrison used the word *sensational* to characterize white newspapers that "feature[d] the Negro only in his lower, or police court aspects," as he suggested in a newspaper article called "The Newspaper and Social Service" (1924).[10] In a piece entitled "The Negro and the Newspapers" (1911), which Harrison reprinted in his book *The Negro and the Nation* (1919), he cited the "eminent Negro socialist" R. R. Wright Jr.'s essay in *McGirt's*, an illustrated race monthly published in Philadelphia, which exposed how "headlines and other newspaper devices" were deployed in modern media, as he accused the "newspapers of this country" of featuring "our criminals in bold headlines" while our "substantial men, when noticed at all, are relegated to the agate type division." On the other hand, Harrison

also deplored the "intensive propaganda" of Marcus Garvey, which he described as emphasizing "sensationalism, self-glorification, and African liberation—although [Garvey] knew next to nothing of Africa." While white newspapers pandered to a "disordered social conscience" by suppressing, distorting, and falsifying facts about black people, Harrison charged, Garvey encouraged ignorance about Africa by making "wild statements about its '400 millions' [that] could not be disproved in New York," which meant that this aspect of his appeal "was a money-getter always."[11] In both cases, Harrison identified sensationalism with the misuse of modern media and with deceptive appeals to the very "masses" of people that he himself hoped to represent and teach through his organizing, speeches, writing, and newspaper editing.

Harrison was also ambivalent about the bourgeois morality that was entangled with ideologies of middle-class uplift, which Gaines characterizes as "repressive," because of its association of "racial integrity, pan-African cultural nationalism, and respectability with patriarchal control, and, by implication, equating deviance or pathology with Black female sexuality."[12] As a young man, he was very interested in anarchism and free thought, both of which were associated with alternative forms of sexuality and community that exceeded the boundaries of middle-class domesticity and usually involved a critique of marriage. Harrison's break with Christianity and his interest in science also probably encouraged him to question middle-class uplift ideals. By 1917, he was offering a Sunday-evening lecture series entitled *Sex* at Lafayette Hall that included lectures on "The Sexual Appeal of Spiritualism and Some Other Religions," "Marriage Versus Free Love," and on the question of whether "we are Monogamists by Nature." And just a little later, he delivered yet another series of lectures called *Sex and Sex Problems* at the Cosmopolitan Club of Chiropractic on such topics as "The Mechanics of Sex," "Analysis of the Sex Impulse," and "Sex and Race." Although no notes or transcripts of these lectures survive, the titles and topics suggest that Harrison was challenging the boundaries of middle-class propriety by explicitly discussing sex in ways that contravened normative uplift's promotion of "fidelity to marriage and family ideals."[13]

Along with his interest in free thought and modern science, Harrison's own financial difficulties and their effects on his family life may have also have made the boundaries and limits of the ideal of the patriarchal family and middle-class domesticity more apparent to him. He was pushed out of

a good post-office job as a result of the pressure of the Tuskegee machine after writing a letter to the editor of the *New York World* in 1910, in which he criticized Booker T. Washington, who had told Europeans during a recent trip that the United States offered "the Negro a better chance than almost any country in the world."[14] For the rest of his life, Harrison struggled to make a living and had trouble supporting his wife and children. What is more, Harrison and his wife did not always get along, so he lived apart from his family much of the time and therefore did not perform the bourgeois domestic respectability that was a key component of middle-class ideologies of uplift and patriarchal control, though he continued to play an active role in the lives of his children and was a caring and attentive parent.[15]

Harrison's extrafamilial social life and his involvement in a radical urban subculture with transnational dimensions sometimes resulted in a certain errancy from bourgeois norms of gender and sexuality as well as an intimacy, at times anxious and at other times joyful, with other kinds of social arrangements and communities. At the dance given by the Virgin Islands' Congressional Council that accompanied his stereopticon lecture, for instance, he observed that "about a third or more of the dancers on the floor" were made up of "female couples," and he asserted that "the homo-sexual tendency is very strongly pronounced among Virgin Island women."[16] Although in this case Harrison resorts to a rhetoric of sexual pathology to describe the dance as "degenerating more and more into a tribade's annual," this example also reveals how modern forms and spaces of popular entertainment that existed beyond the supervision of the middle-class, patriarchal family helped mobilize people to participate in movements such as the Congressional Council.[17] Harrison's diary, moreover, memorializes many everyday encounters with women who desired other women, such as a church organist that he had "the good fortune" to run into coming up from the subway, who had "formed an exclusive homosexual relation with Miss Conrad, the singer, with whom she 'kept house,' at this time," or the two sisters Harrison affectionately referred to as "queer," who shared a horror of babies and men and "an excessive love of cats." And when Harrison attended his first drag ball at the Renaissance Casino, where he encountered large numbers of "homosexual men, white and negro, gorgeously disguised as women," he not only danced and flirted with many of them but also acted as one of three judges who awarded cash prizes for the three most beautiful costumes. Harrison found

this experience "glorious, intoxicating!" and called the drag ball "one of the most delightful evenings" ever.[18] Harrison's delight in the drag ball complicates Shane Vogel's claim in *The Scene of Harlem Cabaret* that Harrison was simply disgusted by "the unfortunate and distasteful sensationalism of Harlem's nightlife."[19] Although in an article on "The Cabaret School of Negro Literature and Art" (1927), Harrison argued that white people "fixated" on the idea that the "Negro . . . existed to furnish entertainment to others" and that as a result "nine-tenths of Negro life" was still "unrepresented," his writing and activism, like that of other authors in Vogel's book, also "consciously marked and enacted a radical break from and rebellion against the politics of normative racial uplift" (5).[20] Harrison's archive, especially his scrapbooks and diaries, provides a unique window onto early-twentieth-century debates over uplift, empire, internationalism, and black world movements in the wake of the First World War.

LOCAL HORRORS, GLOBAL STORIES

In one of the dozens of scrapbooks he created between 1903 and 1927, Harrison pasted clippings of political cartoons and photographs connecting the East St. Louis white riots in 1917 and the lynchings in Tennessee to a global story: the First World War and President Woodrow Wilson's promise to make the world safe for democracy. On one side, in a *Chicago Defender* cartoon, a black mother framed by terrified children implores Wilson to extend that promise to the United States, while in the background smoke rises ominously over a city, identified as East St. Louis, where crowds of small, indistinct figures battle (see figure 66). Underneath that image, a *New York Evening Post* line illustration also connects the battlefields of Europe to East St. Louis by depicting two bodies felled by mobs on a street corner, captioned by the exclamation "Speaking of Atrocities—!" On the facing page in the scrapbook, the bottom image, also from the *Chicago Defender*, exposes a "pitiful scene," a photograph of a black family fleeing the "white savages" of East St. Louis. On top of this image Harrison inserted another *Chicago Defender* photograph, of the "Ruins of the Broadway Theater," showing the rubble that remained after whites set it on fire as part of an attack on black refugees who had "barricaded themselves" within it "in a desperate attempt to save their lives." Pasted over that is a 1918 *New York Evening Post* cartoon of an angry Uncle Sam pointing insistently to a background scene, labeled "Tennessee," in which a black figure is lynched by a mob, while the caption reads "Over here!" and calls atten-

FIGURE 66 "Mr. President, Why Not Make America Safe for Democracy?" In Hubert H. Harrison's scrapbook "The Negro American: Lynching." Courtesy of the Hubert H. Harrison Papers, Rare Book and Manuscript Library, Butler Library, Columbia University, New York.

tion to two men who were "burned at the stake." By layering these images on top of each other and juxtaposing them in a scrapbook entitled "The Negro American, Volume II, Lynching," Harrison created and preserved a counter-archive from the black press and other popular publications of the era that juxtaposes visual evidence and critical commentary to connect the horrors of lynching and white mob violence within the United States to the atrocities and violence of world war, and to insist on the hypocrisy of President Wilson's internationalism if there was no justice for black people around the world.

The ten surviving scrapbooks in Harrison's "Negro American" series, of which the "Lynching" scrapbook comprises a part, are perhaps the remains of a project Harrison referred to in a 1907 diary entry as a "history of the Negro in America" that he wished to write and to which he planned to devote twenty years of labor. In the face of "great ignorance on the part of American whites" about "what the Negro was and is in this country," Harrison declared, as well as what he called the "deplorable ignorance of themselves evinced by the great majority of Negroes here," the idea of producing a "work" which would "make it impossible for a white historian not to know—and dangerous to misrepresent the Negro historically" made a "strong appeal" to him. For more than twenty years, Harrison collected images and clippings that illustrated the wide range of categories he viewed as relevant to "Negro-American" life, then pasted them into scrapbooks. Harrison never followed through on his 1907 plans to "throw off" what he called "incidental works" of history based on these scrapbooks, beginning with a volume on Reconstruction regarded "from the Negro's side," although in 1908, according to Perry, he gave his Reconstruction notebooks to Du Bois, who probably consulted them when he wrote *Black Reconstruction in America* (1935).[21] Harrison himself mined the documentary evidence collected in these scrapbooks when he outlined lectures and wrote newspaper editorials, articles, reviews, and books. But Harrison's scrapbooks are important memory texts in their own right, for they offer alternative views of black transnational life and of white supremacy, empire, and Woodrow Wilson's internationalism as world problems. Like Du Bois's work in producing and organizing photographs for the American Negro Exhibit at the 1900 Paris Exposition, in creating the scrapbooks Harrison became, in Shawn Michelle Smith's words, the creator of a counter-archive, a "framer and organizer" of images, "an assembler of already prepared parts, making meaning by choosing and placing and past-

ing images in relation to one another" in a way that "constructs the knowledge it would seem only to register or make evident."[22]

Often, Harrison illustrated these alternative views and new forms of knowledge with photographs, drawings, and cartoons. Variations on the middle-class portrait dominate a scrapbook in the "Negro-American" series entitled "Pictures," in which Harrison collected images of black achievers such as Matthew Henson, the navigator, Inuit speaker, and proficient dogsled driver who accompanied Robert Peary on several Arctic expeditions, including the famous one that reached the North Pole in 1909. In 1912 Henson published a book entitled *The Negro Explorer at the North Pole* that included a foreword by Peary and an introduction by Booker T. Washington. Henson, who was himself a photographer, illustrated the book with several photographs, including one that reappears in Harrison's scrapbook shorn of its original caption, which refers to Henson's return to "civilization." Instead, the image Harrison preserved is labeled "The Negro Who Reached the Pole," followed by a quote from Peary, who is not identified as the speaker: "Probably a better dog driver than any other man living, except some of the best Eskimo hunters themselves" (see figure 67). While the photograph's caption in Henson's book repeats the racialist language of "civilization" in order to make a place for the "negro explorer" within its boundaries, the one collected by Harrison emphasizes black achievements that are inspired by "Eskimo" skills, not the place of blacks within a white "civilization" defined in opposition to the savagery of nonwhites.

Harrison also cut out and preserved from a range of newspapers and magazines many other photographs and drawings of "eminent" black men, including the *Amsterdam News* founder and managing editor James H. Anderson; the musical composer J. Rosamond Johnson, who wrote the music for the "Negro national anthem," "Lift Every Voice and Sing"; the world champion boxer Jack Johnson; the "great Russo-African poet" Alexander Pushkin; and the poet Claude McKay with Max Eastman in Russia in 1923. And pasted onto many of the same pages that featured portraits and other images of black men, Harrison also collected images of black women, such as Aida Overton-Walker, the renowned beauty, dancer, and vaudeville actress who married George Walker and performed with him and his partner Bert Williams; Miss N. H. Burroughs, a prominent Baptist educator; and Amy Jacques Garvey, who would later become Marcus Garvey's second wife and who is identified as "Miss Amy Jacques," Garvey's "private secretary," in the picture Harrison clipped from a newspaper or maga

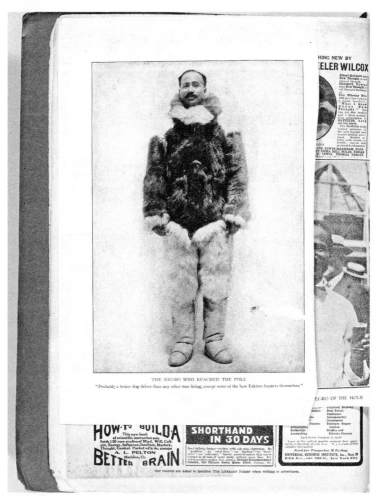

FIGURE 67 "The Negro Who Reached the Pole." In Hubert H. Harrison's scrapbook "The Negro American: Pictures." Courtesy of the Hubert H. Harrison Papers, Rare Book and Manuscript Library, Butler Library, Columbia University, New York.

zine and in which she wears a string of pearls and holds a bouquet of flowers that help to signify her status as a refined and respectable woman (see figure 68). Many of these photographs and drawings of black men and women, like W. E. B. Du Bois's photographs, "signify on," as Smith puts it, "the sentimental and commodified forms of the middle-class portrait to contest the conflation of African Americans under the visual signs of criminality or biological inferiority."[23] However, Harrison includes a wider range of types of people in his scrapbooks, notably including vaudeville

FIGURE 68 "Miss Amy Jacques." In Hubert H. Harrison's scrapbook "The Negro American: Pictures." Courtesy of the Hubert H. Harrison Papers, Rare Book and Manuscript Library, Butler Library, Columbia University, New York.

performers, actors, musicians, and radicals, which expands his collection of types beyond the boundaries of the respectable middle class and into the world of popular entertainment and radical politics.

While portraits of prominent individuals are more uncommon in the other volumes of Harrison's "Negro American" series, he often used photographs, drawings, and cartoons clipped from newspapers and magazines as illustrations in larger narratives, as he does in the "Lynching" scrapbook's montage of clippings linking East St. Louis, Tennessee, and

the world war. But what Harrison chose not to preserve in the "Lynching" and other "Negro-American" scrapbooks is also revealing: there are no gruesome photographs of black corpses like those that circulated in lynching postcards of the era.[24] Instead, the photographs Harrison clipped from the *Chicago Defender* depict the aftermath of the violence in East St. Louis rather than its immediate, brutal effects on the bodies of those who were killed and injured. The "Ruins of the Broadway Theater" photograph (see figure 69) suggests the devastating effects of white violence by focusing on the broken fragments of brick walls and other rubble that remained after the building was set afire by the white mob. The caption narrates how blacks resisted the mob and fought back, and how some blacks escaped and many whites were killed, rather than foregrounding the body of a black victim, as lynching postcards did. The other *Chicago Defender* photograph in the montage also emphasizes black resistance and survival even as it isolates a "pitiful scene" of a refugee family fleeing the white riot by crossing the bridge into St. Louis (see figure 70). Although the caption tells us that one of the children was struck in the head by a stone and another was stripped of some of his clothing, the photograph centers the determined father, in workman's overalls, who was forced to "fight to protect his home from white savages," and, a few steps behind him, the mother, who "carries another half-naked" child.

The drawing and political cartoons that Harrison inserted into this scrapbook montage similarly avoid showing devastated black bodies in realistic detail: instead, the bodies suffering violence are tiny and indistinct, almost hidden in the background, or else shadowy and vaguely drawn. At a time when photographs of the devastated bodies of lynching victims were circulating as commodities and forms of popular entertainment, perhaps Harrison's preference for other kinds of images suggests his doubts about whether making black suffering visible through "realistic" forms of visual representation could provoke true change. In an essay called "The Black Man's Burden," which was published in the *International Socialist Review* in 1912, Harrison observed that after lynchings at "Durant, Oklahoma and elsewhere, the savages have posed around their victim to have their pictures taken" and that a man in Alabama had mailed a postcard to the Reverend John Hayne Holmes of Brooklyn, New York, "bearing a photograph of such a group," along with the inscription "This is the way we treat them down here" and a promise to send one such postcard a month in the future.[25] Such an observation helps clarify why Harrison

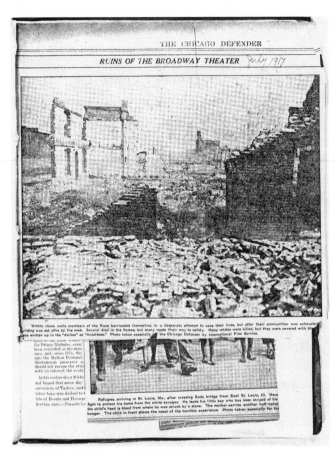

RUINS OF THE BROADWAY THEATER July 1917

Within these walls members of the Race barricaded themselves in a desperate attempt to save their lives, but after their ammunition was exhausted, building was set afire by the mob. Several died in the flames, but many made their way to safety. Many whites were killed, but they were covered with blankets written up in the "dailies" as "mulattoes." Photo taken especially for the Chicago Defender by International Film Service.

Refugees arriving in St. Louis, Mo., after crossing Eads bridge from East St. Louis, Ill. Here a fight to protect his home from the white savages. He leads his little boy who has been striped of his the child's head is blood from where he was struck by a stone. The mother carries another half-naked hunger. The child in front shows the result of the horrible experience. Photo taken especially for the

FIGURE 69 "Ruins of the Broadway Theater." In Hubert H. Harrison's scrapbook "The Negro American: Lynching." Courtesy of the Hubert H. Harrison Papers, Rare Book and Manuscript Library, Butler Library, Columbia University, New York.

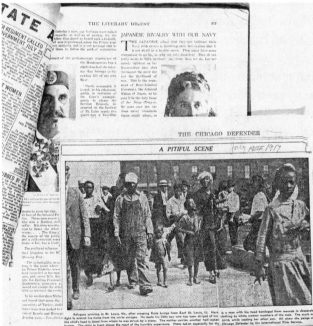

FIGURE 70 "A Pitiful Scene." In Hubert H. Harrison's scrapbook "The Negro American: Lynching." Courtesy of the Hubert H. Harrison Papers, Rare Book and Manuscript Library, Butler Library, Columbia University, New York.

apparently decided that the tactic of representing black bodies in pain in order to move people to act to make lynching a federal crime was a losing strategy.[26] On the other hand, in the two political cartoons in this montage Woodrow Wilson and Uncle Sam loom large; they dominate the frame and draw the eye of the viewer. Wilson's stated goal of making the world safe for democracy is emphasized by the piece of paper in his large hand, while an outraged Uncle Sam is the biggest figure in the *New York Evening Post* cartoon. The white president and the white Yankee, both symbols of the nation, are caricatured as they are brought into the ambit of the cartoonists' appeal to a mass audience to recognize these scenes as atrocities like those the world war was ostensibly fought in order to prevent.[27]

If Harrison rejects the strategy of offering images of black bodies in pain as visual evidence of white violence and black suffering, he provides other kinds of evidence by turning the gaze on whites, as he does when he incorporates political cartoons depicting Wilson and the iconic Yankee into his lynching montage. Harrison was especially distressed by Gompers's response to the riot, in which the "white mob," as the New York newspapers Harrison collected put it, expressed an "avowed determination to rid the city of negroes imported to work in factories and munitions plants." Harrison also preserved a newspaper story in which appeared, set in bold type, as a headline, Gompers's statement blaming the white riot on "employers" and calling the "war" in East St. Louis "real democracy in America."

Other clippings focus on white violence and lawlessness as well as black protests of lynching or further emphasize the connections between the United States and the world. A *Chicago Defender* cartoon preserved by Harrison, for instance, visually connects "the brother over there," sacrificing his body in Europe to the "sister" whose services were rejected by the Red Cross, as well as the "brother over here," represented by a dark, vaguely drawn, lynched body in a burned zone identified by signs that say "the South" and "No man's land," as well as broken boards on which the words "humanity," "justice," "law," and "order" are inscribed (see figure 71). In other volumes of this scrapbook series as well, Harrison selected fragments and images from newspapers and magazines in order to construct narratives of "Negro American" life that connect the domestic to the foreign, understand race as a world problem, and turn a critical gaze on white mobs, leaders, and national symbols rather than circulating more images of black bodies in pain. Although he did not author a singular "work" of history, in the "Negro American" series and in his lectures, writ-

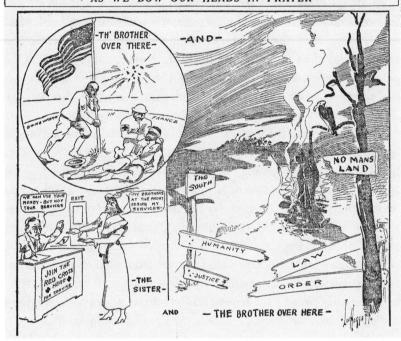

FIGURE 71 "As We Bow Our Heads in Prayer." Cartoon from the *Chicago Defender*, March 23, 1918, in Hubert H. Harrison's scrapbook "Negro American: Lynching." Courtesy of the Hubert H. Harrison Papers, Rare Book and Manuscript Library, Butler Library, Columbia University, New York.

ings, and scrapbooks more generally, Harrison schooled the white historians by presenting a wide range of forms of black personhood and collective life and by arguing against dominant interpretations of the legacies of the Civil War and Reconstruction and the significance of the First World War and the new empire.

ALTERNATE HISTORIES AND NEAR FUTURES

In his scrapbooks, Harrison juxtaposes different moments rather than subordinating all of the images and stories to a linear temporality. The scrapbooks move backward and forward in time, beginning with the "human origins" and "culture history" sections of the "Archeology" volume, where

Harrison disputes white-supremacist race science, and looking ahead to the future in the "Science and Miscellaneous" volume, which contains an array of clippings on new media such as radio and television. Harrison was keenly interested in modern science and new inventions, such as the Photomaton, a "quarter in the slot automatic photographing device" invented by a socialist, which the *New York Times* reported, in a clipping preserved by Harrison, was intended to make "personal photography easily and cheaply available to the masses" and which was immediately popular, as crowds "stood in line to put the quarter in the machine and take a strip of eight sepia photographs of themselves" (see figure 72). He also preserved stories about early television transmission, such as a *New York Times* clipping from 1927 that compared Herbert Hoover's face to a "photo come to life," his face "plainly imaged" as he spoke in Washington, and for the "first time in history," "pictures" were "flashed by wire and radio synchronizing with [the] speaker's voice."[28]

As Harrison looked backward to the past and ahead to the future, he also made connections between the past and present. Revising dominant histories of the Civil War and Reconstruction was of particular concern to him. In his public lectures and writings on Abraham Lincoln, he used Lincoln's "own words," which were "most damning to the Lincoln myth," to prove that Lincoln was "not an abolitionist," "that he had no special love for Negroes," that he "opposed citizenship for Negroes," that "he denied officially that the war was fought to free the slaves." He also insisted that the "Emancipation proclamation did not abolish slavery and was not intended to," that "the war was fought for economic and not for moral reasons," and that the Republican Party opposed abolitionist doctrines and offered to "sell out the Negro" in 1861. All this was offered as evidence of why black people of Harrison's own era should not remain loyal to the Republican Party out of a misplaced sense of gratitude.[29] In a lecture called "Lincoln and Liberty: Fact and Fiction" that he delivered in Liberty Hall before the UNIA in 1920, Harrison declared that the "burden of gratitude alone keeps us from using our own political power solely in our own behalf" as he warned his listeners of the dangers of "falsifying the Records of the Past" in the "interests" of the "Present" through "historical myths of America" and the "purity of the fathers."[30] And in 1923, in a public debate with a Klansman that was covered in the *Paterson Morning Call*, which he clipped and inserted into another scrapbook, Harrison repeated the claim that Lincoln did not free the slaves and that "emancipation was no more

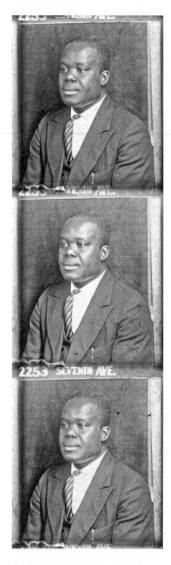

FIGURE 72 Hubert H. Harrison (Photomaton images). Courtesy of the Hubert H. Harrison Papers, Rare Book and Manuscript Library, Butler Library, Columbia University, New York.

than a war measure," as he regretted that Americans "do not know more of the history of their own country than they do," a fact which makes them "the dupes of all kinds of boobs that come along with pretentious versions of the past with which to kid us."[31]

If Harrison's scrapbooks crossed temporal boundaries and juxtaposed different moments in time in response to the present, they similarly traversed national boundaries to situate black history in a global frame by focusing on places other than the United States, such as Mexico, China,

MEXICAN ANTI-NEGRO PROPAGANDA STARTED

White Oil Interests Active in Keeping Negro Out of Mexico. *Courier* 20-11-26

LOS ANGELES, Cal., Nov. 18.—(By A. N. P.)—The latest propaganda attempt to discourage the Black-American farmer of the South from endeavoring to colonize or enter Mexico is a report magnified far beyond its significance, being circulated through the white press of the recent refusal of Adolfo Miranda, Immigration chief at Mexico, Lower California, Mexico to permit a criminal class of American Negroes to cross the line from the United States without special passports.

Refers to Order of Aug. 1924

According to Miranda he is acting under instructions in accordance with Federal regulations issued in August, 1924, to prevent the criminal classes from escaping from the United States border towns into Mexico. His recent order according to the circulated report, requires Negroes to carry special passports, and they will be allowed to cross the line only between the hours of 12 o'clock noon and 9 p. m. and will not be permitted to remain overnight.

Does Not Effect Reputable Negroes

The order is for the criminal class of all races which infest the border American cities and has no bearing whatsoever as the press reports intimate, that reputable Black American farmers or citizens who desire to colonize or travel in Mexico are to be prohibited entry into that country.

The opposition to the Black Americans entry into Mexico for colonization purposes is opposed only by white foreign and American oil interests who started active anti-Negro propaganda several years ago following entry of a colony of Oklahoma Negroes to the oil districts around Tampico and San Luis Potosi.

In July, 1922, Pres. Obregon met a delegation of colored citizens from the United States, headed by Attorney Hugh MacBeth of Los Angeles, and stated in person to them "That Mexico has no color line and the Mexican Constitution forbids Race discrimination on the grounds of race, color, creed or degree of wealth."

At Ensenada, Mexico, the Mayor in addressing the delegation said, "Mexico offers the greatest opportunity and future to any people on the face of the earth. We are inviting the American Negro to come and to cast his lot with us, not because we know that he is mistreated and unjustly dealt with in his own land, but because we believe that in the development of commerce, agriculture and trade in our own country, he will be fair enough to take some and leave some and not try to take all as some Americans have done in the past."

Favor Only Desirable Element

Only industrious type of Black American farmers and business men are desired and this type have no trouble in entering Mexico as evident by the acquisition of 5,000 acres of very valuable farming and mining land in the Santa Clara valley, 200 miles below Los Angeles and adjacent to the thriving Mexican seaport city of Ensenada, owned and farmed by the Lower California Land & Development Co., an all Negro corporation of Los Angeles, and the formation of a $50,000 steamship transportation Negro corporation of California, to handle a shipping business between American and Mexican Pacific ports.

Every week many Black Americans from Los Angeles and San Diego, enter Mexico without the slightest trouble, either for sport, pleasure of permanent abode.

Pittsburgh Courier 20-11-26

Mexico to Bar American Negroes.

Copyright, 1926, by The New York Times Company.
Special Cable to THE NEW YORK TIMES.

MEXICO CITY, Nov. 15.—The Mexican Government, in view of the large number of negroes trying to enter Mexico through Lower California, is planning a new law which will prevent them from entering any part of Mexican territory. 16-11-26

FIGURE 73 Clippings from "Mexico (19 Feb. 1926–24 March 1927)," Folder 4. Courtesy of the Hubert H. Harrison Papers, Rare Book and Manuscript Library, Butler Library, Columbia University, New York.

Africa, and India. Harrison clipped many stories about and images of Mexico, ranging from a glossy and lavishly illustrated *New York Times Magazine* article about revolutionary murals that "glorified Mexican Indian life" to clippings from the *Pittsburgh Courier* about efforts by "white oil interests" to spread "propaganda" in the white press with the aim of keeping "the Black-American farmer of the south" from entering Mexico. Juxtaposed to the *Pittsburgh Courier* piece (see figure 73) is an example of such propaganda, a brief *New York Times* story asserting that the Mexican government was formulating a "new law" to "bar American" negroes from entering any part of Mexico. The *Pittsburgh Courier* clipping included a quotation from the mayor of Ensenada, Mexico, in which he invited "the American Negro to come and cast his lot with us" because "we think he will be fair enough to take some and leave some and not try to take it all as some Americans have done in the past." Harrison also preserved

a *New York Times* book review about democracy and science in the "new Mexico," which commented on José Vasconcelos's and Manuel Gamio's *Aspects of Mexican Civilization*. Other clippings focused on conflicts between Mexican oil workers and federal troops, on Mexico's new Alien Land and Petroleum laws, and on controversies over a pamphlet entitled *Hands Off Mexico!*, probably the one authored by John Kenneth Turner.[32] Harrison was especially interested in race and labor relations in postrevolutionary Mexico, conflicts over oil involving U.S. capitalists, and black migration and settlements in Mexico. In the years before he died, Harrison also closely followed events in China and preserved many clippings about it, including articles, illustrations, and photographs of Sun Yat-sen and his wife, as well as news stories that compared China's struggle to abolish unjust treaties with foreign powers to the American Revolution.

One especially ample scrapbook is "The Negro in Africa and the West Indian," which Harrison filled with many clippings and annotations over more than two decades. In this scrapbook, Harrison emphasized connections among Africans, West Indians, and African Americans by comparing different but overlapping histories of colonialism and imperial administration in Africa and the Americas and by insisting that the U.S. presence in the Virgin Islands, Haiti, Panama, and Cuba, as well as Wilson's internationalism itself, was a part of that history. The scrapbook contains clippings about Harrison's lectures at the Harlem People's Forum on anthropology, sociology, and African society, as well as newspaper stories with such titles as "Zulu Was Most Perfect Man, Says British Surgeon" and "Will Rogers Finds Haiti Ideal because Senatorless." Since Harrison was an immigrant from the Virgin Islands, it is not surprising that he collected many pieces about U.S. rule there.[33] Indeed, he may have consulted this scrapbook when he wrote an essay called "The Virgin Islands: A Colonial Problem" (1923), which was never actually published, for the *Nation* as part of a series entitled *These United States*. In this article, Harrison begins by asserting that the islands "are now a part of our far-flung colonial empire and represent one portion of the 'white man's burden' which our republic has been driven by 'manifest destiny' to assume." Linking Kipling's quote to the racialized expansionist rhetoric of the U.S.-Mexico War era, Harrison emphasized the long history of U.S. empire-building and criticized the "anomalies" that resulted when U.S. Americans, including statesmen, dispensed with the "obligation" to "know something" of the "darker peoples" over whom they assumed sovereignty. Recalling the anti-imperialist irony

of Mark Twain, his favorite American writer, in essays such as "To the Person Sitting in Darkness," Harrison commented, "A captious outsider might be moved to enquire why our nation should take on more of these darker peoples when we find our present freightage too big a burden for our Christianity, democracy, and humanity." Harrison pointed out that the navy administered the Virgin Islands although they had been "peaceably purchased from Denmark," and argued that since the navy had "already achieved such an unsavory reputation in Haiti" and were especially "unruly" when "they have to deal with colored inhabitants," the result is that "'Southernism' runs riot" at the same time that "the doctrine of chromatic inferiors and superiors" is "violently" thrust upon the islanders by "the personnel of the naval administration."[34]

In addition to debates over empire, "The Negro in Africa and the West Indian" scrapbook followed the movements of black people across national boundaries, especially West Indian people's migration to the United States, but also to other parts of the Americas such as Mexico, Panama, and Cuba. One of Harrison's clippings, a 1926 story from an unknown newspaper, is about the Panama Alien Law, which prohibited immigration of "Africans, Chinese, Japanese, Turks, Syrians, East Indians, Dravideans, and negroes of the West Indies and Guiana whose original language is not Spanish." Harrison underlined "negroes of the West Indies," as well as the following statistic: "It is estimated that 50,000 West Indian negroes, 4,000 Chinese and a few hundred Japanese and other excluded races are now resident in Panama." He also marked "auxiliaries," the word that legally exempted employees of the Panama Canal and others of "whatever race" in accordance with existing treaty agreements with the United States. Harrison's interest in black migrants is also visible in scrapbooks on topics organized by logics other than place, such as those on "Migration" and on "Labor and Strikes." In the latter, he grouped together clippings on labor actions both inside and outside the United States, including one story from the *Pittsburgh Courier* about a 1926 strike in the Arizona cotton fields by 561 Puerto Rican laborers—women, men, and children—who had been brought from Cuba by the Cotton Grower's Association of Arizona to "batter down the prevailing starvation labor wage now being paid to the American Negro and Mexican cotton field laborers." After they refused to work "on a piece work basis, at a price less than the rate paid last year," they were "herded into the State fair grounds at Phoenix without proper food or shelter in an attempt to force them into submission."[35]

Harrison viewed such responses, from labor strikes to modern revolutions, as part of a "rising tide of color" in the aftermath of the First World War that he documented in three entire scrapbooks. "The Negro and the War" volume in the "Negro American" series is divided into two sections, "In the U.S." and "Elsewhere," but Harrison's selections emphasize the connections between the two. Stories about black officers assaulted by mobs in the U.S. South are layered on top of each other, as are clippings about the hanging of thirteen members of the black 24th Infantry who mutinied in Houston, Texas, after experiencing segregation and receiving racist treatment from the locals and the police.[36] Here, many of Harrison's pieces of evidence are clipped from black newspapers such as the *Houston Observer*, the *Chicago Defender*, the *New York Age*, and the *Pittsburgh Courier*, and Harrison uses these sources to preserve and synthesize a critical perspective on the world war that was articulated through the black press, one that would not be readily available in mass-circulation papers such as the *New York Times* or the *New York Sun*.

The "America Enters the War (1917)" and "Aftermath of the Great War (1918–1919)" scrapbooks, on the other hand, are more frequently illustrated by articles and images from larger, more capitalized big-city dailies ranging from the relatively staid and conservative *New York Times*, *Philadelphia Public Ledger*, *Washington Post*, and *New York Tribune* to the sensational *New York Journal* owned by Hearst. Several pages compare the United States to Germany, sometimes through visual narratives such as a *Washington Post* cartoon of a German military officer walking a tightrope over "Internal Troubles. The caption with its quotation "This Is No Time for Loose Talk!" refers to the German chancellor who would be forced to resign just two months later as a result of the combined pressures of the majority Socialist Party, which had formed a coalition with centrist forces, and the conservative Right.[37] Across the tightrope, on either side of the German's boots, which appear to be about to slip off the rope, Harrison wrote "Exactly true of America." Harrison's annotation of this political cartoon refers both to the ways the United States clamped down on political dissenters during the First World War through laws such as the Espionage and Conspiracy Acts and also to his hope that the kind of "internal troubles" that frustrated imperial projects of national unity in Germany might also prevail and reshape the political landscape in the United States.

Other clippings foreground examples of how the mass media spread what Harrison called war lies. He wrote "Sample of War Lies," for instance,

in the margins of an article from the *New York Tribune* entitled "German Force Concentrates at Torreon" (1917), which reported that large numbers of German soldiers were assembling in Mexico and that the United States was ready to "block Plots." Harrison's annotation appears next to the subtitle "Many Teutons in High Favor with Carranza Officials Now," thereby emphasizing his view, which he supported with several other examples, that such mass-media stories of collaboration between Germany and Mexico were lies, motivated by the goal of building U.S. support for war.[38] Harrison also saved and commented on stories about the clampdowns on radicals and dissenters that took place in 1917. In the margins of a story in Hearst's *New York Journal* which stated that the IWW leader Frederick S. Boyd had been "beaten by diners" after he refused "to rise at the national anthem" and that he was "mauled and thrown out" for cursing America after he was yanked to his feet, Harrison wrote "a flat lie." And in response to the paper's claim that Boyd declared, "To hell with the United States, here's to the King," Harrison added a second annotation: "Funny little liar."[39]

Harrison also constructed scrapbook pages on war censorship, including a clipping, from the socialist *Appeal to Reason*, of a short piece by Jack London called "A Good Soldier" under the headline "Censored by the Postmaster General." This headline refers to the powers of censorship conferred by the Espionage Act of 1917, which made it a crime to convey information with intent to interfere with the operation or success of the armed forces of the United States or to promote the success of its enemies. The Postmaster General barred from the mail envelopes, circulated by the *Appeal to Reason*, that contained "A Good Soldier," which charged that a soldier "never tries to distinguish right from wrong" and "never thinks; never reasons; he only obeys." Harrison's use of this clipping preserves "A Good Soldier" in the face of state efforts to suppress it and in the service of a larger, critical counternarrative about the dissemination of war lies in the media and about Wilson's use of the war to clamp down on the kinds of internal dissent that contributed to the fall of the German chancellor.[40]

While Harrison pasted all of the "America Enters the War" clippings into one scrapbook, "The Aftermath of the Great War, 1918–1919" clippings on the "political" aspects of the war share space with extracts that document "The Rising Tide of Color and 'The Lesser Breeds'" (see figure 74). This juxtaposition suggests that for Harrison these two subjects were inseparable, that the political aftermath of the war, which had been caused

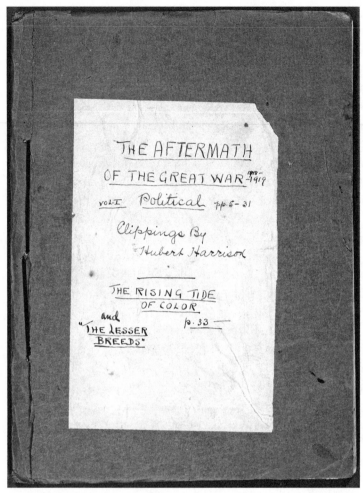

FIGURE 74 "The Aftermath of the Great War: Political" and "The Rising Tide of Color" scrapbook cover. Courtesy of the Hubert H. Harrison Papers, Rare Book and Manuscript Library, Butler Library, Columbia University, New York.

by "the desire of the white governments of Europe to exploit for their own benefit the lands and labor of the darker races," in turn provoked conflicts between "the Black and brown and yellow peoples of the world" and the white world over colonialism, science, international politics, and "the extension of political, social, and industrial democracy." This was in fact one of the main arguments of Harrison's editorial "The White War and the Colored Races," which appeared in 1918 in the *New Negro*, another newspaper that Harrison edited during its brief existence; it was also re-

published in his book *When Africa Awakes*. The articles and images he collected and arranged into mini-narratives in his scrapbooks doubtless shaped his argument that the white race was being "depleted" by the war and that "the colored majority whose preponderant existence our newspapers ignore" would insist on "self-determination" and that "not only the white world, but the whole world, be made 'safe for democracy.'" Harrison not only quoted Wilson's famous words, but also hoped that "freedom from thralldom" and the extension of democracy to the "twelve hundred million Black and brown and yellow peoples of the world" was indeed what "Wilson had in mind" when he championed that ideal. "But whether I am mistaken or not," Harrison concluded, "it is the idea which dominates today the thought of those darker millions."[41]

In this editorial Harrison observed that "in the first great manifesto of the Russian Bolsheviki last year," they "asked about Britain's subject peoples," and the clippings in his "Aftermath" scrapbook document his interest in the Russian Revolution and its implications for the colonized world. Harrison also preserved articles from the *New York Call*, the leading socialist daily newspaper of the period, which opposed the war, was prosecuted under the Espionage Act, and had its second-class mailing privileges revoked until June 1921. On May Day, 1919, the newspaper's offices were wrecked when a large mob of soldiers and sailors appeared, destroyed all the literature in sight, and clubbed many of the workers, sending several to the hospital. Earlier in the decade, Harrison had contributed a series of articles on "The Negro and Socialism" to the paper, and in this scrapbook, despite his disappointment with the Socialist Party, he preserved several clippings from the *New York Call* on the Russian Revolution and on the demand that U.S. troops "Withdraw from Russia." He also inserted stories drawn from the *New York Sun* about police raids on Reds in New York City in 1919 and a full-page advertisement, illustrated by a large photograph of Woodrow Wilson, for his multivolume *History of the American People*, which infamously included an account of Reconstruction that justified the rise of the Ku Klux Klan and was quoted in D. W. Griffith's *Birth of a Nation*. Once again, Wilson looms large as an embodied figure as Harrison turns a critical gaze on Wilson's international policies and creates and preserves narratives that document the violently policed limits of what could be said during the war and the white-supremacist boundaries of Wilson's internationalism.

The title Harrison used for the second part of the scrapbook, "The

Rising Tide of Color and 'The Lesser Breeds,'" refers to Theodore Lothrop Stoddard's best-selling book, *The Rising Tide of Color Against White World-Supremacy* (1920), which Harrison reviewed in *Negro World* just a month after it was published. By this time, Harrison had joined forces with Garvey and was editing the UNIA's weekly paper, which he overhauled by changing its appearance, rewriting copy, contributing editorials, and adding a "Poetry for the People" section as well as a regular book-review column. In his review, Harrison agreed with many of Stoddard's conclusions, though, as he wrote in a letter to Stoddard, "Since I am a Negro, my sympathies are not at all with you: that which you fear, I naturally hope for."[42] Echoing Harrison's "depletion" thesis, Stoddard predicted that "the frightful weakening of the white world during the war opened up revolutionary, even cataclysmic possibilities": Stoddard feared "the menace of fresh white civil wars complicated by the specter of social revolution" and warned that the First World War might be "the first stage in a cycle of ruin" for the white world order.[43] Harrison declared that Stoddard's book "should be widely read by intelligent men of color from Tokio to Tallahasee" and that it proved "the thesis advanced in my brief essay on 'The White War and the Colored Races' . . . that the white race was busy burning up, depleting, and destroying" the "very resources upon which its primacy depended" in a "mad dance of death."[44]

Just a month later, also in the pages of *Negro World*, Harrison responded to the publishing magnate William Randolph Hearst's endorsement of "every word of the warning recently issued by" Stoddard in *The Rising Tide of Color* by insisting that as far back as 1915 Harrison himself had pointed "out to white people that the racial aspect of the war in Europe was easily the most important, despite the fact that no American paper, not even Mr. Hearst's, would present that side of the matter." At the same time, Harrison credited Hearst himself, whom he called "the ablest white publicist in America," albeit one who had not "been famous as a friend of the darker races," with having recognized years earlier that the world war threatened the "quality, physical and mental," of the white race and that the "next generation" of whites would "be less equal to the task of holding down the darker millions than their fathers were." Harrison charged that this "was the thought behind Mr. Hearst's objections to our entering the war." But although Hearst and Stoddard were both defenders of white world supremacy and hoped their warnings would save it, Harrison concluded, "It is thumbs down for the white race in the world's arena, and they

are to be the dealers of their own death blow. Such are the consequences of conquest." Comparing the white world to the "Roman empire in the fourth century of the Christian era," he hoped that "because the white race in trying to settle its own quarrels has called in Black, brown, and yellow to do its fighting for it," the latter "will learn thereby how to fight for themselves even against those they were called in to assist."[45]

The clippings Harrison preserved in this scrapbook, which are mostly drawn from 1925 and 1926 issues of the *New York Times*, the *Chicago Tribune*, and other mass-circulation dailies such as Hearst's paper, also document anticolonial struggles in an inversion and displacement of the paranoid, white-supremacist modality of Stoddard's and Hearst's prophecies. Harrison marked parts of these articles that predicted war "between the white and colored races . . . directed by the Bolsheveki campaign, which will make the fall of the Roman Empire look like a small local affair in the destinies of the white nations." He also underlined passages that fearfully imagined the coalitions that might arise among the world's people of color, such as one warning that "the yellow peoples of the Orient are watching America's treatment of the negro" and that "a lynching in the US makes an echo in Tokio." These citations resonate with passages in Harrison's published editorials and reviews, but while Harrison's sources viewed with great alarm the possibility of postwar coalitions among the world's "colored majority," Harrison hoped that such coalitions might lead to the extension of true "political, social and industrial democracy" to all the world's people.

THE WHITE MAN AT HOME

Although Harrison agreed with Stoddard's main thesis, he advised *Negro World*'s readers that the author remained "an unreconstructed Anglo-Saxon, desirous of opening the eyes of his race to the dangers which beset them through their racial injustice and arrogance; but sternly, resolutely intent that they shall not share their overlordship with any of the other sons of the earth." In other words, like Hearst, Stoddard wanted to open up "the eyes of his race" in order to mount a more effective defense against "the rising tide of color." Harrison's reproduction of the phrase "the lesser breeds" in the title of this scrapbook underlines his quarrel with Stoddard's version of eugenics, which assumed that "Anglo-Saxon" blood was both superior and vulnerable to dilution by the blood of nonwhites. In "The Rising Tide" editorial, Harrison called attention to how white domination

was maintained through science as well as through violence, missionary activities, and the "lies" spun by newspapers and other forms of modern media: "The white race has lied and strutted its way to greatness and prominence over the corpses of other people. It has capitalized, Christianized, and made respectable, 'scientific' and 'natural,' the fact of its dominion." Much of Harrison's work was devoted to debunking modern ideologies of racial Anglo-Saxonism and white supremacy, including those that were supported by race science and promoted by Hearst's emerging media empire, which would soon include twenty-six daily newspapers in eighteen cities, as well as magazines, radio stations, and newsreels. In an essay entitled "Science and Race Prejudice," Harrison accused whites of "putting on the cloak of science" in order to "'put over' their prejudices with greater authority and effect" and advised readers to "produce their own scholars and scientists to the end that they may keep the hands of prejudice from juggling with the weights." One of the main ways the white hands of prejudice juggled with the weights of racial judgment and classification, Harrison suggested, was by using modern media such as newspapers, magazines, radio, and motion pictures to idealize the "dominion" of the "white race," thereby reading "back into history the race relations of today, striving to make the point that previous to its advent on the stage of human history, there was no civilization or culture worthy of the name."[46]

In response, in his two "White Man at Home" scrapbooks, Harrison turned a critical gaze on white "civilization" by preserving articles and images from newspapers and magazines that showed white people in an unflattering light or that showed white people doing things, such as committing crimes, that they often attributed to blacks.[47] In this series, "home" extends beyond the United States to include whites in many different parts of the world, for Harrison viewed white supremacy as a world problem. Often, his clippings invert white-supremacist boasts. Several document white slang, dialect, and bad grammar and thereby trouble the ideas that the speech and writings of whites in English comprised a standard or ideal and that white people were especially intelligent and eloquent. Others scrutinize patriarchal Anglo-Saxon domestic ideology and its heteronormative ideal of white womanhood by showing white women who deviate from the role of race mother and guardian of the white home, such as the flapper, who, with her "musical stride, her tweedy comfort, and her desire to be ten degrees more wicked than she is," was "the inspiration of the modern age," according to the *New York World*'s Sunday magazine. Another clip-

ping Harrison preserved included a photograph of the Italian "poetess and feminist leader" Rossana Zessos, who "submitted to imprisonment" rather than "doff" the "male attire" that she is wearing in the picture, which is identified as "trousers" in the headline but which also includes a hat, tie, a large overcoat, and men's dress shoes. Harrison's clipping emphasizes that the state of Italy imprisoned Zessos for her transgression, an extension of the punishing hand of the state that freethinkers and anarchists would surely find excessive, even as he multiplied types of womanhood that refused or otherwise countered the Anglo-Saxonist heteronorm of gendered separate spheres.[48]

The inside cover of the second scrapbook in "The White Man at Home" series is especially visually striking, for Harrison pasted his clippings and made annotations on top of the February 1921 issue of Hearst's Magazine, a lavishly illustrated, mass-circulation periodical that Hearst would merge with Cosmopolitan in 1925. Hearst's Magazine, which would soon be renamed Hearst's International, claimed to exhibit "more artistic originality in developing page composition and lay-out and enhancing the value of articles and stories through the accompanying art work than all the other magazines put together." The cover Harrison preserved is an illustration of two white women with short strawberry-blond hair, one of whom wears pearls and a small jeweled tiara, who look as though they are about to attend a ball or another social event (see figure 75). In the previous issue, the editor explained that this cover, which represented "The Girl of New New York," would comprise the eighth cover in the magazine's "Penrhyn Stanlaws Famous Beauty Series of See America First."[49] With this last phrase the magazine advertised these cover girls as white heteronationalist eye candy to readers, promising "Next to meeting each month a beautiful new girl is to watch the newsstands for the new Hearst's." These "see America first" covers comprise just a few examples among many of Hearst's cover portraits of iconic types of white heterosexual womanhood, some of which were created by famous illustrators such as Maxfield Parrish, which implicitly "enhanced the value" of the articles and stories contained within Hearst's first mass-circulation, monthly, illustrated magazine.

In addition to purveying iconic illustrations of white American womanhood, Hearst's Magazine also promoted and was connected to the world of motion pictures. The February cover that featured an illustration of "The Girl of New New York" also included, at the bottom of the page, an announcement of the appearance, beginning in that issue, of the Irish writer

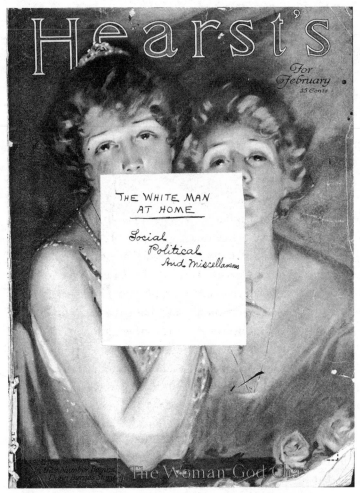

FIGURE 75 "The White Man at Home: Social, Political, Miscellaneous" scrapbook cover. Courtesy of the Hubert H. Harrison Papers, Rare Book and Manuscript Library, Butler Library, Columbia University, New York.

Brian Donn Byrnes's short story "The Woman God Changed," which was also made into a movie and released that very year. As the magazine promised in January, almost as soon as readers finished the three-part story, they would "be able to see it again" as a "motion picture," in an early example of the multiplatform narratives of the modern media age. The story was a crime drama about a dancer who experiences a moral awakening after being trapped on a desert island, which gives her time to regret killing the rich playboy who made her his mistress and then cheated on her.

Harrison may have preserved this cover illustration because he considered it an apt image of white decadence and of the crimes and hypocrisy of rich white people such as those featured in the short story and the motion picture. He might also have wished to emphasize that, as part of Hearst's emerging media empire, *Hearst's Magazine* was in the business of publicizing and defending the very glossy, idealized vision of Anglo-Saxon supremacy and world conquest, inextricably entangled with ideologies of heteronormative white womanhood, that Harrison viewed with a critical eye in these two scrapbooks.

At the same time, however, Hearst's newspapers and magazines provided sensational evidence for a counternarrative created by Harrison, who used them to illustrate aspects of white life that belied the ideals of Anglo-Saxon civilization. In the second volume of the "White Man at Home," as he pasted his "illustrative clippings" over the articles and illustrations in the February issue of *Hearst's Magazine*, Harrison covered up parts of the original, substituted or juxtaposed his own illustrations of whiteness, and critically commented on both as he created new stories about the world's white people in response to those purveyed in an emerging mass culture where Hearst was a major player.

Many of the clippings in the first "White Man at Home" scrapbook focus on the moral and spiritual deficiencies of white people, thereby countering white-supremacist boasts of a superior civilization (see figure 76). Rather than simply inverting racial hierarchies by suggesting that white ignorance was natural and biological, however, many of the stories and images Harrison preserved emphasized how education and material conditions shaped such deficiencies. Harrison saved, for instance, a piece in the *Nation* that charged, echoing Wilson's famous quotation, that the "world was being made safe for simplicity" through a pedagogy that simplified the past and that made children "into good Americans by lying to them," a claim that Harrison underlined. And he pasted into this scrapbook another article that reported that a National Baptist Pastors' organization withdrew support from a college where a professor refused to repudiate the theory of evolution, thereby adding more documentary evidence of what Harrison understood as willful white ignorance. A third clipping from the *New York Evening Sun* entitled "Budding Caesars Blocked by Grammar," revealed that half of the candidates to West Point were rejected because of their "showing in English." Harrison juxtaposed this story to a photograph, captioned "Not a Matinee Idol," of the white actor Louis

FIGURE 76 "The White Man at Home: Moral and Spiritual" scrapbook page. Courtesy of the Hubert H. Harrison Papers, Rare Book and Manuscript Library, Butler Library, Columbia University, New York.

Walheim in costume as the alienated, brutish, working-class "Yank" from Eugene O'Neill's play *The Hairy Ape*. Both of these clippings contradicted idealized visions of whites as exemplars of civilization, the first by emphasizing that half of all applicants to the nation's leading military academy were deficient in grammar, the second by suggesting that whites who experienced harsh working conditions might devolve into the very state of brutishness that racist whites attributed to blacks.[50]

The second "White Man at Home" scrapbook places more emphasis on the larger, persistent, and pernicious social and political dimensions of racial Anglo-Saxonism. More than one of Harrison's clippings from the black press concern white men who blacken their faces before committing heinous crimes, or who lose money and "to avoid detection, place the blame on some colored man," thereby not only evidencing a startling lack of moral character but also inflating statistics about the prevalence of black crime. Others emphasize how white supremacy took diverse public forms in the wake of the Civil War in ways that perpetuated and institutionalized white domination after the demise of slavery. Harrison pasted into this scrapbook, for instance, a *New York Times* story about how, even though the "Civil War closed fifty-five years ago," a proposed lecture on Harriet Beecher Stowe, the author of *Uncle Tom's Cabin*, "caused a row among the faculty of a girls' college at Chatham, VA." The writer—who caustically observed that although remembering Stowe's novel was controversial, "the Blue and the Gray unite their thrilling ranks at every opportunity" in Civil War memorials—looked forward to a future that had not yet arrived, "when stories of the Civil War period can be read without heat, when anti-slavery issues can be treated as history instead of as passionate political controversy." Harrison also preserved a *Pittsburgh Courier* story about the plan of J. L. Bryant, a wealthy Natchitoches, Louisiana, property owner, to erect a life-size bronze statue of what he imagined as "the faithful old Negro of the South" in the business district of that city in order to memorialize the "service" of the "good darkies of Louisiana."[51] This statue is one of many examples of how white supremacists of the period tried to preserve and extend the race relations of the antebellum past by inscribing them onto the public spaces of the postbellum South.

In this regard, Harrison was especially horrified by the burgeoning popularity of the Ku Klux Klan, which was revived in 1915, was producing its own "propaganda," and took new, popular forms in Thomas Dixon's novels and in motion pictures such as Griffith's *Birth of a Nation*. Sev-

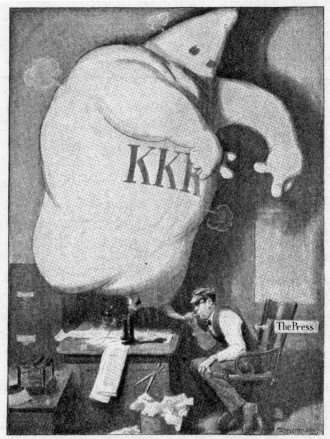

"YOU MADE ME WHAT I AM TO-DAY (I HOPE YOU'RE SATISFIED)"

Life – 9/4/25

FIGURE 77 "You Made Me What I Am To-Day (I Hope You're Satisfied)." Cartoon in *Life*, collected in Hubert Harrison's "White Man at Home: Social, Political, and Miscellaneous" scrapbook. Courtesy of the Hubert H. Harrison Papers, Rare Book and Manuscript Library, Butler Library, Columbia University, New York.

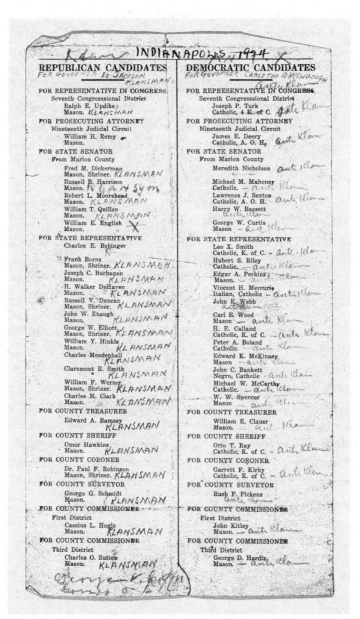

FIGURE 78 Clipping listing candidates for political office in Indianapolis, Indiana, in 1924, with Hubert H. Harrison's "Klan" and "Anti-Klan" annotations, in the "White Man at Home: Social, Political, and Miscellaneous" scrapbook. Courtesy of the Hubert H. Harrison Papers, Rare Book and Manuscript Library, Butler Library, Columbia University, New York.

eral clippings in the "The White Man at Home" scrapbooks emphasize the secret society's connections to mainstream public life not only in the South but also in the North and throughout the nation. Harrison preserved, for instance, a full-page *Life* magazine cartoon from 1925, the year Klan membership peaked at around 4–5 million, which depicted a bespectacled man identified as "the press" hard at work at his desk, blowing up a huge white balloon in the shape of a hooded Klansman (see figure 77). The caption, "You made me what I am to-day (I hope you're satisfied)," charges the press with publicizing the Klan in ways that made it hugely popular among many whites, thereby perpetuating ignorance about the Klan's origins and history.

Even when the press focused on the Klan's violent vigilantism, as Harrison praised the *New York World* for doing, in 1921, after the paper ran a three-week-long exposé, the writers of its editorials still revealed "an abysmal ignorance of the proven facts" about the "band of bloody midnight assassins which terrorized Negroes in the South from 1865 to 1870," a period when laws were passed "reducing the Negroes to a new condition of serfdom more galling and hopeless than slavery had been." Outraged that the *New York World* repeated Klan apologists' claims that the Klan was organized to "save white civilization from the domination of ignorance," Harrison asked, "Isn't it high time that white Americans cease being so grossly ignorant of the facts of their history?"[52] Harrison also included in this scrapbook a long list of the Republican and Democratic candidates for political office in Indianapolis in 1924, which he annotated with the words "Klansman" or "Anti-Klan" (see figure 78). In this way, Harrison emphasized the Klan's power in the public, political life of the North and the nation through its engagement with popular forms and modern media, and despite its associations with the secret, pathological, private life of the fallen South.

7 "Wanted—A Colored International"

HUBERT H. HARRISON, MARCUS GARVEY,
AND MODERN MEDIA

Behind the veil of the color line none of the great world-movements for
social betterment has been able to penetrate.
—HUBERT HARRISON, "SOCIALISM AND THE NEGRO," *INTERNATIONAL
SOCIALIST REVIEW* 13 (JULY 1912)

Hubert H. Harrison's criticisms of and confrontations with the Ku
Klux Klan are documented in his scrapbooks as well as in his let-
ters and published writings. They comprise an important part of
Harrison's life story, which is narrated in six scrapbooks through
clippings of his writings, broadsides, dance programs, lecture
tickets, membership cards, and other ephemera as well as news-
paper stories about his role in the "world movements" of his time.
Three scrapbooks are compilations of his writings (see figure 79);[1]
two feature clippings about Harrison himself (see figure 80); and
another contains material for lectures he gave in the 1920s.[2] These
scrapbooks documenting Harrison's life in movement(s) reveal
the significance of modern media and popular entertainment in
building these movements, as well as Harrison's own ambivalence
about modern mass culture and ideologies of uplift.

Although Harrison tried to appeal to the black masses and be-
lieved that "the way to unity lies through the hearts of the multi-
tude," he was disappointed by their fervent response to Marcus
Garvey.[3] Harrison was distressed by Garvey's promotion of his

FIGURE 79 "Writings of Hubert H. Harrison" scrapbook cover. Courtesy of the Hubert H. Harrison Papers, Rare Book and Manuscript Library, Butler Library, Columbia University, New York.

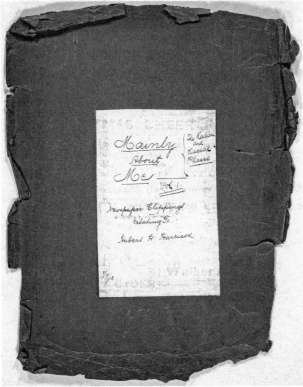

FIGURE 80 "Mainly about Me: The Radical and Racial Phases" scrapbook cover. Courtesy of the Hubert H. Harrison Papers, Rare Book and Manuscript Library, Butler Library, Columbia University, New York.

"self" as an icon and as the leader of a future black empire as well as his lack of knowledge about Africa. What is more, Harrison speculated that Garvey's "sensationalism" and his "intensive propaganda" especially appealed to "intolerant" and "fanatical" West Indian "peasants," whom he distinguished from "the thousands of intelligent and respectable West Indians" who did not believe the hype that "Garvey is a god" who "never did a crooked thing in his life."[4] Here, Harrison's use of the word *sensationalism* distinguishes between intolerant, fanatical peasants, whose responses to Garvey are intensified, Harrison imagines, by their susceptibility to religious feelings and beliefs, and intelligent and respectable West Indians such as Harrison himself, who had broken with Christianity and participated in the free thought movement at an early age. In 1907 he wrote in his diary that it was only because of his desire to be "in full touch with the life" of his "people" in order to better understand them and "write their history" that he attended "revival meetings and prayer meetings, which but for the psychological interest would disgust me."[5] Harrison was "disgusted" by such religious meetings, and feared the "fanaticism" he attributed to the peasant, because he prided himself on having a modern, scientific, materialist perspective on the world. In an inversion of the word's usual meaning Harrison deems "respectable" this materialist worldview, skeptical of religion and authority figures such as Garvey, that he also attributes to the "thousands" of "intelligent" West Indians. But Harrison's remarks also betray a certain jealousy of Garvey, who led the largest mass movement of black people in the world, a role to which Harrison probably aspired. As he wrote admiringly in 1920, "No movement among American Negroes since slavery was abolished has ever attained the gigantic proportions of this."[6] And Harrison also called Garvey's schemes for redeeming Africa "sensational" because he thought they were unsupported by knowledge of Africa, relied on the dissemination of deceptive or misleading information about relocating in Africa, and threatened to become a form of imperialism that marginalized or displaced Africans.

On the other hand, Harrison exposed how modern media promoted sensational, idealized visions of transnational whiteness in mass-circulation magazines such as *Hearst's Magazine* as well as in newspapers, newsreels, and motion pictures. In calling these forms of white mass culture sensational, Harrison was echoing contemporary commentators, who associated sensationalism particularly with the "yellow journalism" of the 1890s and the Spanish–American War. In this context, Harrison used the

word *sensational* to refer to emerging media empires such as Hearst's, which manufactured melodramatic stories and incorporated scare headlines, illustrations, color, and cartoons into the news as part of a larger project of empire-building and white world supremacy. In both cases, for Harrison the "sensational" involves deceptive appeals to the emotions and bodies of the masses, particularly through images and popular culture.

At the same time, however, Harrison used modern media, popular culture, and images to build support for the "great world-movements for social betterment" of which he was a part. Initially, this effort involved trying to push movements such as socialism "beyond the veil of the color line" that they had heretofore failed to "penetrate," partly because some Southern socialists were apologists for the Ku Klux Klan, as Harrison advised the editors of the socialist *New Review* in a 1914 letter that they chose not to publish.[7] When he began publishing his own newspaper, the *Voice*, in 1917, he lost no time in denouncing the Klan, warning that if the police refused to enforce laws allowing people "to kill in defense of their lives," then it was "up to Negroes to help the officers by enforcing the law on their own account." In the pages of *Negro World*, he continued to take on the Klan even as its popularity among whites soared in the years after the First World War.

In Harrison's *Negro World* scrapbook, many of the clippings, including three editorials, narrate a nineteenth-century counterhistory of the Klan in the face of white ignorance about it. These editorials also expose the "revived Ku Klux Klan" that had extended its reach through motion pictures and other forms of mass culture even as it extended its hateful and vicious attacks to Catholics, Jews, and foreigners as well as blacks. In the "Ku Klux Klan in the Past" scrapbook (1921), Harrison deplored the "abysmal ignorance of the proven facts" of the post–Civil War period, when the Klan was organized by the defeated white Southerners, who passed "laws reducing the Negroes to a new condition of serfdom more galling and hopeless than slavery had been." Turning his attention to the "revived," modern Klan, Harrison suggested that "our editors and publishers" should point out that "in regard to disfranchisement and other things, if white Americans ignore them because they only affect Negroes . . . sooner or later . . . these things will also be set in motion against whites."[8] Harrison also continued to pursue a strategy of trying to educate whites about how white supremacy impaired democracy both for blacks and for whites themselves in the years after he broke with Garvey and the UNIA.[9]

But while earlier Harrison had hoped to make the "civilized" world "throb with righteous indignation" at the injustices of white supremacy, as he put it in 1911, during the last few years of his life, as he organized the ICUL he instead returned to the idea, in a column he wrote for the *Boston Chronicle*, of "direct action" in response to the Klan rather than "wasting money on 'publicity,' whether that 'publicity' takes the form of fervid appeals to a moral sense which exists only on paper, of indignant protests, or of bombastic ravings."[10] Although he continued to make appeals, to protest, and to engage modern forms of media and popular culture in order to build world movements in the face of worldwide white-supremacist projects in the years after the war, Harrison became increasingly wary of appeals to whites made in more sentimental and sensational modalities, such as the "fervid appeals," "indignant protests," and "bombastic ravings" that he had concluded were ineffective in mobilizing sentiment against lynching.

In his article "The Negro and the Newspapers" (1911), Harrison grappled with the problem of how to most effectively protest the "white man's injustice to the Black," particularly since the "American press" colluded in the racial project of white supremacy by constantly appealing to "the putrid passion of race hatred." Thus Harrison warned that the "terrible task of setting Truth free" had to be assayed by "the Negro in the very teeth of the American press." But even though this terrible task was not "easy," Harrison insisted, "the attempt must be made again and again until the seared conscience of the civilized world's hall throbs with righteous indignation at such outrage."[11] At this moment, Harrison imagined that protests of white supremacy might aim to sear the conscience of the white world by provoking whites to feel righteously indignant at the outrageous injustices done to black people. He hoped that exposing the injustice of white supremacy and educating white people to feel and understand the injustices of the past and present might provoke change, that outrage over such injustices might displace the "putrid passion of race hatred" stoked by the American press.

For most of that decade, Harrison continued to work with white people in radical interracial organizations and to teach in white-dominated spaces such as the Lenox Casino, where in 1915 he occupied what he called "the unique position of being the Black leader and lecturer of a white lecture forum, organized by white liberals, radicals and others."[12] Harrison preserved memorabilia from this part of his life in the "Mainly about Me"

scrapbook, where he pasted notices for "Some Stirring Talks on Timely Topics by Hubert H. Harrison, America's Foremost Negro Lecturer" and "Who Put the Bomb in St. Patrick's Cathedral?: A Startling Lecture by Hubert H. Harrison at Lenox Casino" on top of a map of Persia that appeared in the pages of the *Literary Digest* (see figure 81). On the same page, he placed a card advertising one of his lectures at the Harlem Casino, formerly the Lenox Casino, which promised talks on such controversial topics as "The Class Struggle: A Criticism and Confession," "Sex, Sinners, and Society," "The Materialistic Interpretation of Morals," and "A Defense of Atheism." An ad for one of these lecture series claimed that Harrison's success with "indoor and outdoor audiences" proved that "in the Republic of Knowledge there is no such thing as Race" and that his "influence touches not only the hearts, but also the heads of the people, and those who come within its reach are stimulated to think independently and intelligently." Pitched to a white radical audience, this ad, which was part of his "radical" phase, articulated a utopian vision of a race-less "Republic of Knowledge" where Harrison's "influence" could "stimulate" the "hearts" and "heads" of "the people" on key questions of the day.

Such a race-less republic did not really exist, of course, and during the period when Harrison lectured for the Socialist Party, he was referred to in a 1912 clipping from a socialist newspaper that he preserved as the "well known colored speaker" and "one of the most forceful speakers in the movement," who "created a sensation by delivering the minority report at the New York state convention of the Socialist Party." In addition to serving as an organizer and lecturer for the socialists, he also contributed several articles on "The Negro and Socialism" to the *New York Call* and the *International Socialist Review*. In his first piece for the *New York Call*, which was published in 1911, he took up once again the "terrible task" of teaching whites to recognize that the "denial of social, political, and economic justice to all people not white" puts "our democracy to the proof and reveals the falsity of it." Warning white radicals that when the "public mind accustoms itself to seeing" such things as "lynchings, segregation, public proscription and disfranchisement," it is more easily able to "look with complacency upon the jailing of innocent labor leaders and the murder of working girls in a fire trap factory," Harrison tried to help white people see the connections among the denial of justice to black people, the unjust imprisonment of labor organizers, and the disposable lives of factory girls.[13] He analyzed the problem, moreover, precisely in visual terms,

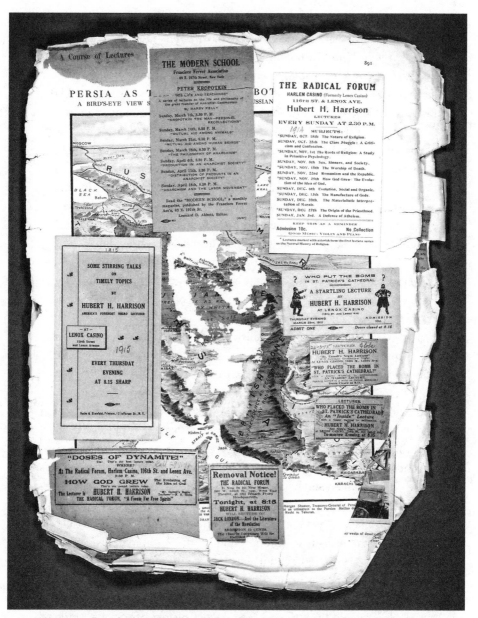

FIGURE 81 "Mainly about Me: The Radical and Racial Phases" scrapbook page. Courtesy of the Hubert H. Harrison Papers, Rare Book and Manuscript Library, Butler Library, Columbia University, New York.

warning that people who became accustomed to seeing lynchings and other forms of racial injustice, such as those depicted in the postcards of the era, might "look with complacency" at the imprisonment and murder of white workers. And in his articles for the more radical *International Socialist Review* in 1911–12, he continued to shoulder what he called "the Black man's burden" of drawing the attention of whites to "certain pitiful facts" that "furnish such a damning indictment of the Negro's American over-lord as must open the eyes of the world."[14] Expertly surveying the political, economic, educational, and social dimensions of black subjection and subordination, Harrison concluded that since "the mission of the Socialist Party is to free the working class from exploitation, and since the Negro is the most ruthlessly exploited working class group in America, the duty of the party to champion his cause is as clear as day."[15] But by 1914, he apparently feared that no indictment, however damning, would open the "eyes of the world," or at least of the Socialist Party, to its duty, at least as long as it was willing to accommodate Southern white-supremacist members.

Harrison contrasted the Socialist Party's willingness to compromise with white supremacists in order to boost its popularity and "to increase its membership and vote among all classes of the population" with the IWW's opposition to "race prejudice in the South" in places such as Louisiana.[16] Although he continued to support many aspects of the socialist agenda and philosophy, he began to feel what one clipping that he preserved called a "revulsion" against "the purely political and non-industrial Socialist propaganda" that relied on moral suasion and that was limited to "groups mostly of the skilled and better paid workers, leaving the great arm of unskilled men, women, and children with nothing to protect their interests." Instead, he championed the IWW's "powerful tendency toward 'industrial unionism,' 'syndicalism' or direct action on the economic field" and defended Big Bill Haywood's endorsement of sabotage.[17]

Harrison retained several clippings that document the speeches he made alongside IWW leaders during the Paterson silk strike of 1913. In one speech, he situated the strike within a longer history of socialist workers' strikes that mobilized immigrants when he reminded his audience of "the strike for an eight-hour day in Chicago in 1886 when many leaders were hung" because "the people in authority, when the law did not give them the power to break the strike at all costs, made other laws to suit their purposes and took the stand that anything that was against their interests was

illegal." Looking backward to the execution of the Chicago Haymarket anarchists, Harrison insisted that "we socialists are defined more by what we do than what we say," and he appealed to a longer, more heterodox history of transnational socialism and internationalism that was irreducible to the orthodoxies, blindnesses, and boundaries of the U.S. Socialist Party of his era. While Harrison defended a more expansive vision of the socialist movement, however, he was disappointed that the *New York Call* had "willfully injured the strikers" by refusing a "paid advertisement appealing for aid" and had also "refused to print a letter from a prominent speaker at a recent meeting arranged by the Paterson Defense Conference," as Harrison charged in an article, which he pasted into his scrapbook, that identified him as the chair of a meeting held to protest these incidents. By December 1917, at a moment when he felt that he had to clarify his "present standing with the SP" because an advertisement for a public debate between himself and Chandler Owen had incorrectly suggested he would be defending a socialist position, he had already begun to articulate the "Negroes First" doctrine that comprised the debate topic. The "Racial Phase" of his life had begun.

During the next decade, Harrison shifted his focus from participating in interracial movements in order to educate white people about racial injustice, move them to act, and bring black people into these movements. Instead, he turned to organizing movements of black people, educating black people about race as a world problem, and imagining a separate black state within the United States. Although he continued to make occasional contributions to newspapers and periodicals that were owned and edited by whites, his main focus became editing and contributing to black periodicals such as the *Voice*, the short-lived monthly magazine *New Negro*, *Negro World*, and the *Boston Chronicle*, which was founded by Jamaican immigrants. He also became increasingly suspicious of appeals to whites made in sentimental and sensational modalities even though he continued to use modern forms of popular entertainment and media to mobilize black people and build protest movements.

The *Voice* was a weekly "Newspaper for the Negro," aimed particularly at "the Plain People of Negro ancestry," that first appeared in July 1917 in the wake of the white riots in East St. Louis, which Harrison documented in the "Lynching" scrapbook. Harrison responded to the war at home in an editorial on "The East St. Louis Horror" by praising the many "East Saint Louis Negroes" who "organized themselves during the riots and fought

back under some kind of leadership." He also observed that "white news-papers" suppressed this sort of "news broadcast" out of fears that it "might teach Negroes too much."[18] This emphasis on collective organization and self-defense recalls the photographs and illustrations that Harrison clipped and preserved throughout this scrapbook. He wanted the *Voice* and the Liberty League, on the other hand, to be antidotes to the elisions of the mass-circulation daily newspapers: he claimed that these "Negro-American" institutions were "organized to take practical steps to help our people all over the land in the protection of their lives and liberties."[19]

In the first issue of the *Voice*, an article told of the "interesting history" of the Liberty League, which "grew out of the labors of Hubert H. Har-rison," after he "withdrew from an international political organization," obviously the Socialist Party, and "gave up lecturing to white people, to devote himself exclusively to lecturing among his people." Harrison orga-nized a "Mass Meeting of Colored Citizens" at Bethel Church on June 12, 1917, which he later claimed was packed "from top to bottom with 2,600 of our people" and which was attended by Garvey, Owen, Clayton Powell, and other black leaders. At another meeting, participants established the *Voice* as "the medium of expression for the new demands and aspirations of the New Negro."[20] The league and the *Voice* incorporated popular enter-tainment into their appeal, sponsoring a dance "carnival" at the Manhat-tan Casino and a "winter frolic" with "dance and fun," including "comic vaudeville, cut-ups, humorous songs and recitations" at the Palace Casino. The league also advocated direct action as a response to white lawlessness and emphasized the organization's "international . . . duty to the seven-teen hundred millions who are colored—Black and brown and yellow." Harrison suggested that the league and the new "Negro masses" it repre-sented were "aiming at the white man's respect—not at his sympathy." In other words, the world war and the mass-mediated popularity of white supremacy and white violence during this period pushed Harrison and the movement he organized to reject the strategy of trying to change the hearts and minds of whites, educate them, or make them feel differently about racial injustice so that they might sympathize with its victims and be moved to act to end lynching, segregation, and disfranchisement. The "barbarous" nature of the violent attacks on black people in East St. Louis, as well as the AFL president Samuel Gompers's callous response defend-ing white working-class violence, surely helped to motivate this shift in strategy.

During Harrison's time as an editor and then a contributor to *Negro World*, which began in March 1920 and continued through 1922, he remained wary of the strategy of trying to use "publicity" to expose white supremacy and change whites' hearts and minds. In 1920, in a commentary on the beating of John Shillady, the white executive secretary of the NAACP, by white supremacists, Harrison suggested that the beating made it clear that "simple publicity" could not abolish "lynching and the other evils which beset the Negro in the South." Indeed, the aim of "affecting the minds of white people" was the NAACP's "great weakness," Harrison declared, as he called for "something more effective than protests addressed to the other fellow's consciousness."[21] And in an editorial entitled "Stupidity and the NAACP" (1921), Harrison argued that picketing *Birth of a Nation* was misguided, for although the film "had dropped down to the level of a third-class attraction, in a fair way to be forgotten," the NAACP's "pig-headed" picketing had "elevated it to the level of a first-class sensation and money-maker for its promoters." Harrison argued that far from turning "white theatergoers away from an evening's enjoyment," such publicity instead made "thousands" of whites even more eager to see it, for protestors underestimated the pleasure many whites would take in such a spectacle of black degradation in spite or even because of the protests of black people.

Instead, in the pages of *Negro World*, as Harrison labored in what he called "the field of New Negro sentiment," he tried to educate black people about world history and international politics and urged them to "join hands across the sea," to "link up with other colored races of the world."[22] During his time as editor, *Negro World*'s circulation grew from 10,000 to 50,000, partly because of the many changes Harrison made, including altering the paper's policy of reprinting stories from "white newspapers" without "changing a word." Harrison used more material from the black press and made it part of his job to "shape up the clippings to snip off, insert, and re-write many portions of them."[23] He also gathered together poetry submissions in a "Poetry for the People" section; began writing a regular book-review column, which he claimed was "the first known to Negro newspaperdom"; and translated parts of the work of Arab writers into modern English.

A major focus of his editorials for *Negro World* was the larger project of forging links among the world's people of color in order to oppose what he called "the pseudo-internationalism of the short-sighted savants

who are posturing on the stage of capitalist culture." In a editorial called "Wanted—A Colored International" (1921), Harrison repeated his point that "protest and publicity addressed to the humane sentiments of white America have availed us nothing," before calling on his readers to "come together" to "organize, plan, and act" and to "establish their own centers of diffusion of their own internationalism," a "stark internationalism of clear vision" in order to confront "white capitalist internationalism." By doing so, Harrison contended, "we meet our oppressors upon their own ground," for despite the latter's praise "for the god of 'internationalism' in the temple of 'civilization,'" these "lords of misrule" denounced "the idea of internationalism as anarchy, sedition, Bolshevism, and 'disruptive propaganda'" when "any portion of the world's disinherited (whether white or Black) seeks to join hands with any other group in the same condition." But Harrison argued that despite this repression, a "similarity of suffering is producing" in "the darker peoples of the world" a "similarity of sentiment" that should be used "to strengthen our position."[24]

For Harrison, literature and culture played crucial roles in shaping such a "similarity of sentiment," but in his many lectures on literature as well as in his book and theater reviews he repeatedly challenged what Jeffrey Perry calls "a central ideal of uplift: that art should elevate." Instead, Harrison defined "literature as a criticism of life" and the "drama" as a "mirror of social conditions."[25] In a favorable review of the Southern white writer H. A. Shands's "realistic" Texas novel *White and Black*, Harrison observed that one virtue of the novel was that "the mawkish sentimentality of the officious 'uplifter' is thrown into the discard." He believed that "great books" had "great power to plumb the depths, to stimulate," and considered Twain the greatest American writer because of what Harrison called the "tragedy of his humor."[26] He also provocatively claimed that there was no "Negro literary renaissance," despite his own high regard for the poetry of Claude McKay, and argued that that those who championed such a notion "were blissfully ignorant of the stream of literary and artistic products which have flowed uninterruptedly from Negro writers, including Pauline Hopkins and Charles Chesnutt, from 1850 to the present."[27] Harrison was especially interested in drama and wrote a great deal about it. As a young man, he planned to write a study of "Negro Society and the Negro Stage," of which only fragments survive, that would focus on black vaudeville "and the social conditions lying back" of this popular art, in which "passing quips and seemingly idle jests . . . are the certain index of social situations, which it

should profit us to understand."[28] And in *Negro World*, he published several theater reviews, including an appreciation of *The Emperor Jones* as the "joint product of the genius of Eugene O'Neill and Charles Gilpin," the former Lafayette Theater player whose "creative acting" and ability "to rise to crescendos of effective intensity" as the lead character, Brutus Jones, made the play "a six months' sensation" at the Princess Theater on Broadway, which had originally booked the play for two weeks.[29]

Harrison's glowing review of *The Emperor Jones* in the pages of the June 3, 1921, issue of *Negro World* was especially significant because just two years later he would call the play "a fine picture of the psychology of the whole Garvey movement . . . at the end of the spectacular career of our Emperor Jones." When Garvey was convicted of mail fraud, Harrison made this comparison in an article entitled "Marcus Garvey at the Bar of United States Justice" that he distributed through the Associated Negro Press, a Chicago news agency that was established in 1919 and that provided stories for most of the black newspapers in the nation. Harrison charged that from his own Liberty League Garvey had "appropriated every feature that was worth while in his movement," as well as many of the league's tactics, including "outdoor and indoor lectures, a newspaper," and "protests in terms of democracy." Harrison also claimed that Garvey "took bodily" the idea of the Black Star Line from one of the original members of the Liberty League, then developed it "not as a bona-fide business" but as a way to "seduce credulous Negroes" into "putting more of their money into Garvey's hands." The fraud conviction was based on circulars that advertised shares in a ship, the *Phillis Wheatley*, which Harrison characterized as "a phantom ship that was never bought nor seen, but on which Garvey by false and misleading advertisements had collected thousands of dollars paid in as passage-money to Africa and as stock sales." Harrison accused Garvey of "swindling members of his race by means of the Black Star Line, whose fleet of ships to sail the seven seas existed mainly on paper and in the mind of Marcus Garvey."[30] He also insisted that Garvey "got a fair trial" and compared Garvey to Brutus Jones by quoting dialogue from the play in which the latter admits to only holding down the "Emperor job" for the "money" and confesses that he offered a lot of "fuss and glory" and a "big circus show" in order to "turn . . . heads."[31]

In his June 1921 *Negro World* review, however, Harrison did not make such a direct comparison between Garvey and Emperor Jones. Such a provocation would have been difficult to make in the pages of the offi-

cial publication of Garvey's organization and would have further eroded his relationship with the UNIA, with which he was still connected despite his rapidly growing disdain for Garvey as a leader. Instead, Harrison defended the play in modernist terms, claiming that "the external setting of the drama is really of no importance whatsoever" and that the play was "a psychological study" of a "successful faker lording it over a group of his people in the style of an emperor." Harrison's retelling of the play's story emphasizes how the fake emperor, Brutus Jones, a former "Alabama field hand" and a former convict, lands "among a mass of Negroes in a primitive state of intellect" and rises rapidly to power through "appeals to the supernatural and the far away." Harrison initially emphasizes the eponymous character's ability to "fool and cow the people while he sucks up every dollar in sight."[32]

But although up to this point it might seem that Harrison is writing off the masses as dupes of swindling charlatans who prey on their "primitive" gullibility, in this review he ultimately emphasizes how "the people 'get wise' in time to their Emperor's graft" and band together to drive him away. Here Harrison's standard of critical judgment shifts from a modernist mode to one that is more appreciative of the sensational aspects of the play, which Harrison described as "a marvel of stage setting and stage-effects" that were as important as any other element. When Brutus Jones flees to the forest, to which the people have already escaped after deserting his palace and where they now incessantly beat a tom-tom, it is full of specters, which take the shape of "the past horrors of racial experience" that "rise from the roots of Jones' unconscious mind" and hold him in the grip of "terror," until finally he is "shot by the soldiers of his own Negro army." If the tale has a moral, Harrison concluded, it "might be this: That the good Lord watches over the poor and ignorant to protect them even from clever sharpies of their own tribe." The sensational stage effects of the play's conclusion, many of which are, within the story, orchestrated by the people rather than the "good Lord," are thus key to the transformation of the meaning of the play, in Harrison's analysis, from one in which the "masses" are the inevitable dupes of demagogues who make sensational appeals to one where the "poor and ignorant" collaborate in the use of sensational devices not only to free themselves from the fake emperor but also to precipitate his downfall.[33]

Harrison might have imagined he was engaging in an analogous sensational counter-sensationalism when he wrote in his diary about delivering

on the "radio broadcasting machine of the American Telephone and Telegraph Company's WEAF" an address on "The Negro and the Nation" at the "same hour" that "Marcus Garvey was sentenced by Mr. Justice Mack to 5 years in a Federal prison for using the mails to defraud his 'fellow-men of the Negro race.'" Proudly noting that his voice was transmitted by "the most powerful radio at present in the Eastern U.S. with a wave-length of 492 meters," Harrison wishfully emphasized how his own ideas were being extensively aurally disseminated through an ultramodern mass communications machine at the very hour of Garvey's downfall. Just before he began editing *Negro World*, Harrison wrote a memorandum entitled "The Control of Negro Sentiment," which detailed "specific organs" that shaped the "sentiment" of the black masses, including the pulpit and the press; the Associated Negro Press, the news agency he used in 1923 to publish his article on Garvey's trial; the "Bolshevistic" radicals involved with Cyril Briggs's *Crusader* magazine, which he commented had "no visible means of support"; and W. E. B. Du Bois's NAACP, which he observed "had a tremendous slump," including the loss of more than a hundred branches in one year and a decline in the circulation of the organization's periodical, the *Crisis*, which Harrison attributed to the "aristocratic aloofness" of the NAACP's "social control" methods. Both Harrison and Garvey, on the other hand, appealed to the black masses, but Garvey had just been found guilty of swindling them, while Harrison's own efforts to reach a mass audience were getting a boost from new broadcasting technology. At this moment, Harrison may well have imagined that he was ultimately going to win the media battle with Garvey to help define the vision of the future offered by the most popular black "world-movement for social betterment" the world had ever seen.

In his radio address, Harrison harshly criticized Garvey's dream of a black empire in Africa. Arguing that the "present Negro population of Africa is quite able to work out its salvation on the spot," Harrison declared that the "destiny of the American Negro lies in the future of America and no one need think that he will mortgage that future for the sake of a barbaric dream of African Empire with Dukes of Uganda and Ladies of the Nile."[34] In calling this dream barbaric, Harrison did not mean to suggest that Africans were barbarians, but rather that the dream of a black empire in Africa was a step backward, one that disregarded the fact that Africans had their own plans and aspirations for Africa. In notes he wrote in his diary, Harrison outlined the reasons he broke with Garvey, includ-

ing that Garvey transformed the organization's policy, as he saw it, "from Negro Self Help to the Invasion of Africa."[35] After Harrison organized the International Colored Unity League, in 1924, he preserved newspaper clippings that told of the ICUL's plans to "found a Negro state, not in Africa, as Marcus Garvey would have done, but in the United States." The league was international, Harrison explained, because "all Negroes in America, no matter what parts of the world they originally came from" would be eligible to join.[36] To explain his rejection of Garvey's vision of Africa, Harrison commented that "African Negroes . . . did not need any help, and if they did, it could not come from American Negroes." When he pasted this clipping into one of scrapbooks that documented his life, he must have hoped that his own appeals to the black masses to unite in support of a black state in the United States made up of blacks from all "parts of the world" would ultimately win out over what he saw as the sensational, amnesiac appeal of a black empire in Africa.[37]

For the next three years, Harrison participated in various projects that aimed to teach black people about the world in order to help build a black "world movement" that was grounded in knowledge of other places, international relations, and the histories of multiple empires, from the remote past to the present, rather than in black fantasies about Africa that reproduced a logic of empire. These projects included the ICUL, the weekly "Trend of the Times" columns he wrote for the *Boston Chronicle*, his lectures, and the "World Problems of Race" seminar he led in Harlem in 1926. In "Our International Consciousness," a piece he published in the *Boston Chronicle*, Harrison suggested that blacks in the United States needed to take a lesson from the rest of the world, since "publicists of color in West Africa, North Africa, Egypt, Afghanistan, India and China relate the international aspects of their local problems so that their common implications are equally clear to all of them while to us the only thing that is clear is our need for clarity." In an effort to provide some clarity for readers on the "international aspects" of "local problems," Harrison promised to provide in his weekly columns "brief interpretations of what's what in the larger world of international affairs, to the end that thereby some needful light may be shed on the trend of the times as it affects colored people here and elsewhere." His "World Problems of Race" seminar continued this project of illuminating the international aspects of local problems under the auspices of Harlem's Institute for Social Study, a community organization that was dedicated to the "study of the vital social problems which affect the

FIGURE 82 Institute for Social Study circular advertising Hubert H. Harrison's "World
Problems of Race" seminar. Courtesy of the Hubert H. Harrison Papers, Rare Book and
Manuscript Library, Butler Library, Columbia University, New York.

lives and welfare of the great masses of the people" (see figure 82). The goal
of the institute was "to discover and to diffuse knowledge" directed toward
the end of "complete social emancipation," since the group believed that
the "great mass" should not be shut out from the "light" cast by "the social
heritage of race and ideas." According to an advertisement for his seminar,
Harrison was "particularly appreciated for his remarkable skill in render-
ing difficult matters clear, vivid, and simple, and for his animated, forceful,
and stimulating mode of presentation."

In the course of the ten-week seminar, Harrison traced "modern ideas
of race" by lecturing on the history of the "expansion and domination of
Europeans," who five hundred years ago, his syllabus suggested, lagged
"behind Africa and Asia" (see figure 83). He also considered "the racial
aspects of European imperialism" as well as its political and economic di-
mensions. The geographical scope of the class was vast: Harrison included
units on Africa, "Race Problems in America" (including the West Indies,
Haiti, and Latin America), "India and the British Empire," "China and the

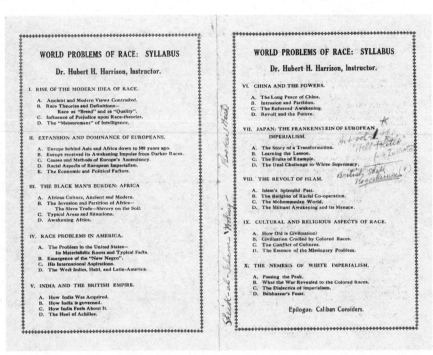

FIGURE 83 "World Problems of Race: Syllabus." Courtesy of the Hubert H. Harrison Papers, Rare Book and Manuscript Library, Butler Library, Columbia University, New York.

Powers," "Japan: The Frankenstein of European Imperialism," and "The Revolt of Islam." He explored the "Cultural and Religious Aspects of Race" as well, teaching that "Civilization" was "Cradled" by the "Colored Races" and explaining "The Essence of the Missionary Problem." In the final unit, the class studied "The Nemesis of Modern Imperialism" as Harrison lectured on "What the War Revealed to the Colored Races" and concluded with an epilogue, "Caliban Considers."

Harrison kept a large photograph, lodged in a cardboard frame, of the last meeting of the class (see figure 84). In the photograph sixty members of his seminar sit and stand in long rows, while Harrison turns around in his chair at the front to regard the camera, which is positioned slightly above the class. All of the men, including Harrison, are wearing jackets, and almost all wear ties; the twelve women in the class are also elegantly dressed for this important occasion. A promotional circular Harrison preserved claimed the class would "provide the equipment necessary for intelligent participation in the work of Inter-racial Conferences and Committees." The men and women who faced the camera had responded to Harrison's promise to cultivate "that rare but needful quality wherein is hope for the

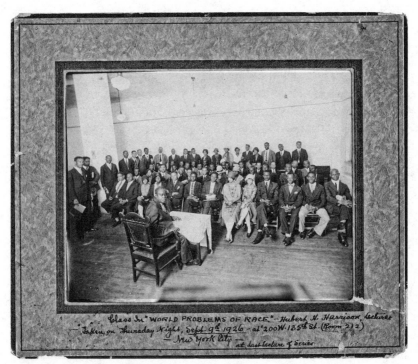

FIGURE 84 Hubert H. Harrison's "World Problems of Race" class, December 9, 1926. Courtesy of the Hubert H. Harrison Papers, Rare Book and Manuscript Library, Butler Library, Columbia University, New York.

future, namely, intelligent and courageous race statesman-ship." Harrison's classroom was a black public space where Enlightenment and Progressive ideals of clarity, the discovery and diffusion of knowledge, and mass education prevailed as Harrison tried to teach the race statesmen and women of the future "the fundamental facts about the great and challenging problem of race" by understanding it precisely as a "world problem."

Harrison's efforts to build a black world movement extended beyond the classroom and the pages of the newspaper, however, to spaces of popular entertainment, consumption, education, organization, and pleasure such as the Renaissance Casino. Harrison sometimes documents his activities in these other kinds of spaces in his diary, but his scrapbooks also preserve traces of his intermittent immersion in a different public world, one that was less respectable and more sensational, filled with the sounds and images of mass-mediated modernity, and animated or interrupted by dancing and other kinds of kinetic and bodily movement and performance. Harrison's diary also reveals how he departed from middle-class

ideals of respectability that made monogamous heterosexual domesticity a key criterion of black progress and civilization as he struggled to simultaneously build a world movement of black people and provide financial support to his large family, often while living apart from them in nearby boarding houses. Indeed, Harrison's diary provides an alternative archive of his life in movements, as he transgressed the boundaries of middle-class domesticity and moved into other kinds of black public spaces, which are also richly documented in his scrapbooks, where sounds, images, performances, dances, and other cultural forms that involved or engaged bodies and bodily life helped to mobilize people in support of transnational organizations such as the Virgin Islands' Congressional Council and the West Indian Association.[38]

In a newspaper article entitled "The Right Way to Unity" that he wrote in the last years of his life and while he was in the process of organizing the ICUL, Harrison suggested that though "there was a commendable striving on the part of prominent Negroes to attain unity for the masses," most were not "clear just what they meant by that mis-used word." Arguing that "unanimity of thought and ideas" was neither possible nor desirable, he proposed that the "masses sometimes have more effective brains in their feet than the 'intellectuals' have in their heads." Instead of trying to "enflame" the "hearts of the multitude" by trying to "unite the intellectuals at the top," he insisted, the "fire" must be lit "at the bottom of the pile. . . . Then 'your young men shall see visions'—and your young women too. And, in the meanwhile, 'where there is no vision the people perish.'"[39] Quoting Acts and Proverbs from the King James Bible despite his own disbelief in and even disgust for religion, Harrison ultimately hoped that the "visions" of the black masses, shaped by both their brains and their bodies, could kindle a "fire" of "common feeling"—a different kind of sensational response—that might change the world. By then, he had concluded that sentimental and sensational appeals to white people would not do so, and he feared the new, far-reaching damage that sentiment and sensation could do in the service of white world supremacy in the hands of media magnates such as William Randolph Hearst. Laboring in the "field of New Negro sentiment" and sensation in the first quarter of the twentieth century, Harrison honed a trenchant critique of both modalities even as he distinguished between different adaptations and transformations of the sentimental and the sensational in mass visual culture and in the visionary cultures of the black masses and other great world movements of the period.

Deportation Scenes

Radical Sensations begins with three portraits of radicals connected to the great world movements of the 1880s through the 1920s—Lucy Parsons, Ricardo Flores Magón, and Ben Fletcher—that illustrate relationships between and among movements that have often been viewed in isolation from each other. These portraits by Carlos Cortez remember, in both form and content, a long, entangled history of radical transnational movements, state violence, and struggles over sentimentalism and sensationalism. While the Cortez linocuts in the introduction look backward to the wood engravings of the Haymarket era to make connections among moments and movements, however, I want to end by foregrounding three photographs—one of Emma Goldman, another of Enrique Flores Magón and his family, and a final one of Marcus Garvey—that document the deportations of the First World War era and the 1920s. In the wake of the First World War and the Mexican and Russian Revolutions, deportation became a key weapon for state officials, who used it to clamp down on immigrant radicals and who thereby transformed radical movements in the United States, pushing them further toward the cultural nationalisms and ethnic Americanisms of the Popular Front era.

Even though the ethnic Americanisms of the 1930s were, as Michael Denning suggests, "a complex and contradictory amalgamation" of different tendencies, notably including "popular internationalism," such a "pan-ethnic internationalism was always an unstable combination, challenged by official Americanisms,

conservative anti-Communist ethnic nationalisms, and persistent racial and ethnic antagonism."[1] The Red Scares and deportations of the 1910s and 1920s help us to understand how this reorientation of radical culture around the idea of America came to be. At the same time, the more radical internationalisms and world movements of the earlier era remained an important "field of possibility" to which radicals in and after the 1930s could return in their efforts to "act in the present in the service of a new futurity."[2]

Indeed, along with imprisonment, transnational print communities, and sentimentalism and sensationalism, deportation links together many of the prime movers of these movements as well as the three parts of *Radical Sensations*. Toward the end of this period of radical cultural history, deportation was increasingly used as a tool to remove dissidents, one that allowed the state to largely sidestep issues of due process. The Immigration Act of 1918 expanded the definition of anarchism encoded in earlier anarchist exclusion laws and removed restrictions forbidding the deportation of aliens who had lived in the United States for more than five years. The Espionage Act of 1917, which was passed shortly after the United States entered the First World War, made it a crime to "willfully cause or attempt to cause insubordination, disloyalty, mutiny, refusal of duty, in the military or naval forces of the United States" or to otherwise "willfully obstruct the recruiting or enlistment service of the United States." The Sedition Act of 1919 expanded the definition of criminal activity to encompass "whoever, when the United States is at war, shall willfully utter, print, write, or publish any disloyal, profane, scurrilous, or abusive language about the form of government of the United States, or the Constitution of the United States, or the military or naval forces of the United States, or the flag . . . or the uniform of the Army or Navy of the United States." After the war had ended, the Alien Act of May 10, 1920, mandated the deportation of aliens of "certain classes," including those who had been convicted of violating the Espionage Act and other laws, if the secretary of Labor decided that such "aliens" were "undesirable residents of the United States." These laws enabled the state to target and imprison thousands of radicals and to deport hundreds, thereby suppressing or fundamentally reshaping the movements of which they were a part.[3]

Anarchists, socialists, IWW members, and black internationalists were all caught up in this dragnet, and key figures from all three parts of *Radical Sensations* were imprisoned and deported, including Emma Goldman,

Alexander Berkman, Enrique Flores Magón, and Marcus Garvey. As Goldman recalled in her memoir, *Living My Life*, "The Espionage Act resulted in filling the civil and military prisons of the country with men sentenced to incredibly long terms; Bill Haywood received twenty years, his hundred and ten I.W.W. co-defendants from one to ten years, Eugene V. Debs ten years, Kate Richards O'Hare five. These were but a few among the hundreds railroaded to living deaths."[4] But immigrant anarchists were vulnerable to both imprisonment and deportation, and Goldman herself was soon targeted by the state when J. Edgar Hoover identified her and Berkman as "two of the most dangerous anarchists in this country" and warned of the "undue harm" that would "result" if they were "permitted to return to the community" after their prison terms expired in 1919.[5] The two anarchists had been convicted of conspiring to obstruct the draft and of violating the Espionage Act because of their activities as founders of the No-Conscription League, an organization of "internationalists" and "antimilitarists" who vowed to "resist conscription by every means in [their] power," to "sustain those who refuse to be conscripted," and to serve as a "voice of protest against the coercion of conscientious objectors," because "a powerful voice and an all-embracing love are necessary to make the living dead shiver."[6]

As a young Department of Justice official, Hoover presented the case against Goldman and Berkman in their deportation hearings, and in December 1919, he invited members of the House Immigration Committee to join him as he watched Goldman, Berkman, and 249 other radicals leave Ellis Island on their way back to Russia on a ship that was dubbed the "Soviet Ark" and the "Red Ark" by the daily newspapers.[7] The *New York Tribune* found their departure "as dramatic as it was great in political significance," since it was "the first time in the history of the country that such deportation, carried out on a wholesale plan and with the cooperation of the Department of Labor, the Department of Justice, and the War Department took place." Congressman Isaac Siegel called it "an impressive sight."[8] Even though access to this deportation scene was restricted and mediated, however, views of the "Red Ark" were widely disseminated and accompanied by extensive descriptions in the daily newspapers, which emphasized the "drama" of the scene and how it was elaborately staged as a "sight" and a spectacle that aimed to impress those who witnessed it, whether in person or not, with the force of state power.

During the same period, Enrique Flores Magón became the target of

deportation proceedings while he was imprisoned at Fort Leavenworth, Kansas, where he finished a three-year sentence for violating postal regulations by mailing "obscene" material: the Partido Liberal Mexicano's newspaper, *Regeneración*. In a deportation interview that was accorded him "with a view to his deportation from the United States upon the expiration of his sentence," Flores Magón told the immigrant inspector Warren Long that he especially resented the charge that the literature he had written was "obscene," maintaining that "it is wrong to call it obscene when it is revolutionary."[9] He also said he was not going to "fight the case to remain in this country," since "if they do not want me, I do not want to stay."[10] But he asked not to be deported to Mexico, fearing that he would be killed there, and requested that he be sent to Russia instead. For a few years after he was released from Leavenworth prison in 1920, his status remained unsettled due to disagreements among officials about how to administer the laws and questions about whether anarchists of all stripes were "undesirable aliens" who should be deported. Although Inspector Long recommended that Flores Magón be deported to Mexico, Assistant Secretary of Labor Louis F. Post canceled the deportation order on grounds that Enrique was a "political refugee" for whom deportation would be a "death sentence." Post also extensively argued that the word "anarchist" should not be used as a "verbal brickbat," since it had a wide variety of meanings, and he found Enrique's theory of government, that "each country follows the sentiments of the majority of its inhabitants," perfectly compatible with the "American theory of peaceable government by the majority."[11]

Although the state often disrespected family ties in deportation cases, Post also made a sentimental appeal that Flores Magón be recognized not as a dangerous, bomb-throwing anarchist, but rather as an American father with deep roots in the nation, when he emphasized that "the alien is married and has six American-born children living in the United States."[12] A photograph of Enrique and his family, taken not long before they were deported, marks the boundaries of such an official sentimentalizing universalism around the family, however (see figure 85). Despite the attachment to place suggested by details such as the school sweater of one of the sons in the picture, the Flores Magón family was deported anyway, just a few months after Ricardo died in prison under mysterious circumstances.

It is difficult to guess exactly in what forms and how extensively this photograph of the Enrique Flores Magón family circulated. Held at the International Institute for Social History (IISH), in Amsterdam, it bears

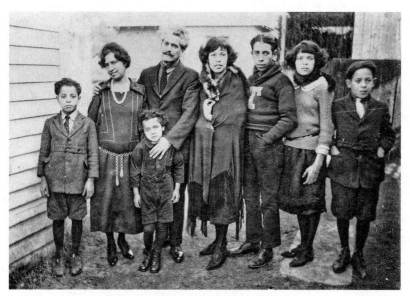

FIGURE 85 Enrique Flores Magón and his family just before deportation. Courtesy of Collection International Institute of Social History, Amsterdam.

an inscription with a dedication to Emma (Goldman?) on the back, once again connecting the struggles of radicals across space and time. The inscription suggests that this photograph was a memento of radical struggle that circulated among friends and fellow travelers, but it also may have been produced to publicize the family's plight and rally others to the cause of trying to prevent their deportation. This photograph may have been a part of the Flores Magón family's memorabilia, but now that it is part of the IISH's international archive of social movements and freedom struggles, it reminds a world of strangers about how the deportations of radicals in the United States in the First World War era pressured transnational ties and affiliations and reshaped U.S. social movements into more distinctly nationalist configurations.

The photograph is an example of one of the most popular genres of contemporaneous photography, the family portrait, but one that starkly reveals that, in Laura Wexler's words, "the formal principles of family photography can only evolve in relation to the political principles that govern the recognition of families in the first place."[13] Since the state ultimately did not recognize the Magón family as a part of the national family, it is not surprising that in its "staging of affect," this family photograph reveals some of the "hierarchies of domesticity" as well as the limits, blind spots,

and exclusions of white, middle-class, nationalist, sentimental ideologies of family.[14] The photograph shows Enrique surrounded by his family, standing outside a small house or building that might have been where the Flores Magón family was living in 1922 or 1923, as they awaited the state's decision about their future. In his deportation hearing, in 1920, Enrique stated that his "wife" Teresa and their six children resided at 1120 East Twenty-Eighth Street in Los Angeles, but according to other accounts in 1922 the family was living in a back house at 1098 Exposition Boulevard. This change in residence suggests that the family was probably experiencing financial hardships due to Enrique's imprisonment and impending deportation: the family home, in these contexts, is an unstable structure and one that registers fissures in dominant narratives of domesticity.

Although in his deportation hearing Enrique answered yes when asked if he was married, and although he identified "Mrs. Teresa V. Magón" as his "wife," it is unclear whether they were legally married, and Teresa is more often referred to as Enrique's "compañera" or "companion" than as his wife. In *The Decolonial Imaginary* Emma Pérez also calls Teresa Arteaga Enrique's longtime "companion" and distinguishes her from his "former wife," Paula Carmona de Flores Magón. The Flores Magón brothers and other PLM members experimented with alternative, communal living arrangements that violated the norms of white bourgeois domesticity, which called for husband, wife, and children to live together in a single-family dwelling. From 1914 to 1916, Enrique and Teresa lived on a communal farm in Los Angeles with several other PLM members, including Ricardo and his companion, Maria Talavera, whom he never married. The PLM criticized the institution of marriage as a kind of prostitution sanctioned by law, especially when it was loveless, and Pérez explains that like many male anarchists at this time, such as Peter Kropotkin, the Flores Magóns combined such a critique of marriage with the belief that women were instinctive nurturers whose "destined sphere" was the "home," even though Pérez also points out that *Regeneración* ran many articles on women's issues, including some written by women, and thereby "opened a space for a feminist politics within the (inter)nationalist agenda."[15] In Enrique's deportation hearing, it would not have been expedient to introduce such complexities or to explain that Teresa was really his companion, not his wife: his chances for avoiding deportation or of keeping Teresa and his family with him if he were deported apparently depended partly on avoiding such a discussion and successfully performing the role of husband and father in

the interview, although he was still deported even though the paper trail suggests that officials believed what he said.

Whether they were legally married or not, the relationship between Enrique and Teresa appears not to have been loveless. Although in the photograph their heads are slightly tilting away from each other, Enrique's right arm encircles Teresa's shoulder, while with the other hand he reaches down to hold his youngest son in position for the camera. Despite their hardships, all of the members of the family are elegantly dressed: Enrique and the boys wear ties, sweaters, and jackets, while the women are adorned with jewelry and fur scarves. Still, the family's pose is somehow off-kilter. They look off in different directions: Enrique, Teresa, and two of the boys stare at the camera, while the other four family members look at something to the left of the frame. This is not a carefully composed studio portrait of a white, middle-class family, but rather a family portrait made under less than ideal circumstances, probably taken outdoors to take advantage of the natural light: it is marked by hierarchies of domesticity and newly sharpened legal distinctions between natives and aliens that make it look different than most other family photographs of the era.

That the family portrait was taken outdoors, in front of a modest structure, on a mostly bare patch of dirt, emphasizes the family's imminent homelessness and forced departure from the city where all but one of the six children had been born. All of the members of Teresa's and Enrique's family look serious and sad: stiffly posed, the older boys' hands are in their pockets, while the two youngest boys frown at the camera, arms at their sides, the littlest one looking as though he is tired of posing and might soon try to break away. The expressions on the faces of the two girls are more neutral: even as they pose for the camera, they look off to the side with interest, as though something happening nearby has caught their eye. Both Teresa and Enrique make more of an effort to engage the viewer of the photograph, looking out at us in a mute but eloquent appeal for recognition and justice across space and time. Their tilted heads suggest that they are just barely still standing and might easily fall down and collapse: Enrique appears particularly weary. Dressed mostly in black, the family seems to be mourning many things at once, including the official deportation ruling and perhaps also Ricardo's recent death.

The title of a *Los Angeles Times* article on their deportation, "Magón Family Says Adios: Socialistic Circle's Activities Expected to Subside with Deported Leader's Departure," might have served as an apt caption for this

photograph, had it appeared in that newspaper, as well as a gloss on the limits of state sentimentality in regard to the family. On March 2, 1923, the paper reported that Enrique, his "wife," and their children had departed for Mexico City on the previous day. After Post became the target of congressional inquiries into his "leniency," the Department of Labor reversed his decision and authorized Enrique's deportation to Mexico in late 1922 as an "undesirable alien." As the Los Angeles Times noted, Enrique's brother, Ricardo, had died in Leavenworth prison only a few months earlier, which made the deportation scene in Los Angeles even gloomier, despite the massive crowds that met Ricardo's funeral train, paid for by the workers of the Federation of Railway Unions, as it stopped in towns throughout Mexico.

But the intense support that thousands of workers displayed for the brothers and their movement changed the Flores Magón family's deportation scene and may have made U.S. officials especially eager to see them go quietly. In any case, when, according to the Los Angeles Times, Enrique "asked as a personal favor" that he be allowed to go back to Mexico City, unaccompanied by any officials of the immigration department to the border, this "privilege was accorded him." Thus instead of being forced to participate in a humiliating public spectacle of deportation, he and his family were "checked out" by immigration officials in El Paso, Texas. But in the wake of Ricardo's death and the return of his body to Mexico, Enrique returned to Mexico as a hero rather than as a criminal. He and Teresa soon went on a speaking tour of Mexico in which thousands turned out to see them, thereby casting into relief both the gloomy deportation family portrait and the potentially humiliating deportation scene that the family successfully avoided. According to the historian Elizabeth Norvell, when Enrique visited Veracruz, Mexico, soon after he and his family left Los Angeles, a group of workers welcomed him by presenting his brother Ricardo's play Tierra y Libertad, a sensational melodrama of direct action that authorizes ongoing revolution. Once the Flores Magón family arrived in Mexico, then, the scene shifted because it was re-envisioned by workers and others who remembered Ricardo and the PLM and turned it into a scene of victory rather than of defeat.[16]

Of all these deportations, Marcus Garvey's was the most public and visible. A photograph (see figure 86) captures him on that rainy day, December 2, 1927, stepping on board the S.S. Saramacca, the United Fruit Company ship that transported him from New Orleans to Panama, where he was transferred to another ship that took him back to Kingston,

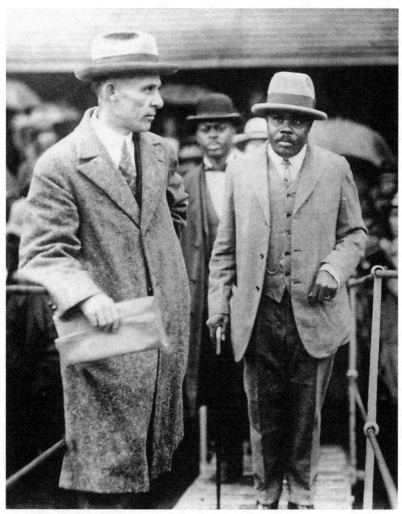

FIGURE 86 Marcus Garvey's deportation from New Orleans. Courtesy of Everett Collection / SuperStock.

Jamaica. The state opened a deportation case against Garvey in the wake of his conviction for mail fraud, and a warrant for his deportation was issued on June 25, 1926. Since Garvey was not a U.S. citizen, he, like Flores Magón, Goldman, and Berkman, could be deported as an "undesirable alien." After President Coolidge commuted Garvey's five-year sentence, the *Chicago Defender* reported, "the colorful figure who caused a sensation with his gigantic program of a 'Back to Africa' movement" was released from the Atlanta federal penitentiary and "turned over to agents for immediate deportation" from New Orleans, where "five hundred of his fol-

lowers crowded the wharves to say good-by." This crowd was comprised of "men, women and children" who "marched in single file during a steady downpour of rain on one of the coldest days of the year to press the hand of their leader and hear what he had to say."[17] Although he was permitted to address the crowd, according to the *Baltimore Afro-American*, Garvey "was accompanied by immigration officials, who never left his side until he was safely outside of the United States' jurisdiction."[18] Thus while Flores Magón's family was allowed to leave the United States without an official escort, such a privilege was not extended to Marcus Garvey, although he was, surprisingly, granted the small liberty of saying a few words to the many members of his movement who came to see him off.

Speaking to the crowd while "standing bareheaded in the driving rain," Garvey turned the humiliation of the deportation ritual into a public stage where he expressed "heartfelt" thanks to "his supporters and friends and to the American public in general" for their support during his trial and imprisonment, which he regarded as "wonderful testimony of the knowledge they have of my innocence."[19] The photograph shows Garvey boarding the ship wearing what the *Chicago Defender* called a "snappy tailored light brown checked suit" and carrying a "silver-headed Malacca cane." The policing presence of immigration officials is also visible in the figure of the white man in the foreground who dominates the frame, looming large in the photographic scene. But in the background, a black man wearing a hat, suit, and bow tie just behind Garvey and in front of the crowd, whose umbrellas are faintly visible, watches Garvey with an alert, protecting look. The *Los Angeles Times* observed that a committee of UNIA officers from New York, Chicago, Cincinnati, Cleveland, and Pittsburgh showed up to witness Garvey's exit from the United States, and the story's headline, "Negro Sails Away in Triumph," suggests that Garvey, the crowd, and the UNIA leaders ended up stealing the scene from the state.[20] In other words, within the constraints of the official deportation scene, Garvey was able to take some control over his own image and to emphasize his large and enthusiastic following—the movement that he still led, along with his wife, Amy Jacques Garvey—both in the United States and Jamaica, where *Negro World* claimed he was met by thousands of Jamaicans, a parade, and a "monster mass meeting."[21] The presence of a waiting crowd comprised of hundreds of black people and the arrival of key UNIA officials in New Orleans perhaps pressured the officials who guarded him to let him speak to his followers in hopes that they would eventually disperse.

Scene stealing was a more challenging task for Alexander Berkman and Emma Goldman in December 1919, when they were deported to Russia on the *Buford*, a former British steamship the United States had deployed in the Spanish–American War. According to the newspapers, strict censorship was maintained at Ellis Island in the days leading up to the sailing of the Red Ark, and the images that remain to document the detention and mass deportation of the radicals are few, heavily mediated, and at some distance from the deportation scene. But Goldman, especially, used her trial and its aftermath to condemn what she called the sensational methods of the police and the press as well as the hypocrisy of the accusations that she believed in violence and had declared that anarchists would use violence. She also drew on discourses of sentiment and sensation to elaborate alternative visions of the future and to urge people to sustain a "righteous passion for justice" and be a "power" in the world even if it put them at odds with state power. Her writings, speeches, and performative gestures extend and expand the deportation scene beyond the heavily censored views that were authorized by officials and politicians and beyond the narrow temporal boundaries of the event itself.

In doing so, Goldman was remembering Haymarket. Like the Chicago Haymarket anarchists, during her trial in 1917 Goldman turned the tables on her accusers, charging the state with sensationally inciting and inflaming the violence it attributed to the anarchists. Although she originally declined to take part in the trial, when "active participation" was "thrust" upon her, she and Berkman decided to defend themselves in order "to wring from our enemies every chance to propagate our ideas," so that, for "the first time since 1887," anarchism would "raise its voice in an American court."[22] In her address to the jury, Goldman called the circumstances of her arrest "sensational enough to satisfy the famous circus men, Barnum & Bailey," since police charged in while she and Berkman were "quietly at work at their desks, wielding not a sword, nor a gun or a bomb, but merely" their "pens."[23] She also cited her own essay "The Psychology of Political Violence," in which she argued "it is organized violence on top which creates individual violence at the bottom." As well, she insisted on the political necessity of feeling something in response to these forms of organized violence, maintaining that those who remained "indifferent to the crimes of poverty, of war, of human degradation, are equally responsible for the act committed by the political offender."[24]

One such mode of political feeling, she asserted, was the "righteous

passion for justice which can never express itself in human slaughter—that is the force which makes the conscientious objector." State officials and leaders were hypocrites, Goldman suggested, because they violently punished such a passion for justice, misrecognizing it as a passion for violence, and such a response was hardly worthy of a nation that claimed it made war to make the world safe for democracy. How could the "world take America seriously," Goldman wondered, "when democracy at home is daily being outraged, free speech suppressed, peaceable assemblies broken up by overbearing and brutal gangsters in uniform; when free press is curtailed and every independent opinion gagged"? Echoing charges of state hypocrisy made by black internationalists and antilynching advocates such as Hubert Harrison, Goldman finally inquired, "Verily, poor as we are in democracy, how can we give of it to the world?"[25]

Despite this eloquent appeal, the jury found Goldman guilty of violating the Espionage Act and she soon began serving a two-year prison sentence in Missouri. The judge also recommended to immigration officials that she and Berkman be deported when their prison terms expired. Berkman refused to participate in his deportation hearing, which occurred while he was imprisoned in the federal penitentiary at Atlanta, but Goldman initially decided to make a "fight" in order to "publicly disclose the utter hollowness of American political claims and the pretence that heralded citizenship as a sacred and inalienable right" (703). Once she saw what a "farce" the proceedings were, however, she, too, refused to answer any questions, remaining silent until the end of the hearing, when she handed officials a statement protesting "with all the power and intensity of my being" the "star chamber proceedings" and the deportations, which exiled "those who do not fit into the scheme of things our industrial lords are so eager to perpetuate."[26]

While Goldman performed a meaningful silence at her deportation hearing, she used her writings and speeches to move people to act and to inflame a righteous passion for justice in other situations. As she recalled in Living My Life, the "Federal deportation mania was terrorizing the foreign workers of the country and there were many calls on me to speak on the matter." In the weeks before they were ordered to appear at Ellis Island, she and Berkman held "monster demonstrations," in Chicago, Detroit, and elsewhere, that were attended by thousands, whom Goldman described as a "collective soul, thrilled by new hope and aspiration." In her memoirs, she remembers thinking it might be her "last opportunity to raise my

voice against the shame of my adopted land."[27] And while Goldman, Berkman, and the other radicals waited to be deported, thousands of people marched in the streets of New York City wearing manacles to protest the impending event and scores of supporters sent Goldman silk stockings and other gear to protect her from the harsh Russian winter.

During their time at Ellis Island, Goldman and Berkman wrote a pamphlet, entitled *Deportation, Its Meaning and Menace: Last Message to the People of America* (1919), in which they deplored continuing state violence and pointed out that, although the world war was over, on "a score of fronts human slaughter is going on as before; men, women, and children are dying by the hundred of thousands because of the blockade of Russia; the 'small nations' are still under the iron heel of the foreign oppressor; Ireland, India, Egypt, Persia, Korea, and numerous other peoples, are being decimated and exploited even more ruthlessly than before the advent of the Great Prophet of World Democracy; 'self-determination' has become a by-word, nay a crime, and world-wide imperialism has gotten a strangle hold upon humanity." In addition to the world problems of colonialism and imperialism, state violence also continued to be a domestic problem in Woodrow Wilson's United States, the authors insisted, since "alleged war necessity" had been used "to incorporate in the statute books new laws and new legal principles that would remain operative after the war, and be effective for the continued prohibition of governmentally unapproved thoughts and views." This "practice of stifling and choking free speech and press, established and tolerated during the war, sets a most dangerous precedent for after-war days," they predicted as they called attention to the contradictions between deportation and democracy and emphasized how wartime laws and principles were used after the war to police the free expression of thoughts and views. Because Goldman and Berkman believed the manuscript would be confiscated by Ellis Island authorities, they wrote it at night while their roommates kept watch, then discussed what they had written during their morning walks and exchanged suggestions. Finally, Berkman made the necessary revisions and had a friend smuggle it out.[28]

Newspaper stories about the radicals' detention at Ellis Island and their deportation also dwell on this pervasive climate of surveillance and censorship suggested by Goldman's story of the secret writing of the pamphlet. In the days leading up to the event, journalists speculated daily about the "special trains" of radicals that were arriving from other parts of the country to Ellis Island to be deported in the wake of Department

of Justice raids on "Red" hotbeds. But the *New York Times* emphasized that "strict censorship" prevailed at Ellis Island, for the time of departure was kept secret and the captain's orders about the deportees' destination were to remain sealed until twenty-four hours after the ship left the United States. The day before the ship sailed, the *Los Angeles Times* reported that "a thick veil of secrecy was thrown about preparations for departure and passes to the piers where the ship is docked were cancelled."[29] Finally, in the middle of the night, the deportees were alerted to their imminent departure and over the course of the next few hours were taken by a tugboat, the *Immigrant*, to the larger ship that would take them to Russia. Making the immigration-in-reverse narrative explicit, the *New York Times* reporter observed that with their belongings bundled up at the water's edge, the deportees looked like a "party of immigrants" arriving "in the new land of opportunity," except that "there was none of the materials from which Americanism is made" in their "sullen faces" or the "conversation."[30]

In the end, officials kept the press at some distance from the deportation scene, "spiriting" the radicals "away," as Goldman would later put it, at an hour when few people were stirring and as the first rays of sunlight had just begun to break up the darkness. Although officials and politicians insisted on personally witnessing the scene, they mostly kept the public in the dark about it, preferring to provide their own accounts of the details of the scene to newspaper writers. The illustrations that were used most often in the press featured the ship itself, such as a *New York Tribune* photograph of the *Buford* that was accompanied by the caption "The Statue of Liberty smiled approvingly as the Soviet Ark, the US transport ship Buford, set out for an unknown port last Sunday with a cargo of 249 alien anarchists— among them Alexander Berkman and Emma Goldman—the first shipload in Uncle Sam's campaign of deporting radicals" (1919). On the day the ship left for Russia, the *New York Times* rejoiced that those who had been found "guilty of seeking the overthrow of American ideals and institutions" had "passed out to sea while the city slept," "without the slightest chance to pose as the martyrs they considered themselves to be."[31] As in the case of the Haymarket anarchists at the beginning of our period of radical cultural history, in the case of Goldman's and Berkman's deportation the state orchestrated a heavily mediated and policed but widely disseminated spectacle of punishment (see figure 87) with clear disciplinary aims but unexpected consequences, as such scenes have also inspired radical cultural memories of histories of rebellion and revolution down through the years.

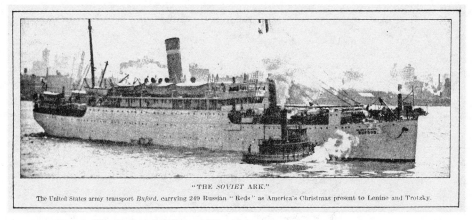

"THE *SOVIET* ARK."

The United States army transport *Buford*, carrying 249 Russian " Reds " as America's Christmas present to Lenine and Trotzky.

FIGURE 87 "The *Soviet* Ark," *Literary Digest*, January 3, 1920.

Although a fleeting glimpse of Goldman can be seen in a period news-reel, there are no photographs of her at the moment of getting on the boat, no spectacle of the *Buford* deportees that includes the faces of those who were being sent away: the spectacle of state power anchored in remote views of the former warship turned deportation vessel would have to suffice, distant views that symbolize the deportation itself and anticipate the ship's disappearance on the horizon. But in the days leading up to their deportation, Goldman remembered, "we were photographed, finger-printed, and tabulated like common criminals."[32] Augustus F. Sherman, a clerk and assistant to Commissioner of Immigration Caminetti, as well as an amateur photographer, even took a picture of Goldman while she was awaiting deportation, along with over two hundred photographs of other detainees (see figure 88). While in many of his photographs Sherman asked his subjects to dress in distinctive outfits in order to construct them as representative types, in his photograph of Goldman she wears a simple black dress with a lace decoration at the throat and confronts the camera with a dour stare. Although Sherman rarely attached names to his portraits, the handwriting across the top of this photograph clearly identifies the subject as "Emma Goldman" who was "deported SS Buford-December 31 1919," and as a "Russian Jewish Anarchist," a category into which could be placed many others who passed through Ellis Island. Thus the image is part of a genre of state repression photographs, suggesting a taxonomizing gaze that marks Goldman in terms of national origin, religion, and political beliefs, but which she challenges with her own fierce look.

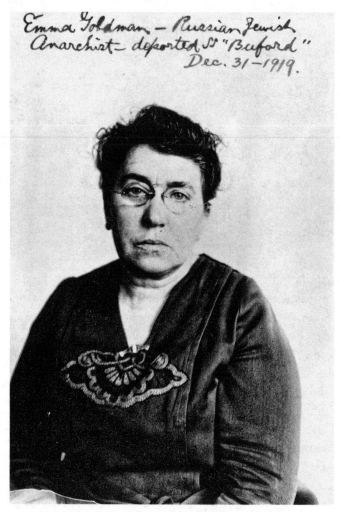

Emma Goldman — Russian Jewish Anarchist — deported S^s "Buford" Dec. 31 – 1919.

FIGURE 88 Emma Goldman deportation photo. Courtesy of Getty Images.

Perhaps she looked something like this when she boarded the *Buford* in the early hours of December 21, 1919. Goldman remembers the corridor at Ellis Island suddenly filling with "State and federal detectives, officers of the Immigration Bureau and Coast Guards," with "Commissioner General of Immigration" Caminetti in the lead. After being ordered to line up and march, she reports, the deportees moved along one by one, "flanked on each side by the uniformed men, curses and threats accompanying the thud of their feet on the frozen ground."[33] The *New York Tribune* reported that Goldman, who was "dressed in mourning Black," ap-

peared "to be the calmest of the lot and seemed rather bored with the entire proceeding."[34] On the other hand, the *Chicago Daily Tribune*, which also noted that Goldman and the other two women were dressed in "deep mourning Black," claimed that "although flanked on either side by husky, khaki clad, and fully armed marines," Goldman "shouted, 'This is the beginning of the end of United States! I shall be back! We shall all be back! I am proud to be among the first deported! The czar in all his career never treated his subjects as we are being treated!'"[35] It was also reported that on her way out Goldman announced plans to organize a movement called the Russian Friends of American Freedom. In her memoir, she explained that since the "American Friends of Russia" had "done much to help liberate that country," it was "now the turn of free Russia to come to the aid of America."[36] According to the *Washington Daily Post*, after Goldman and the others had boarded the *Buford*, the "motley crowd on the decks of the steel gray troopship shouted 'Long live the revolution in America!'" as the ship "churned her way past the Statue of Liberty."[37]

Like the *New York Tribune* and the *Washington Daily Post*, Goldman and other radicals were also struck by the proximity of the Statue of Liberty to the deportation scene. While the *Washington Daily Post* imagined the statue smiling on the scene of the "Soviet Ark" departing for Russia, however, radicals presented darker visions of this juxtaposition, depicting it as a backward inversion of the stereotypical immigrant narrative and its iconography as it was being invented in this period through films such as Charlie Chaplin's *The Immigrant* (1917). In the February 1920 issue of the *Liberator*, an illustration depicting a thick stream of smoke from the *Buford* obscuring the head of the statue shows how radicals made use of this juxtaposition in visual culture. And in *Living My Life* Goldman emphasizes her own backward look at the statue as she was sent away on the *Immigrant* to be transferred to the *Buford*. Sitting at the ship's porthole, she sees "the great city, receding into the distance, its sky-line of buildings traceable by their rearing heads" and can scarcely believe that it is indeed her "beloved city, the metropolis of the New World." Dizzily envisioning "America" repeating the scenes of tsarist Russia, she suddenly "glance[s] up" and sees the "Statue of Liberty!"[38]

Goldman's account of the deportation scene intervenes in practices of looking by emphasizing her backward view of the paradigmatic iconography of immigrant arrival in order to illustrate the threat deportation posed to democracy. Recalling Walter Benjamin's last angel of history, the

backward view of the Statue of Liberty from the perspective of the deportee undermines myths of U.S. democratic progress and exceptionalism. Her revision of the deportation scene reminds us of all the other radicals who were imprisoned and deported during these years; of how sentiment, sensation, and an emergent, mass-mediated visual culture both enabled and constrained their efforts to imagine different and better worlds; and of how imprisonment and deportation reshaped the boundaries of U.S. radical movements and prepared the way for the cultural nationalisms and ethnic Americanisms of the Popular Front era, despite still active legacies of earlier movements, persistent histories of solidarities made below and beyond the level of the nation-state, and enduring transnational visions of justice.

NOTES

INTRODUCTION

1. On adaptation as part of a comparative method, see Gillman, "Otra vez Caliban / Encore Caliban." Gillman suggests that "comparability entails a theory of space (meaning geography and place) and time (meaning temporality and history) that would recognize the 'palimpsestuous' quality of the present, where multiple times exist simultaneously within and across the same places, or coexist as uneven temporalities" (193). See also Seigel, "Beyond Compare."

2. Throughout, in theorizing cultural memory I draw on Marita Sturken's *Tangled Memories*. Sturken distinguishes cultural memory from both "personal memory" and the "history" that is "valorized by institutional frameworks or publishing enterprises" (4). She defines it as "a field of contested meanings in which Americans interact with cultural elements to produce concepts of the nation, particularly in events of trauma, where both the structures and the fractures of a culture are exposed" (2–3). She persuasively analyzes how memory is often produced by and through images and how it always involves both remembering and forgetting. While Sturken focuses on contested meanings around the nation, I examine alternative archives and subjugated knowledges that emerge in relation to transnational movements, international conflicts, and global visions from the 1880s through the 1920s. See also Yoneyama, *Hiroshima Traces*.

3. Fletcher was, however, far from being the only black radical to be prosecuted during this era. See Kornweibel, *"Investigate Everything."*

4. Trautmann, *Proceedings of the First Convention of the Industrial Workers of the World*, 170.

5. Eugene Nelson, "Introduction," 5.

6. Avrich, *Anarchist Portraits*, 211. This letter, which was written on November 20, 1920, continues: "Fortunately, the number of the advocates of 'Art for Art's sake' is negligible, and there is no danger of Art ever foundering in its turbid waters. Life in its myriad manifestations is against that absurd school, and so long as man continues to be a being built up of blood, and sinews, with a heart, and brains, Art shall exist, the genuine Art which you conceive, my good comrade, 'with meaning and depth, true and beautiful.'" See Archivo Electrónico Ricardo Flores Magón, http://www.archivomagón.net. This letter can be found by following the links to "Obras Completas" and *"Correspondencia (1899–1922)."*

7. Ricardo Flores Magón, letter to Lily Sarnow, October 15, 1922. See "Correspondencia (1899–1922)" at http://www.archivomagón.net.

8. In his recent book *The Trial of the Haymarket Anarchists*, Timothy Messer-Kruse, who uses the transcript of the trial as his major source, concedes that "extensively using speeches and publications as evidence" is a "questionable practice" but argues that it remains a feature of today's judicial order and that although it "falls short of what counts as fair and just today, the Haymarket defendants were accorded the rights and protection generally recognized by courts in the Gilded Age" (180). While Messer-Kruse's careful attention to the transcript sheds new light on the trial itself, it also privileges a juridical framing of the meaning of Haymarket as well as the accounts of police officers, such as Captain Michael Schaack, who was hated and feared by movement radicals. Messer-Kruse also paints a very sympathetic portrait of Judge Gary and seems to endorse the argument of Benjamin Magruder, author of the decision of the Illinois Supreme Court that upheld the anarchists' conviction, that the anarchists' publications would not have been admitted if that were "the only evidence of encouragement of the crime" (144). As Messer-Kruse summarizes, "had there been no larger conspiracy aimed at bombing police on the night of Tuesday, May 4, the anarchists could not have been tried just for extolling the virtues of dynamite, even if these words had inspired the bomber" (145). This rather circular argument begs the question of why anarchist literature would need to be introduced as evidence if the existence of a "larger conspiracy" could be proven in other ways; neither does it acknowledge the complicated relationships and mediations between written words and actions. Messer-Kruse argues that the preponderance of evidence suggests that "Chicago's anarchists were part of an international terrorist network and did hatch a conspiracy to attack police with bombs and guns that May Day weekend" (8), but his discussion of the anarchists' views of violence are decontextualizing: they elide the history of police and state violence that preceded and contributed to this moment of crisis, and too quickly dismiss the anarchists' many statements that they reluctantly advocated violence only in response to state and police violence rather than advocating violence as an end in itself. I agree with Messer-Kruse, however, that it is important to see the Haymarket anarchists as "actors" rather than only as "victims" (8).

9. For an English translation of this manifesto, which originally appeared in *Regeneración* on March 16, 1918, see "Manifesto to the Anarchists of the Entire World and to the Workers in General," trans. Chaz Bufe, in Flores Magón, *Dreams of Freedom*, 145–47.

10. Peter Cole makes this connection in his introduction to *Ben Fletcher*, 21. He also provides an account of Fletcher's trial and imprisonment that I draw on here. See also Cole's *Wobblies on the Waterfront* for the best account of Fletcher's activism as well as his arrest, trial, and imprisonment.

11. Fred Thompson, "Ben Fletcher Remembered," *Industrial Worker*, August 1981, 5.

12. Industrial Workers of the World, *The History of the IWW*, 29. The pamphlet also

claimed that "The Spanish IWW paper, for instance, is a great factor in Mexico, and Central and South America. The IWW preamble has been printed in Greek, Chinese, Japanese, and other languages. The internationalism of the IWW is evident in the character and circulation of its publications . . . [and in its] affiliations with labor organizations all over the world" (26).

13. Cited in Cole, "Introduction," 20.

14. "A New Poster Available," *Industrial Worker*, October 1974, 2.

15. Cortez purposefully used cheap materials and sold his work for cheap prices. The linocut is linked to the world of cheap reproductions. As a form of print permitting editions of multi-originals, linocuts and woodcuts have been popular since the mid-nineteenth century.

16. See Rosemont and Roediger, *The Haymarket Scrapbook*, for many examples of these and other Haymarket images.

17. Cortez, *Viva Posada*, 11. Cortez calls attention to Posada as an artist who "illustrated broadsides and periodicals with hand-carved plates using the technique of woodcut or wood-engraving as well as engraving on metal." He observes that Posada "did his carving directly on type lead and later—when the photo-engraving process gave him competition—he switched over to relief-engraving, drawing directly on zinc with acid-resistant ink, after which the plate was treated with acid" (5). Thus Posada introduced zinc engraving to Mexico, making possible strong effects in which black lines crisscross each other, which Cortez emulated. See also Frank, *Posada's Broadsheets*; Ades, "Posada and the Popular Graphic Tradition"; Ades and McClean, *Revolution on Paper*, 12–21. In his work for Vanegas Arroyo, Posada "almost exclusively used" a technique that involved "engraving on type metal (a lead alloy)" and that produces results similar to linocuts. See Berdecio and Appelbaum, "Introduction," xvii.

18. Verter, "Chronology," 344.

19. On Hearst and the Spanish–American War era, see Kaplan, *The Anarchy of Empire in the Making of U.S. Culture*, 146–70.

20. Walker C. Smith, "Introduction," *Mr. Block: Twenty-Four IWW Cartoons* by Ernst Riebe, ed. Franklin Rosemont (Chicago: Charles H. Kerr, 1913; 1984), 1.

21. Carlos Cortez, "The Funnies Ain't Funny No More," *Industrial Worker*, September 16–October 15, 1980, 6.

22. Ibid.

23. Goldsby, *A Spectacular Secret*, 52.

24. For an analysis of the role of illustrations in other African American periodicals of the era, such as *The Crisis, Opportunity, Survey Graphic, The New Negro*, and *Fire!*, see Carroll, *Word, Image, and the New Negro*. See also Baker, *Modernism and the Harlem Renaissance*. Barbara Foley also analyzes several images from the *Messenger* and the *Crusader* in *Spectres of 1919*, 54–69. See also Kornweibel, *No Crystal Stair*.

25. On sentimentalism, sensationalism, and melodrama in the Americas, see especially Luis-Brown, *Waves of Decolonization*; Gillman, "The Epistemology of

Slave Conspiracy," "Ramona in Our America," and "The Squatter, the Don, and the Grandissimes in Our America"; and Lomas, *Translating Empire*. Doris Sommer's *Foundational Fictions* is indeed foundational for much of this work. Luis-Brown's analysis of sentimentalism and melodrama and how both "traveled across national boundaries into new cultural and historical contexts and occasionally crossed into the hands of the lower classes and colonized" is especially rich and insightful (*Waves of Decolonization*, 37).

On sentiment, sensation, race, and visual culture, see Berlant, *The Female Complaint*; Joshua Brown, *Beyond the Lines*; Klein, *Cold War Orientalism*; Jane Gaines, *Fire and Desire*; Goldsby, *A Spectacular Secret*; Nudelman, *John Brown's Body*; Wexler, *Tender Violence*; Williams, *Playing the Race Card*. On sensationalism, melodrama, and mass visual culture, see also Entin, *Sensational Modernism*, and Singer, *Melodrama and Modernity*. See also Moten, "Black Mo'nin'" and *In the Break*; and Ioanide, "Story of Abner Louima."

26. I elaborate on the sentimental and the sensational in relation to the U.S.-Mexico War of 1846–48 in *American Sensations*.

27. Foucault, *"Society Must Be Defended": Lectures at the College de France, 1975–1976*, 34. On the "coincidence of violence and law constitutive of sovereignty," see Agamben, *Homo Sacer: Sovereign Power and Bare Life*, 34.

28. Joel Olson, "Between Infoshops and Insurrection: U.S. Anarchism, Movement Building, and the Racial Order," 7. See also Olson, *The Abolition of White Democracy*. In many cases, these radicals criticized different versions of what Glen Coulthardt calls a "liberal politics of recognition," which accommodates oppositional identities, movements, and political orders by reconciling them with the state in ways that reinforce and even intensify state power. See Coulthardt, "Subjects of Empire: Indigenous Peoples and the Politics of Recognition in Colonial Contexts," 437. Thanks to Jayna Brown for calling my attention to these sources.

29. On literatures and cultures of black radical internationalism, see Baldwin, *Beyond the Color Line and the Iron Curtain*; Edwards, *The Practice of Diaspora*; Kelley, *Freedom Dreams*; Robinson, *Black Marxism*; Singh, *Black Is a Country*; and Stephens, *Black Empire*. On transnational print networks, empires, and anti-imperialisms in the Americas, see Anderson, *Under Three Flags*; Bauer, *The Cultural Geography of Colonial American Literatures*; Brickhouse, "Autobiografia de un esclavo, el negro mártir, and the Revisionist Geographies of Abolitionism," "Hemispheric Jamestown," "L'Ouragan de Flammes (The Hurricane of Flames)," and *Transamerican Literary Relations and the Nineteenth-Century Public Sphere*; Gruesz, *Ambassadors of Culture*, "America," "Delta Desterrados," "The Gulf of Mexico System and the 'Latinness' of New Orleans," and "The Mercurial Space of 'Central' America"; and Lazo, *Writing to Cuba*. On questions of method in American Studies work on the Americas, see Gruesz, "Translation: A Key(word) into the Language of America(nists)."

30. Work on the "multi-valiant intimacies" of colonialism and empire by Lisa Lowe, Nayan Shah, Ann Laura Stoler, Tiya Miles, and others is also helpful in under-

standing these transnational connections and disconnections. See Lowe, "The Intimacies of Four Continents"; Miles, "His Kingdom for a Kiss"; Shah, "Adjudicating Intimacies on U.S. Frontiers"; and Stoler, "Tense and Tender Ties." For other important transnational histories, specifically of the 1920s, see Sinha, *Specters of Mother India*, and Temkin, *The Sacco-Vanzetti Affair*.

31. In *Under Three Flags*, Anderson suggests that "the Spanish American nationalist independence movements are inseparable from the universalist currents of liberalism and republicanism" (1).

32. In understanding Martí as a sentimental man, I also follow the lead of José David Saldívar, who suggested to Chapman and Hendler that Martí was another good example of the "intimate and active links between masculinity and sentimentality" documented in their influential anthology. See Chapman and Hendler, *Sentimental Men*, 13 and 16n43. See also Gillman, "The Epistemology of Slave Conspiracy," and Luis-Brown, *Waves of Decolonization*, 36–37, 72–80.

33. The sentimental and the sensational modes are also connected, moreover, to a broader set of debates that have been taking place for quite a while now across several different fields, especially political theory and gender and sexual studies, about the role of affect and feeling in political life. Among many diverse examples and discussions, see Ahmed, "Affective Economies" and *The Cultural Politics of Emotion*; Berlant, *The Queen of America Goes to Washington City*; Clough and Halley, *The Affective Turn*; Cvetkovich, *An Archive of Feelings*; Hardt, "Affective Labor"; Massumi, *Parables for the Virtual*; Muñoz, "Feeling Brown"; Puar, *Terrorist Assemblages*; and Sedgwick, *Touching Feeling*.

34. See Sturken and Cartwright, *Practices of Looking*, and Joshua Brown, *Beyond the Lines*. In thinking about the category of visual culture in the nineteenth century, a useful collection is Schwartz and Przyblyski, *The Nineteenth-Century Visual Culture Reader*. See also Crary, *Techniques of the Observer*; Gonzalez-Day, *Lynching in the West, 1850–1935*; Harris, "Iconography and Intellectual History"; Shawn Michelle Smith, *Photography on the Color Line*. A useful interdisciplinary reader of visual culture is Mirzoeff, *The Visual Culture Reader*. See also Tejada, *National Camera*.

35. Literary and cultural forms that could travel and take on new significance in diverse locations, especially new forms of visual culture such as photographs and political cartoons, were crucial components of these movements, helping to create networks above and beyond the level of the nation.

36. Schreiber, *Cold War Exiles in Mexico*, xiii. For some useful reflections on the category of the transnational, see Briggs, McCormick, and Way, "Transnationalism." As the authors note, "One can say a great many contradictory things about what is wrong with transnationalism and they will all be true about someone's transnationalism" (626). They note that transnationalism in itself is neither automatically radical nor automatically reactionary, and they trace a genealogy of the term through three intellectual traditions in which it has been helpful: the work of "anticolonial thinkers, from Fanon and Wallerstein to peas-

ant and subaltern studies" (628); scholarship on gender, race, and ethnicity; and labor history and migration. They find the term *transnational* especially useful in "making the nation and nationalism an explicit question" (644) rather than reifying them. Other valuable ideas about the possibilities and perils of the term *transnational* appear in *Social Text* 25, no. 3 (fall 2007), edited by David Kazanjian and Josefina Saldana-Portillo, "The Traffic in History: Papers from The Tepoztlán Institute for the Transnational History of the Americas."

37. *Regeneración*, January 1, 1916. Owen also commented, "In these columns I brand unceasingly Hearst's jingoism, but never for one moment do I forget that Wilson has opened the way for him." He had earlier argued that Wilson's interventions in Mexico aimed "to protect, at enormous sacrifice of life, the vast monopolies which U.S. speculators have acquired in Mexico" (April 23, 1914). He was also critical of Wilson's Pan-Americanism, contending that "the Preparedness and Pan-American programs nail us to the cross of Militarism."

38. All of these words have vexed histories and none can satisfactorily resolve the complicated problems of institutional and geopolitical power that they aspire to fix.

On the term *hemisphere*, Gillman, who also sometimes finds it useful, observes that "it has the imperious Monroe Doctrinaire ring that gave area studies such a bad name in the context of Cold War Latin America. This was the model of area studies in which coverage masquerades as comparison, language acquisition substitutes for method, and the nation-state becomes a stand-in for other conceptions of region" ("Otra vez Caliban / Encore Caliban," 189). Despite this history, however, it can also be a generative term in particular contexts, as it is at times in Gillman's work and in the work of Anna Brickhouse, such as her essay "Hemispheric Jamestown," where she deftly unpacks Jamestown's layered history as "a crossing point of the hemispheric axes that define . . . the extended Caribbean" and urges scholars to "make self-conscious the geopolitics of knowledge delimiting the work that we do" (19, 33).

While many of the critiques of the use of the category of empire come from scholars for whom it has been an important concept, others have emerged in new scholarship that takes the hemisphere as its frame, such as the anthology *Hemispheric American Studies* (2008). The editors, Carolyn Levander and Robert Levine, define their project in opposition to empire studies as they introduce "a range of exciting new comparative work in the burgeoning field of hemispheric studies." "Empire studies" emerges as the bad other for the editors, who worry that "recent tendencies to conceive of the U.S. in the American hemisphere solely in terms of empire and imperialism tend to overlook the complex series of encounters that collectively comprise national communities in the Americas," such as the "hemispheric cultural flows" that move in multiple directions (7). Levander and Levine therefore describe their project as "a corrective to critical endeavors to understand geographic encounters in the hemisphere in terms of a developing US-centered world system" and argue

for the importance of approaching "literary and cultural history from the vantage point of a polycentric American hemisphere with no dominant center" (7). It is important to assume such a polycentric, hemispheric vantage point, they suggest, because "studies that focus on a US-centered system carrying out imperial designs in different geographic locales have made US nation-building the default center of comparativist analysis, often in unhelpful ways" (Carolyn Levander and Robert Levine, "Introduction: Hemispheric American Literary History," 401). Levander and Levine thereby define the comparative work of hemispheric studies in opposition to what they characterize as a U.S. empire studies paradigm that overlooks complex encounters and hemispheric cultural flows by taking the United States as the dominant center of the hemisphere as well as the default center of comparative analysis.

Although I agree that it is important to consider multidirectional flows and encounters, such an emphasis on a polycentric hemisphere with no dominant center disregards asymmetries of power. It is also the case that the difficulties of truly taking a hemispheric vantage point are many, as are the risks of reclaiming the term, and since all of the essays either focus on the United States or make the United States one of the main points of comparison, the United States arguably remains the default center of analysis. But more to the point, perhaps, the choice between empire studies and hemispheric or transnational studies is a false one and one that we should refuse to make.

39. On these points, see also Kramer, "Sliding Scales: Race, Empire, and Transnational History" in *The Blood of Government*, and Gretchen Murphy, *Shadowing the White Man's Burden*.

40. See McAlister, *Epic Encounters*, 303.

41. Lipsitz, *American Studies in a Moment of Danger*, 28. This book is a model of such a method of analyzing social movements and culture. Michael Denning's body of work is another rich example of a social-movements-and-culture approach that has shaped my own method. See Denning's afterword to the revised introduction of *Mechanic Accents* for reflections on his own "shift from a model of text-and-reader to one of social-movement-and-cultural formation" (264).

42. For a few notable examples among many, see Conway, "The Limits of Analogy"; Foner, "Introduction," 38–40; and Rotker, *The American Chronicles of José Martí*, 99–100.

43. Anderson, *Under Three Flags*, 1. Anderson reminds us that in the 1880s and after, "anarchism, in its characteristically variegated forms, was the dominant element in the self-consciously internationalist radical Left" (2). On anarchism in Mexico, see Hart, *Anarchism and the Mexican Working Class, 1860–1931*. On anarchism in Spain, see Esenwein, *Anarchist Ideology and the Working-class Movement in Spain*.

44. Stephens, *Black Empire*, 2.

45. Ibid., 99.

46. Briggs was a migrant from St. Kitts-Nevis who came to the United States in 1905

and worked at the *Colored American Review* and the *Amsterdam News*, where he covered "the Harlem theatrical and dramatic scene" and wrote editorials, before launching the *Crusader* in August 1918. On Briggs and the *Crusader*, see Robert Hill, "Introduction," v–lxvi.

47. Stephens, *Black Empire*, 37–38.

48. See Muñoz, *Cruising Utopia*, 16, 17. In "Looking for M—," Keeling considers temporal structures of blackness and queerness "in conjunction with one another" and reads "poetry from the future" in films that interrupt straight, neoliberal time to offer "an index of a time to come in which what today exists potently—even if (not yet) effectively—but escapes us will find its time" (567). In *In a Queer Time and Place* Halberstam writes of strange temporalities and imaginative life schedules which "disrupt the normative narratives of time that form the base of nearly every understanding of the human" (152), swerving away from a "middle-class logic of reproductive temporality" governed by "a biological clock for women and strict rules of respectability and scheduling for married couples" (5), challenging "conventional logics of development, maturity, adulthood, and responsibility." See also Elizabeth Freeman, *Time Binds*. All of this work and the large body of scholarship on queer and straight time and queer futures that it engages have been incredibly generative for me in thinking about visions of alternate worlds and near futures in the literatures and cultures of radical transnational movements in this era.

49. Nyong'o, "Race, Reenactment, and the 'Natural Born Citizen.'"

50. Ibid. See also my response, "Doing Justice to the Archive: Beyond Literature."

51. See also Luciano, *Arranging Grief*. Luciano elaborates a rich analysis of the sentimental mode and how "attention to feeling can alter the flow of time" in ways that signal a "distinctively modern affective chronometry: the deployment of the feeling body as the index of a temporality apart from the linear paradigm of 'progress'" (1). Drawing on Foucault, she also speaks of "the cyclical time of domestic life, the sacred timelessness of the originary bond and of the eternal reward toward which the faithful subject progressed; or beyond these norms, the wayward time of perversity, the non-progressive time of pure sensation, et cetera" (10). Like Luciano, I am interested in "modes of untimely presence as a means of multiplying the futures of the past" (17).

52. In *The Cultural Front* Denning observes that the 1930s Popular Front, along with "the Socialist, feminist, and syndicalist insurgencies of the 1910s" and "the New Left, Black liberation, and feminist movements of the 1960s and 1970s" are central instances of "radical insurgency in modern U.S. history" (4). He also emphasizes that the "politics of international solidarity" was one of the main forms of Popular Front public culture (11).

1. LOOKING AT STATE VIOLENCE

1. *Illinois v. August Spies et al.* trial transcript no. 1, Court's instructions to the jury on behalf of the people, 1886 Aug. 19. "The Haymarket Affair Digital Collec-

tion, Chicago Historical Society, "The Trial Documents," Volume O, 1–10, http://www.chicagohistory.org/hadc/hadctoc.htm.

2. As Joy James suggests in *Resisting State Violence*, the nineteenth-century genealogy of transformations in punishment and state violence that Michel Foucault elaborates in *Discipline and Punish* erases state-sanctioned spectacles of violence against nonwhites both before and after the demise of slavery and in colonial contexts. On the other hand, the Haymarket executions both challenge and confirm Foucault's theory of the disappearance of state punishment of (white) people as a spectacle in the United States over the course of the nineteenth century.

3. See Foner, "José Martí and Haymarket," 215–16.

4. Anderson, *Under Three Flags*, 2.

5. Martí, *En Las Estados Unidos*, 331.

6. Roediger's and Rosemont's *Haymarket Scrapbook* (1986) reproduces many Haymarket illustrations from around the world, including from Italy and Spain, as well as from the emergent U.S. mass media of the 1880s (see 106, 111, 126, and 214 for a few of many wonderful examples).

7. Martí, *En Las Estados Unidos*, 347.

8. My understanding of Martí's chronicles has been greatly enhanced by Ramos's work and by my conversations with John Blanco, who translated Ramos's *Desencuentros de la modernidad en América Latina* into English and who generously shared his notes on Martí, Haymarket, and anarchism with me. See Ramos, *Divergent Modernities*. See also Belnap and Fernández, *José Martí's "Our America"*; Luis-Brown, *Waves of Decolonization*; Ferrer, *Insurgent Cuba*; Lazo, *Writing to Cuba*; Lomas, *Translating Empire*; and Rotker, *The American Chronicles of José Martí*.

9. Ramos, *Divergent Modernities*, 107.

10. Two of the key works on Lucy Parsons are Ashbaugh, *Lucy Parsons*, and Ahrens, *Lucy Parsons, Freedom, Equality, and Solidarity*.

11. Lomas, *Translating Empire*, 1.

12. See Ronning, *Jose Martí and the Émigré Colony in Key West*, and Poyo, *With All and for the Good of All*.

13. The Pittsburgh Manifesto was published in Albert Parsons's newspaper *The Alarm* (Chicago) on November 1, 1884. It was also introduced as evidence for the state during the Haymarket trial and can be found on the Library of Congress's "American Memory" website under the headings "Chicago Anarchists on Trial: Evidence from the Haymarket Affair, 1886–1887" and "Illinois vs. August Spies et al. trial evidence book. People's Exhibit 19." See http://memory.loc.gov.

14. Joshua Brown, *Beyond the Lines*, 8.

15. Wexler, *Tender Violence*, 7.

16. Hartman wonders whether the "routine display of the slave's ravaged body" and the repeated invocation of the "shocking and the terrible" in sentimental and sensational antislavery literature may simply reinforce "the spectacular char-

acter of black suffering" (*Scenes of Subjection*, 4). Shawn Michelle Smith turns the gaze on the white lynch mob rather than focusing on the bodies of the victims, precisely out of concern that "the representation and reproduction of the violated black body can function as a kind of fetish, obscuring from view the white torturers who also inhabit these images" (*Photography on the Color Line*, 118). Goldsby situates lynching photography in relation to the transformation of late-nineteenth-century visual culture more generally as she argues that the "violence of lynching" was "enveloped in a milieu that encouraged looking for its own sake, and that sanctioned the threat of mass injury or death to be a fun, leisure activity" (*A Spectacular Secret*, 224), as it was in the Coney Island disaster spectacles that she analyzes.

17. "The Anarchist Funerals," *Sun*, November 12, 1887.

18. Foucault, *Discipline and Punish*, 15.

19. Schaack, *Anarchy and Anarchists*, 643.

20. See Clymer, *America's Culture of Terrorism*.

21. Like the film scholar Linda Williams, I analyze the sentimental and sensational not as discrete genres, but rather in their "more general and pervasive operation" as modes that cut across genres, where they sometimes converge and overlap. This means that sentimentalism and sensationalism often show up in unexpected places, such as in realist and naturalist texts, in "male" genres such as war narratives, and in music, photographs, and motion pictures. See Williams, *Playing the Race Card*; Berlant, *The Female Complaint*; Jane Gaines, *Fire and Desire*; and Brooks, *The Melodramatic Imagination*.

22. Spies, *August Spies' Auto-Biography*, i.

23. See Chapman and Hendler, *Sentimental Men*. As part of a larger argument about how "sentimentalism traveled across national boundaries into new cultural and historical contexts and occasionally into the hands of the lower classes and colonized," David Luis-Brown calls attention to the ways Martí strategically deployed and transformed sentimentalist discourse (*Waves of Sentimentalism*, 37). As Luis-Brown, Lomas, Gillman, and others have discussed, Martí translated Helen Hunt Jackson's sentimental novel *Ramona*, about an "arrogant mestiza," and in the process reworked Jackson's sentimentality to emphasize, as Lomas persuasively argues, "the significance and reach of indigenous revolts," transforming "the novel into a warning against identifying with or accommodation to either Spanish or Anglo-American governments" (*Translating Empire*, 252). Lomas even briefly suggests that Martí claims Lucy Parsons as "another kind of mestiza" and thereby "confirmed her belonging to his and his Mexican and Spanish speaking readers' America" (ibid.). See also Gillman, "The Epistemology of Slave Conspiracy."

24. Sekula, "The Body and the Archive."

25. Brown, *Beyond the Lines*, 195–96.

26. Ibid, 197.

27. "Anarchist Leaders Who Are Responsible for the Chicago Outbreak," *Frank Leslie's Illustrated Newspaper*, May 15, 1886, 197.

28. "Chicago Anarchists," *Frank Leslie's Illustrated Newspaper*, November 19, 1997, 219.
29. For a rich analysis of Haymarket elegies and their references to Christian eschatology and gallows scenes, see Boudreau, *The Spectacle of Death*, 67–104. Boudreau incisively analyzes how Haymarket poets "transformed apolitical sentimentality into calls for direct action" (101). For comparisons between the Haymarket case and the antilynching struggle, see Rebecca N. Hill, *Men, Mobs, and Law.*
30. Lomas, *Translating Empire*, 24.
31. Joshua Brown, *Beyond the Lines*, 74.
32. Ashbaugh, *Lucy Parsons: American Revolutionary*, 207–8.
33. "The Story Told by Helen Wilmans," *Woman's World*, June 15, 1886, in "Appendix," *Life of Albert R. Parsons* (1903), 231.
34. For more on how Lucy's race became an issue, see Roediger, "Strange Legacies," 94.
35. Schaack, *Anarchy and Anarchists*, 167.
36. For an analysis of this chapter that places it in the context of nineteenth-century discourses of manhood and family, see Carl Smith, *Urban Disorder and the Shape of Belief*, 155–56.
37. Parsons, *Twenty-Fifth Anniversary Eleventh of November Memorial Edition of the Famous Speeches of Our Martyrs*, iii.
38. Ibid.

2. FROM HAYMARKET TO REVOLUTION

1. See Berkman, *Life of an Anarchist*. See also Avrich, *Anarchist Portraits* and *The Modern School Movement*. On the strike, see Krause, *The Battle for Homestead, 1890–1892*.
2. There is a huge literature on the Flores Magóns and the PLM in the United States. Some of the important studies include Gómez-Quiñonez, *Sembradores, Ricardo Flores Magón y el Partido Liberal Mexicano*; Langham, *Border Trials*; MacLachlan, *Anarchism and the Mexican Revolution*; Marez, *Drug Wars*; Pérez, *The Decolonial Imaginary*; Sandos, *Rebellion in the Borderlands*; and Torres Parés, *La Revolución sin frontera*. See also Marez, "Pancho Villa Meets Sun Yat-sen."
3. Examples of Owen's animus against Hearst abound. Owen charged that "Hearst clamors perpetually for war with Mexico, as he clamored for war with Spain fifteen years ago" (April 19, 1913). In "Will Somebody Lend Hearst a Gun?" (November 22, 1913), Owen called Hearst "one of the chief pillars of that absentee landlordism" that had made necessary the revolution in Mexico and charged that "the whole chain" of Hearst papers had been "built up on the basis laid by the original anti-Spanish newspaper campaign"; in "Denounce Hearst" (January 24, 1914), Owen reported that the Chicago city council had passed a resolution condemning Hearst for "seeking by every resource known to yellow, sensational, unscrupulous, and irresponsible journalism to arouse the passions of the thoughtless and heedless in an effort to precipitate war"; and in

"Another Hearst Lie" (January 22, 1914), Owen claimed that Hearst's paper the *New York American* had printed a halftone reproduction of a photograph in an attempt to "manufacture evidence," since the same picture had been used in an earlier, completely different story captioned "Carib children bathing." In a piece that appeared on October 9, 1915, Owen also criticized the *Los Angeles Times* and the "Republican Imperialism" they ceaselessly fomented, in response to a *Times* article claiming the Flores Magóns planned to take over Texas and California and annex them to Mexico. Owen attacked the "steadfast campaign in the newspapers, stirring the patriotism of the American people in order to precipitate intervention . . . [a campaign comprised of] uninterrupted hammering reports, narratives, and descriptions of the horrors, violences, murders, and excesses of all kinds, a number of which I have been able to recognize intentionally disfigured" (October 9, 1915). He pointed out that Ricardo used to compile, "week after week," details of the outrages then being committed habitually against Mexicans in Texas. And a few weeks earlier, the *Regeneración* writers had pointed out in response to reports of Zapata's "atrocities," that "atrocities" had been "perpetrated . . . upon the inhabitants of West Virginia, Colorado, and Michigan, by private gunmen and State militia" (July 4, 1914).

4. For more on Jay Fox, see Rosemont and Roediger, *The Haymarket Scrapbook*, 186–87.

5. In an earlier review of the 1903 edition of *Life of Albert R. Parsons* that was republished as an advertisement for the book, a writer for a Knights of Labor paper predicted that "it will be difficult to get this book into circulation, and more difficult still to get it out of circulation. . . . It is the prose epic of the great struggle for labor emancipation. Someday it will be the 'Uncle Tom's Cabin' of a new deliverance" (311).

6. Ashbaugh, *Lucy Parsons*, 226–44.

7. Ibid., 232.

8. Ibid., 234–35.

9. Quoted in ibid., 207.

10. Parsons was remarkably successful at maintaining affiliations with a changing array of radical and other labor groups—including local, regional, and national anarchist, socialist, communist, IWW, and AFL organizations—that were often at odds with each other.

11. "Mrs. Lucy E. Parsons. Her First Address in London at a Welcome Extended Her on Arrival. Burning and Eloquent Words which Stirred the Audience to Intense Enthusiasm," *Alarm*, December 8, 1888, 1.

12. See also Roediger, "Strange Legacies," 94.

13. Quoted in Ahrens, *Lucy Parsons, Freedom, Equality, and Solidarity*, 70.

14. "In the Anthracite Coal Regions," *Liberator*, October 29, 1905, 2.

15. Certainly it would help to know more about the lectures on "Mexico and Mexicans" that Parsons, who was described in a newspaper ad for the event as a "native," delivered in the 1920s before the Chicago Society of Anthropology

Forum, a group that was formed by people who supported Ida B. Wells's protest of the exclusion of African Americans from the World's Congress of Religions at the Chicago World's Fair. See Ahrens, *Lucy Parsons, Freedom, Equality, and Solidarity*, 17–18.

16. Daniel DeLeon, the leader of the Socialist Labor Party, led a faction of socialists who, along with their leader Eugene Debs, left the IWW in 1908, after the organization amended its constitution to affirm the commitment to direct action and to emphasize that "the IWW does not endorse or wish to be endorsed by any political party." On anarchists in the IWW, see Salerno, *Red November, Black November*.

17. Trautmann, *Direct Action and Sabotage*.

18. *The History of the I.W.W.*, 23.

19. Since the Civil War had resulted in the abolition of chattel slavery, they reasoned, another war might lead to the abolition of wage slavery. Certainly, the militarized response to strikes and other labor actions, which became especially violent during the 1870s and 1880s, made labor conflicts feel like war to those who were engaged in them. *Life of Albert R. Parsons* is full of examples of the war on workers. In that work Lucy Parsons reproduces Albert's warning that "to maintain their legal right to control the natural rights of others the property-holding class are strengthening the police, increasing the army, recruiting the militia, building new jails, work-houses, poor houses, and enlarging the penitentiaries. Entrenched behind 'organic law,' church and State, sustained by bayonets, [they] maintain the supremacy of our capitalistic 'law and order' regime" (79). And speaking to a group of workers in South Bend, Indiana, who had struck the previous January to protest "starvation wages," Albert compared the conflict to the Civil War as he recalled how "the Grand Army of the Republic, which twenty-five years ago, drew its sword to liberate the black chattel slave from bondage, came to South Bend, and with gleaming bayonets and flashing swords riveted the chains of slavery upon wage-laborers and compelled them to submit to the dictation of the property beasts" (ibid., 41). After the Civil War and at least through the late nineteenth century, comparisons of chattel slavery, other forms of unfree labor (such as Mexican peonage and Chinese contract labor), and so-called free labor or wage slavery persisted even as workers faced changing conditions. See Almaguér, *Racial Fault Lines*; Saxton, *The Indispensable Enemy*; Streeby, *American Sensations*. As Roediger and others have suggested, the language of wage slavery risked minimizing chattel slavery since it could imply that the former was even worse, and the idea that the Civil War was fought "to liberate the black slave from bondage," as Albert Parsons puts it, is wishful thinking. But while older associations still cling to it, Parsons's comparison also took on new meanings in the postbellum context: he underlined the limits of formal emancipation and emphasized the state's use of military force against laborers in order to support the widely shared view that one civil war had given way to another, that the state and capitalists were

making war on workers, and that workers therefore needed to find ways to defend themselves. Such a perspective could authorize an insurgent response, one that was not defused but rather intensified by Parsons's conviction and execution. Indeed, many Haymarket memory-makers constructed John Brown as a precursor figure, one who had been executed by the state but whose powerful afterlife as a martyr made him more threatening dead than alive. Just as the example of Brown's martyrdom helped to end slavery, they argued, so might memories of the Haymarket anarchists' "legal murder" provoke a fundamental transformation of U.S. society, a revolution that might radically alter existing labor, property, and social relations. See Avrich, *Haymarket Tragedy*, 319–21, 410–11; and Nelson, *Beyond the Martyrs*, 154. *Mother Earth* published appeals from the Los Angeles–based Rangel-Cline Defense Fund, in which they connected U.S.-Mexico border struggles to the Civil War and to Haymarket, arguing that "to hang Rangel is to hang another John Brown, and well might prove another Harper's Ferry. To hang, or imprison for life, our other comrades, whose only real crime is devotion to the poor and disinherited, is to repeat the legal butchery that followed the Haymarket tragedy in Chicago" (December 1913, 306).

20. Ricardo Flores Magón, "Mexican Rebels Appeal to American Workers," *Agitator*, April 1, 1911, 1.

21. Andrews, *Shoulder to Shoulder?*, 3, 12.

22. Sandos, *Rebellion in the Borderlands*, 12.

23. Foley, *Spectres of 1919*, 87–88.

24. Another infamous moment in this history, which was frequently mentioned by Owen, was the April 12, 1911, issue of the socialist *New York Call*, which included an article denouncing the PLM and the Flores Magóns as anarchists.

25. Owen frequently criticized the socialists for their racism, claiming that while the IWW did not draw "race or color lines," the socialists supported the exclusion of the Japanese and Chinese and looked down on "so-called inferior races" due to their anxiety to get votes. Owen claimed that this was the policy of socialist leaders, anyway; he believed that the "rank and file" condemned "that inhuman and suicidal policy as heartily as we do" (*Regeneración*, October 18, 1913).

26. William C. Owen, "What Mexico's Struggle Means," *International Socialist Review*, May 1912, 739–43.

27. After de Cleyre's death, in 1912, the Mother Earth Publishing Company issued a collection edited by Alexander Berkman (1914) that included one of these speeches, along with some of de Cleyre's poems, essays, sketches, and stories. Paul Avrich included several of her published writings along with others that he found in manuscript collections, in his edited volume of de Cleyre's *The First Mayday*. There has been something of a Voltairine de Cleyre revival lately; three different critical anthologies of her work have appeared in the last few years. See de Cleyre, *The Voltairine de Cleyre Reader*; DeLamotte, *Gates of Freedom*; and de Cleyre, *Exquisite Rebel*. Brigati's AK Press edition is the only one of the three to include de Cleyre's important speech, essay, and pamphlet "The Mexican Revo-

lution," but Delamotte's book includes the short *Mother Earth* article "Report of the Work of the Chicago Mexican Defense League." Presley's and Sartwell's collection contains many interesting essays by de Cleyre, especially on direct action and on her "anarchist feminist philosophy," but none of her writings on Mexico. Berkman's edition includes the poem "Written in Red (To Our Living Dead in Mexico's Struggle)" and "The Mexican Revolution."

28. Avrich, *An American Anarchist*, 44.

29. Ibid., 7–8.

30. Voltairine de Cleyre, "Report of the Work of the Chicago Mexican Liberal Defense League," *Mother Earth*, April 1912, 60. "The longer we studied developments," she wrote in a report on the work of the group published in *Mother Earth*, "the clearer it became that [the Mexican Revolution] was a social phenomenon offering the greatest field for genuine Anarchist propaganda that had ever been presented on this continent; for here was an immense number of oppressed people endeavoring to destroy a fundamental wrong, private property in land, not through any sort of governmental scheme, but by direct expropriation."

31. De Cleyre, "The Mexican Revolution," 167, 255; Avrich, *An American Anarchist*, 225–31.

32. See Boudreau's analysis of the elegies of the Haymarket poets, which "lingered on this 'old-time wound' of November 11 without offering cheering sentiments" (327). She emphasizes the poets' "refusal of consolation": "they refused to be easily comforted because they wished to put their grief to political use rather than transcend it" (327).

33. De Cleyre, "Sex Slavery" in *Exquisite Rebel*, 228, 229.

34. Stanley, *From Bondage to Contract*, 210.

35. Ashbaugh, *Lucy Parsons, American Revolutionary*, 204–6.

36. De Cleyre, "Sex Slavery" in *Exquisite Rebel*, 232.

37. Avrich, *An American Anarchist*, 149–51; DeLamotte, *Gates of Freedom*, 26–27.

38. Sandos, *Rebellion in the Borderlands*, 41. In *The Decolonial Imaginary*, however, Emma Pérez argues while *Regeneración* "printed at least one essay on women, their rights, or their subjugation in almost every issue of the newspaper from its initial publication," the anarchists "generally denounced marriage at the same time that they held certain ideas about women's 'natural' duties and desires" (63–64). Thus when some members of the PLM moved to a "communal farm" in Los Angeles, she points out, women and men "shared fieldwork but not housework" (67). Nonetheless, Pérez also foregrounds the contributions made to the movement by women writers and activists such as Blanca de Moncaleano, Paula Carmona de Flores Magón, and María Talavera. While anarchists and others took different positions on questions of marriage as slavery and on the place of women within revolutionary struggles, transnational anarchist movements undoubtedly brought such questions to the forefront and often articulated questions of "sex" to questions of labor, nation, and race when the former might

have otherwise remained peripheral to such discussions. At the same time, the divisions over these questions, as well as the possibility, exhilarating to some and threatening to others, that a true revolution would include transformations in gender and sex relations as well as economic changes, helps to explain why it may have been difficult to construct an international labor coalition to support and extend the aims of the PLM and other more radical participants in the Mexican Revolution.

39. De Cleyre, *The First May Day*, 27. It is not surprising, then, that in 1911 de Cleyre concluded her address on "The Mexican Revolution" (which also appeared in *Mother Earth*) by bowing "to these heroic strugglers, no matter how ignorant they are, who have raised the cry Land and Liberty, and planted the blood-red banner on the burning soil of Mexico" (275). The word *ignorant* in this sentence is used ironically, since much of the address is devoted to chastising U.S. radicals for imagining that Mexican peasants had to be ignorant if their actions were not guided by the "jargon of [U.S.] land reformers or of Socialists" (267). Her opening premise, moreover, is that people in the United States are the ones who are ignorant. She begins by trying to understand why so many in the United States are "ignorant of the present revolution in Mexico," which is taking place "in their backyard" (253). In "The Mexican Revolt" she reserved her most pointed criticisms for radical papers that "refused to print the Manifestoes and Appeals of the Mexican Liberal Party, to afford the publicity of their columns to the real demands of the revolutionists, that their readers might give their sympathy and support, and the influence of their understanding" (169).

40. Mexican Liberal Party, *Land and Liberty*, 4.

41. Nelson, *Beyond the Martyrs*.

42. Goldman and Berkman also published other writings by Enrique, as well as PLM literature, including an appeal to the "the workers of the United States," which appeared in *Mother Earth* in April 1915 and was endorsed by Goldman.

43. Several weeks later, in the April 12, 1913, issue, *Regeneración* adapted another Barnett cartoon from the *Los Angeles Tribune* and added the caption "La Causa de la Revolución de Mexico" to explain its meaning to readers of Spanish. In this cartoon, the "peonage" ball and chain reappears, attached to the leg of a worker who acts as a human ox, yoked to a plow on which sits a land baron, wielding the whip of "land monopoly."

44. For more on Caminita, see Salerno, "Paterson's Italian Anarchist Silk Workers and the Politics of Race"; Antliff, *Anarchist Modernism*; Cannistraro and Meyer, *The Lost World of Italian-American Radicalism*, 184. Caminita was an Italian printer and draftsman who edited *La Questione Sociale* but was removed from his position after writing a series of articles that resulted in the removal of the paper's second-class postal privileges due to obscenity. See Avrich, *Anarchist Voices*. Sandos includes a poster designed by Caminita in *Rebellion in the Borderlands*, 53. In 1911 he began writing an Italian-language column as well as contributing graphics to *Regeneración*.

45. See also the November 30, 1912, issue of *Regeneración*, which includes a "Future Proximo" cartoon that shows the "pueblo" kicking Madero over to Uncle Sam. Caption: "Que se largue a los estados unidos! No mas gobierno! / Step down to the United States!"

46. On the uses of melodramatic simultaneity by Oscar Micheaux and others, see Gaines, *Fire and Desire*.

3. SENSATIONAL SOCIALISM

1. Anderson, *Under Three Flags*.

2. My discussion is indebted to the conceptualization of collaborative authorship in Brickhouse's discussion of the transamerican genealogies of the novel *Jicotencal*. See Brickhouse, *Transamerican Literary Relations and the Nineteenth-Century Public Sphere*, 37–62.

3. Ethel Duffy Turner, *Writers and Revolutionists*, 2. Although Ethel Duffy Turner's time with Ricardo Flores Magón and the PLM was brief, she decided to write a book about it many years later, when Lázaro Cardenas, the former president of Mexico, offered to pay her living expenses while she wrote it in Mexico. The manuscript was translated from English to Spanish and published a few years later, and I draw on both the Spanish translation and the original English manuscript, which comprises part of the two cartons of material that Turner donated to the University of California's Bancroft Library, along with photographs, clippings, and ephemera that provide a unique window into the world of early-twentieth-century transborder radicals. See also Ethel Duffy Turner, *Ricardo Flores Magón y el Partido Liberal Mexicano*.

 For a useful account of John Kenneth Turner's time in Mexico, see Meyer, *John Kenneth Turner, Periodista de México*. See also Lomnitz, "Chronotopes of a Dystopic Nation."

4. "Notes on the Life of John Kenneth Turner," Carton 1, Ethel Duffy Turner Papers, Bancroft Library, University of California, Berkeley.

5. "Ricardo Flores Magón y el Partido Liberal Mexicano," Carton 1, Ethel Duffy Turner Papers, Bancroft Library, University of California, Berkeley.

6. Turner, "Preface to the Third Edition," *Barbarous Mexico* (1910), 6.

7. Gutiérrez de Lara and Pinchon, *The Mexican People*, 297. See Escobar, *Race, Police, and the Making of a Political Identity*, 61–66, 67; Raat, *Revoltosos*; and Zamora, *The World of the Mexican Worker in Texas*.

8. See La Feber, *The New Empire*. For more on the history of the new empire in Mexico, see Hart, *Empire and Revolution*.

9. Turner, *Shall It Be Again?*, 319–61.

10. Commenting on Turner's *Shall It Be Again* in the *Freeman* in 1922, the noted British theorist of imperialism J. A. Hobson said, "Reviewing recent history in Mexico, Nicaragua, Haiti, Santo Domingo, and other weak American states, [Turner] shows the rising of an aggressive expansion of Monroeism for economic exploitation. . . . No more trenchant and revealing work upon the new

career, political and economic, to which the unmakers of American democracy are striving to commit their country has ever issued from the press." See "John Kenneth Turner, Shall It Be Again—Reviews," Carton 2, Ethel Duffy Turner Papers, Bancroft Library, University of California, Berkeley.

11. On William C. Greene and Cananea, see Truett, *Fugitive Landscapes*, 145–56.

12. "Ricardo Flores Magón y el Partido Liberal Mexicano," Carton 1, Ethel Duffy Turner Papers, Bancroft Library, University of California, Berkeley.

13. According to the historian Edward J. Escobar, the "arrest, imprisonment, and possible deportation of Gutiérrez de Lara became a cause celebré in Los Angeles," uniting "white progressives and socialists" with "segments of the Mexican community." During the ensuing trial, the defense focused on proving that Gutiérrez de Lara was not an anarchist, since "advocating anarchy" was the "only charge" for which he could be deported. While the federal government ended up dropping all charges against him, the stakes of this widely publicized trial suggest how damaging the charge of anarchism could be. See Escobar, *Race, Police, and the Making of a Political Identity*, 61–66.

14. "Mexican Agitator Accused of Being Alien Anarchist Wins Freedom," *New York Call*, November 16, 1909, Scrapbook, "Mexican Revolution, 1909–1910," Carton 1, John Murray Papers, Bancroft Library, University of California, Berkeley.

15. "Ricardo Flores Magón y el Partido Liberal Mexicano," Carton 1, Ethel Duffy Turner Papers, Bancroft Library, University of California, Berkeley.

16. Ethel Duffy Turner, *Writers and Revolutionists*, 23, 24.

17. "Ricardo Flores Magón y el Partido Liberal Mexicano," Carton 1, Ethel Duffy Turner Papers, Bancroft Library, University of California, Berkeley.

18. "Ricardo Flores Magón y el Partido Liberal Mexicano," Carton 1, Ethel Duffy Turner Papers, Bancroft Library, University of California, Berkeley.

19. Ethel, on the other hand, turned her attention to other matters, including writing short stories and plays, briefly editing a San Francisco poetry journal (*The Wanderer*, 1923–24), and raising their daughter, Juanita. In the 1950s, however, she decided to write a book about Ricardo Flores Magón and the PLM because, as she put it, "the people who knew the story were dropping off. There wasn't anybody around to do it."

20. John Kenneth Turner, "Hands Off Mexico," *Appeal to Reason*, March 27, 1915, 1.

21. See Streeby, *American Sensations*.

22. "Manifesto to the Workers of the World" in *Dreams of Freedom*, 136.

23. *Appeal to Reason*, July 3, 1915, clipping in Carton 2, Ethel Duffy Turner Papers, Bancroft Library, University of California, Berkeley.

24. John Kenneth Turner, *Barbarous Mexico*, 6.

25. Flores Magón, *Obras Completas de Ricardo Flores Magón 1*, 459. See also "The 1908 Revolution" folder in "Notes—Ricardo Flores Magón," Carton 1, Ethel Duffy Turner Papers, Bancroft Library, University of California, Berkeley.

26. Tejada, *National Camera*, 49–50. Tejada concludes, "Given his exile status in the United States and his second-order relation to the English language" in his

art criticism, and "as a Mexican national with ambivalent notions of human variation, of 'purity' and 'mixing' that surround mestizaje as the colonial difference—de Zayas performs a series of contradictions whose perplexity is marked with the desire for hierarchical formulations inherent to both racism and formalism, with its valuations of 'superior' to 'inferior,' of 'civilized' to 'primitive,' and of art to photography" (52). See also de Zayas, *A Study of the Modern Evolution of Plastic Expression* and *How, When, and Why Modern Art Came to New York*.

27. Gutiérrez de Lara and Pinchon, *The Mexican People*, 343.

28. Ibid., 5–6.

29. See Devra Weber, "Keeping Community, Challenging Boundaries," for an analysis of how at this time in Mexico, in tandem with the state's idealization of *mestijaze*, "narrow definitions of 'Indian' downplayed or erased indigenous roots" and Indians therefore "began to disappear through redefinition" (212). At the same time, Weber suggests that the shifting and hardening of the racial categories "Mexican" and "American" in the United States during the same period "obliterated more nuanced distinctions which had existed earlier among the indigenous population, mestizos, Mexican immigrants, Anglo-Americans, Europeans, Chinese, and other immigrants" (213). Weber argues that these inadequate racial classifications have obscured the fact that "indigenous Mexicans were part of internationalist responses to the ravages of early-twentieth-century globalization" (209).

30. Even so, however, he spoke up in support of Indians and others whose lands were being enclosed as he helped to make connections between radical movements in the United States and Mexico. For more on ideas about civilization and barbarism in Mexico, see Alonso, *Thread of Blood*, especially 57–71.

31. Weber, "Keeping Community, Challenging Boundaries," 224, 225.

32. Turner gratefully acknowledged Gutiérrez de Lara's help, claiming that he was at once "companion, guide, friend, and an easy bridge across the chasm of reserve which naturally separates the people of one race from those of another" ("The Slaves of Yucatan," 527).

33. For a history of the deportation of Yaquis in the early years of the twentieth century, see Hu-De Hart, *Yaqui Resistance and Survival*, 155–200. For an excellent analysis of the Yaqui deportations and conflicts with the Mexican state that draws on a wide range of sources from both the United States and Mexico, see Guidotti-Hernández, *Unspeakable Violence*.

34. "Ricardo Flores Magón y el Partido Liberal Mexicano," Carton 1, Ethel Duffy Turner Papers, Bancroft Library, University of California, Berkeley.

35. See Williams, *Playing the Race Card*, 44–95.

36. Sinclair Snow's introduction to John Kenneth Turner, *Barbarous Mexico*, xxiv.

37. Phillips, "A Magazine Monologue," n.p.

38. "Ricardo Flores Magón y el Partido Liberal Mexicano," Carton 1, Ethel Duffy Turner Papers, Bancroft Library, University of California, Berkeley.

39. John Kenneth Turner, *Barbarous Mexico*, xxxi.

40. Joshua Brown, *Beyond the Lines*, 239–40.

41. "Ricardo Flores Magón y el Partido Liberal Mexicano," Carton 1, Ethel Duffy Turner Papers, Bancroft Library, University of California, Berkeley.

42. Turner, *Barbarous Mexico*, 5.

43. Ibid.

44. John Kenneth Turner, "Barbarous Mexico: The Slaves of Yucatan," 526, 530.

45. Turner, "Barbarous Mexico: The Tragic Story of the Yaqui Indians," 33.

46. Ibid., 40.

47. Ibid., 33.

48. Turner, "Barbarous Mexico: With the Contract Slaves of the Valle Nacional," 261.

49. Turner, "Barbarous Mexico: The Tragic Story of the Yaqui Indians," 48.

50. Halttunen, "Humanitarianism and the Pornography of Pain in Anglo-American Culture."

51. Turner, "Barbarous Mexico: The Tragic Story of the Yaqui Indians," 34.

52. Ibid., 33.

53. Turner, "Barbarous Mexico: With the Contract Slaves of the Valle Nacional," 257.

54. Ibid.

55. Turner, "Barbarous Mexico: The Slaves of Yucatan," 534.

56. Turner, "Barbarous Mexico: The Tragic Story of the Yaqui Indians," 43.

57. Ibid.

58. Ibid., 53.

59. Ibid., 45.

60. Ibid., 45.

61. Ibid., 43.

62. See Saxton, *The Indispensable Enemy*.

63. Turner, "Barbarous Mexico: The Tragic Story of the Yaqui Indians," 48.

64. Ibid., 33.

65. Ibid., 35.

66. Ibid., 37. This image is perhaps the same one reproduced in the Charles H. Kerr book version of *Barbarous Mexico* [1911].

67. Ibid., 43.

68. Turner, "Barbarous Mexico: The Slaves of Yucatan," 538. On these troubling comparisons, see Roediger, *The Wages of Whiteness*.

69. Douglass, *Narrative of the Life of Frederick Douglass, an American Slave*, 58.

70. Berkman and Goldman, "Uncle Sam in Mexico," 182–83.

4. THE END(S) OF *BARBAROUS MEXICO*

1. Calling itself "the one great illustrated magazine in the English language that is of, by, and for the working class," the magazine had 27,000 readers in 1910, the year that "The American Partners of Díaz" appeared in the December issue. See Gutman, "The International Socialist Review, Chicago, 1900–1918."

2. Kipnis, *The American Socialist Movement, 1897–1912*, 293–94.

3. Turner, *Barbarous Mexico*, 253, 254, 259.

4. Ibid., 271.

5. Quoted in Tejada, *National Camera*, 6–7.

6. Clippings, Volume 1, Murray Scrapbooks, John Murray Papers Bancroft Library, University of California, Berkeley.

7. See Ruff, *We Called Each Other Comrade: Charles H. Kerr and Company, Radical Publishers*.

8. Kipnis, *The American Socialist Movement, 1897–1912*, 335.

9. Marcy, "Editorial," 919.

10. Jack London, "Mexico's Army and Ours," *Colliers' Magazine*, May 3, 1914.

11. Lye, *America's Asia*, 11. On the history of Chinese immigrants in Mexico during this period, see Camacho, "Crossing Boundaries, Claiming a Homeland," and Romero, *The Chinese in Mexico, 1882–1940*. See also Erika Lee, *At America's Gates*.

12. Cutler, *Gilbert Patten and His Frank Merriwell Saga*, 31.

13. Bill Brown, "Reading the West," 39.

14. Williams, *Playing the Race Card*, 13.

15. Brooks, *The Melodramatic Imagination*.

16. Berlant, "Poor Eliza," 636.

17. John Kenneth Turner, *Barbarous Mexico*, 260.

18. Ibid., xxi.

19. Ibid., 330.

20. Ibid.

21. Kelly, *Yaqui Women*, vii.

5. SENSATIONAL COUNTER-SENSATIONALISMS

1. Harrison was born in the Virgin Islands, followed his older sister to New York City in 1900, soon after his mother died, attended school while working several jobs, and was so brilliant his high-school achievements were recognized in the *New York Times*. For more on the important "roles played by women in helping to settle family members" during this period of immigration from the Caribbean to the United States, see Watkins-Owens, *Blood Relations*, 25. Richard B. Moore was preceded by his two older sisters, "who had arrived the year before and located jobs" after leaving Barbados; W. A. Domingo's sister left Jamaica and opened a boarding house for Jamaican immigrants in Boston before he joined her there; and in 1905 Cyril Briggs's mother moved to New York, where he, too, migrated after he finished school in St. Kitts.

By 1916, Harrison began to defend a "race first" position that responded not only to the persistence of white supremacy within the U.S. Socialist Party and the labor movement, but was also, he suggested, the result of the "recent World War," which "chiseled the channels of race-consciousness deeper among American Negroes than any previous external circumstances" (Hubert Harrison,

"Race Consciousness," *Boston Chronicle*, March 15, 1924, reprinted in Harrison, *A Hubert Harrison Reader*, 116–17). During the First World War, he organized the Liberty League, edited the *Voice*, and also chaired the Colored National Liberty Congress, which convened in Washington, D.C., in June 1918 to appeal to the U.S. Congress to pass federal antilynching laws in response to "the grievances of the 12 million people of our race and their demand for democracy at home" from a "nation" that was "at war to 'to make the world safe for democracy'" (Hubert H. Harrison Diary, July 1, 1918). In Hubert Harrison Papers, Rare Book and Manuscript Library, Columbia University, New York. See also Perry, *Hubert Harrison*, 8, 373–92.

I draw extensively on Perry's groundbreaking biography and anthology throughout part 3. Perry's two books are an invaluable addition to the scholarship on Harrison and should make possible many more projects on Harrison as a major figure in this period. Perry elaborates on the disagreement between Du Bois and Harrison about whether blacks should "close ranks" during the First World War and suggests that "Harrison's response to Du Bois marked him as a spearhead of the opposition to 'Close Ranks' and as a spokesperson for the militant 'New Negro Movement'" (*Hubert Harrison*, 387). For a comprehensive critical anthology on this movement, see Gates and Jarrett, *The New Negro*, which includes selections by Harrison on 101–12 and 373–74. For another account of the controversy over Du Bois's editorial and his response to the First World War, see Lewis, *W. E. B. Du Bois*, 535–60. On the significance of the world war and the race riots of 1919 for the New Negro movement, see Foley, *Spectres of 1919*. See also Baldwin, *Beyond the Color Line and the Iron Curtain*; Maxwell, *New Negro, Old Left*; and Nadell, *Enter the New Negro*.

2. Harrison, *Negro World*, January 8, 1921, reprinted in Harrison, *A Hubert Harrison Reader*, 76–78.

3. Harrison, "The Negro and the Labor Unions," *Voice*, 1917, reprinted in Harrison, *When Africa Awakes*, 22, and in Harrison, *A Hubert Harrison Reader*, 80–81.

4. Harrison, *When Africa Awakes*, 9–11, reprinted in Harrison, *A Hubert Harrison Reader*, 87.

5. Harrison, "The Descent of Dr. Du Bois," *Voice*, July 25, 1918, reprinted in *When Africa Awakes*, 66–70, and in Harrison, *A Hubert Harrison Reader*, 170–72.

6. Hubert Harrison, "Programs and Principles of the International Colored Unity League," *Voice of the Negro* 1, no. 1 (April 1927): 4–6, reprinted in Harrison, *A Hubert Harrison Reader*, 400.

7. See Taylor, *The Veiled Garvey*.

8. On the *Messenger*, see Foley, *Spectres of 1919*, 34, 40, 49–61, 66–67, 95–98, 105–9, 111–12, 144, and Kornweibel, *No Crystal Stair*.

9. "Why Negroes Should Join the I.W.W.," *Messenger* 2, no. 7 (July 1919): 8.

10. "A Group of I.W.W. Class War Prisoners," *Messenger* 3, no. 3 (August 1921): 235.

11. Quoted in Foley, *Spectres of 1919*, 61.

12. Foley, *Spectres of 1919*, 52, 53.

13. "Program of the A.B.B.," *Crusader* 5, no. 2 (October 1921): 15.

14. "With Our Readers," *Crusader* 1, no. 6 (February 1919): 189.

15. Robert A. Hill, "Introduction," xxiii.

16. Stephens, *Black Empire*, 99.

17. Harrison, *A Hubert Harrison Reader*, 196, 197.

18. Black Star Line Flyer and Promotional Letter from Marcus Garvey, President of the Black Star Line, J. R. Casimir Papers, Box 2, Schomburg Center for Research in Black Culture, New York Public Library.

19. Cyril V. Briggs Letter, October 11, 1921, J. R. Casimir Papers, Box 1, Folder 9, Schomburg Center for Research in Black Culture, New York Public Library.

20. "The Garvey Movement: A Promise or a Menace," *Messenger* 2, no. 12 (December 1920): 170.

21. "Garvey Unfairly Attacked," *Messenger* 4, no. 4 (April 1922): 387.

22. "Marcus Garvey! The Black Imperial Wizard Becomes Messenger Boy of the White Klu Klux Kleagle," *Messenger* 4, no. 7 (July 1922): 437.

23. "Deportation," *Messenger* 2, no. 3 (March 1920): 5.

24. "Time to Go," *Messenger* 4, no. 8 (August 1922): 457.

25. "Should Marcus Garvey Be Deported?" *Messenger* 4, no. 9 (September 1922): 479, 480.

26. "The Policy of *The Messenger* on West Indian and American Negroes: W. A. Domingo v. Chandler Owen," *Messenger* 5, no. 3 (March 1923): 639.

27. Stephens, *Black Empire*, 119.

28. Cyril Briggs, "The Decline of the Garvey Movement," 178–79.

29. Winston James, *Holding Aloft the Banner of Ethiopia*, 156.

30. Cyril Briggs, "The Socialist Surrender," *Crusader* 4, no. 6 (August 1921): 9.

31. Cyril Briggs, "Is Not This Treason?" *Crusader* 5, no. 2 (October 1921): 8.

32. Cyril Briggs, "A Free Africa," *Crusader*, 5, no. 2 (October 1921): 9, and Cyril Briggs, "Program of the ABB," *Crusader*, 5, no. 2 (October 1921): 18.

33. Cyril Briggs, "On With the Liberation Struggle," *Crusader* 6, no. 1 (January–February 1922): 5.

34. "What They Say of Us," *Crusader* 1, no. 1 (September 1918): 21.

35. Tal, "That Just Kills Me," 67.

36. Romeo Dougherty, "Punta Revolutionist," *Crusader* 1, no. 5 (January 1919): 9, 10.

37. Romeo Dougherty, "Punta, Revolutionist," *Crusader* 1, no. 6 (February 1919): 191, 192.

38. Romeo Dougherty, "Punta, Revolutionist," *Crusader* 2, no. 1 (September 1919), 14.

39. Romeo Dougherty, "Punta, Revolutionist," *Crusader* 2, no. 2 (October 1919): 15, 16.

40. Stephens, *Black Empire*, 38.

41. Cyril Briggs, "Partners in Frightfulness," *Crusader* 2, no. 5 (January 1920): 9. Briggs also made connections to the "murder of Egyptian, Indian, and Afghan women and children by British airmen" and charged that imperial England and America were "partners in frightfulness, and the successors in that business to the much-reviled Germans."

42. Cyril Briggs, "The American Negro's Duty toward Haiti and Santo Domingo," *Crusader* 5, no. 4 (December 1921): 11.

43. Cyril Briggs, "The Fight for Freedom," *Crusader* 2, no. 2 (October 1919): 16.

44. Cyril Briggs, "Horrors," *Crusader* 2, no. 7 (March 1920): 8.

45. Cyril Briggs, "Gathering War Clouds," *Crusader* 3, no. 4 (December 1920): 12.

6. BLACK TRANSNATIONAL MODERNITY

1. Hubert Harrison Diary, Hubert Harrison Papers, Rare Book and Manuscript Library, Columbia University, New York.

2. Michael Henry Adams, *Harlem Lost and Found*; Lewis, *When Harlem Was in Vogue*; and Corbould, *Becoming Black American*.

3. On the stereopticon and illustrated lectures, see Musser, *The Emergence of Cinema*, 29–42. Musser observes that the increasing use of the stereopticon by vaudeville and popular theater coincided with their adoption of moving pictures in 1896–97. But he also notes that stereopticon lectures were frequently sponsored by white church-based and civic groups. See also Stewart, *Migrating to the Movies*, 126, 261n37, 284n35. Stewart suggests that by Harrison's time, "visual representations of the progress of the race were also projected in the form of stereopticon slide presentations, which were extremely popular among African American audiences" (261n37).

4. Stephens, *Black Empire*, 2, 46, 49.

5. For an excellent study of black internationalism that focuses on a slightly later period, see Singh, *Black Is a Country*. See also Gore, *Radicalism at the Crossroads*; McDuffie, "'A New Freedom Movement of Negro Women'"; Ransby, *Ella Baker and the Black Freedom Movement*; and Young, *Soul Power*.

6. Robinson, *Black Marxism*, 176.

7. On African American memory books, see Tucker, "Telling Particular Stories." As Tucker explains, during the first three decades of the twentieth century, "prefabricated memory books" were marketed to consumers, but there is also a much longer history of the significance of the scrapbook in African American culture: the antislavery movement published compilations of clippings as evidence of the horrors of slavery, such as Theodore Weld's *American Slavery as It Is* (1839), and collectors such as William Dorsey, who created 140 scrapbooks "devoted wholly to African Americans," were motivated by a desire to enable black people to "know" their "history." See also Martin, "Bibliophiles, Activists, and Race Men."

8. Kevin Gaines, *Uplifting the Race*, xv, 250, 258.

9. Hubert Harrison, "Introduction [to a book], Draft [unpublished]. Autograph manuscript, 1 Nov. 1919," Folder 5, Box 5, Hubert H. Harrison Papers, Rare Book and Manuscript Library, Columbia University. Although the finding aid says this introduction was unpublished, parts of it are identical to Harrison's article "The Negro and the Newspapers" (1911), which was reprinted in Harrison's *The Negro and the Nation* (1919).

10. Hubert Harrison, "The Newspaper and Social Service," *Boston Chronicle*, February 9, 1924, in "Misc. Writings Vol. 2 [Scrapbook]," Folder 4, Box 13, Hubert H. Harrison Papers, Rare Book and Manuscript Library, Columbia University.

11. Hubert Harrison, "Marcus Garvey at the Bar of United States Justice," Associated Negro Press, July 1923, reprinted in Harrison, *A Hubert Harrison Reader*, 187.

12. Kevin Gaines, *Uplifting the Race*, 126.

13. Ibid.

14. See Harrison, "Insistence Upon its Real Grievances the Only Course for the Race," in Harrison, *A Hubert Harrison Reader*, 164–66.

15. See Ross, *Manning the Race*. Harrison married his wife, Irene Louise Horton, better known as Lin, after she became pregnant in 1909, and as Perry observes, in Harrison's extensive archive of personal papers there is "a noticeable lack of material" indicating that he and Irene "ever shared a driving, consuming, passionate love" (*Hubert Harrison*, 110). On the other hand, Harrison "documented over ten passionate heterosexual relationships in his diary" and even briefly enjoyed an intimate and "wonderful friendship" with Amy Ashwood, Marcus Garvey's first wife, whom Harrison characterized as a "very, very passionate woman" that he "wished he could get" as his "helpmeet" because she was so ambitious and "inspirational." Harrison generally does not seem to have attributed deviance or pathology to the women with whom he had extramarital liaisons, but he did closely monitor the behavior of his four daughters, and to a lesser extent of his son, whom he continued to try to supervise even when he was not living with them. In 1926 he proudly gave his twelve-year-old daughter Ilva a "hug and a kiss" after she and a team of girls triumphed over a male team by taking the negative position in a debate over whether "the American whites had dealt justly with the American Indians." Just a few months later, however, right before leaving for the Renaissance Casino to speak in explanation of the stereopticon pictures, he physically punished one of his older daughters after she failed to come home and then lied to him.

16. Hubert Harrison Diary, November 16, 1926.

17. On tribadism, see Halberstam, *Female Masculinity*, 59–65. Halberstam suggests that tribadism was "often linked to female masculinity" and other forms of "perversion" practiced by women and suggests that the word is related but irreducible to the contemporary term *lesbian*, partly because it is a "practice" and not an "identity." She also observes that the tribade should be situated "in relation to the history of females who cannot conform to the category of woman" (61).

18. In the diary, Harrison frequently switches to a complicated code when he alludes to his many extramarital liaisons with women. In an entry dated February 26, 1926, he also shifts from English to code when he describes the drag ball he judged at the Renaissance Casino and elaborates on an encounter he had with "a beautiful light brown person, 'Bubbles,' with wonderful legs," whom he

found out afterward was a West Indian "cum nos osculamos in gradibus quod nos faciunt multos tempos" and who was too scared to give Harrison her name, though he gave her his and "she promised" something that Harrison refused to reveal even in his diary. He did confess, however, that "it was hard to believe that some of them were not really women. There was one white friend of Elsie's whom she called 'the Tiger woman,' with languishing eyes and a voice like falling water in a moonlit night. My boldness brought us together and we had several dances. . . . Another named Jackson, I think, gave me two dances, and I am to get in touch with her later. One young temptress was said to be a male—but I can't believe it. She was ravishing! I tried to get dances with her, and failed. But I did make bold to kiss her bare shoulder." Other writers who mention Harrison cite Claude McKay's comment in his autobiography that Harrison was "erotically . . . very indiscriminate" as well as a government intelligence report, published in 1921, that was extraordinarily attentive to what the agent pathologized as Harrison's "abnormal sexualism." See McKay, *A Long Way from Home*, 118 and Parker Hitt, Letter to Director, Military Intelligence Division, Washington D.C., June 23, 1921, cited in Winston James, *Holding Aloft the Banner of Ethiopia*, 129, 320.

19. Vogel, *The Scene of Harlem Cabaret*, 4. On drag balls in Harlem during this era, see Chauncey, *Gay New York*, 227–67, and Mumford, *Interzones*, 73–92.

20. "The Cabaret School of Negro Literature and Art" reprinted in Harrison, *A Hubert Harrison Reader*, 356.

21. Hubert H. Harrison Diary, November 25, 1907, reprinted in Harrison, *A Hubert Harrison Reader*, 33–34. The titles of the ten volumes are "Eminent Men and Remarkable Deeds"; "The Color Line"; "Lynching"; "Economic"; "Manners and Customs (1) Real Defects (2)"; "The Negro Factions: 1. The Protestants; 2. The Subservients"; "Opinions, a. favorable, b. unfavorable, c. impartial"; "Miscellaneous Clippings"; "The Negro and the War"; and "Pictures."

22. Shawn Michelle Smith, *Photography on the Color Line*, 7.

23. Ibid., 11.

24. On lynching postcards, see Allen, *Without Sanctuary*; Goldsby, *A Spectacular Secret*, 263–81; and Shawn Michelle Smith, *Photography on the Color Line*, 118–26. Goldsby observes that "the breakthrough technology of 'real photo' postcards in 1910 made it possible for lynching murders to be quickly converted into visual artifacts and souvenirs" which "were more likely to be printed by local entrepreneurs in small-size lots" (*A Spectacular Secret*, 262). She argues that "the postcard archives the way in which these lynching murders were symptomatic of American modernization" (ibid., 273). Smith suggests that lynching postcards "played a crucial role in producing and reproducing the crime itself as a 'scene'" and analyzes how white spectators "reconfirm sentimental bonds" through "images of white violence" (*Photography on the Color Line*, 121). In response to this problem, Smith focuses "on the spectacle of the white audience" in order not to "repeat and reinforce the spectacle of Black death" that lynching photographs risk reproducing (ibid., 118).

25. "The Black Man's Burden" reprinted in Harrison, *A Hubert Harrison Reader*, 71.

26. For an account of how Du Bois's *Crisis* responded to lynching, see Carroll, *Word, Image, and the New Negro*, 30–37, and Castronovo, *Beautiful Democracy*, 106–35. The magazine reproduced some lynching photographs, and Du Bois defended their presence in an editorial entitled "The Gall of Bitterness" (1912) by asking, "Can the nation otherwise awaken to the enormity of this beastly crime of crimes, this rape of law and decency?"

27. On political cartoons of lynching, see Goldsby, *A Spectacular Secret*, 252–53. She notes the "prevalence" of political cartoons about lynching in African American newspapers of the period and suggests that "in their insistence on hyperbole and caricature, hand-drawn illustrations allowed viewers to see lynching's violence in a way that documentary photographs did not, because artists could use the drawing techniques of line, proportion, and point of view to determine what and how the viewer experienced the scenes staged in the cartoon's visual field" (252).

28. Folder 12, Box 11, Hubert H. Harrison Papers, Rare Book and Manuscript Library, Columbia University.

29. "Lincoln and Liberty: Fact versus Fiction Notes (1911–1914)," Folder 12, Box 5, Hubert H. Harrison Papers, Rare Book and Manuscript Library, Columbia University.

30. "Lecture Outlines and Notes," Folder 3, Box 13, Hubert H. Harrison Papers, Rare Book and Manuscript Library, Columbia University.

31. "Public Notices, Records, and References, Vol. 2 The Upward Climb," Folder 6, Box 13, Hubert H. Harrison Papers, Rare Book and Manuscript Library, Columbia University.

32. "Mexico (19 Feb. 1926–24 March 1927)," Folder 4, Box 11, Hubert H. Harrison Papers, Rare Book and Manuscript Library, Columbia University. For a fascinating study of African Americans' involvement in the Mexican Revolution, see Horne, *Black and Brown*.

33. "The Negro in Africa and the West Indian," Folder 7, Box 11, Hubert H. Harrison Papers, Rare Book and Manuscript Library, Columbia University.

34. Folder 48, Box 6, Hubert H. Harrison Papers, Rare Book and Manuscript Library, Columbia University. Reprinted in Harrison, *A Hubert Harrison Reader*, 241–50. These conclusions resonate with many of the clippings in "The Negro in Africa and the West Indian" scrapbook, including a 1927 piece from the *New York World* in which Professor Robert Herrick criticized the U.S. occupation of Haiti and observed that "the American of our occupational force is an ignorant, prejudiced small-town product, who doesn't want to understand the problem before him," a formulation that Harrison underlined.

35. "Labor and Strikes," Folder 1, and "Migration," Folder 5, Box 11, Hubert H. Harrison Papers, Rare Book and Manuscript Library, Columbia University.

36. In an article for the *Voice*, Harrison commented that "Negro soldiers (disguise it how we will) must always be a menace to any state which lynches Negro civilians."

37. Clipping from the *New York Evening Post*, May 17, 1917, in "America Enters the War (1917)," Folder 3, Box 10, Hubert H. Harrison Papers, Rare Book and Manuscript Library, Columbia University.

38. "Carranza Troops Paid by Agents of Germany," clipping from the *New York Evening Post*, March 28, 1917.

39. Clipping from the *New York Journal*, April 7, 1917.

40. For more on the repression of black radicals during the First World War era, see Ellis, *Race, War, and Surveillance*, and Kornweibel, *"Investigate Everything."*

41. Harrison, "The White War and the Colored Races," *New Negro* 4 (October 1919), reprinted in Harrison, *A Hubert Harrison Reader*, 203–8.

42. Hubert Harrison, "The Rising Tide of Color against White World Supremacy by Lothrop Stoddard," *Negro World*, May 29, 1920; "Aftermath and Rising Tide" scrapbook, Folder 3, Box 10, Hubert H. Harrison Papers, Rare Book and Manuscript Library, Columbia University, reprinted in Harrison, *When Africa Awakes*, and Harrison, *A Hubert Harrison Reader*, 305–9. Perry cites the letter to Stoddard in the introductory note to this article in the reader.

43. Stoddard, *The Rising Tide of Color against White World Supremacy*, vi.

44. Harrison, "Rising Tide," 306.

45. Hubert Harrison, "The Rising Tide of Color," *Negro World*, June 12, 1920, reprinted in Harrison, *When Africa Awakes*, and Harrison, *A Hubert Harrison Reader*, 309–10. See Nasaw, *The Chief*, 58–60, 112, 167, 171, 195, 203, 212, 214, 229, 248, 381, 384. On *Patria*, the Hearst-produced "preparedness" serial about an "adventuress who saved her dangerously unprepared country from an invading military force," see Nasaw, *The Chief*, 261–63. The *New York Telegraph* in a November 20, 1917, review called the serial "frankly anti-Mexican and anti-Japanese in line with William Randolph Hearst's policies" (quoted in Nasaw, *The Chief*, 261). Japanese and Mexican spies foment a strike at the munitions factory owned by the adventuress's family; in the end she saves the United States from invading Japanese and Mexican military forces. Hearst and Pathé News had re-edited the film in response to official suggestions that the film should be withdrawn because of the harsh representations of U.S. ally Japan. Wilson later personally asked that the film be withdrawn or edited, and the film was revised again in order to eliminate all "images of Japanese kimonos, costumes, servants, interior fittings, flags, and military uniforms" (Nasaw, *The Chief*, 263).

46. Hubert Harrison, "Science and Race Prejudice," n.d., in "Misc. Writings Vol. 2 [Scrapbook] Literary Criticism / First Phase, Second Phase, Other writings of the 2nd phase," Folder 4, Box 13, Hubert H. Harrison Papers, Rare Book and Manuscript Library, Columbia University. Harrison also proposed that "when we know a man to be a Catholic, a Russian Grand Duke, a Ku Kluxer, or a Californian Senator, we expect that the bias of his religion, class, or nationality will enter into the results of his mental processes and prejudice his views on birth-control, Bolshevism, patriotism, and Chinese immigration."

47. The first of these scrapbooks encompassed the "Moral and Spiritual" dimen-

sions of white life, while the second was entitled "Social, Political, and Miscellaneous: A Series of Illustrative Clippings." Box 11, Folders 15 and 16, Hubert H. Harrison Papers, Rare Book and Manuscript Library, Columbia University.

48. Still other clippings focus on white men who deviate from ideals of Anglo-Saxon manhood, such as a husband who was arrested after his wife accused him of being a "white slaver."

49. The January cover featured an illustration of "The Girl of the Golden West," which the editor claimed explained why "Balboa waded up to his waist before he discovered the Pacific Ocean": "With his head turned by one of the Pacific Coast beauties, the explorer quite naturally walked right off the American continent before he remembered his duty to the good Queen of Spain." Surprisingly (or not?), the golden girl that turned Balboa's head turns out to be a blonde!

50. "The White Man at Home: Moral and Spiritual" scrapbook, Folder 15, Box 11, Hubert H. Harrison Papers, Rare Book and Manuscript Library, Columbia University. In this scrapbook Harrison also reproduced a cartoon from the *Evening Journal* entitled "Remove the Root and the Vine Will Die" (1922), which visually suggested that "poverty" was the root that caused the vine of "crime" to flourish and threaten the tree of "civilization."

51. "The White Man at Home: Social, Political, and Miscellaneous," Folder 16, Box 11, Hubert H. Harrison Papers, Rare Book and Manuscript Library, Columbia University.

52. Hubert Harrison, "Ku Klux Plan in the Past," *Negro World*, September 24, 1921, reprinted in Harrison, *A Hubert Harrison Reader*, 267–70.

7. "WANTED—A COLORED INTERNATIONAL"

1. Harrison divided his writings into the following categories: "early" writings (1911–19); "major" and "minor" contributions to *Negro World* (January 1920–February 1922); and "Miscellaneous Writings Vol. 2: Literary Criticism and Other Writings" (1921–27).

2. These scrapbooks are formally entitled "Mainly about Me, Volume 1, The Radical and Racial Phases: Newspaper Clippings Relating to Hubert H. Harrison" (1905–1920) and "Public Notices, Records and References Vol. 2: The Upward Climb" (1903–1927).

3. Hubert Harrison, "The Right Way to Unity," *Boston Chronicle*, May 10, 1924, reprinted in Harrison, *A Hubert Harrison Reader*, 402–4.

4. The word *propaganda* was more neutral at the time Harrison was writing, but was beginning to take on some of its current pejorative connotations, partly because of its associations with the world of advertising as well as recent state efforts to mobilize support for the First World War. See the debates over art and propaganda involving Eric Walrond, Du Bois, Locke, and others, in Gates and Jarrett, *The New Negro*, 255–61.

5. Hubert Harrison Diary, Hubert H. Harrison Papers, Rare Book and Manuscript Library, Columbia University.

6. Hubert Harrison, "An Open Letter to the Socialist Party of New York City," *Negro World*, May 8, 1920, reprinted in Harrison, *A Hubert Harrison Reader*, 113–16.

7. As early as 1914, Harrison wrote a letter to the editors of the *New Review*, a socialist monthly that had previously published pieces by Du Bois and others on white racism within the party, especially among Southerners. In this letter Harrison charged that the "Southern environment" of Mrs. Ida Raymond, the state secretary of the Socialist Party of Mississippi, had vitiated her "notion of history" when she defended the emergence of the Klan in the nineteenth century by asserting that the threatened extension of "full political rights" to black men meant that the Klan "had to take matters into their own hands and save their women, their homes, and their country from the terrible outrages that were perpetrated by the Negroes." She also defended segregation and objected to having whites and blacks meet together. In response, Harrison pointed out that the Klan had begun its "terrorism" in 1865, "long before the vote was given to Negroes in the South" to protect them from the Klan and other violent white supremacist organizations that emerged after the Civil War ("Southern Socialists and the Ku Klux Klan," unpublished letter to the editor of *New Review*, reprinted in the *Negro World*, January 8, 1921; reprinted in Harrison, *A Hubert Harrison Reader*, 77–78). Raymond's ignorance of "known facts" did not bother Harrison as much, however, as the "attitude of Southern socialists which it so naively reveals": that the party did not "stand for the full civic and political equality of all workers" because of the persistence of white supremacist "attitudes" and a vitiated notion of the history of the period between the Civil War and the present. This letter remained unpublished until 1921, when it appeared in the UNIA newspaper *Negro World*, for which Harrison was at that time a contributing editor. That the editors of a socialist publication chose not to publish the letter and that Harrison preserved it and published it himself later reveals much about the boundaries of the Socialist Party at that time as well as the continuing relevance of the letter six years later, in the wake of the First World War, when the Klan's popularity surged.

8. Hubert Harrison, "The Ku Klux Klan in the Past," *Negro World*, September 24, 1921, reprinted in Harrison, *A Hubert Harrison Reader*, 268, 270.

9. In 1923, for example, the *Paterson Morning Call* reported that the Klan had threatened to kidnap Harrison but that he had issued a challenge, while police stood guard, to debate on a public platform "the Subject, 'Resolved, that the Ku Klux Klan Is a Menace to American Liberty.'"

10. Hubert Harrison, "How to End Lynching," *Boston Chronicle*, June 28, 1924, reprinted in Harrison, *A Hubert Harrison Reader*, 270–71.

11. Hubert Harrison, "The Negro and the Newspapers," 1911, reprinted in Harrison, *A Hubert Harrison Reader*, 46–49.

12. Harrison, *When Africa Awakes*, 96.

13. Hubert Harrison, "The Negro and Socialism I: The Negro Problem Stated," *New*

York Call, November 28, 1911, reprinted in Harrison, *A Hubert Harrison Reader*, 52–55.

14. Hubert Harrison, "The Black Man's Burden [I]," *International Socialist Review* 12 (April 1912), reprinted in Harrison, *A Hubert Harrison Reader*, 62–67.

15. Hubert Harrison, "Socialism and the Negro," *International Socialist Review* 13 (July 1912), reprinted in Harrison, *A Hubert Harrison Reader*, 71–76.

16. Harrison, "Southern Socialists and the Ku Klux Klan," 78; "Southern Socialists and the Ku Klux Klan," unpublished letter to the editor of *New Review*, reprinted in the *Negro World*, January 8, 1921; reprinted in Harrison, *A Hubert Harrison Reader*, 77–78.

17. "Harrison Lecture," Elizabeth, New Jersey, December 7, 1912. In "Mainly About Me" Scrapbook, Hubert H. Harrison Papers, Rare Book and Manuscript Library, Columbia University.

18. Hubert Harrison, "The East St. Louis Horror," *Voice*, July 4, 1917, reprinted in Harrison, *A Hubert Harrison Reader*, 94–95.

19. Ibid.

20. Hubert Harrison, "The Liberty-League of Negro-Americans: How It Came to Be," *Voice*, July 4, 1917, reprinted in Harrison, *A Hubert Harrison Reader*, 86–88.

21. Hubert Harrison, "Shillady Resigns," *Negro World*, June 19, 1920, reprinted in Harrison, *A Hubert Harrison Reader*, 177–78.

22. Hubert Harrison, "The Line-Up on the Color Line," *Negro World*, December 4, 1920, reprinted in Harrison, *A Hubert Harrison Reader*, 216–19.

23. Hubert Harrison Diary, March 17, 1920, Hubert H. Harrison Papers, Rare Book and Manuscript Library, Columbia University, reprinted in Harrison, *A Hubert Harrison Reader*, 185.

24. Hubert Harrison, "Wanted—A Colored International," *Negro World*, May 28, 1921, reprinted in Harrison, *A Hubert Harrison Reader*, 223–28.

25. Harrison, *A Hubert Harrison Reader*, 372.

26. At the New York Public Library and other venues, Harrison gave literary lectures with titles such as "Negro Poets of Note," "Rider Haggard's African Romances," "The Negro in American Literature," "Cooper's Leatherstocking Tales," "Folk Songs of the American Negro," "Moby Dick: The Unique Masterpiece of Herman Melville," and "Lincoln as a Master of English."

27. Hubert Harrison, "'No Negro Literary Renaissance', Says Well-Known Writer," *Pittsburgh Courier*, March 12, 1927, reprinted in Harrison, *A Hubert Harrison Reader*, 351–54.

28. Hubert Harrison, "Negro Society and the Negro Stage," *Voice*, October 3, 1917, reprinted in Harrison, *A Hubert Harrison Reader*, 373–76.

29. Hubert Harrison, "The Emperor Jones," *Negro World*, June 4, 1921, reprinted in Harrison, *A Hubert Harrison Reader*, 378–83. In response to critics who objected that "the play does not elevate the Negro," Harrison contended that the play mirrored life in "the imaginative terms of inner experience" and that it was "a great play acted by a great actor and in a noble manner."

30. Harrison on the *Phillis Wheatley*: "Pictures of her were faked in the office of the B.S.L. [Black Star Line] and printed in the *Negro World*, each picture showing a different type of ship."

31. Hubert Harrison, "Marcus Garvey at the Bar of United States Justice," Associated Negro Press, July 1923, reprinted in Harrison, *A Hubert Harrison Reader*, 194–99.

32. He also quotes a more extensive version of the same part of the play he cited in the 1923 review, adding a minor Cockney character's observation that there is "little stealin'" and "big stealin'," and while the former "gets you in jail" the latter "makes you emperor."

33. Harrison's 1923 article on Garvey's trial and conviction, "Marcus Garvey at the Bar of United States Justice," on the other hand, reveals that he intensely hoped for such an outcome, but instead of holding out for a moral to Garvey's story that might restore collective agency to "poor and ignorant" people as he did in 1921, in this piece, which was widely copied in the nation's black press, he declared that the "Garvey Case will go down in history as a splendid illustration of the race's gullibility."

34. Hubert Harrison, "The Negro and the Nation," Hubert H. Harrison Papers, Rare Book and Manuscript Library, Columbia University, reprinted in Harrison, *A Hubert Harrison Reader*, 286–90.

35. Harrison repeatedly complained about Garvey's "ignorance" of Africa, which included calling it a "country." In a commonplace book that Harrison kept for a while, he observed that "it was a wise American who had traveled all over the world who said that 'Human beings love to be humbugged.'" He points to Garvey, along with Woodrow Wilson and Billy Sunday, as three humbuggers who showed that if you fool the people "to the top of their bent," they "will pour their wealth into your pocket and enshrine you in their admiration. Jesus, John Brown, and Father Damien died poor and despised, while Billy Sunday, Marcus Garvey and Woodrow Wilson lived in luxury and ease." Hubert Harrison, "Notes from the Diaries," Box 9, Folder 3, Hubert H. Harrison Papers, Rare Book and Manuscript Library, Columbia University.

36. "Negroes Plan New American State," *Monitor*, June 7, 1924: "International Colored Unity League Organizing Branches to Further Project." The idea of the "setting aside of a section of the US to be occupied exclusively by Negroes, who will thus have an outlet for their 'racial egoism,' is now being put before the Negroes of the US by HH, a noted Negro lecturer, journalist, and welfare worker of NY." From Public Notices, Records and References, Vol. 2: The Upward Climb, Scrapbook, Box 13, Folders 5 and 6, Hubert H. Harrison Papers, Rare Book and Manuscript Library, Columbia University.

37. Hubert Harrison, "Miscellaneous Writings Vol. 2: Literary Criticism and Other Writings Scrapbook," Box 13, Folder 4, Hubert H. Harrison Papers, Rare Book and Manuscript Library.

38. In his important study *Holding Aloft the Banner of Ethiopia*, Winston James sug-

gests that one of the reasons that Marcus Garvey was more "successful with the masses" and has been remembered in a way that Harrison has not was that "Harrison developed a certain notoriety as a philanderer and this diminished his standing and popularity" (129). James speculates that "black Harlemites preferred Garvey's magic" partly because he was more "disciplined and driven," with "little time for anything that was not directly connected with what he regarded as the redemption of Africa" (129). Although there is no doubt that Garvey attained a greater worldwide popularity than Harrison did and that he has been remembered while Harrison has been largely forgotten, the reasons for this are multiple, complex, and ultimately irreducible to sexuality alone. At the same time, it is perhaps true that Garvey managed to more successfully embody and represent the norms of bourgeois manhood that were central to middle-class ideals of uplift, in no small part because of the writings and activities of his second wife, Amy Jacques, who energetically promoted this image, especially while Garvey was imprisoned and in the years after his death. See Taylor, *The Veiled Garvey*.

Ironically, however, one of the last times Harrison used the word *sensational* was in a letter he wrote in January 1927 to the editor of the *Pittsburgh Courier* to complain about how his participation in Garvey's divorce trial was covered in the white press. Garvey's efforts to divorce his first wife, Amy Ashwood Garvey, a co-founder of the UNIA, captured headlines and created a scandal in December 1926, when both were found guilty of adultery at the conclusion of a trial in which Harrison was called to the stand. Harrison objected that the "sensational version" of one part of the trial that "was given by the white newspapers of this city was a deliberate misrepresentation designed to furnish something spectacular." That part, according to a *Pittsburgh Courier* clipping that Harrison preserved, was the reading of a "passionate letter" into the record which was said to be "from Mrs. Garvey No. 1 to Dr. Harrison, telling the noted Harlem lecturer that she loved him alone and as soon as she got enough money she would establish a love-nest and the two of them would lead the Negro race." "Letter to the Editor," *Pittsburgh Courier*, January 1, 1927; "Both Garveys Found Guilty: H. H. Harrison Denies Mrs. Garvey Wrote Him 'Love Note,'" *Pittsburgh Courier*, December 18, 1926, Box 13, Hubert H. Harrison Papers, Rare Book and Manuscript Library, Columbia University. Harrison observed that the letter was not addressed to him nor signed by her, and claimed that he had visited her at her home simply because he was helping her write a book entitled *The Rise and Fall of Marcus Garvey*. His diary, however, tells a far different story. Although it was true that Harrison was "casting" Ashwood's story "into literary form," he also reported that the two of them got "along like a house afire" and that he wished he had her as his "helpmeet" so he could "rise to giddy heights of achievement." Harrison's letter to the editor of the *Pittsburgh Courier* may have been partly designed to shield Ashwood and himself from scandal, but it also registers his objections to being made part of a spectacle of transgressive sexuality in

which black politics and black world movements disappeared in the lurid light of the white newspapers' sensational versions of what happened, which misrepresented the trial scene, Harrison insisted, in order to provide "something spectacular." Although Garvey's efforts to perform normative manhood were perhaps more successful, he was also scrutinized and persecuted by the state, and his erotic and familial relationships were investigated and turned into a scandal as part of an effort to shut down his movement by turning him and it into a spectacle.

39. Hubert Harrison, "The Right Way to Unity," *Boston Chronicle*, May 10, 1924, reprinted in Harrison, *A Hubert Harrison Reader*, 402–4.

EPILOGUE

1. See Denning, *The Cultural Front*, 131, 132. Denning discusses what he calls "ethnic Americanisms," which he defines as "pride in ethnic heritage and identity combined with an assertive Americanism," and which reclaim "the figure of 'America' itself, imagining an America that would provide a usable ethnic past for ethnic workers" (9). See also 128–32.

2. Muñoz, *Cruising Utopia*, 17.

3. For the relevant extracts from the Espionage and Sedition Acts, see http://www .firstworldwar.com. See also Kohn, *American Political Prisoners*; Paul Murphy, *World War I and the Origin of Civil Liberties in the United States*; Preston, *Aliens and Dissenters*; and Thomas, *Unsafe for Democracy*. On deportation as a "racialized system of social control," see Buff, "The Deportation Terror" and *Immigrant Rights in the Shadows of Citizenship*.

4. Goldman, *Living My Life*, vol. 2, 667.

5. "J. Edgar Hoover Recommends Goldman and Berkman Deportation," August 23, 1919, United States National Archives, Record Group 60. Document reposted at the Berkeley Digital Library SunSITE http://sunsite.berkeley.edu. Important scholarship on Goldman includes Clark, *Sentimental Modernism*; Drinnon, *Rebel in Paradise*; Drinnon and Drinnon, *Nowhere at Home*; Falk, *Emma Goldman*, vols. 1 and 2; Falk, *Love, Anarchy, and Emma Goldman*; Marsh, *Anarchist Women 1870–1920*; and Zinn, *Emma*.

6. "Manifesto of the No-Conscription League," Government's Exhibit 1, Supreme Court of the United States, Emma Goldman and Alexander Berkman, Plaintiffs-in-Error, vs. the United States (1917). Posted at the Jewish Women's Archive, http://jwa.org. Accessed April 26, 2011.

7. Although Goldman claimed U.S. citizenship through marriage to her first husband, years after he died, at a time when officials were looking for ways to strip Goldman of citizenship rights, her former husband's citizenship was declared invalid on grounds that he had not been of age when he was naturalized.

8. "Federal Campaign to Deport Alien Radicals Under Way in Earnest," *New York Tribune*, December 22, 1919.

9. United States Congress, *Communist and Anarchist Deportation Cases*, 106, 11.

10. Ibid., 106.

11. Ibid., 120.

12. Ibid., 20.

13. Wexler, *Tender Violence*, 3.

14. Ibid., 3, 65, 66. On family photographs as a genre, see Hirsch, *The Familial Gaze* and *Family Frames.*

15. Pérez, *The Decolonial Imaginary*, 57.

16. Norvell, "Syndicalism and Citizenship," 111. Thanks to Curtis Marez for calling this to my attention.

17. "Garvey Sails with Pledge to Fight On: Hundreds Plan to Join Him in Exile," *Chicago Defender*, December 10, 1927, 1.

18. "Garvey Deported," *Baltimore Afro-American*, December 3, 1927, 1.

19. *The Marcus Garvey and Universal Negro Improvement Association Papers: Africa for the Africans, 1921–1922*, vol. 9, 4.

20. "Negro Sails Away in Triumph," *Los Angeles Times*, December 3, 1927, 1.

21. "Hon. E. B. March Describes Leave-Taking in New Orleans," *Negro World*, December 17, 1927, reprinted in Clarke, *Marcus Garvey and the Vision of Africa*, 274.

22. Goldman, *Living My Life*, vol. 2, 615.

23. *Trial and Speeches of Alexander Berkman and Emma Goldman in the United States District Court, in the City of New York, July, 1917*, 56–66.

24. Ibid., 64.

25. Ibid.

26. Goldman, *Living My Life*, vol. 2, 704.

27. Ibid., 708.

28. See Berkman and Goldman, *Deportation, Its Meaning and Menace*. Goldman discusses the process of writing the pamphlet in *Living My Life*, 713.

29. "Emma to Sail Today," *Los Angeles Times*, December 21, 1919.

30. "249 Reds Sail; Exiled to Soviet Russia; Berkman Threatens to Come Back," *New York Times*, December 22, 1919.

31. Ibid.

32. Goldman, *Living My Life*, vol. 2, 715.

33. Ibid., 717.

34. "The Soviet Ark Departs Amid Rousing Cheers: Deportation of Anarchists are Approved and More Are Called For," *New York Tribune*, December 28, 1919.

35. "More Reds to Go; First 249 on First Ship Curse U.S.," *Chicago Daily Tribune*, December 22, 1919.

36. Goldman, *Living My Life*, vol. 2, 715.

37. "Sails with 249 Reds," *Washington Post*, December 22, 1919.

38. Goldman, *Living My Life*, vol. 2, 717.

BIBLIOGRAPHY

MANUSCRIPTS AND ARCHIVAL COLLECTIONS

Bancroft Library, University of California, Berkeley
Emma Goldman Papers
John Murray Papers
Ethel Duffy Turner Papers

Hatcher Library, University of Michigan
Joseph A. Labadie Collection

Mandeville Special Collections Library, University of California, San Diego
Flores Magón Documents (1907–11), MSS 582

Rare Book and Manuscript Library, Columbia University
Hubert H. Harrison Papers

Ruether Library, Wayne State University
George and Grace Brewer Collection
Sam Dolgoff Collection
E. F. Doree Papers

Schomburg Center for Research in Black Culture, New York Public Library
J. R. Casimir Papers

Tamiment Library, New York University
Alexander Berkman Papers
Eugene V. Debs Papers
Emma Goldman Papers
Industrial Workers of the World, New York City Branch Record
Printed Ephemera Collections on Individuals, Organizations, and Subjects
Radical Pamphlet Literature Collection
Socialist Party (U.S.) Printed Ephemera Collection

NEWSPAPERS AND MAGAZINES

Agitator (Home Colony, Wash.)
Alarm (Chicago, Ill.)

American Magazine (New York, N.Y.)
Appeal to Reason (Girard, Kans.)
Baltimore Afro-American (Baltimore, Md.)
Blast (San Francisco, Calif.)
Boston Chronicle (Boston, Mass.)
Chicago Defender (Chicago, Ill.)
Crisis (New York, N.Y.)
Crusader (New York, N.Y.)
Frank Leslie's Illustrated Newspaper (New York, N.Y.)
Hearst's Magazine (New York, N.Y.)
Industrial Worker (Chicago, Ill.)
Industrial Worker (Spokane and Seattle, Wash.)
International Socialist Review (Chicago, Ill.)
Liberator (Chicago, Ill.)
Los Angeles Times
Messenger (New York, N.Y.)
Mother Earth (New York, N.Y.)
Negro World (New York, N.Y.)
New Negro (New York, N.Y.)
New York Call
New York Sun
New York Tribune
Regeneración (Los Angeles, Calif.)
Tip Top Weekly (New York, N.Y.)
Voice (New York, N.Y.)

PRIMARY SOURCES

Ahrens, Gale, ed. *Lucy Parsons, Freedom, Equality, and Solidarity: Writings and Speeches, 1878–1937.* Chicago: Charles H. Kerr, 2004.
Berkman, Alexander. *Life of an Anarchist: The Alexander Berkman Reader.* Edited by Gene Fellner with an introduction by Howard Zinn. New York: Seven Stories, 2004.
———. *Prison Memoirs of an Anarchist.* 1912. Reprint, Pittsburgh: Frontier Press, 1970.
Berkman, Alexander, and Emma Goldman. *Deportation, Its Meaning and Menace: Last Message to the People of America.* Ellis Island: M. E. Fitzgerald, 1919.
———. "Uncle Sam in Mexico." *Mother Earth* 5, no. 6 (August 1910): 182–83.
Briggs, Cyril. "The Decline of the Garvey Movement." *Marcus Garvey and the Vision of Africa*, ed. John Henrik Clarke, 178–79. New York: Vintage, 1974.
Cortez, Carlos. *Crystal Gazing, the Amber Fluid, and other Wobbly Poems.* Chicago: Charles Kerr, 1990.
de Cleyre, Voltairine. *Exquisite Rebel: The Essays of Voltairine de Cleyre— Anarchist, Feminist, Genius.* Edited by Sharon Presley and Crispin Sartwell. Albany: State University of New York Press, 2005.

————. *The First Mayday: The Haymarket Speeches 1895–1910*. Edited by Paul Avrich. Orkney, U.K.: Cienfuegos Press, Libertarian Book Club, and Soil of Liberty, 1980.

————. "The Mexican Revolution." *Selected Works of Voltairine de Cleyre*, ed. Alexander Berkman. New York: Mother Earth Publishing, 1914.

————. *The Voltairine de Cleyre Reader*. Edited by A. J. Brigati. Oakland: AK Press, 2004.

De Zayas, Marius. *How, When, and Why Modern Art Came to New York*. Cambridge, Mass.: MIT Press, 1996.

————. "Photography and Artistic-Photography." *Classic Essays on Photography*, ed. Alan Trachtenberg, 125–32. New Haven, Conn.: Leete's Island Books, 1980.

————. *A Study of the Modern Evolution of Plastic Expression*. New York: "231," 1913.

Douglass, Frederick. *Narrative of the Life of Frederick Douglass, an American Slave*. 1845. Reprint, New York: Penguin, 1982.

Drinnon, Richard, and Anna Maria Drinnon, eds. *Nowhere at Home: Letters from Exile of Emma Goldman and Alexander Berkman*. New York: Schocken, 1975.

Falk, Candace, ed. *Emma Goldman: A Documentary History of the American Years*. Vol. 1, *Made for America, 1890–1901*. Berkeley: University of California Press, 2003.

————, ed. *Emma Goldman: A Documentary History of the American Years*. Vol. 2, *Making Speech Free, 1902–1909*. Berkeley: University of California Press, 2004.

Fletcher, Ben. *Ben Fletcher: The Life and Times of a Black Wobbly*. Chicago: Charles H. Kerr, 2007.

Flores Magón, Ricardo. *Dreams of Freedom: A Ricardo Flores Magón Reader*. Edited by Chaz Bufe and Mitchell Verter. Oakland: AK Press, 2005.

————. *Obras Completas de Ricardo Flores Magón 1: Correspondencia*. Edited by Jacinto Barrera Bassols. Calz, Mexico: Consejo Nacional Para La Cultura y Las Artes, 2001.

————. *Obras De Teatro / Ricardo Flores Magón*. Mexico City: Antorcha, 1980.

Goldman, Emma. *Living My Life*. 2 vols. 1934. Reprint, New York: Dover, 1970.

Gutiérrez de Lara, Lázaro, and Edgcumb Pinchon. *The Mexican People: Their Struggle for Freedom*. Garden City: Doubleday, Page, 1914.

Harrison, Hubert. *A Hubert Harrison Reader*. Edited by Jeffrey B. Perry. Middletown, Conn.: Wesleyan University Press, 2001.

————. *The Negro and the Nation*. New York: Cosmo Advocate Publishing Co, 1919.

————. *When Africa Awakes: The "Inside Story" of the Stirrings of the New Negro in the Western World*. New York: Porro, 1920.

Industrial Workers of the World. *The History of the IWW: A Discussion of Its Main Features* (by a Group of Workers). Chicago: Industrial Workers of the World, 1923.

"Manifesto of the No-Conscription League." *Transcript of Record: Supreme Court of the United States, Emma Goldman and Alexander Berkman, Plaintiffs-in-Error,*

vs. the United States, 451–54. Ann Arbor: University of Michigan Library, 1917. Available at the Jewish Women's Archive web page, http://jwa.org.

The Marcus Garvey and Universal Negro Improvement Association Papers. Edited by Robert A. Hill. Berkeley: University of California Press, 1994.

Martí, José. *En Las Estados Unidos*. Vol. 11 of *Obras Completas*. Havana: Editorial de Ciencias Sociales, 1975.

———. *José Martí: Selected Writings*. Edited and translated by Esther Allen. New York: Penguin, 2002.

McKay, Claude. *A Long Way from Home*. New York: Mariner Books, 1970.

Mexican Liberal Party. *Land and Liberty: Mexico's Battle for Freedom and Its Relation to Labour's World-Wide Struggle*. Los Angeles: Mexican Liberal Party, 1913.

Parsons, Lucy. *Life of Albert R. Parsons: With Brief History of the Labor Movement in America* Chicago: Lucy E. Parsons, 1889; 1903.

———. *Twenty-Fifth Anniversary Eleventh of November Memorial Edition of the Famous Speeches of Our Martyrs*. Chicago: Lucy E. Parsons, 1910.

Phillips, John. "A Magazine Monologue." *American Magazine* 68, no. 6 (October 1909): n.p.

Riebe, Ernest. *Twenty-Four Cartoons of Mr. Block*. Minneapolis: Block Supply, 1912.

Schaack, Michael J. *Anarchy and Anarchists: A History of the Red Terror and the Social Revolution in America and Europe*. Chicago: F. J. Schulte, 1889.

Spies, August. *August Spies' Auto-Biography: His Speech in Court, and General Notes*. Chicago: Nina Van Zandt, 1887.

Stoddard, Lothrop. *The Rising Tide of Color against White World Supremacy*. New York: Scribner's, 1920.

Trautmann, William E. *Direct Action and Sabotage*. Pittsburgh: Socialist News, 1912.

———. *Proceedings of the First Convention of the Industrial Workers of the World*. New York: Labor News Company, 1905.

Trial and Speeches of Alexander Berkman and Emma Goldman in the United States District Court, in the City of New York, July, 1917. New York: Mother Earth Publishing, 1917.

Turner, Ethel Duffy. *Ricardo Flores Magón y el Partido Liberal Mexicano*. Mexico City: Comisión Nacional Editorial del C.E.N., 1984.

———. *Writers and Revolutionists: An Interview Conducted by Ruth Teiser*. Berkeley: Regional Oral History Office, Bancroft Library, University of California, 1967.

Turner, John Kenneth. "The American Partners of Diaz," *International Socialist Review* 11, no. 6 (December 1910): 321–28.

———. *Barbarous Mexico*. Austin: University of Texas Press, 1969.

———. "Barbarous Mexico: The Slaves of Yucatan," *American Magazine* 68, no. 6 (October, 1909): 525–38.

———. "Barbarous Mexico: The Tragic Story of the Yaqui Indians," *American Magazine* 69, no. 1 (November 1909): 33–48.

———. "Barbarous Mexico: With the Contract Slaves of the Valle Nacional,"
American Magazine 69, no. 2 (December 1909): 250–62.

———. *Hands Off Mexico!* New York: Rand School of Social Science, 1920.

———. "Preface to the Third Edition." *Barbarous Mexico*. Chicago: Charles H.
Kerr, 1910, 5–6.

———. *Shall It Be Again?* New York: B. W. Huebsch, 1922.

United States Congress. *Communist and Anarchist Deportation Cases: Hearings before a Subcommittee of the Committee on Immigration and Naturalization, House of Representatives, Sixty-sixth Congress, Second Session, April 21 to 24, 1920: Statement of W. A. Blackwood*. Washington: Government Printing Office.

Weld, Theodore. *American Slavery As It Is: Testimony of a Thousand Witnesses*.
New York: American Anti-Slavery Society, 1839.

SECONDARY SOURCES

Adams, Michael Henry. *Harlem Lost and Found: An Architectural and Social History, 1765–1915*. New York: Monacelli, 2002.

Adams, Rachel. *Continental Divides: Remapping the Cultures of North America*.
Chicago: University of Chicago Press, 2009.

Ades, Dawn. "Posada and the Popular Graphic Tradition." *Art in Latin America: The Modern Era, 1820–1980*, ed. Dawn Ades, 110–23. New Haven, Conn.: Yale University Press, 1993.

Ades, Dawn, and Alison McClean. *Revolution on Paper: Mexican Prints 1910–1960*.
London: British Museum, 2009.

Agamben, Giorgio. *Homo Sacer: Sovereign Power and Bare Life*. Trans. by Daniel
Heller-Roazen. Stanford: Stanford University Press, 1998.

Ahmed, Sara. "Affective Economies." *Social Text* 22, no. 279 (summer 2004): 117–39.

———. *The Cultural Politics of Emotion*. London: Routledge, 2005.

Allen, James. *Without Sanctuary: Lynching Photography in America*. Foreword by
John Lewis. With contributions from Leon F. Litwack and Hilton Als. Santa Fe:
Twin Palms, 2000.

Almaguér, Tomas. *Racial Fault Lines: The Historical Origins of White Supremacy in California*. Berkeley: University of California Press, 1994.

Alonso, Ana María. *Thread of Blood: Colonialism, Revolution, and Gender on Mexico's Northern Frontier*. Tucson: University of Arizona Press, 1995.

Anderson, Benedict. *Under Three Flags: Anarchism and the Anti-Colonial Imagination*. New York: Verso, 2002.

Andrews, Gregg. *Shoulder to Shoulder?: The American Federation of Labor, the United States, and the Mexican Revolution, 1910–1924*. Berkeley: University of California Press, 1991.

Antliff, Allan. *Anarchist Modernism: Art, Politics, and the First American Avant-Garde*. Chicago: University of Chicago Press, 2007.

Ashbaugh, Carolyn. *Lucy Parsons: American Revolutionary*. Chicago: Charles H.
Kerr, 1976.

Avrich, Paul. *An American Anarchist: The Life of Voltairine de Cleyre*. Princeton: Princeton University Press, 1978.

———. *Anarchist Portraits*. Princeton: Princeton University Press, 1990.

———. *Haymarket Tragedy*. Princeton: Princeton University Press, 1986.

———. *The Modern School Movement: Anarchism and Education in the United States*. Princeton: Princeton University Press, 1980.

Baker, Houston. *Modernism and the Harlem Renaissance*. Chicago: University of Chicago Press, 1987.

Baldwin, Kate A. *Beyond the Color Line and the Iron Curtain: Reading Encounters between Black and Red, 1922–1963*. Durham: Duke University Press, 2002.

Bauer, Ralph. *The Cultural Geography of Colonial American Literatures: Empire, Travel, Modernity*. London: Cambridge University Press, 2003.

Belnap, Jeffrey, and Raúl Fernández. *José Martí's "Our America": From National to Hemispheric Cultural Studies*. Durham: Duke University Press, 1998.

Berdecio, Roberto, and Stanley Appelbaum. *Posada's Popular Mexican Prints*, by José Guadalupe Posada. New York: Dover, 1972.

Berlant, Lauren. *The Female Complaint: The Unfinished Business of Sentimentality in American Culture*. Durham: Duke University Press, 2008.

———. "Poor Eliza." *American Literature* 70, no. 3 (September 1998): 635–68.

———. *The Queen of America Goes to Washington City: Essays on Sex and Citizenship*. Durham: Duke University Press, 1997.

Brickhouse, Anna. "Manzano, Madden, 'El Negro Martir,' and the Revisionist Geographies of Abolitionism." *American Literary Geographies: Spatial Practice and Cultural Production, 1500–1900*, ed. Martin Bruckner and Hsuan Hsu, 209–35. Delaware: University of Delaware Press, 2007.

———. "Hemispheric Jamestown." *Hemispheric American Studies*, ed. Caroline Levander and Robert Levine, 18–35. New Brunswick, N.J.: Rutgers University Press, 2008.

———. "L'Ouragan de Flammes (The Hurricane of Flames): New Orleans and Transamerican Catastrophe, 1866/2005." *American Quarterly* (December 2007): 1097–27.

———. *Transamerican Literary Relations and the Nineteenth-Century Public Sphere*. London: Cambridge University Press, 2004.

Boudreau, Kristin. *The Spectacle of Death: Populist Literary Responses to American Capital Cases*. New York: Prometheus, 2006.

Briggs, Laura, Gladys McCormick, and J. T. Way. "Transnationalism: A Category of Analysis." *American Quarterly* 60, no. 3 (September 2008): 625–48.

Brooks, Peter. *The Melodramatic Imagination: Balzac, Henry James, Melodrama, and the Mode of Excess*. New Haven, Conn.: Yale University Press, 1995.

Brown, Bill. "Reading the West: Cultural and Historical Background." *Reading the West: An Anthology of Dime Westerns*, 1–40. Boston: Bedford Books, 1997.

Brown, Joshua. *Beyond the Lines: Pictorial Reporting, Everyday Life, and the Crisis of Gilded Age America*. Berkeley: University of California Press, 2002.

Buff, Rachel Ida. "The Deportation Terror." *American Quarterly* 60, no. 3 (September 2008): 523–51.

———. *Immigrant Rights in the Shadows of Citizenship*. New York: New York University Press, 2008.

Camacho, Julia María Schiavone. "Crossing Boundaries, Claiming a Homeland: The Mexican Chinese Transpacific Journey to Becoming Mexican, 1930s–1960s." *Pacific Historical Review* 78, no. 4 (November 2009): 545–77.

Cannistraro, Philip, and Gerald Meyer, eds. *The Lost World of Italian-American Radicalism: Politics, Labor, and Culture*. London: Praeger, 2003.

Carroll, Ann Elizabeth. *Word, Image, and the New Negro: Representation and Identity in the Harlem Renaissance*. Bloomington: Indiana University Press, 2005.

Castronovo, Russ. *Beautiful Democracy: Aesthetics and Anarchy in a Global Era*. Chicago: University of Chicago Press, 2007.

Chapman, Mary, and Glenn Hendler. *Sentimental Men: Masculinity and the Politics of Affect in American Culture*. Berkeley: University of California Press, 1999.

Chauncey, George. *Gay New York: Gender, Urban Culture, and the Making of the Gay Male World, 1890–1940*. New York: HarperCollins, 1994.

Clark, Suzanne. *Sentimental Modernism: Women Writers and the Revolution of the Word*. Bloomington: Indiana University Press, 1991.

Clarke, John Henrik, ed. *Marcus Garvey and the Vision of Africa*. New York: Vintage, 1974.

Clough, Patricia, and Jean Halley, eds. *The Affective Turn: Theorizing the Social*. Durham: Duke University Press, 2007.

Clymer, Jeffory A. *America's Culture of Terrorism: Violence, Capitalism, and the Written Word*. Chapel Hill: University of North Carolina Press, 2002.

Cole, Peter. "Introduction." *Ben Fletcher: The Life and Times of a Black Wobbly*, by Ben Fletcher, 1–43. Chicago: Charles H. Kerr, 2007.

———. *Wobblies on the Waterfront: Interracial Unionism in Progressive Philadelphia*. Urbana: University of Illinois Press, 2007.

Conway, Chris. "The Limits of Analogy: José Martí and the Haymarket Anarchists." *A Contracorriente* 2, no. 1 (fall 2004): 33–56.

Corbould, Claire. *Becoming Black American: Black Public Life in Harlem, 1919–1938*. Cambridge: Harvard University Press, 2009.

Cortez, Carlos. *Viva Posada: A Salute to the Great Printmaker of the Mexican Revolution*. Chicago: Charles H. Kerr, 2002.

Coulthardt, Glenn. "Subjects of Empire: Indigenous Peoples and the Politics of Recognition in Colonial Contexts." *Contemporary Political Theory*, no. 6 (2007): 437–60.

Crary, Jonathan. *Techniques of the Observer: On Vision and Modernity in the Nineteenth Century*. Cambridge: MIT Press, 1990.

Cutler, John Levi. *Gilbert Patten and His Frank Merriwell Saga: A Study in Subliterary Fiction, 1896–1913*. Orono: University of Maine Press, 1934.

Cvetkovich, Ann. *An Archive of Feelings: Trauma, Sexuality, and Lesbian Public Cultures*. Durham: Duke University Press, 2003.

DeLamotte, Eugenia C. *Gates of Freedom: Voltairine de Cleyre and the Revolution of the Mind*. Ann Arbor: University of Michigan Press, 2004.

Denning, Michael. *The Cultural Front: The Laboring of American Culture in the Twentieth Century*. London: Verso, 1998.

———. *Culture in the Age of Three Worlds*. London: Verso, 2004.

———. *Mechanic Accents: Dime Novels and Working Class Culture in America*. London: Verso, 1987; 1998.

Drinnon, Richard. *Rebel in Paradise: A Biography of Emma Goldman*. Chicago: University of Chicago Press, 1961.

Edwards, Brent Hayes. *The Practice of Diaspora: Literature, Translation, and the Rise of Black Internationalism*. Cambridge: Harvard University Press, 2003.

Ellis, Mark. *Race, War, and Surveillance: African Americans and the United States Government during World War I*. Bloomington: Indiana University Press, 2001.

Entin, Joe. *Sensational Modernism: Experimental Fiction and Photography in Thirties America*. Chapel Hill: University of North Carolina Press, 2007.

Escobar, Edward J. *Race, Police, and the Making of a Political Identity: Mexican Americans and the Los Angeles Police Department, 1900–1945*. Berkeley: University of California Press, 1999.

Esenwein, George. *Anarchist Ideology and the Working-class Movement in Spain*. Berkeley: University of California Press, 1989.

Falk, Candace. *Love, Anarchy, and Emma Goldman*. New Brunswick, N.J.: Rutgers University Press, 1990.

Ferrer, Ada. *Insurgent Cuba: Race, Nation, and Revolution, 1868–1898*. Chapel Hill: University of North Carolina Press, 1999.

Foley, Barbara. *Spectres of 1919: Class and Nation in the Making of the New Negro*. Urbana: University of Illinois Press, 2003.

Foner, Philip. "Introduction." *Inside the Monster: Writings on the United States and American Imperialism*, by José Martí and Philip S. Foner, 15–48. New York: Monthly Review Press, 1975.

———. "José Martí and Haymarket." *The Haymarket Scrapbook*, ed. Franklin Rosemount and David Roediger, 215–16. Chicago: Charles H. Kerr, 1986.

Fox, Claire. *The Fence and the River: Culture and Politics at the U.S.-Mexico Border*. Minneapolis: University of Minnesota Press, 1999.

Foucault, Michel. *The Birth of Biopolitics: Lectures at the Collège de France, 1978–1979*. Trans. Graham Burchell. New York: Picador, 2010.

———. *Discipline and Punish: The Birth of the Prison*. Trans. Alan Sheridan. New York: Vintage Books, 1995.

———. *Security, Territory, Population: Lectures at the Collège de France 1977–1978*. Trans. Graham Burchell. New York: Picador, 2009.

———. *Society Must Be Defended: Lectures at the College de France, 1975–1976*. Trans. David Macey. New York: Picador, 2003.

Frank, Patrick. *Posada's Broadsheets: Mexican Popular Imagery 1890–1910*. Albuquerque: University of New Mexico Press, 1998.

Freeman, Elizabeth. *Time Binds: Queer Temporalities, Queer Histories*. Durham: Duke University Press, 2010.

Gaines, Jane. *Fire and Desire: Mixed Race Movies in the Silent Era*. Chicago: University of Chicago Press, 2001.

Gaines, Kevin. *Uplifting the Race: Black Leadership, Politics, and Culture in the Twentieth Century*. Chapel Hill: University of North Carolina Press, 1996.

Gates, Henry Louis, Jr., and Gene Andrew Jarrett. *The New Negro: Readings on Race, Representation, and African American Culture, 1892–1938*. Princeton: Princeton University Press, 2007.

Gillman, Susan. "The Epistemology of Slave Conspiracy." *Modern Fiction Studies* 49, no. 1 (spring 2003): 101–23.

———. "Otra vez Caliban / Encore Caliban." *American Literary History* 210, nos. 1 and 2 (spring/summer 2008): 187–209.

———. "Ramona in Our America." *José Martí's "Our America": From National to Hemispheric American Studies*, ed. Jeffrey Belnap and Raúl Fernández, 91–111. Durham: Duke University Press, 1998.

———. "The Squatter, the Don, and the Grandissimes in Our America." *Mixing Race, Mixing Culture: Inter-American Literary Dialogues*, ed. Monika Kaup and Debra Rosenthal, 140–60. Austin: University of Texas Press, 2002.

Goldsby, Jacqueline. *A Spectacular Secret: Lynching in American Life and Literature*. Chicago: University of Chicago Press, 2006.

Gómez-Quiñonez, Juan. *Sembradores, Ricardo Flores Magón y el Partido Liberal Mexicano: A Eulogy and Critique*. Los Angeles: Aztlán, 1973.

Gonzalez-Day, Ken. *Lynching in the West, 1850–1935*. Durham: Duke University Press, 2006.

Gore, Dayo. *Radicalism at the Crossroads: African American Women Activists in the Cold War*. New York: New York University Press, 2011.

Green, James. *Death in the Haymarket: A Story of Chicago, the First Labor Movement, and the Bombing that Divided Gilded Age America*. New York: Pantheon Books, 2006.

Gruesz, Kirsten Silva. *Ambassadors of Culture: The Transamerican Origins of Latino Writing*. Princeton: Princeton University Press, 2001.

———. "America." *Keywords for American Cultural Studies*, ed. Bruce Burgett and Glenn Hendler, 16–22. New York: New York University Press, 2007.

———. "Delta *Desterrados*: Antebellum New Orleans and New World Print Culture." *Look Away!: The U.S. South in New World Studies*, ed. Jon Smith and Deborah Cohn, 52–79. Durham: Duke University Press, 2004.

———. "The Gulf of Mexico System and the 'Latinness' of New Orleans." *American Literary History* 18, no. 4 (fall 2006): 468–95.

———. "The Mercurial Space of 'Central' America: New Orleans, Honduras, and the Writing of the Banana Republic." *Hemispheric American Studies*, ed. Caroline Levander and Robert S. Levine, 140–65. New Brunswick, N.J.: Rutgers University Press, 2007.

———. "Translation: A Key(word) into the Language of America(nists)." *American Literary History* 16, no. 1 (spring 2004): 85–92.

Guidotti-Hernández, Nicole. *Unspeakable Violence: Remapping U.S. and Mexican National Imaginaries*. Durham: Duke University Press, 2011.

Gutman, Herbert. "The International Socialist Review, Chicago, 1900–1918." *The American Radical Press, 1880–1960*, vol. 2, ed. Joseph R. Conlin, 82–86. Westport, Conn.: Greenwood, 1974.

Halberstam, Judith. *Female Masculinity*. Durham: Duke University Press, 1998.

———. *In a Queer Time and Place: Transgender Bodies, Subcultural Lives*. New York: New York University Press, 2005.

Halttunen, Karen. "Humanitarianism and the Pornography of Pain in Anglo-American Culture." *American Historical Review* 100, no. 2 (April 1995): 303–34.

Hardt, Michael. "Affective Labor." *boundary 2* 26, no. 2 (summer 1999): 89–100.

Harris, Neal. "Iconography and Intellectual History: The Half-Tone Effect." *New Directions in American Intellectual History*, ed. John Higgins and Paul Conkins, 304–17. Baltimore: Johns Hopkins University Press, 1979.

Hart, John Mason. *Anarchism and the Mexican Working Class, 1860–1931*. Austin: University of Texas Press, 1987.

———. *Empire and Revolution: The Americans in Mexico since the Civil War*. Berkeley: University of California Press, 2002.

Hartman, Saidiya. *Scenes of Subjection: Terror, Slavery, and Self-Making in Nineteenth-Century America*. New York: Oxford University Press, 1997.

Hill, Rebecca N. *Men, Mobs, and Law: Anti-Lynching and Labor Defense in U.S. Radical History*. Durham: Duke University Press, 2008.

Hill, Robert A. "Introduction." *The Crusader, Volume 1: September 1918–August 1919*, v–lxvi. London: Garland, 1987.

Hirsch, Marianne, ed. *The Familial Gaze*. Hanover, N.H.: University Press of New England, 1999.

———. *Family Frames: Photography, Narrative, and Post-memory*. Cambridge, Mass.: Harvard University Press, 1997.

Horne, Gerald. *Black and Brown: African Americans and the Mexican Revolution*. New York: New York University Press, 2005.

Hu-De Hart, Evelyn. *Yaqui Resistance and Survival: The Struggle for Land and Autonomy, 1821–1910*. Madison: University of Wisconsin Press, 1984.

Ioanide, Paula. "Story of Abner Louima: Cultural Fantasies, Gendered Racial Violence, and the Ethical Witness." *Journal of Haitian Studies* (spring 2007): 4–26.

James, Joy. *Resisting State Violence: Radicalism, Gender, and Race in U.S. Culture*. Minneapolis: University of Minnesota Press, 1998.

James, Winston. *Holding Aloft the Banner of Ethiopia: Caribbean Radicalism in Early Twentieth-Century America*. London: Verso, 1998.

Kaplan, Amy. *The Anarchy of Empire in the Making of U.S. Culture*. Cambridge, Mass.: Harvard University Press, 2002.

Keeling, Kara. "Looking for M—: Queer Temporality, Black Political Possibility, and Poetry from the Future." *GLQ* 15, no. 4 (2009): 565–82.

Kelley, Robin D. G. *Freedom Dreams: The Black Radical Imagination*. Boston: Beacon, 2002.

Kelly, Jane Holden. *Yaqui Women: Contemporary Life Histories*. Lincoln: University of Nebraska Press, 1978.

Kipnis, Ira. *The American Socialist Movement, 1897–1912*. New York: Columbia University Press, 1952.

Klein, Christina. *Cold War Orientalism: Asia in the Middlebrow Imagination*. Berkeley: University of California Press, 2003.

Kohn, Stephen M. *American Political Prisoners: Prosecutions under the Espionage and Sedition Acts*. Westport, Conn.: Praeger, 1994.

Kornweibel, Theodore, Jr. *"Investigate Everything": Federal Efforts to Compel Black Loyalty during World War I*. Bloomington: Indiana University Press, 2002.

———. *No Crystal Stair: Black Life and the Messenger, 1917–1928*. Westport, Conn.: Greenwood, 1975.

Kramer, Paul. *The Blood of Government: Race, Empire, the United States, and the Philippines*. Chapel Hill: University of North Carolina Press, 2008.

Krause, Paul. *The Battle for Homestead, 1890–1892: Politics, Culture, and Steel*. Pittsburgh: University of Pittsburgh Press, 1992.

La Feber, Walter. *The New Empire: An Interpretation of American Expansion, 1860–1898*. 1963. Reprint, Ithaca, N.Y.: Cornell University Press, 1998.

Langham, Thomas. *Border Trials: Ricardo Flores Magón and the Mexican Liberals*. Southwestern Studies: Monograph 65, 1982.

Lazo, Rodrigo. *Writing to Cuba: Filibustering and Cuban Exiles in the United States*. Chapel Hill: University of North Carolina Press, 2005.

Lee, Erika. *At America's Gates: Chinese Immigration during the Exclusion Era, 1882–1943*. Chapel Hill: University of North Carolina Press, 2007.

LeFalle-Collins, Lizzie, and Shifra M. Goldman. *In the Spirit of Resistance: African American Modernists and the Mexican Muralist School*. New York: New York University Press, 2005.

Levander, Caroline, and Robert S. Levine. "Introduction: Hemispheric American Literary History." *American Literary History* 18, no. 3 (autumn 2006): 397–405.

———. *Hemispheric American Studies*. New Brunswick, N.J.: Rutgers University Press, 2008.

Lewis, David Leavering. *W. E. B. Du Bois: Biography of a Race, 1868–1919*. New York: Macmillan, 1994.

———. *When Harlem Was in Vogue*. New York: Knopf, 1981.

Límon, José. *American Encounters: Greater Mexico, the United States, and the Erotics of Culture*. Boston: Beacon, 1998.

Lipsitz, George. *American Studies in a Moment of Danger*. Minneapolis: University of Minnesota Press, 2001.

Lomas, Laura. *Translating Empire: José Martí, Migrant Latino Subjects, and American Modernities*. Durham: Duke University Press, 2009.

Lomnitz, Claudio. "Chronotopes of a Dystopic Nation: Cultures of Dependency and Border Crossings in Late Porfirian Mexico." *Globalizing American Studies*,

ed. Brian Edwards and Dilip Gaonkar, 209–39. Chicago: University of Chicago Press, 2010.

Lowe, Lisa. "The Intimacies of Four Continents." *Haunted by Empire: Geographies of Intimacy in North American History*, ed. Ann Laura Stoler, 191–212. Durham: Duke University Press, 2006.

Luciano, Dana. *Arranging Grief: Sacred Time and the Body in Nineteenth-Century America*. New York: New York University Press, 2007.

Luis Brown, David. *Waves of Decolonization: Discourses of Race and Hemispheric Citizenship in Cuba, Mexico, and the United States*. Durham: Duke University Press, 2008.

Lye, Colleen. *America's Asia: Racial Form and American Literature, 1893–1945*. Princeton: Princeton University Press, 2005.

MacLachlan, Colin. *Anarchism and the Mexican Revolution: The Political Trials of Ricardo Flores Magón in the United States*. Berkeley: University of California Press, 1991.

Marez, Curtis. *Drug Wars: The Political Economy of Narcotics*. Minneapolis: University of Minnesota Press, 2004.

———. "Pancho Villa Meets Sun Yat-sen: Third World Revolution and the History of Hollywood Cinema." *American Literary History* 17, no. 3 (2005): 486–505.

Marsh, Margaret. *Anarchist Women 1870–1920*. Philadelphia: Temple University Press, 1981.

Martin, Tony. "Bibliophiles, Activists, and Race Men." *Black Bibliophiles and Collectors: Preservers of Black History*, ed. Elinor Des Verney Sinnette, W. Paul Coates, and Thomas C. Battle, 23–24. Washington, D.C.: Howard University Press, 1990.

Martínez, Anne. "Lucy G. Parsons." *The Oxford Encyclopedia of Latinos and Latinas in the United States*, ed. Deena Gonzales and Suzanne Oboler, 331–33. New York: Oxford University Press, 2005.

Massumi, Brian. *Parables for the Virtual: Movement, Affect, Sensation*. Durham: Duke University Press, 2002.

Maxwell, William. *New Negro, Old Left: African-American Writing and Communism between the Wars*. New York: Columbia University Press, 1999.

McAlister, Melani. *Epic Encounters: Culture, Media, and U.S. Interests in the Middle East*. Updated edn. with a post-9/11 chapter. Berkeley: University of California Press, 2003.

McDuffie, Erik S. "'A New Freedom Movement of Negro Women': Sojourning for Truth, Justice, and Human Rights during the Early Cold War." *Radical History Review* 101 (spring 2008): 85–106.

Messer-Kruse, Timothy. *The Trial of the Haymarket Anarchists: Terrorism and Justice in the Gilded Age*. New York: Palgrave Macmillan, 2011.

Meyer, Eugenia. *John Kenneth Turner, Periodista de México*. Mexico City: Ediciones Era, 2005.

Miles, Tiya. "His Kingdom for a Kiss: Indians and Intimacy in the Narrative of John Marrant." *Haunted by Empire: Geographies of Intimacy in North American History*, ed. Ann Laura Stoler, 162–88. Durham: Duke University Press, 2006.

Mirzoeff, Nicholas. *The Visual Culture Reader.* 2d edn. London: Routledge, 1998.

Moten, Fred. "Black Mo'nin'." *Loss: The Politics of Mourning*, ed. David Eng and David Kazanjian, 59–76. Berkeley: University of California Press, 2002.

———. *In the Break: The Aesthetics of the Black Radical Tradition.* Minneapolis: University of Minnesota Press, 2003.

Mumford, Kevin. *Interzones: Black/White Sex Districts in Chicago and New York in the Early Twentieth Century.* New York: Columbia University Press, 1996.

Muñoz, José Esteban. *Cruising Utopia: The Then and There of Queer Futurity.* New York: New York University Press, 2009.

———. "Feeling Brown: Ethnicity and Affect in Richard Bracho's *The Sweetest Hangover (and other STDs).*" *Theater Journal* 54, no. 1 (March 2000): 67–79.

Murphy, Gretchen. *Hemispheric Imaginings: The Monroe Doctrine and Narratives of U.S. Empire.* Durham: Duke University Press, 2005.

———. *Shadowing the White Man's Burden: U.S. Imperialism and the Problem of the Color Line.* Durham: Duke University Press, 2010.

Murphy, Paul. *World War I and the Origin of Civil Liberties in the United States.* New York: W. W. Norton, 1979.

Musser, Charles. *The Emergence of Cinema: The American Screen to 1907.* Berkeley: University of California Press, 1990.

Nadell, Martha. *Enter the New Negro: Images of Race in American Culture.* Cambridge, Mass.: Harvard University Press, 2004.

Nasaw, David. *The Chief: The Life of William Randolph Hearst.* Boston: Houghton Mifflin, 2000.

Nelson, Bruce. *Beyond the Martyrs: A Social History of Chicago's Anarchists, 1870–1900.* New Brunswick, N.J.: Rutgers University Press, 1988.

Nelson, Eugene. "Introduction." *Crystal Gazing, the Amber Fluid, and Other Wobbly Poems*, by Carlos Cortez, 1–9. Chicago: Charles Kerr, 1990.

Norvell, Elizabeth Jean. "Syndicalism and Citizenship: Postrevolutionary Workers Mobilizations in Veracruz." *Border Crossings: Mexican and Mexican-American Workers*, ed. John Mason Hart, 93–116. Wilmington, Del.: Scholarly Resources, 1998.

Nudelman, Franny. *John Brown's Body: Slavery, Violence, and the Culture of War.* Chapel Hill: University of North Carolina Press, 2004.

Nyong'o, Tavia. "Race, Reenactment, and the 'Natural Born Citizen.'" *Unauthorized States: New Essays in 19th Century American Literary Studies*, ed. Ivy Wilson and Dana Luciano. New York: New York University Press, forthcoming.

Olson, Joel. *The Abolition of White Democracy.* Minneapolis: University of Minnesota Press, 2004.

———. "Between Infoshops and Insurrection: U.S. Anarchism, Movement Building, and the Racial Order." Available at http://jan.ucc.nau.edu/~jo52 /Anarchism-and-Race-public.pdf.

Pérez, Emma. *The Decolonial Imaginary: Writing Chicanas into History*. Bloomington: Indiana University Press, 1999.

Perry, Jeffrey. *Hubert Harrison: The Voice of Harlem Radicalism, 1883–1918*. New York: Columbia University Press, 2009.

Poyo, Gerald E. *With All, and for the Good of All: The Emergence of Popular Nationalism in the Cuban Communities of the United States, 1848–1898*. Durham: Duke University Press, 1989.

Preston, William, Jr. *Aliens and Dissenters: Federal Suppression of Radicals, 1903–1933*. 2d edn. Urbana: University of Illinois Press, 1994.

Puar, Jasbir K. *Terrorist Assemblages: Homonationalism in Queer Times*. Durham: Duke University Press, 2007.

Raat, Dirk. *Revoltosos: Mexico's Rebels in the United States, 1903–1923*. College Station: Texas A&M University Press, 1981.

Ramos, Julio. *Divergent Modernities: Culture and Politics in Nineteenth-Century Latin America*. Trans. John D. Blanco. Durham: Duke University Press, 2001.

Ransby, Barbara. *Ella Baker and the Black Freedom Movement: A Radical Democratic Vision*. Chapel Hill: University of North Carolina Press, 2005.

Robinson, Cedric. *Black Marxism: The Making of the Black Radical Tradition*. Chapel Hill: University of North Carolina Press, 2000.

Roediger, David. "Strange Legacies: The Black International and Black America." *The Haymarket Scrapbook*, ed. Franklin Rosemount and David Roediger, 93–96. Chicago: Charles H. Kerr, 1986.

———. *The Wages of Whiteness: Race and the Making of the American Working Class*. London: Verso, 1994.

Romero, Robert Chao. *The Chinese in Mexico, 1882–1940*. Tempe: University of Arizona Press, 2010.

Ronning, C. Neale. *José Martí and the Émigré Colony in Key West: Leadership and State Formation*. New York: Praeger, 1990.

Rosemont, Franklin, and David Roediger, eds. *The Haymarket Scrapbook*. Chicago: Charles H. Kerr, 1986.

Ross, Marlon B. *Manning the Race: Reforming Black Men in the Jim Crow Era*. New York: New York University Press, 2004.

Rotker, Susana. *The American Chronicles of José Martí: Journalism and Modernity in Spanish America*. Hanover, N.H.: University Press of New England, 2000.

Ruff, Alan. *We Called Each Other Comrade: Charles H. Kerr and Company, Radical Publishers*. Urbana: University of Illinois Press, 1997.

Sadowski-Smith, Claudia. *Border Fictions: Globalization, Empire, and Writing at the Boundaries of the United States*. Charlottesville: University of Virginia Press, 2008.

Salerno, Salvatore. "Paterson's Italian Anarchist Silk Workers and the Politics of Race." *Working USA* 8, no. 5 (September 2005): 611–25.

———. *Red November, Black November: Culture and Community in the Industrial Workers of the World*. Albany: State University of New York Press, 1989.

Sandos, James. *Rebellion in the Borderlands: Anarchism and the Plan of San Diego, 1904–1923.* Norman: University of Oklahoma Press, 1992.

Saxton, Alexander. *The Indispensable Enemy: Labor and the Anti-Chinese Movement in California.* Berkeley: University of California Press, 1995.

Schreiber, Rebecca. *Cold War Exiles in Mexico: U.S. Dissidents and the Culture of Critical Resistance.* Minneapolis: University of Minnesota Press, 2008.

Schwartz, Vanessa R., and Jeannene M. Przyblyski, eds. *The Nineteenth-Century Visual Culture Reader.* New York: Routledge, 2004.

Sedgwick, Eve Kosofsky. *Touching Feeling: Affect, Pedagogy, Performativity.* Durham: Duke University Press, 2003.

Seigel, Micol. "Beyond Compare: Comparative Method after the Transnational Turn." *Radical History Review,* no. 91 (winter 2005): 62–90.

Sekula, Alan. "The Body and the Archive." *The Contest of Meaning: Critical Histories of Photography,* ed. R. Bolton, 343–48. Cambridge: MIT Press, 1992.

———. *Photography Against the Grain: Essays and Photo Works, 1975–1983.* Halifax: Press of the Nova Scotia College of Art and Design, 1984.

Shah, Nayan. "Adjudicating Intimacies on U.S. Frontiers." *Haunted by Empire: Geographies of Intimacy in North American History,* ed. Ann Laura Stoler, 116–39. Durham: Duke University Press, 2006.

Shukla, Sandhya, and Heidi Tinsman. "Introduction: Across the Americas." *Imagining Our Americas: Toward a Transnational Frame,* ed. Sandhya Shukla and Heidi Tinsman, 1–33. Durham: Duke University Press, 2007.

Singer, Ben. *Melodrama and Modernity: Early Sensational Cinema and Its Contexts.* New York: Columbia University Press, 2001.

Singh, Nikhil Pal. *Black Is a Country: Race and the Unfinished Struggle for Democracy.* Cambridge: Harvard University Press, 2005.

Sinha, Mrinalini. *Specters of Mother India: The Global Restructuring of an Empire.* Durham: Duke University Press, 2006.

Smith, Carl. *Urban Disorder and the Shape of Belief.* Chicago: University of Chicago Press, 1995.

Smith, Shawn Michelle. *Photography on the Color Line: W. E. B. Du Bois, Race, and Visual Culture.* Durham: Duke University Press, 2004.

Sommer, Doris. *Foundational Fictions: The National Romances of Latin America.* Berkeley: University of California Press, 1991.

Stanley, Amy Dru. *From Bondage to Contract: Wage Labor, Marriage, and the Market in the Age of Slave Emancipation.* Cambridge: Cambridge University Press, 1998.

Stephens, Michelle Ann. *Black Empire: The Masculine Global Imaginary of Caribbean Intellectuals in the United States, 1914–1962.* Durham: Duke University Press, 2005.

Stewart, Jacqueline Najuma. *Migrating to the Movies: Cinema and Black Urban Modernity.* Berkeley: University of California Press, 2005.

Stoler, Ann Laura. "Tense and Tender Ties: The Politics of Comparison in North

American History and (Post) Colonial Studies." *Haunted by Empire: Geographies of Intimacy in North American History*, ed. Ann Laura Stoler, 829–65. Durham: Duke University Press, 2006.

Streeby, Shelley. *American Sensations: Class, Empire, and the Production of Popular Culture*. Berkeley: University of California Press, 2002.

———. "Doing Justice to the Archive: Beyond Literature." *Unauthorized States: New Essays in 19th Century American Literary Studies*, ed. Ivy Wilson and Dana Luciano. New York: New York University Press, forthcoming.

Sturken, Marita. *Tangled Memories: The Vietnam War, the AIDS Epidemic, and the Politics of Remembering*. Berkeley: University of California Press, 1997.

Sturken, Marita, and Lisa Cartwright. *Practices of Looking: An Introduction to Visual Culture*. New York: Oxford University Press, 2004.

Tagg, John. *The Burden of Representation: Essays on Photographies and Histories*. Minneapolis: University of Minnesota Press, 1988.

Tal, Kali. "That Just Kills Me: Black Militant Near Future Fiction." *Social Text* 20, no. 2 (summer 2002): 65–91.

Taylor, Ula Yvette. *The Veiled Garvey: The Life and Times of Amy Jacques Garvey*. Chapel Hill: University of North Carolina Press, 2002.

Tejada, Roberto. *National Camera: Photography and Mexico's Image Environment*. Minneapolis: University of Minnesota Press, 2009.

Temkin, Moshik. *The Sacco-Vanzetti Affair: America on Trial*. New Haven, Conn.: Yale University Press, 2009.

Thomas, William H., Jr. *Unsafe for Democracy: World War I and the U.S. Justice Department's Covert Campaign to Suppress Dissent*. Madison: University of Wisconsin Press, 2008.

Torres Parés, Javier. *La Revolución sin frontera: El Partido Liberal Mexicano y las relaciónes entre el movimiento obrero de México y el de Estados Unidos, 1900–1923*. UNAM, Mexico City: Ediciónes y Distribuciónes Hispanicas, 1990.

Trachtenberg, Alan. *Reading American Photographs: Images as History, Mathew Brady to Walker Evans*. New York: Hill and Wang, 1990.

Truett, Samuel. *Fugitive Landscapes: The Forgotten History of the U.S.-Mexico Borderlands*. New Haven, Conn.: Yale University Press, 2006.

Tucker, Susan. "Telling Particular Stories: Two African American Memory Books." *The Scrapbook in American Life*, ed. Susan Tucker, Katherine Ott, and Patricia Buckler, 220–34. Philadelphia: Temple University Press, 2006.

Verter, Mitchell. "Chronology." *Dreams of Freedom: A Ricardo Flores Magón Reader*, by Ricardo Flores Magón, ed. Chaz Bufe and Mitchell Verter, 338–74. Oakland: AK Press, 2005.

Vogel, Shane. *The Scene of Harlem Cabaret: Race, Sexuality, Performance*. Chicago: University of Chicago Press, 2009.

Watkins-Owens, Irma. *Blood Relations: Caribbean Immigrants and the Harlem Community, 1900–1930*. Bloomington: Indiana University Press, 1996.

Weber, Devra. "Keeping Community, Challenging Boundaries: Indigenous Mi-

grants, Internationalist Workers, and Mexican Revolutionaries, 1900–1920."
Mexico and Mexicans in the Making of the United States, ed. John Tutino, 208–
35. Austin: University of Texas Press, 2012.

Wexler, Laura. *Tender Violence: Domestic Visions in an Age of U.S. Imperialism.*
Durham: University of North Carolina Press, 2000.

Williams, Linda. *Playing the Race Card: Melodramas of Black and White from Uncle
Tom to O. J. Simpson.* Princeton: Princeton University Press, 2001.

Williams, Randall. *The Divided World: Human Rights and Its Violence.* Minneapo-
lis: University of Minnesota Press, 2010.

Yoneyama, Lisa. *Hiroshima Traces: Time, Space, and the Dialectics of Memory.*
Berkeley: University of California Press, 1999.

Young, Cynthia A. *Soul Power: Culture, Radicalism, and the Making of a U.S. Third
World Left.* Durham: Duke University Press, 2006.

Zamora, Emilio. *The World of the Mexican Worker in Texas.* College Station: Texas
A&M University Press, 1993.

Zinn, Howard. *Emma.* Boston: South End, 2002.

INDEX

Africa: in the *Crusader*, 179, 188, 190; in
Hubert Harrison's scrapbooks, 28,
196, 214–15, 247; Marcus Garvey and,
28, 180–82, 185, 187, 194, 199, 233, 243,
245–46, 259, 300fn35
African Blood Brotherhood, 1, 14, 179
Alarm (Chicago, Illinois), 40, 71–72,
79–83, 95
American Magazine, 24, 114–15, 119, 130,
135, 137, 139–62
Anarchism, 1–2, 5, 72, 74, 128, 183, 252;
Alexander Berkman and, 75–77, 149;
anarchist-socialist relations, 121–22;
Chicago Haymarket anarchists, 6, 7, 9,
11, 15–16, 21–22, 25–70, 80, 81, 82, 84;
critique of state power, 16; Emma Gold-
man and, 253–54, 261–65; Hubert Har-
rison and, 223, 239; Lazaro Gutiérrez
de Lara and, 118–19; Ricardo Flores
Magón's and PLM's, 6, 19, 23–24,
88–89, 96–97, 101, 107, 114, 117, 129, 146,
158–60; and sexuality, 30, 199; Vol-
tairine du Cleyre and, 91–94
Anderson, Benedict, 39, 45, 58, 136
Appeal to Reason (Girard, Kansas), 117,
122–23, 125–26, 131, 147–48, 151, 217
Arbeiter-Zeitung (Chicago, Illinois), 57,
95–96

Baldwin, Kate, 26
Barbarous Mexico (John Kenneth Turner),
24–25, 97, 114–68, 170–71
Berkman, Alexander, 16, 41, 74–76, 149,
182, 253, 259, 261–64
Berlant, Lauren, 37, 165
Birth of a Nation (D. W. Griffith), 28, 227,
241

Black, William, 67, 87
Brickhouse, Anna, 17, 274n38, 285n2
Briggs, Cyril, 26–27, 179, 181, 183–88, 191–
94, 273, 275n46, 289n1
Brown, Bill, 161
Brown, David Luis, 15
Brown, John, 85–86, 282n19
Brown, Joshua, 15, 18, 41, 48, 51, 58, 61,
137

Caminita, Ludovico, 100–103, 107, 285n44
Cartoons, 17, 18, 19, 22, 37, 234, 273n35;
in the black press, 14, 187, 295n27;
Carlos Cortez and, 4, 12–14; in Hubert
Harrison's scrapbooks, 196, 201–2,
204, 206–10, 216, 228, 230, 297n50; in
Mexico, 11–12, 107, 127–28; in *Regenera-
ción* and PLM publications, 72, 74–75,
96–103, 107, 284n43, 285n27
Chicago Defender, 180, 182, 201, 207, 209–
10, 216, 259–60
China: anarchism in, 36; in Hubert Har-
rison's scrapbooks, 212, 214, 246–47
Chinese workers: in *Barbarous Mexico*,
144–46; in Hubert Harrison's scrap-
books, 215; in *The Mexican People*
(160); in Mexico, 167–72
Civil War (U.S.), 15, 29; comparison of
Mexican conflicts to, 78, 91, 117, 132–34,
147, 149; continuities between freedom
and slavery after, 84–86, 93–94, 281n19;
in Hubert Harrison's scrapbooks, 28,
196, 210–11, 227, 234
Clymer, Jeffory, 44
Cortez, Carlos, 2–14, 251, 271n15, 271n17
Crusader, 14, 21, 26–27, 179–80, 183–94,
245

Hartman, Saidiya, 41, 277n16
Haymarket: anarchists, 7, 8, 9, 11, 15, 21, 75; Emma Goldman and, 261, 264; global dimensions of, 2, 21–23, 36–109; Hubert Harrison and, 239; in José Martí's chronicles, 36–57; memorialization of, 29, 72, 81–96, 282n19; in *Regeneración*, 80, 96, 97; riot, 1, 2, 4, 6, 35; trial, 270n8; in visual culture, 42–70
Haywood, Big Bill, 9, 86, 176, 238, 253
Hearst, William Randolph: in the *Crusader*, 192–93; *Hearst's Magazine*, 28, 196, 223–25; Hubert Harrison's view of, 194, 220–25, 233, 250; media empire, 18, 216, 217, 222; and *Patria*, 296n45; promotion of war with Mexico, 79, 192; in *Regeneración*, 90, 113, 274n37, 279–80n3; and sensationalism, 14, 233; yellow journalism, 12
Hemispheric American Studies, 274–75n38
Henson, Matthew, 204–5
Holmes, Lizzie, 64–66
Hoover, J. Edgar, 178, 253

Imperialism: in Caribbean contexts, 192; connections to Dutch term plunderbund, 74; critique of Garvey as imperialist, 233; European imperialism, 247–48; in Hubert Harrison's scrapbooks, 196; new empire, 117, 147, 263; sentimental erasure of, 41
Industrial Workers of the World, 1–14, 22, 26, 38, 72, 75, 81, 86–87, 129, 175–78, 196, 217, 238, 252, 270n12, 281n16, 282n25
International Colored Unity League, 1, 28, 177, 235, 246, 250
Internationalism: black, 17, 25–26, 28, 179; in Hubert Harrison's scrapbooks, 196–97, 203, 219, 239, 241–42; and the IWW, 86, 271n12; revolutionary, 149, 151–67; struggles over, 20, 87, 194, 241–42, 251, 252; Woodrow Wilson's, 1, 21, 203, 219
International Socialist Review, 24, 88–89, 115, 117, 151–59, 207, 231, 236, 238, 288n1
International Working People's Association, 1, 40, 41, 72

Kaplan, Amy, 19, 271n19
Keeling, Kara, 29, 276n48
Kelley, Jane Holden, 167–72
Ku Klux Klan, 14, 179, 182, 183, 198, 219, 227–28, 231, 234, 298n9

League of Nations, 1, 26, 179
Leavenworth Prison, 2, 7, 8, 77, 178, 254, 258
Liberty League, 14, 176, 177, 181, 240, 243
Lincoln, Abraham, 93, 211
Lingg, Louis, 37–39
Linocuts, 2, 4, 11, 251, 271n15, 271n17
Lipsitz, George, 20–21, 275n41
Lomas, Laura, 15, 40, 45, 278n23
London, Jack, 159, 217
Luciano, Dana, 276n51
Lye, Colleen, 182
Lynching: anti-lynching movement, 16, 28, 176, 179, 262, 295n26; in Hubert Harrison's scrapbooks, 201–10, 221, 235, 236, 239–41; Lucy Parsons on, 85; in Mexican contexts, 147, 192; political cartoons and, 14, 128, 295n27; postcards of, 193, 277n16, 294n24

Marcy, Mary, 151, 158–59
Marine Transport Workers, 1, 8–9, 177
Marriage, 2; anarchist view of, 30, 93–94, 199, 256, 283n38; Lucy Parsons and, 41, 52, 93–94; uplift and, 99
Martí, José, 17, 21–22, 35–58, 64, 65, 66, 68–69
Mass culture, 11, 12, 14, 16, 18, 21, 22, 25–28; and black internationalism, 176–94; and Haymarket, 35–66, 96; in Hubert Harrison's scrapbooks, 196, 198–99, 209, 216–17, 221–34, 240, 244–46, 249–50; and U.S. intervention in Mexico, 113, 167
McAlister, Melani, 20
McKay, Claude, 204, 242, 294n18
Melodrama: in *Barbarous Mexico*, 153, 158; in the Frank Merriwell dime novels, 163–67; heroes, victims, and villains in, 17; Lucy Parsons and, 65–66, 69; Martí and, 44–45, 56; in mass culture, 234; Ricardo Flores Magón and, 106–7, 113,

Reveles, Nicolas, 80, 100–107
Robinson, Cedric, 17, 197
Roediger, David, 277n6, 279n34, 280n4, 281n19, 288n68

Saxton, Alexander, 145
Schaack, Michael, 39, 43, 48, 62, 64, 68, 270n8
Schreiber, Rebecca, 19, 52
Sekula, Alan, 52
Sensation, 251–52, 261, 268; in the Americas, 17, 45, 47, 56, 271–72n25; in the black press, 14, 27, 175–94; focus on bodies, 161; Hubert Harrison's critiques of, 26, 28, 198–99, 201, 225, 233–34, 235–37, 239, 244–45, 249–50, 301n38; in mass culture, 12, 16, 17; in Mexican contexts, 11, 24–25, 73, 80, 88, 98, 106–7, 111, 113–14, 115, 124–48, 158, 167, 258; pejorative meanings of, 17; persistence of, 30–31; radicals' debates over, 1–2; relation to the sentimental, 15, 273n33, 278n21; and temporality, 276n51; in U.S.-Mexico War literature, 166; in visual culture, 41–42, 52, 57, 65–70
Sentiment, 1–2, 14–15, 22, 268; in the Americas, 15, 17, 22, 45, 56, 107, 125; in the black radical press, 190, 241, 245; in dime novels, 160–67; Emma Goldman and, 261; and the Enrique Flores Magón deportation case, 254, 256, 258; Hubert Harrison's critique of, 26, 27, 28, 235, 239, 242, 250; in mass culture, 18, 54, 62, 64, 65, 66, 179; in Mexican contexts, 24–25, 73–74, 113–15, 130, 133, 135, 137, 140, 142, 144, 148, 160; persistence of, 30–31; and portraits, 58, 205; sentimental domesticity, 59; social movements and, 124; sympathy and, 46–47, 52–53; in visual culture, 18, 20, 21, 36, 41–42, 44–45, 69–70
Sexuality: association of anarchism with perversion, 50; debates within radical movements over, 1, 92–94, 284n38; 301–2n38; homosexuality, 75, 200; Hubert Harrison's lectures on, 199, 236;

in sensational literature, 27, 186; in the uplift movement, 194, 197, 250
Slavery: in the Americas, 40; continuities between freedom and, 15, 23, 83, 84–86, 211, 227, 230, 234, 281–82n19; marriage as, 91–94, 283n38; in Mexican contexts, 24–25, 73, 87, 90, 113–15, 124, 131–34, 138–40, 144, 147–49, 152–53, 156, 158; scrapbooks and, 292n7
Smith, Shawn Michelle, 41, 203, 205, 278n16, 294n21
Socialism: Cyril Briggs and, 186; Hubert Harrison and, 219, 231, 234, 236, 239
Socialist Party of America, 158; London Socialist League, 84; and mode of production narrative, 88–89; in U.S.-Mexico borderlands contexts, 89, 111–72; view of revolution as a transformation in government, 122
Spanish American War, 14, 27, 189, 191, 193, 233, 261
Spies, August, 45–47, 52, 54, 56–57, 75, 96
State: black statehood, 26–27, 190–94, 196, 239, 246; capture of mass culture by, 18; collaboration between the state and capitalism, 117, 125, 128, 129, 141; critiques of the, 16, 24, 31, 77, 80–81, 94, 97, 102, 107, 113, 149, 160; debates over role of, 1–2, 22, 25; deportation and the, 251–68; socialist view of the, 88–89, 158; state power, 6, 8, 16, 19, 21, 87, 156; state violence, 15–16, 17, 30, 35–70, 75, 78, 86, 115, 116, 148, 167–72, 251; transnational collaboration between states, 40, 72–73
Stephens, Michelle, 17, 25–27, 180, 183, 190, 196
Stereopticon, 195–97, 200, 292n3
Stoddard, Theodore Lothrop, 220–21
Stowe, Harriet Beecher, 24, 133, 148, 162, 227

Taft, William Howard, 83, 134, 148, 153–56
Tejada, Roberto, 128, 153, 156
Telegraph, 37, 42–44, 54
Time and temporality, 29–30, 212, 269n1, 276n48, 276n51
Tip Top Weekly, 161–64

Tribadism, 195, 200, 293n17

Turner, Ethel Duffy, 21, 23, 115–16, 119–22, 129, 133, 135, 138, 158, 159, 285n3

Turner, John Kenneth, 21, 23–25, 30, 88, 111–61, 166, 167, 168, 170, 171, 214, 285n10, 287n32

Uncle Tom's Cabin (Stowe), 24, 132–33, 148, 163, 227, 280n5

Universal Negro Improvement Association (UNIA), 1, 14, 17, 21, 26, 28, 176, 177, 179–84, 194, 195, 196, 211, 220, 234, 244, 260

Uplift ideology, 25, 27, 30, 186, 194, 197–201, 231

U.S.-Mexico War, 20, 117, 128, 132, 133, 137, 138, 160, 166–67, 214, 272n26

Utopia, 19, 36, 101, 106, 185, 190, 236, 242, 301n38

Van Der Zee, James, 26, 180

Van Zandt, Nina, 45, 46, 64

Varian, George, 137, 142–45

Villa, Pancho, 23, 87, 117

Virgin Islands, 26, 175, 177, 192, 195–96, 214–15, 250, 289n1

Weber, Devra, 129, 287n29

Wexler, Laura, 14, 41, 255

Whiteness, 28, 52–54, 225, 233

Williams, Linda, 15, 133, 163

Wilson, Woodrow, 278n21

Yaquis, 129, 131, 152; in Chepa Moreno's testimonio, 167–72; deportation of, 115, 137, 139–49, 153–54, 160, 277n33; in dime novels, 161–66; Mexico's wars on, 16, 21, 24, 25, 132–34

Shelley Streeby is professor of ethnic studies and literature at the University of California, San Diego. She is the author of *American Sensations: Class, Race, and the Production of Popular Culture* (2002) and the editor (with Jesse Alemán) of *Empire and the Literature of Sensation: An Anthology of Nineteenth-Century Popular Fiction* (2007).

Library of Congress Cataloging-in-Publication Data
Streeby, Shelley, 1963–
Radical sensations : world movements, violence, and
visual culture / Shelley Streeby.
p. cm.
Includes bibliographical references and index.
ISBN 978-0-8223-5280-8 (cloth : alk. paper)
ISBN 978-0-8223-5291-4 (pbk. : alk. paper)
1. Arts, Modern—20th century—Political aspects. 2. Political violence—History—20th century. 3. Social movements—History—20th century. I. Title.
NX456.S85 2013
700.1′0309041—dc23 2012033856